# Poor
# but Sexy

## Culture Clashes in Europe
## East and West

# Poor
# but Sexy

Culture Clashes in Europe
East and West

Agata Pyzik

Winchester, UK
Washington, USA

First published by Zero Books, 2014
Zero Books is an imprint of John Hunt Publishing Ltd., Laurel House, Station Approach,
Alresford, Hants, SO24 9JH, UK
office1@jhpbooks.net
www.johnhuntpublishing.com
www.zero-books.net

For distributor details and how to order please visit the 'Ordering' section on our website.

Text copyright: Agata Pyzik 2013

ISBN: 978 1 78099 394 2

A CIP catalogue record for this book is available from the British Library.

Design: Stuart Davies

Printed and bound by CPI Group (UK) Ltd, Croydon, CR0 4YY

We operate a distinctive and ethical publishing philosophy in all
areas of our business, from our global network of authors to
production and worldwide distribution.

# CONTENTS

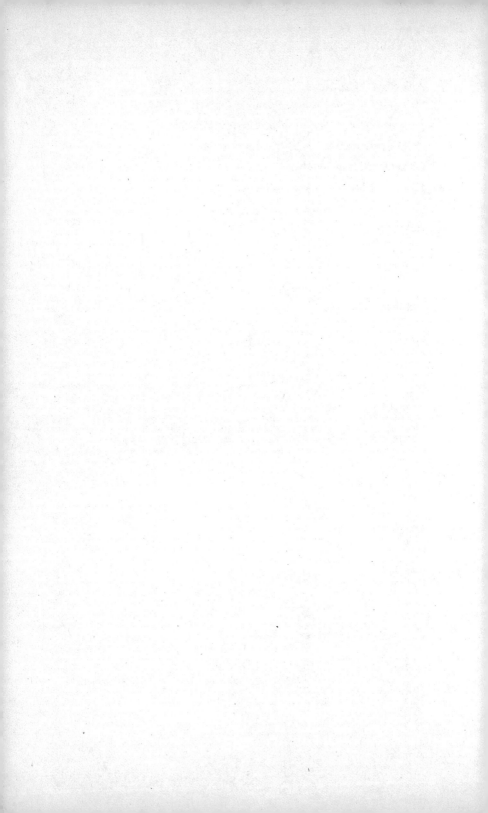

For Owen

*Who controls the past, controls the future*
*Who controls the present controls the past*
George Orwell, *Nineteen Eighty-Four*

*A cheap holiday in other peoples misery*
*I don't wanna holiday in the sun*
*I wanna go to the new Belsen*
*I wanna see some history*
*'cause now I got a reasonable economy*

*Now I got a reason, now i got a reason to be waiting*
*The Berlin Wall*
*Sensurround sound in a two inch wall*
*Well I was waiting for the communist call*
*I didn't ask for sunshine and I got World War Three*
*I'm looking over the wall*
*And they're looking at me!*

*Well they're staring all night and*
*They're staring all day*
*I had no reason to be here at all*
*But now I gotta reason it's no real reason*
*And i'm waiting at the Berlin Wall*

*Claustrophobia there's too much paranoia*
*There's to many closets I went in before and*
*Now I gotta reason, it's no real reason to be waiting*

*The Berlin Wall*
*Gotta go over the Berlin Wall*
*I gotta go over the wall*
*I don't understand this bit at all…*
*Please don't be waiting for me*
The Sex Pistols, 'Holidays in the Sun'

# Introduction

When at some point in writing this book I went to Housman's, the renowned socialist bookstore in King's Cross, London, to make sure I had everything I needed for writing on the legacy of the Soviet socialist times, I had a shock. The shop's cellar, clearly neglected, presented a real dustbin of history: piles upon piles of books, torn, dusty, and clearly untouched for decades, all on the now obviously unwanted subject of Soviet socialism. Years of magazines, brochures, journals, political analyses of events that used to light up the nations, now presented the possibly most undesired moment of history. Is it really all over? Now, as I once heard from a Polish friend in London, we're "all free and happy". Moreover, those of us, who were lucky and entered the club of so-called normal countries (i.e., entered the EU) could "help" those others less lucky, like Belarus, Ukraine or Russia, to achieve this ideal of democracy.

But could anyone seriously come to such a conclusion? The Big Change, promised after '89 didn't happen. Instead, we developed political and cultural polarizations that are dividing the public sphere in most ex-communist countries. Every day, dozens of cheap flights carrying a migrant workforce from Poland and elsewhere in Eastern Europe are launched back and forth from the British Isles; and every day, racist articles in the gutter press seem to tell a different story. Three decades ago Eastern Europe was on everybody's lips because of communism, revolutions, invasions, workers struggle. Now Western newspapers, if they write about us at all, it's because we comprise an "eastern danger" to the British job market, or they praise us for "growth", i.e. successful austerity measures. The respective countries are described mostly with disappointment, as they didn't exactly become what they were supposed to, rather becoming a liability to the initially so open European Union. As all the force of the liberal governments in

those countries was at best aimed at erasing that there was ever communism in there, the reality confirmed that over 23 years after the collapse of the Wall we're still defined by the past, in economic, cultural and every other respect lagging behind the ideal that is Western Europe. As the EU now suffers the biggest crisis since its inception, there emerges a space for a discussion over whether Club Europe or Club West are really the best possible worlds.

The relationship the West, by which we mostly mean Western Europe and the United States, has with the former Bloc still often brings to mind the Cold War era hostility. Indeed, to use the concept of the popular liberal pundit Edward Lucas' book, *The New Cold War* (with the subtitle "And how to win it"), prefaced by Norman Davies and recommended by Anne Applebaum no less, spreads the popular opinions on the former East (specifically, Russia) as still dangerous to "our" democracy. Association with the "East" is still nothing positive or to be proud of: for that reason we even designed the term "Central Europe", a geographical manipulation, to drag us more to the West, or more like, away from the East, as much as we can.

Although Russia, Poland, the Baltic states, Hungary, have all become capitalist, and often to an extreme degree, it seems that they have not become so enough, or not enough for Western standards. In the criticism of Russia especially, while public opinion rightly points out the censorship, homophobia, mistreatment of political prisoners and other abuses of democracy, there is rarely a criticism of the economic turn Russia has taken after 1991. In the criticism of the previous regime, rarely is it mentioned that since the beginning of the 1990s there were over 2.5 million 'excess deaths', mostly as a result of poverty and its malaises, like alcoholism, causing a drastic lowering of life expectancy, from 63.5 for men in 1991 to 58.6 ten years later.

All of the post-socialist economies underwent a massive collapse, but what we mostly get as a response is a shrug of the shoulders: 'it had to hurt'. As we can see though, especially since

0.1 Center of Warsaw, capital of 'a regular European country'. Gigantic adverts cover the modernist pavilion, with the Leszek Balcerowicz installed 'register of public debt' over the Sin Strip Club

the capitalist crash in 2008, there has been a growing tendency to discuss the socialist and communist project again, to shyly come back to reading Marx and classics of Marxism, which slipped from public debate a long time ago. Such discussions happen not only in narrow academic or leftist/activist circles, but are discussed at large by prominent economists, like Paul Krugman, who are openly critical of the way the Former East is currently beating recession and crisis with drastic austerity measures. Still, in the former East itself, this debate barely exists. We still pursue the already obsolete model of "creative capital", bankrupted elsewhere, privatisation and credit bubbles, still discuss the "information society", while the dismantled health care and lack of jobs are leaving more and more people below the poverty line. We tackle the crisis with austerity, with no discussion about the alternatives.

So yes, the East is still more beastly than the West, but perhaps

it has become more so during the 'transition', finally fulfilling all the negative stereotypes the West had about it while it was ruled by its decaying communist parties. The Western New Left, when it arose in the 60s, had abandoned looking to us as a source of inspiration a long time ago already, when we were mired in the post-50s and 60s stagnation – they preferred to look at Asia and Latin America's revolutionary communism instead, and today there's no doubt they remain places to look towards. But maybe there was a different reason why all those copies of *Labour Focus on Eastern Europe* were rotting away forgotten in the basement. Today we're not in a great need of a new theory, but rather find ourselves incredibly passive. The half-rotten papers at Housman's presented the rise and decay of one of the biggest grass-roots oppositional movements in history, Solidarność, today a shadow of what it once was, plagued by its right wing factions and disdained by the rest of Polish society and the governing parties it created, who are now more likely to send police with truncheons than support their strikes. Yet we feel that something has changed since the Russian protests in late 2011, that Eastern Europeans, from silently accepting their inferiority have finally risen, tired of living in countries of which the Western commentators say "they have the love of despotism in their blood."

The dissolution of communism in the countries involved led to a social desert, in which people are more than others immersed in the capitalist "state of nature". We reproduce this state abroad, while our culture is nearly wholly disinterested in debating the schizophrenic state we live in. I decided to write this book because of the daily, habitual sense of shame I felt, for not belonging to any of the groups: neither feeling a part of the successful creatives, promoting our "culture" abroad, nor really having that much to do with the working class majority and without a real possibility of reconnecting with this lost social class. Seeing the depoliticization of my own class back in Poland, people of my generation unwilling to recognize their position and the unpopularity of politics, I took

refuge in emigration, soon after the capitalist crisis that started in 2008.

That's why I decided there's a sense to revisiting this blackened era, both to reveal it for myself and to see how much there is to learn or take from it. We often behave like the 50 years before 1989 didn't really happen. Anyone who lived in that era is made to publicly criticize it, even if there were positive sides to it. We have to go beyond the ritual war between security of jobs and flats and lack of democracy in one system, or free speech and the uncontrolled free market, but also with a large danger of poverty, unemployment, lack of education and a crippled welfare state on the other. There's no doubt that the communist ideology, as it was practiced between the years 1945 and 1989 is dead. But we know the current ideology is dead as well, with the catastrophic lack of clue what we should do about it.

But another reason I had to write it is because despite my growing politicization, I couldn't find myself in the narratives carried on by the Western left. I or anyone from where I was, hardly feature in the current discussions on the left. Because it turned out, the left had little clue about post-communism, about the post-communist transition or even problems of underdevelopment. The Western left seemed to have lost interest in us and then hasn't noticed the strange conundrum of people like me, for whom the Western-Eurocentric themes of "1968", Italian autonomism or accelerationism bore little relation to our experience. We may all live in "post-industrial" reality, a lost generation with no chance of a job. Yet we grew up in very different conditions. A Stasiek from Opole or Vlad from Timişoara are still less well off than a Dai from the Rhondda Valley, as the latter may still benefit from some residual welfare state. Even if mining towns in Silesia are in some ways facing similar trouble as those in South Wales, there's still a reason why people are migrating from Silesia to South Wales and not the other way round. In Poland or Czechoslovakia 1968 meant something radically different: anti-

Semitic purges and Soviet invasion. I can't see any current debates in the Western left telling the story of the several countries, which in an act of socio-economical experiment, were trying an alternative to the West, and for some time they were even succeeding. At the same time, we started to be pervaded by the same problems, of the new far right movements and hostility towards migrants, yet nobody was seeing any connection.

To me, there still exists something like "values of the West" and the "East" and I realized that living in affluent Western Europe. I also learned that I definitely do not want to belong to those Western values, shaped by the global capitalism. As capitalism is of course now reigning completely in Eastern Europe, it is at least still combined with certain forms of the older life, both in the memory of the pre-'89 past, and the existing, appalling poverty we deal with, unheard of in the West.

I was born 1983 and I never really lived through the problems within communism that older generations had to. No crossing of the Wall, no scary officers, no parents interned by communists. Still, I observed the dramatic changes in the social fabric after '89, when at the very beginning of the 1990s I went to a state primary school, attending it mostly with working class children from the tower blocks in the area, and then, in 1998, went to a private elite high school, conducted by people from the former democratic opposition. In the new Poland they decided that the best way of educating children was to create schools for elites who can afford a significant fee every month. The contrast between the way children could learn and how they were treated in both schools was rather astounding. Still, hardly anyone from my former high school mates, now mostly in secure jobs, sees this as problematic.

The attempts at reviving the leftist politics in the Former East have been happening especially in the last decade: we have the contours of an independent left for the first time since the interwar period. Significant amounts of cultural activity are carried out by left-leaning groups, of which Krytyka Polityczna is very prominent.

In Croatia and Slovenia it is the Right to the City initiative, responsible for the first anti-austerity protests there in 2012. Russia had a revival and brief unification of the left efforts which emerged during the protests on Bolotnaya Square in 2011, where the Left Front was formed - and last but not least, the influence of intellectual and artistic groups, like Chto Delat from St Petersburg, and Voina, who are trying to establish a new left without necessarily condemning or dwelling on the communist past.

Still, the percentage of the population identifying their political and social position with this movement is nearly nonexistent. 'Manifa', the feminist demo on International Women's Day in Poland, that has 14 years of tradition, had pitiful numbers in 2013 - and this in a year that saw some of the biggest attacks on women's rights since 1989 (an enduring ban on abortion, restrictions on contraceptives, the rejection of civil partnerships in Parliament), showing that nobody is identifying this abuse of their rights with the possibility of political action. Instead, within post-communist countries, citizens increasingly don't vote, with numbers often below 50% during elections. Post-politics rules over the minds of Poles when there's nobody to vote for, with over half of the society not even participating in the democratic processes.

As the historical project itself is rejected, we observe the aestheticization of the communist period. And the greater the aestheticization, the bigger the political passivity, almost without exception. In this book, I'm going to focus on the ways politics is feigned in between the former East and West, in the form of popular Ostalgia, a specific "vulturism", a dubious sympathy for communist culture and the symbols of the past without any political investment, uprooting them and rendering them meaningless. In recent years we have seen how popular art exhibitions bringing back the legacy of the communist years, with *Cold War Modern* in 2008 at the V&A in London, Star City in Nottingham Contemporary and Ostalgia in new Museum, New York, could often obliterate the politics and social situations the featured

countries live in now. These aesthetics-of-communism shows have spread across the world, including some progressive institutions in the "former East". Yet in the mainstream of these countries themselves, it remains a highly unpopular topic. If there are ideas for 'Museums of Communism', they are usually for creating a highly dubious freakshow out of it.

Any ambivalent feelings about the communist past are understandable, yet in the New Europe there's no time for subtleties in remembering it. More progressive thinking groups, historians, experts, are now trying in their own way to both restore the memory of the neglected communist past just as, perhaps, they see it as an attractive way of promoting the culture of their still slightly exotic countries abroad, using the positive conjuncture created by the likes of *Cold War Modern*.

I don't want negate the prevailing legacy of the Cold War. On the contrary – I believe the years between the Yalta congress and the fall of the Iron Curtain, and in particular the 80s, with Solidarity, Martial Law and the slow way to what they used to call "freedom", provide a foundational, mutual "great narrative". I want to tell the story of the relations between the East and West during the Cold War, from a perspective that was not present enough equally in popular historiography and in the exhibition trend, where the current politics, social reality and clashes will come to the foreground. The Cold War provided a mutual frame and narrative for both sides. It runs contrary to the popular belief that we're more "together" now in the New Europe. It is like the Croatian writer Dubravka Ugresic said in a recent interview on Yugoslavia: the dissolution of the federation on national lines actually meant the loss of identity and cultural legacy for Yugoslavians. In turn, it's the differences in wealth that are more openly dictating the mutual relations in Western Europe, with countries now like Greece, Ireland or Spain told to "get better" by those better off.

This book should read like my coming to terms with being from the former East and what it means to me, as well as the discoveries

I made on my way. The typical view of the migrant is that everything is better in the new country. For me, a migrant not forced economically, equipped only with cultural capital, I looked at it from the beginning with mixed feelings. In fact, economically the contemporary West has never had so much in common with the East as it does now. Our economies may differ in scale, and though Polish propagandists like to imagine that in the near future they'll overtake the UK, the British economy is still 70% bigger than the Polish - but in the current critical state they all function more similarly than before. This is the world of post-Fordism, a stream of cheap labor, flowing from one country to another, all equally fucked despite differences. It is perhaps this disgust with what the West did with all its opportunities, political chances, stock and philosophy that motivates this book.

Those years between 1945 and 1989 require a living and lived cultural history, where personal engagement and experience is not a curse, but a value. Many memoirs and accounts have been produced since the dissolution of the Soviet Bloc, and mine wants simply to ask the question - where are we now, after 23 years? If the Soviet Union 23 years into its existence wasn't called post-tsarist, why are we still defined as "post-communist", and why is it relevant? Did history take a slower pace, or was it finished, as Fukuyama said, after 1989?

The title, *Poor But Sexy*, is a slogan taken from Berlin's mayor Klaus Wowereit, now part of the city's strategic promotion. After the fall of the Wall, Berlin became a depopulated, empty city, scaring potential dwellers with its voids and destruction, the new policies after the capital was moved there from Bonn hoped to use the poverty of Berlin as an attractor. The city had low rents, but little real industry - and with the banks staying in Frankfurt am Main, a new reason for visiting Berlin had to be invented. The failure of it as a traditional capital, a center of financial and political power, was turned to an advantage. City authorities realized they could solve the problem by advertising the city as cheap, but

attractive: with cultural and historical capital. Hence, Berlin the creative city emerged, attracting expats to the clubs, galleries and the spirit of a dangerous *je ne sais quoi*. The city became more vivid, but at what cost? There appears a new pressure on some of the poorest areas of it, which at the same time are the most attractive, like Mitte, Prenzlauer Berg, Kreuzberg, Friedrichshain. Subsequently, what the city boasts of so much - the rebel spirit - is what suffered. The squats are being removed and evicted, as the city becomes so successful that they let it roll out: privatize more and more, so that even the main attractors, like techno clubs, have to be eventually evicted. 'Poor but sexy' is that appeal - Berlin's authorities wanted to prove it's possible to live solely on the creative capital. Yet, it only concerned selected parts of the city. The peripheral Berlin remains untouched. Nobody goes to the West Berlin districts of Gropiusstadt, Hansaviertel, or the tower block estates like Marzahn in the east. Somehow this didn't work in Prague, which was after ''89 the favorite Western expat Eastern hang out. To realize the dream of a nice European city, Prague was too really alive as the Czech Republic's capital, not enough of a hipster playground.

The geographical logic of the East and West still has an impact. Somehow this fashionable *drang nach Osten* nearly universally stops in Berlin. Berlin is usually the farthest people go to the east, and then stop. Yet, this policy, this "poor but sexy tactic", has since inspired and dominated many other cities to the east of Berlin, even if in much poorer countries. Keen on attracting foreign investment, cities allow low rents for Western capital, gentrify the poorer areas, capitalize on the fictitious creative capital.

We'll look at what led to this. From politics to art and artistry, the artistic creation on both sides reveals how much the two Blocs were intimately dependent on each other and closely tied up together - with the lack of objective information and censorship they had to fantasize and dream of each other. This is when the Iron Curtain becomes a "dream factory", a dreamland, without which

culture as we know it would never emerge. From LIFE magazine to computer technology, from visual arts to fashion, from fashion to politics, and from pop music to national elections, the spirit of the Cold War is everywhere.

The first chapter, 'Welcome to the House of Fear', will bring us to the present: the world we currently live in, supposedly with no more borders, no more divisions, equal. But still the miasma of the past seems to determine our lives. We will see how the past of the two camps affects the present and in what ways: politically, in social structures, in individual and collective attitudes. We will discuss the politics of memory and changing geographies, and how we neither dealt with nor should simply deal with the past. The second chapter, 'Ashes and Brocade' will tell the story of Berlin, Warsaw and Moscow as spaces of a magical Cold War transformation: where the Cold War anxieties of the seemingly "safer" Western world were bringing hordes of young people to the land crossed by Walls and secret police, while their Eastern counterparts, with the image of the West censored or known only partially or from legends, also participated in this dream, by imagining life outside of the Iron Curtain. The third chapter, 'O Mystical East', will deal with the even deeper dreamlands, with the psychology of the East vs. West and will psychoanalyse the "Mystical East" and the myths around Easternness: geographical, gender-related, religious and philosophical. We'll analyse the inferiority/superiority complexes between the two. What does it mean mentally to be from the East? Is the West "normality"? We'll revisit the Romanian depressive ex-fascist Emil Cioran. Here, we'll get to the guts of the area's traumatized history. Chapter Four, 'Socialist Realism On Trial' will analyse the premises around the realism vs. avant-garde debate, which was crucial to the development of art in the two Blocs. What was (is) socialist realism in the Communist East and what were its philosophical and historical conditions? What was or were supposed to be its opposite in the West? What is their legacy in today's art? Is realism possible at all? Does realism

have a special political power we may need today? The last, fifth chapter, 'Applied Fantastics', will deal with the Cold War era competition between the East and West and the ever-scary specter of 'Americanisation'. Nikita Khrushchev vs. John F Kennedy, noble existentialism and jazz contra pop-art & Elvis, socialist vs. capitalist fashion, radiophonic workshops, world exhibitions, material culture, aspirational magazines. It's a little primer on the "communist civilisation", from the usually unknown side. We'll analyze what it meant to be an artist under socialism, and what are the hidden conditions of "free creation" under capitalism/ socialism.

Past and present will get mixed up, forgotten memories will come out with the force of the repressed, like on the Paulina Ołowska painting on the cover. If your joy is a Joy Division, and you dream to the sound of Depeche Mode, you'll follow me.

# 1

# Welcome to the House of Fear

## Introducing the New Europe

*'That's the problem with you Americans. You expect nothing bad ever to happen. When the rest of the world expect only bad to happen. And they are not disappointed'.*
Svetlana Kirilenko, *The Sopranos*

There are arguments that the "post" in "post-communism" should be treated like the "post" in "post-colonialism". But the question arises: who of whom? Who was the colonizer and who was the colonized is not always as obvious as it would seem. By all accounts, many of the post-communist countries, despite the 23 years of "democracy", still display the elements of traumatic and obsessive behavior typical of post-colonial countries. But because things were happening so fast between the late 80s and first few years of the 90s, today it's hard to say if this trauma comes entirely out of the communist years, or is an effect of the brutal capitalist shock therapy most of the eastern Bloc underwent.

History has made a strange circle. As 2012, a year of intense protest in Eastern Europe (Russia, Romania, Bulgaria, Slovenia) has shown, only now are people acting out the clumsily put together capitalist democracy of the early 1990s. It started on Bolotnaya Square in Moscow in late 2011. Still nobody dares to call it a class war: sometimes in the public discourse there passes a word on the "excluded", which is quickly dismissed as evidence of "populism". Political scenes all over the bloc nearly universally got divided into nationalism and neoliberalism, often complementary.

What we were to become was the "New Europe" - as the Hungarian low-cost airline Wizzair puts it, 'Wizz off to New

Europe!' As a term it has been used several times in history: it emerged in the 90s, as a name for the group of countries who had "successfully beaten communism". It was the name that American Defence Secretary Donald Rumsfeld gave to those (mostly East-) European countries that supported the Iraq war. It gained an even stronger meaning in 2004, when the first slot of the "former East", Poland, the Czech Republic and Hungary, joined the European Union. Since then especially, the new breed of Polish politicians have been stressing how much it meant that Poland had become "a normal European country", which has become the main government slogan ever since. We were "normal" (and even the "second Ireland"), when we were taking large sums of direct European subsidies, and we were normal when applying neoliberalism. When we entered the EU and some were saying 'welcome to Europe', some in the media were outraged: But we were always the center of Europe! This constant indignation hides a tremendous lack of self-confidence in confrontation with the former West. We know that the more politicians talk about "becoming a normal country", the farther we are from really becoming it. But what is really the benchmark we could compare ourselves to?

## The "Polish Miracle"

It is of course the West, like in the good old days, that we're supposed to model ourselves on. What followed the fall of the decaying communist economy around 1989 in most of the East, was the express adjustment to Western capitalism, where features like conformity to all that's new and the rejection and despising of everything associated with the old regime (like collectivity, for instance), were the ticket to a career. The American scholar Elisabeth Dunn in her breakthrough monograph *Privatizing Poland* described the very beginnings of Polish capitalism as being exemplified by the many previous state-owned factories which were gradually taken over and privatized by Western owners, who mostly laid off all the previous staff. The more they felt connected

1.1 Land of sleaze and glory, Eastern Europe becomes the capital of grot

with the old system, i.e., showing inclinations for defending the collective ethic, the more likely they were to go. 1990s Poland was a territory of brutal, fast class-making, where the previous mostly classless society had to quickly acknowledge the delicate but crucial rules of distinction. Among them was the cherishing of objects and status-symbols. The new managerial class were presenting their oversize cell phones with seriousness worthy of a Catholic mass. Yet what was happening was christened as the "Polish miracle", *Polnische Wunder*, by Germany. Poland had its international debt cancelled, unlike many other countries in the Bloc, the foundation of the strong economic growth it has enjoyed in the last few years. It has registered strong if massively unequal growth, largely down to emigration, German-owned factories, and

EU subsidy for infrastructure projects like Euro 2012 stadiums, railways and motorways. A patronising coverage from our western neighbour never ceases, as just before Euro 2012 began *Der Spiegel* greeted us with headlines like: "Germans used to think of Poland as a country full of car thieves and post-communist drabness. On the eve of hosting the European Football Championship, however, the country has become the most astonishing success story in Eastern Europe. Relations between Berlin and Warsaw have never been better" (May 25$^{th}$ 2012). This is only the tip of the iceberg, as the very same article also greeted us for being "desperate" to join the Eurozone (in the middle of its greatest crisis) and for being "cosmopolitan and courageous" (in the East? Wow, amazing! etc.).

As we joined the normal countries, we were told, there would be free speech, a free press and free debate, all of which were prevented during the years of communist oppression. But in practice, this free liberal debate became a strange unison. Whenever someone in post-communist countries wanted to criticize the style of capitalist transformation, their voice was either ridiculed, or made inaudible. Media, especially the liberal newspaper *Gazeta Wyborcza*, played an enormous role in this. But first of all, we were completely astounded by something like "the media" at all. I remember the sacred feeling of awe that accompanied our first watching of the "new" post-communist telly, new jingles announcing commercials, the new design of the national TV News.

But I'd be rather careful with that regular element of any former East citizen's memory, that is the awe inspired by the Western supermarkets with all the goods in the world displayed on their shelves. I never lived enough under this system to see much of the difference. I also observed the growing wealth of my middle class-becoming parents, who started working for a Dutch company, how our life on an enormous People's Republic tower block estate and everyday rituals were becoming increasingly that of the (petit) bourgeoisie, and how we moved to a semi in the suburbs.

What Poland was then can be most efficiently told by one

picture: the opening of the first McDonald's restaurant in the center of Warsaw. It collected all the intellectual elites of Warsaw, who hurried there to eat their first Big Mac. You can see in the picture the legends of intellect, writers, and poets, overwhelmed by sitting on the plastic chairs. This was America, this was the dream. The ribbon was cut by no one else but Jacek Kuroń, a former leftist legend of the opposition, who gave a little speech. I'd give a lot to hear what he had to say to the first people in the Bloc who were to sink their teeth into the legendary quality buns. That this is what we were fighting for, and, finally, we got it? Were those the horizons of the members of Solidarity, was this what people sat in prisons for? As for myself, I loved McDonald's and it was only in my teens that I grew too sophisticated and learned to despise it. This is another stereotype about 'People's Poland' anyway, as it transpires that in the late 1970s McDonald's was negotiating with Edward Gierek's government to open bars in Poland, but it was the political crisis (i.e., Solidarity), that got in the way!

The magic of the Western commodity and its nearly metaphysical influence on the post-communist psyche is one of the big topics of this book, which will be discussed in later chapters. In here, I only want to briefly mention this wonderful world and the role Western brands played across the Bloc. Western goods were of course sporadically available in the East, as smuggled, as packages from family and friends in the West, or in carefully supplied single brands, like Pepsi-Cola, which were readily available.

It was partly a story communist countries knew all too well, rehearsed since the 1920s even, if you'll look at advertisements in early communist Russia. The problem of the desire for goods is already problematized in Mayakovsky/Rodchenko's collaboration over the famous Mosselprom Moscow department store advertisements. Wary of commodity fetishism and its discontents, when advertising goods they also created unique ads for "products to come", products that neither did, nor could have ever existed. As the cookies of Mosselprom stood for the greater projects of

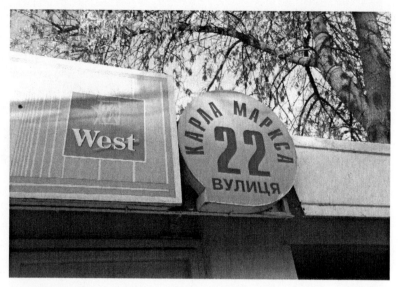

1.2 Name clash, Marx meets the West cigarettes in Kharkov, Ukraine

socialism, those to be, 80s communist countries were populated by kiosks and fairs where complete substitutes of goods, like stickers (omnipresent "West" cigarettes or Snickers) were standing for the heavens of the capitalism to come, that in the end will be produced by the (post-) Soviet industry and economy. They're what Christina Kiaer, historian of Soviet art, using the phrase of child psychologist Winnicott, called 'transitional objects', which help to adjust to the reality principle. The dream object for the Russian avant-garde, though, was the object which will be so rich in meanings, so intricate, so evocative in its industrial form, that it'll change the sensory apparatus of man forever, inducing an awakening from the phantasm of commodities. The dream of late Soviet citizens was the opposite of these high ambitions – they unsophisticatedly wanted exact Western goods and were waiting for their materialization. Somewhere in between them were the expectations of Walter Benjamin, who in the *Moscow Diary* of his visit in 1926 describes his acquaintance with the window dressings, and seeing the lacquered black box from Mosselprom calls it a "Soviet Madonna With

Cigarettes", seeing there, on that display, the future collective.

The problem with the access to the desired goods of course wasn't solved by the sheer accession to capitalism. This made it more problematic, because suddenly we were very unequal in how much we could have of the freshly available goods. Out of that not-yet-availability, a new kind of 'brand' started to emerge in Poland, fake brands that were like-but-not-quite the mega-brands. In the 90s and sometimes today still you can see on the Polish streets working class folk parading with the plastic bags branded as BOSS, but be not deceived they ever purchased anything in the luxurious BOSS boutique. We grew up with a lack of means, saturated by goods often made in China, but also in other cheap workforce parts of the world, supported by the familial fake brands, various Abibas-es, Diar-s, Polo-Cocta's. It was as in the communist era, when we had always chocolate-like products not made of real chocolate, pseudo coca-cola and fake hamburgers. In the photographic reportage from this era, you see the poverty of the shop window dressings, which can often boast only loaves of bread.

## The new middle classes and their Bible

*Gazeta Wyborcza* was the publishing phenomenon of the Polish 90s, just like *Przekroj* was of the 50s and 60s. As the mission of the latter (which will be discussed in the last chapter) was to lead the new socialist classes through the maelstrom of the Polish People's Republic (*Polska Republika Ludowa*, 'PRL' for short) while carrying some of the system's values, so *Wyborcza* was the real carrier of the intelligentsia ethos, when, though nobody at the time saw it as such, all the previous natural ethos-maintaining forces disappeared. The cultural formation of the PRL middle classes (liking similar things, from literary canon to TV programmes), mutual values (only if they were built of the anti-communist resentment) – they were all replaced with the new ethos of the free market economy, in which it wasn't your education, as in PRL, that was your distinguishing feature. With all the previous certainties of life

disappearing, it was *Wyborcza*'s responsibility to carry us towards an enlightened middle-classness. Founded by the ex-opposition, most prominently Adam Michnik, as an 'Electoral Gazette' for the first semi-free elections in 1989, it was an organ of the Solidarity union, i.e. the architects of the new freedoms, in which many of the editors were involved as members of the Worker's Defence Committee (*Komitet Obrony Robotników*, KOR). To this they owed their mission as the conscience of the nation, even if they had increasingly less to do with actual workers. While capitalizing on the legend of Solidarity, *Wyborcza* started to represent the interest of the entrepreneurial class and did nothing to stop the development of neoliberalism, or the creation of a nationalistic populism in Poland, passively observing the ever-increasing toll of unemployment. People involved in the initiative of the 'Round Table', the talks between the Opposition's inner circle and the Communist Party that effectively ended Communist rule, let the increasingly bigoted Lech Wałęsa take the reins, reacting way too late after the right wing had already spread. Increasingly it started echoing Margaret Thatcher and later Tony Blair, as they were patiently teaching the Poles how they should think to really become a middle class. Soon, the free public debate in free Poland became a strange unison. If you had not founded a little enterprise (at least, on time, early in the 90s), you could always be an educated member of the previous intelligentsia. But if you asked whether this meant that someone had been implicated in the previous system, you were carefully silenced. Now we all knew who to vote for - libertarian Union of Freedom and Leszek Balcerowicz, whose policies as minister of finance put Poland into the worst recession in its history in the early 90s, then 'Solidarity' Electoral Action, which grew out of the right wing mutation of the union. Today it's Civic Platform, neoliberal and at the same time, 'progressive' enough to look good cast against the far-right nationalism and 'populism' of Law & Justice, another post-Solidarity party. Interestingly, our whole political scene since '89 always was and remains to this day nearly

wholly dominated by people involved very closely with Solidarity, as its legend of liberators clearly still has a strong clout among the society. Yet the union itself is today attacked by them on the very premise of exclusively defending worker's rights.

Suddenly it turned out that if you had different opinions on the financial reforms, if you wanted to support workers rights and the unions, you were blocking Polish entrepreneurs. *Wyborcza* also 'civilized' its readership in its weekend supplement with essays from leading European intellectuals, with Vaclav Havel, Timothy Garton Ash and Norman Davies as its intellectual and political guides, *Wyborcza* spread liberalism as the leading "thought of the West", with ritual attacks on the red past and habitual essays on the qualities of the liberal/libertarian approach to the economy. It was obvious where there was 'us' and where there was 'them', especially, since from the early 2000s there entered onto the Polish scene a far-right, purporting to represent the frustrated, deprived part of Polish society. Similar was the mainstream take on "feminism", which in the the supplement *Wysokie Obcasy* ("High Heels") professes mostly entrepreneurialism and portrays "strong women" excelling in business and politics, with a relatively liberal take on sexuality. A single more 'radical' article on, for example, women's rights at work or abortion is usually far outnumbered by articles on cosmetics and a good portion of "life wisdom" from psychologists. Its predominant middle classness goes without saying.

Within post-communist Europe, Poland is in the so called Visehrad group, the 'Central European' core of the New Europe, along with the Czech Republic, Slovakia and Hungary.

Until today, progressive magazines of that region, like *Visehrad Focus*, discuss the recent events, crisis, strikes and protests rather in the fashion of "what are the chances of the middle classes" rather than "how can we change the class system". Basically, it turned out that the best thing was to consume, read *Wyborcza* and shut up. Today, anyone trying to discuss any solutions to the current crisis

other than accepting austerity measures is dismissed.

Similarly, the rights to welfare, sexual equality and reproductive rights in most post-communist countries have circled the square. As the 90s were to reject everything belonging to the communist past, together with the erasure of the ideology, we had in Poland a total rejection of liberal social rights, such as mass availability of contraception and abortion. Now, those countries that once enjoyed some social liberalism, have the strongest anti-abortion law in Europe, together with recurring rejection of civil partnerships and intolerance towards LGBT people (with a ban on adoption/reproductive rights for gays) and a serious anti-feminist backlash. It is curious, that in Romania, which had a draconian anti-abortion law under Ceaușescu, this led of course to the liberalisation of the law after 1989.

One of the most ground-breaking films from the post-communist East of the last few years, *4 Months, 3 Weeks and 2 Days*, dealt with the outcomes of the anti-abortion laws in Romania for the lives of ordinary people, presenting in all its harshness the conditions in which women underwent illegal terminations. In Poland it provoked a discussion rejecting abortion as 'horrible', rather than rethinking the ways women could obtain legal help so that they wouldn't have to go through the same as the girls on the screen.

It is this optic/epistemic schizophrenia that pervades post-communist Europe. With the negative memories still remaining, the later governments almost universally used the communist red rag to force through reactionary laws. What a weird combination: a low-tax free market laissez-faire economy, with religious obscurantism, anti-feminist and homophobic laws, and a massively conservative society. This is precisely what makes us so attractive for the foreign investors, for whom at the same time our country seems so obviously secondary, lesser, that it begged to be exploited, with little regards to its economy or citizens. Yet the reasons for the profound role of the church within the contemporary, and officially

secular countries of the ex-Bloc differ enormously. In Russia, the church is an element of the pro-Putin lobby – as the recent case of anarcho-punk group Pussy Riot makes clear. In Poland, it takes advantage of the previous anti-communism to influence restrictive civil and reproductive rights.

## A Tale of Two Cities, or On The Real Meaning of Borders

How does the West react to this? Let's focus on the UK. In the European Parliament, the Conservative Party is in the same camp as the nationalists and exotic right from the former East, forming the so called European Conservatives and Reformists, because the previous center-right coalition of Christian Democrats had turned out too liberal for them. So interestingly, when on the international arena, this right-wing nationalism very rarely meets any real opposition. This was felt greatly in Hungary, which met with criticism from the EU not when its human rights were abused, not when Fidesz gained power two years ago and basically abolished opposition. It happened when Victor Orban's government threatened the EU with a ban on imports. The message is clear – we won't mess or take interest in your politics, even if it clearly abuses any notions of "democracy". But we will interfere, if our financial fluidity through Europe is put in danger.

With the present crisis in the UK, watching Tory politicians attempting to make Britain, with its current unemployment, a "competitive", low cost economy, we can see Britain in a 'transitional phase', similar to the early 90s Eastern Europe. If they force down wages enough, maybe Britain will be as successful as Poland. Of course, the privatisation and asset stripping we learned from Britain's blatant 80s.

The period since EU accession has seen completely new patterns of trans-European migration – but today it's economic criteria, that decide about who leaves the country, not political. When Poles left the country in late communism, it was dictated by

Martial Law, and often there was no hope of return for them. Today, there's no problem with obtaining a passport and all borders have disappeared, except for the economic ones. These seem to be more important though, given that more people have left Poland in recent years than even during the darkest years of Stalinism or the late PRL. At the moment, around 1.5 million to 2 million Poles are on an over-a-year emigration. They get married, have children. Only last year 100,000 people left Poland and numbers are growing. All this in a situation when in their own country the young are bombarded with culpability for the low birth-rate.

What is linking us together now, despite the still enormous differences in our economy, is the landscape of post-Fordism. In his under-appreciated film *It's a Free World* (2006), Ken Loach tells the other story of the "New Europeans". Now coming legally, Poles have a better situation than illegal political refugees from Iran, or the migrants from Ukraine. A young working class woman runs a company that hires (mostly Polish) migrants for building and factory jobs. But raised in a completely neoliberal world, she completely internalizes its methods and mentality: if you won't do it, it will be done to you. If you won't exploit, you'll be exploited. Sacked after being sexually harassed in her job with an Anglo-Polish employment agency, she next, with a help of a friend, organizes groups of workers to work for almost nothing (and frequently not getting their wages anyway, as, under pressure she regularly cheats them and takes their part of the money). If for a moment we believe she begins to understand, as when she helps falsifying a passport for an Iranian refugee, when unpaid workers attack her, she reacts sharply. In the last scene, we see her going one step further, continuing the same 'colonization' east of the EU's border, in Ukraine - now in the illegal business, giving them false papers. Loach perfectly describes how the weird circuit of capital in the modern world subjugates individuals.

There are few things more unpleasant than crossing the UK border. Since I really began to travel here regularly in late 2009,

Poland was already in the EU and it would be really cheeky to complain, knowing what people from non-EU Europe, the Americas and rest of the world have to go through to be able to get into this country. We are the Wizzair generation: beneficiaries of the accession of the lesser Europe to the First World, who rushed there as soon as they could leave their jobless and miserable countries. A typical traveller to London from Eastern Europe is a working class unskilled person, who hopes to earn some money in care or cleaning business, along with skilled workers with families and more rarely, specialists, like doctors. In this way Polish has become the third most spoken language in the UK after English and Welsh.

Queuing with dozens of my compatriots, who feed the financial power of all the Wizzairs, Ryanairs and Easyjets of this world every single day, I'm not strictly one of them, I'm a fake: a middle class overeducated Polish girl, who is there seduced by the cultural lure of the West, rather than led by material necessity. The gigantic rent-a-car companies sponsor billboards telling us "Welcome to London", but we couldn't be further from our Western dream here: we are, of course, in Luton, the biggest transit space for Eastern Europe's migrants, travellers, small-time businessmen, British working class youths in flip flops going to Ibiza and, as the posters everywhere are suspecting/informing us, we might be human traffickers and all sorts of frauds, crooks and cheats, who, as the posters suggest, speak with thick Eastern European accents. As British Airways is well beyond my league, I travelled, travel and will be travelling with my compatriots on those crying-children-ridden cattle cars, until there's any job they can possibly take.

One look at my birth date – 1983 – will tell you the whole story of my getting around the world. Born when borders were still a serious business indeed, I didn't really experience the incapability of travelling, especially as my parents were small entrepreneurs typical for the early 90s era of "transition".

The trip back can be quite different. If any academic/culture-

worker friends from London are travelling in the opposite direction, it'll be only for one reason: they are international conference guests, part of the growing industry of "studies on Eastern Europe", festivals of architecture, design, Jewish culture, post-communism, Walter Benjamin or Alina Szapocznikow, warehouses where tolerance, mutual understanding and curiosity for the changes between us are supposed to be built. The fact that the vast and fascinating world of EU financing encompasses not only our agriculture, but our culture, is what enables this world of wonderful, newly established friendship. I travelled first to the UK, because a certain cultural worker lured me by romantic visions of

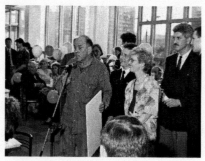

1.3 Jacek Kuroń makes a little speech on the opening of the first ever McDonalds restaurant in Poland

concrete buildings and council estates. Being seduced by a vision in which the Krzysztof Kieslowski's *Dekalog* estate in which I spent my childhood could be romantic, instead of a horror of boredom, a Warsaw girl, I embarked on my first, self-financed trip to the Smoke, to interview him for a progressive art magazine by a city-theory-inspired NGO. Then the aforementioned romantic culture worker went the way back to Warsaw, as a guest of a major artistic institution to speak there on a politics of urban renewal. Then I went back to the better world to pursue my knowledge on political aspects of the ruination of the city where I lived. Since then, there were many travels back and forth between the City that was being stripped down of its old, post-war regime buildings and the City which already got rid of a pretty large amount of buildings of this regime. Together, we also travelled on Wizzair lines to other culture workers Eastern European destinations: Kiev, Ukraine; Zagreb, Croatia; Belgrade, Serbia, Budapest,

Hungary, Bratislava, Slovakia.

The periphery, as we were repeatedly told by post-modern thinkers, is more interesting than the center. Neoliberal reality would agree with this only if you were to look for its dark places. The dark spaces of status quo are placed irregularly: it is both Pristina and Moscow; both Luton and London, both Łódź, "Polish Manchester", now in the turmoil of becoming a 'creative city', while most of its population is vegetating. It is yet unknown, what the authorities plan to do with the impoverished population, when their task, which in among other things included an investment from David Lynch, in revitalizing an old power plant, will be completed.

We live both at the margins of Europe and, as we like to see it, in the spotlight, especially when we either disrupt the international congresses for climate change with our big $CO_2$ emissions, or the debates of the European Parliament with our irrepressible right wing populists. A mutual relation between Eastern and Western Europe I'd describe as a bad love affair. Not unrequited love, which it has been mostly in travelogues or memoirs, especially of Eastern migrant intellectuals, writing up their tormented history exiled to one of the big, capital(ist) cities. This perspective is over, because, unlike in the past, this seductive West wants something from us, it needs us. Needs our bodies for working for less, for filling places for skilled workers or, last but not least, needs us for self-assurance and reassurance. We need the West for too many reasons: we need its money, but we also need its elegance, class and consumption patterns. As in every bad love affair, after a while and saving some money, we learn we don't really need them, we are ready to live a life on our own. Nothing better highlights the way capital works than a young woman from a small Eastern European town, who went to hypothetical big Western European capital to work temporarily and raise funds who decides to stay as long as she can, rather than come back. What is at stake is not only the monetary relation, but the whole set of Western social gains: a welfare state

which she won't have in her collapsing country; feminism, multi-culturalism. Everything is better than coming back to the rough-hewn conditions of unemployment, patriarchy and frustration in her native city.

In the end it is not a matter of geographical snobbery, but a niche in neoliberal Europe, that keeps her there. A niche, that enables fragments of the old-regime's welfare state in the middle of the ultra-capitalist feast of the City, La Defense or other financial districts, dictating the rules for the rest of us. For the middle class intelligentsia the situation is different. Deprived of the securities of the 90s boom, many of them today are employed only temporarily on so called 'trash contacts'. If the cold world of London symbolizes the flat desert of the contemporary form of capitalism, its ultimate manifestation, then it must be said the Eastern cities conform variously to this scheme. The biggest barrier is the money, but as the example of Łódź shows perfectly, it is a question of a proper PR and attracting famous names combined with the magic word 'revitalization' to basically be allowed to do anything one wants. But as the myth of London – in mass imagery a city of power, vice, bling, fashion and the royals – proves, it is the myth and presence in mass imagery, or lack thereof, that is equally significant as actual money. Warsaw will never be the place where the creatives go, because it was on the wrong side when the points for mythmaking were being distributed.

## The strange silence of liberal Poland

When *Przekroj* ("Slant"), a prominent Polish news weekly, after undergoing several erratic makeovers in the 90s and 2000s by several owners was all of a sudden given over to a left-oriented editorial board in winter 2011, there was a sudden breeze of fresh air blown into a public debate devoted to rehearsing the ritual wars between the ex-communists and the right wing. Yet, after several months, with the circulation shrunk by roughly 50%, the editors were sacked, and within a fortnight replaced with well-known

specialists in the entertainment and lifestyle press.

The leftist *Przekroj* was trying to initiate a debate about capitalism in a country that didn't dare to use a class language supposedly discredited by its use in the previous system. It interviewed trade unionists and spoke about strikes and opposition against austerity in a committed way. They interviewed critics of America and Israel, wrote on the "rebel cities" of David Harvey, the Occupy movement, Indignados, or 2011's riots in the UK – and took them seriously, unlike most of the liberal media, including *Gazeta Wyborcza*, who after '89 did their best to dismiss the fight for workers' rights. Wait a minute, you might ask, wasn't it a union, Solidarity, who were the architects of the great freedom of '89? What happened to them? You'd be surprised: when recently the union, or rather what's left of it, protested the raising of the pension threshold by Donald Tusk's neoliberal government from 65 to 67 years, their previous leader Lech Wałęsa said in an interview that in the PM's place he'd have sent truncheons to these ungrateful spongers. "Tusk works behind the desk, what does he know about being old and having have to work in the coal mine?", one of the protesters was quoted, but not in liberal outlets, busy condemning them for greediness, but on 'Beyond the Transition', a blog run by an English leftist in Warsaw. Class is on the agenda, but the media refuses to talk about it.

This protest, as well as recent strikes of nurses, was a rarity, because in the whole ex-Bloc the culture of protest died off with communism. It's sufficient enough to look at the map depicting the Indignados & Occupy solidarity marches on October 15 2011, which was nearly empty east of the Iron Curtain, with tiny, 100-200 groups in Warsaw, Bucharest or Prague. There was a better turnout in Slovenia or Croatia, but this they owe to a much better-remembered tradition of Titoism, where the left was always stronger. Yet Eastern Europe – the Balkans and Baltic states especially – has been hit very hard by the crisis. Latvia has experienced economic collapse on the scale of Greece. But there is no Latvian Syntagma

Square or a party like SYRIZA proposing alternatives. Instead, there were harsh cuts and unopposed austerity, which led to the recent praise from the West for Latvia's economic "growth" and the example it could set up for the rebellious Greece.

In Poland there are only two kinds of protests that can gather thousands: the old generation of Solidarity, or the post-89 young-sters, protesting against the internet censorship bill ACTA. Yet the only reason the jobless or insecure young took to the streets was the fear of free culture being taken from them. This, in a situation where the state thinks only of liberalizing employment legislation, tax-cuts and privatization. Leszek Balcerowicz, an idol to all "shock therapy" architects across the ex-Bloc, talks today of a "swollen public sector", while his old comrades in the west, economists Sachs and Stiglitz, admit they were wrong. Nobody writes exposés of the ATOS company, who will soon be taking care of "benefit reform" in Eastern countries, but the UK knows their results very well. Poland, so far masking the crisis' toll through mass emigration, EU subsidies and manufacturing goods for Germany, doesn't want to debate capitalism.

But now, *Przekroj*'s solution to the jobs crisis is "it's everywhere, it's enough to make a move!", amongst articles about luxurious toasters. Needless to say, after the announcement of the editorial change, the public debate was full of pleased liberals, who otherwise hypocritically argue for "free debate". If this is how current events are talked about, when the crisis really hits, Poland will be taken unawares.

To the majority in the post communist countries, a class discourse died together with the previous regime. The biggest paradox is that the hatred of the unions happens in the country of "Solidarność", the mass trade union that was the main agent of the collapse of communism. But Solidarity members themselves didn't care about private ownership, which was never the part of their programme, they wanted to reform socialism. No country had as significant a grass roots oppositional movement as Polish Solidarity

in the 70s and 80s, none was more legendary, more mythologized afterwards and also, more betrayed. The crash of the Solidarność legacy is best visible in the decline of its former leader, our biggest success story of the Twentieth Century, electrician turned president, Lech Wałęsa, whose public pronouncements now are reduced to advocating police beating up strikers and excluding homosexuals from parliament.

Solidarity was not an organisation speaking with one voice, but there were many currents and factions, right and left-wing, in what was never a monolithic organization. What united them was the mutual enemy. In the new Poland, when this enemy, already seriously crippled in the 1980s, disappeared, it was the intelligentsia, the more market-oriented ex-members of KOR, that convinced the Solidarity union leaders to accept the shock therapy. The existing, incredibly harsh class divisions that exist in Polish society are the consequence of this. Poland is divided into two groups, those successful and unsuccessful after the transition.

While the destiny of workers was so radically neglected, the right wing currents started to largely re-emerge and established a reign over the souls of the remaining union members. The social costs of transition were high, and what was there for the workers was the Church, which during communism especially played an enormous role as the opposition to the system, with the election of Karol Wojtyła as Pope John Paul II as its peak. At this time, those currents within the church that were the domain of the intelligentsia and the democratic opposition, after '89 wanted to win over the new bourgeoisie and often lost a general, more popular influence. What filled its place was the untamed, fanatical church, which cynically used the social quietude and turmoil produced when Poland was pervaded by strikes. This new church proposed the narrative of victimology, which was taken up especially after 2010, when a plane with the president and over 90 other government officials crashed in Smolensk during a journey to that typical space of memory, the site of the Soviet mass murder of

Polish officers, Katyń.

In this way, Poland is now divided between the "victims", who, on that wave, have become also anti-progress, anti-modernity, anti-liberal laws, and the liberals, who, though economically neoliberal, when cast against the background of the right wingers, look so good it makes them win the election. This are false political alternatives, ritual wars, that with a slight margin of error and a different display of political accents, most post-communist societies are subjugated to. Poland because of its history has a strong martyrological streak, the counter-modernist narrative of a victim, allowing it to locate the blame for the negative elements of the transition in the 'external enemies'. These were, though, people abandoned by the left – the left understood as a Labour Party that has never existed in Poland since the war, and it didn't happen either in the key moment of us mentally and economically leaving communism - too busy trying to get rich fast.

## Communist Ghosts in the Closet

In the post communist reality there are still deep influences from the pre-89 divisions, and our political scenes are still determined by the pre-democratic order. The rule that made us condemn universally everything pre-89 made us live in a schizophrenic reality, in which both ex-communists and the previous opposition are given every credit in following the neoliberal rules. Poland is one of the most red-witch-hunt pervaded country of the ex Bloc, yet, to believe the paranoid far right wing press, we have to still beware, as not only commies, LGBT and various other 'lewaks', known also as "the red motley', but practically everybody who benefited from PRL and the transition, so including also the neoliberals such as Civic Platform and *Gazeta Wyborcza*, are threatening us.

If we have communism at all, it managed to survive as a zombie, as an un-dead monster we're supposed to be afraid of. We can't, for example, let the Berlin Wall die – like a remnants of a dead organism, loose body parts - it must be left scattered around the city

for the excitement of the tourists. Tourists also don't want this myth to die: one of the attractions of the Mini-Europe theme park in Brussels, where each EU country is symbolized by animatronic architectural models, is the mechanized Berlin Wall, which – after being overthrown by bulldozers, is a few seconds of strange mourning later magically resurrected, only to be overthrown again and again, as if we're stuck in the traumatic repetition of the primal scene, capable only of an endless repetition, but not an understanding.

In this process, the memory begins to be manipulated. Berlin has become a House of Fear at the fun fair, where we pay to be led through a set of nightmares of history, with the premise that the monsters are our good friends, we know them very well and we know that the nightmare is not actually for real. The reason we must keep the monster alive is crucial for us to not to change anything about the present and to exist in this morbid clutching onto the past. The past is used to scare, so that anything we do now cannot be put into question. And when what we do now visibly fails, we can again and again reach for our little scare bot: See what will happen if we allow this ever again?

This is not the full picture. The unknown secret of the recent post-communist societies is how often, especially right after the collapse, they voted for communists. Poland twice elected the Democratic Left Alliance, the renamed and 'reformed' Communist Party – similar parties were elected in Hungary, Slovakia, Lithuania, Romania and Bulgaria. People not only gave the ex-communists a chance, they did so repeatedly, and did so not only because of the communist nostalgia, but because the 'good guys', the former Oppositionists in right wing anti-communist governments had made these weakened economies collapse completely. Because of this the political landscape is that of ritual battles between the ex-communists and the ex-opposition, both basically neoliberal but replacing one another every four years in the government, when a society disgusted by one in the meantime

manages to forget the faults of the other, but both eventually erasing the welfare state and dragging the economy to the drain.

Of course, the political situation of the respective countries differed greatly. Ex-Yugoslavia drowned in the horrible war, and some of the countries had to live permanently on international help, like Albania, which had practically no industry or jobs at all in the first half of the 90s.

There's a lot of post-colonial trauma to post-communism, but the level of barbarism that came after caused people to miss the past. Yet the erecting of a new statue of Stalin in Ukraine (as happened a few years ago in Dniepropetrovsk), and the city of Volgograd's regular petitions to rename itself Stalingrad have more to do with the memory of the World War Two, in which 25 million Russians died, not necessarily the love for despotism. But what is the value now the Russian Communist Party, by all accounts reactionary, from whom the Russian 'new left' want to disassociate? Large, unreformed Communist Parties remain also in the Czech Republic, and Ukraine, where both had big increases in their votes in elections in 2012; the Communists have regularly been elected as the governing party in Moldova. To me, there's little appeal to these organisations, as they are often socially reactionary. In rich countries, like Germany, Die Linke, formed out of the former Communists and a left-wing split from the Social Democrats, feel more of a modern alternative to the careless neoliberal newspeak of the Social Democrats, who remain so only nominally, while Germany is holding the rest of the continent to ransom during the Eurozone crisis.

This leads us to the notorious 'lustration' cases, where the names of public figures who ever testified or appear in the communist Secret Services files were publicly disclosed. That often meant civil death. Something which in principle was supposed to lead to punishing people who once could've beaten people to death (during the repression of mass strikes in 1970 and 1981, or the anti-Semitic repression of student protests in 1968), transformed into a

regular witch-hunt consciously set up by the right wing to get rid of their political opponents. The mood of conspiracy never left us, and the Smolensk catastrophe was obviously an eruption of this. From the belief that Russians caused it wilfully to the view that it happened from their negligence, it was all to the benefit of the far right in Poland. Still, lustration appealed to the large part of the society who felt they were wronged somehow in 1989, by the opposition elites who had made a cushy deal with the communists at the Round Table. Thus, we landed again with the unbearable threat of 'populism', that is supposed to wipe out all the blame from the neoliberals. The 'populist' right are often public defenders of the remnants of the welfare state, helping the spread of negative propaganda about the 'politics of welfare'.

A quite opposite phenomenon is Russia's nostalgia towards communism. There are several modes of it. The contemporary Russian left is rejecting the legacy of communism after the first ten years of the revolutionary period, until Stalinism. But the nostalgia of the ordinary man in Russia, as many post-Soviet liberal intellectuals believe, the one that makes people vote for Putin, is a nostalgia for Stalin, and the 'glorious' empire he represents. But this isn't just confined to the impoverished workers and peasants of Russia. When you listen to most popular music in contemporary Russia, (like the mega-popular counter-tenor singer Vitas) or read aspirational magazines, like *Snob* (the title of the popular magazine of the liberal intelligentsia!), or look at contemporary art, the prevailing feeling is that of imperialism. The residual love for splendor and bling was necessary after the demise of Soviet blankness. At the same time, Russia is a country with some of the biggest inequalities in the world. Older people may feel in a need of a tsar-like, strong leader, but their existence is shrinking.

## Post-politics of nostalgia

After '89 we observed the waning of and even the hostility towards any politicized thinking that would, especially in the former East,

be called 'ideological', labelled as belonging to the previous system and so on. It is funny how when the leading liberal-leftist association, Krytyka Polityczna, published a book on post-1989 documentary film, where authors wrote on the 'ideologies of Polish capitalism', there was a sacred outrage all over the liberal press, a shock at calling capitalism too an 'ideology', as if this word was necessarily reserved for the fearful 'Komuna' (a derogatory term for communism used universally in Poland). Just as everywhere else, the 1990s meant for the ex-Bloc the end of politics as we knew it: end of politics practised with the help of political programs, political differences, with everything landing in a undifferentiated mass. Political parties lost their original meaning – in the recent election in Poland it was hard to say what any candidate associated himself with. This is the world of postpolitics, as we know it from the last decades of elections in Italy, Russia and, increasingly, the rest of the Bloc.

These manipulations of history and memory are a direct revenge on the communist system, in which it isn't a mystery why uncomfortable, inconvenient facts from history were erased from the books and not put in the public domain. As the PRL was silencing the memory of the Independence Day (as it was connected with the inter-war, bourgeois Poland), the wartime Home Army or the Warsaw Uprising, in contemporary Poland history is nothing but the remembrance of those three facts. In this vein, the religious right wing part of the Polish political scene founded the National Remembrance Institute, established as an organ to 'pursue the crimes against the Polish state', which given our history, were many, but transformed with time into basically a way to persecute anyone who had anything to do with the old system, in a witch-hunt not dissimilar from McCarthyism, touching many leading figures. This led to the absurd situation where it aimed to discredit people like Ryszard Kapuścinski, the Polish star reporter, who was a believer in socialism and later a supporter of Solidarity, but somehow started to be a liability in the new system. Many of our

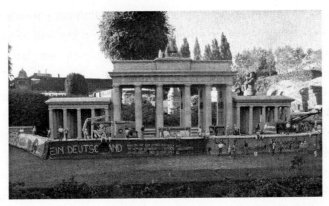

1.4 Dig your own Berlin Wall, animatronic set in the Mini Europe theme park in Brussels

artistic and moral authorities had to pretend they didn't live under communism, or had to quickly erase their engagement with the system to remain in the government's good books.

What is not remembered enough, and to a greater disgrace, is the Holocaust, which happened nearly entirely on the lands of the current Poland. The recent Polish film *Consequences*, about the aftermath of a pogrom in Jedwabne, caused the outrage not only of the right wing – magazine covers were calling for lynching of the main actor. Many ex-communist countries are plagued with anti-Semitism, which, given the near-non-existence of a Jewish population is all the more outrageous. Many of them were directly implicated in the Holocaust, especially Hungary, Lithuania, Romania and Western Ukraine, those who are now the most willing to commemorate the 'crimes of communism', and want to be seen as its 'great crashers'. One of the biggest "successes" of e.g. Lithuania in the EU was in trying to force a European Day of Memory to the victims of Nazism and Stalinism, trying to enshrine in law the levelling of the two totalitarianisms in the EU parliament a few years ago. This leads to the trivialisation or obliteration of Jewish suffering during the Holocaust and justifying anti-Semitism with anticommunism. In all the post-communist countries there

are now great anti-communist museums to be built: in Romania, Estonia, Latvia, Lithuania and Hungary, soon in Poland, where we still have a commonly-used word, *Żydokomuna*, that conflates Jews and Communists. It was justly criticized not only by the left, but also by liberal British commentators, with Jonathan Freedland being appalled by the ideas behind the 'double genocide'. In his recent *Bloodlands*, historian Timothy Snyder tells the story of the war crimes in the East caught 'between Hitler and Stalin', yet doesn't highlight enough the participation of the locals in the Holocaust, which was pointed out by the Vilnius-based Jewish historian Dovid Katz. In Poland, this discussion is mostly due to Jan Tomasz Gross's ground-breaking books *Neighbours* and *Fear* on the collaboration of some Poles with the Germans in assisting the Holocaust for the sake of personal financial gain. Focusing on communist crimes not only whitewashes the scale of collaboration with Nazi crimes against the Jews and denigrates the significance of the Holocaust, the real idea behind this elision is to show that the evil comes from the outside, and we are good, therefore we haven't done anything wrong, ever.

The backdrop of this manipulation of historical memory is a shadowy justification to all the policies introduced after '89. How else, than by the ritual beating of 'komuna', would the subsequent governments justify themselves? In many countries, Hungary being the most blatant, it leads to some atrocious right wing and racist politics on the part of the government. But as we've seen, the European Union didn't react when Hungarian authorities were introducing censorship. It didn't react to the president Orban marginalizing the opposition's legal rights. It didn't react to government ministers' recent racist comments on Jews and Roma, comparing them to animals and bringing back the rhetoric of Nazism. It did intervene, though, when Hungary started to limit free trade. The message is: we don't care what your politics are, unless you'll mess with our economic requirements. The recent rise of the right in Eastern Europe is a result of the messy communist

transition into capitalism. The people who were the architects of it, today very often speak disdainfully of the exotic Eastern right-wingers, yet little is done in terms of boycott.

## Toxic Ruins

While so many of us are outraged at our own ineptitude, this means different things for different social and political parties, factions and classes. Neoliberal politicians claim our capitalism is not capitalist enough, the Right claims to be besieged by the 'leftist tanks' in the country, where the majority is intolerant of homosexuality, the government rejects any liberalisation of women's and gay rights and over 90% declare themselves Catholic, and where there was arguably no organized independent left since the inter-war period. The rhetoric of a besieged fortress is conflated with a post-colonial rhetoric, in which the westernization of the country is a danger – and that including the seemingly tiny impact of the left. But the question is whether the EU was always so neoliberal or only at the time when we entered it? If communism came to us too soon, the West invited us to the party way too late.

At the same time, our own fucked-upness turns out to be quite interesting within the modern economy. In the traditionally more affluent West, the domination of simulacra is never-ceasing, only deepening and widening its reach, producing people who are willing to pay and to pay well for the possibility of feeling 'in your own skin', how it is to live in an area of heightened insecurity, be it political, ecological or historical. Numerous tourist companies with a sophisticated programme are willing to take you to the former East. For instance, one of them called Political Tours, in the case of Kosovo, promises "aided by local experts, politicians, and analysts, the tour [explores] the origins of the conflict in Kosovo and looks at the enormous changes that have taken place since 1999", notwithstanding "what the country has to offer in terms of its rich culture, cuisine, and even nightlife". Political Tours will take you to the places of crisis, political upheaval, and specializes in

(post)communist regimes: this way, places like Serbia, Bosnia, North Korea (as well as Canary Wharf) get the treatment. It seems that even if everything is ruined there's still a way of making money by picking over the corpse.

The past history has literally become a theme park for us – hence the various 'Parks of Memory' throughout the ex-Bloc, or the communist statue parks popular among European tourists, like Grutas Park in Lithuania and the Memorial Park in Budapest – but also the present in the contemporary world, a present, which is especially tormented, making people's lives difficult or unbearable – can be just as easily turned into a funpark for the rich and bored.

On our first visit to Ukraine, when bumping to friends and art curators, the first thing we were asked was "are you going to Chernobyl?" They obviously were: you could tell that with the same enthusiasm they'll put on the famous silvery protective uniforms, as when they penetrated the galleries in New York or any "hot" place on the art map. It didn't occur to me, that by then, in 2010, the sightseeing of the ruined ex Soviet Union had become somewhat an industry, a kind of still-a-little-bit "frightening" (all those ex-communists, radioactivity and whatnot) type of tourism, largely popular among a community of so called "urban explorers", internet-bred geeky fans of danger, willing to pay a decent sum of money and risk their health a little to experience the thrill of entering the Zone. They are currently scavenging some of the USSR's darkest places, and Pripyat, the city in northern Ukraine, then USSR, the nearest town to Chernobyl, where the reactor in a nuclear power plant erupted in 1986, is their "holy Grail", as one of them put it recently on the pages of *Icon* monthly, in a special ruin-themed issue. The Zone of Exclusion, as it is called, meant everybody was evacuated in the 30km surrounding it.

This new fashion was made possible not only because the state of Ukraine saw a potential in opening the former dead zone as a tourist attraction. The higher popularity of the so-called ruin porn, made ever popular by internet forums and blogs, is a direct effect

of the fall of traditional industry and the rise of the so called "creative industries". The now omnipresent photographs of abandoned, depopulated cities like Detroit, or New Orleans destroyed by Hurricane Katrina, transforming quickly into beautifully produced coffee table books, turn the tragedy for some into a source of visual delight for others, who may ponder their tragedy from a philosophical point of view. You may say it's the media saturation which turns the images of disaster into everyday experience. But the fascination of "urbex", as it is gently called, not accidentally focuses also on places of great historical importance and scenes of dramatic events.

An "urbex" is a usually a well-off, well educated Western male from a big city who might or might have not have read a lot of SF fiction in his youth, who wants to give his usually safe, sedentary job an exciting kick. It is this factor, that casts some shadow on the perhaps vacuous, but seemingly not very endangering activities. For instance, the former USSR has become a scene of such fetishization exponentially with its own economical fall after the collapse of the socialist system and capitalist shock therapy, as pictures of heavy drinking, impoverished folk from Siberia populate the internet as "Hipsters from Omsk". The tons of pictures from Pripyat notwithstanding, Ukraine and Russia haven't had a worse press from Western commentators since the dissolution, for jailing their liberal West-friendly politicians, like Yulia Tymoshenko, or anarchist activists Pussy Riot.

The ongoing fascination/repulsion that the capitalist West had with the ex-Soviet Bloc started during the Cold War years and prepared the ground very well for the flourishing of all sorts of urban and political myths, that were only confirmed by photos circulating in magazines like *LIFE*. They were consolidated by a few works by the most popular Russian director in history, a man with an extraordinarily distinct vision, Andrey Tarkovsky, most notably *Stalker*, which, despite being shot in 1979, is popularly perceived as a "Chernobyl" film for its uncanny prophecy. It is

endlessly reproduced in the company of the reactor-trips pictures and transformed into a video game, *STALKER: Shadow of Chernobyl*, where instead of indulging in philosophical debates, one becomes an amnesiac urban explorer, one of whose tasks is to kill a villain called "Strelok".

Let's get one thing straight - ruin porn is at least 200 years old. When the romantics encountered the freshly rediscovered Roman and Greek ruins of towns like Pompeii and trips to Rome became a favorite activity of romantic poets, there was nothing more trendy than a pensive ruin contemplation; English gardens had randomly scattered "ruins" and fake ancient architectural fragments purposely built in around for trysts and contemplation. Painters since classicism have relished in plotting architectural riddles, as different as Canaletto and Piranesi. There was in this a longing for the lost past, for the "golden age", that was never to come. Interestingly, Tarkovsky probably also believed in the idea of an irretrievably lost golden age.

Tarkovsky has a reputation of a pensive, sinister, gloomy prophet-saint, famous for three hour films full of endless contemplative scenes fixated on nature, the rural and antiquity as opposed to industry, cities and modernity in general. Yet despite saturation with symbols and obsession over nature, if you examine the films closely, something quite modern emerges. Of the four most quoted films in the West - that is: *Andrey Rublev, Stalker, Solaris* and *Mirror* - two of them are starkly modern, futuristic, and adaptations of SF literature; the two others, most notably *Mirror*, are usually quoted to prove Tarkovsky's love for obscurantism and dismissal of everything later than JS Bach and the old masters, like Breughel or Leonardo. *Andrey Rublev* sits uncomfortably as a portrait of an artist, who is critiqued for his innovation: a clear alter ego self-portrait of Tarkovsky himself and his ambivalent relations with the communist authorities, which did not begrudge him money for usually extremely opulent and expensive productions. It is enough to quote one scene from *Solaris*, when the characters have a video-

phone conversation, one sitting in a bucolic little hut in paradisiacal forest surroundings, while another is in a car, which turns out to be on an extremely high-speed highway around a grim, menacing metropolis. The sequence that ensues is one of the most mysterious in the whole of Tarkovsky's career. Right from the heavenly greenery we're taken on a crazy ride through the never-ending flyovers and tunnels, Brutalist skyscrapers, slabs and blocks, accompanied only by an uncanny noise, which turns out to be an extremely futuristic, now cult soundtrack by electronic composer Eduard Artemiev. What is this city and does Tarkovsky look at it with fascination or repulsion? Probably both, and this is what makes it such a thrilling scene still today.

1.5 Eye to eye with history, Budapest's cemetery of communist sculpture, Szoborpark

The universality of *Stalker* and the source of its ongoing inspiration regardless of nationality has several reasons. One is its status as a universal image of decaying, post-industrial civilisation, a sinister glimpse of the real cost of industrialization in terms of people and climate, where the happiness and comfort of some is

paid for by the poverty and crumbling lives of others. Is it though a critique or a complete rejection of it? Tarkovsky was neither a liberal intellectual, nor purely a "yurodivy" - a holy fool or a shaman, living only on spiritual values. He was an uncanny mixture of both, applying his westernized doubts to the (according to some), incurably "crazy", irrational part of the Russian soul, necessarily in love with despotism, tsarism and nationalism, and his fanatically spiritual part was undermining the possibility of seeing anything positive in late Western civilization. This wasn't, importantly, a stance of any of the authors of the novels he adapted: Stanislaw Lem of *Solaris* famously rejected his novel's adaptation, while the Strugatsky brothers' novella *Roadside Picnic* adapted for *Stalker* is significantly more rigorous and less inclined to existentialism than Tarkovsky's view.

It's a strange candidate for a patron saint of hipster land explorers. And paradoxically, this mixture gave a very coherent, at least on film, worldview, in which neither is true: we see clearly that neither the cynical, self-pitying, hollow Poet's reasoning, nor a fanatical conviction of the Professor, is correct. The Stalker himself, an incurably melancholic, unhappy creature was by many compared to a Gulag prisoner, not only because he famously says the enclosed Zona is nothing in comparison to the "prison that is the world". Geoff Dyer, an English essayist and author of the latest book-length interpretation of the film, *Zona: A Book About a Film About a Journey to a Room*, confirms this by giving us a rather sentimental quote from Anne Applebaum's *GULAG* on the never-ending "zone behind the barbed wire". Dyer's shot-by-shot analysis, despite its over 200 pages, seems strangely abortive in how little of the essence of the film it delivers. Everything becomes obvious: Zona is USSR, Stalker is a victim of the regime, the regime is eternal, there's no escape.

And yet, the Zona fascinates: fascinates the characters in the film and now the scavengers, who want nothing more than be in it. Why? Slavoj Žižek suggests that its popularity is prompted exactly

by its prohibition: its properties are augmented by the fact they are somehow wrong, bad for us. Lacanian interpretations of the Real as an area of exclusion prompting its power aside, the ex-communist area, as possessive of dark forces is for that reason precisely popular among the Westerners. The bad thing is that what they do, the money they leave in the former East is based on this place staying toxic: remaining forbidden, radioactive, sick. And the guarantee this world can remain sick is that where we come from remains safe and healthy. This has an additional touch of the macabre, in that this film had a number of "victims", a true chain of corpses behind it. It was not shot in Russia, but in Estonia, near Tallinn, at two deserted power plants on the Jagala River and several other toxic locations, like a chemical factory, which was pouring toxic liquids. At least three people involved in the production, Anatoliy Solonitsyn, Larissa Tarkovska and Tarkovsky himself, died of cancer in the aftermath.

This perception of the former East as a constantly sick place, needing our help/advice/political intervention is enduring. It also prompts the specific kind of nostalgia after communism, Ostalgia. The neoliberal governments of the ex-communist countries, like Estonia or Ukraine, are only too happy to exploit this for their perhaps irrational yet profitable interest. Estonia based even its cultural offer for the film-makers and other creative industries as a "land of *Stalker*". Toxic ruins keep influencing the imagery of the natural catastrophe in new generations of films, like Hollywoodian blockbusters *Chernobyl Diaries* or *The Darkest Hour*. Another example of this mutual misunderstanding is Baikonur, formerly Leninsk, in Kazakhstan, the city of the Soviet space programme still launching Russian satellites, which people usually think is a dead, abandoned area. The deserted post-nuclear landscapes of *Stalker* were recalled even during the recent tragedy of Fukushima by a *Guardian* journalist. Yet there is little Western interest in contemporary cultural and political issues in these places, not only because in the situation of civilisational and economical

weakening, the ex-Bloc was left with the choice between the manipulation of oligarch-driven economy or death, abandoned by the state support. The recent Euro 2012 tournament in Poland and Ukraine saw the England team and its fans visiting the reactor, alongside Auschwitz in Poland.

The wisdom of Tarkovsky's films was that they offered a kind of post-religious, post-spiritual consolation in the empty world "after God", in a way that was neither simplistically existential nor devoid of a kind of higher moral stance. It's the mystery of Tarkovsky how he understood so well the awkward spiritual side of the seemingly mechanical process of industrialization, a legacy of the Bolshevik regime he no doubt hated. Like Kafka, who worked in a gigantic insurance company and got an insight to bureaucracy as a universal model of the modern world, Tarkovsky saw through the USSR and the strange ambiguity between the system and the modernization, the tension between Western capitalism and supposed socialism; as a director and visionary, he understood their strange interdependence in the world pushed by mechanisms of history, man's striving for perfection and cynicism of politics, creating a world balancing between utopia and hell on earth. Yet as Putin's Russia recently strives towards a nationalistic orthodoxy, tourism based on seeing the former USSR as a toxic Disneyland ceases to be as innocent as it may initially seem.

## You can scream here

Situated 450 kilometres from the Russian mainland, Kaliningrad is an isolated territory created by the Soviet Union. Carved out of the German East Prussian city of Königsberg and its hinterland after the war, bordered by southern Lithuania and northern Poland, it sits on the edge of the Baltic Sea, geographically separated from Russia but officially still part of the country, a hangover from a bygone era of empire. With its neighbors now part of the EU and NATO, as well as the Schengen zone, the city's detachment from Russia is only growing. Kaliningrad's extraordinary position in

Europe has inspired strong responses in adjoining countries, and particularly in Poland, not only from politicians, but also from artists. In January 2012 a simultaneous exhibition, *Enclave*, was held at Warsaw's Center for Contemporary Art and Kaliningrad's National Center for Contemporary Art. Artists from Poland and Russia were asked to reflect on the idea of an enclave, with regard to Kaliningrad itself.

What are the principal associations of the word "enclave"? Mostly negative: isolation, xenophobia, alienation. Judging from many contributions to the exhibition, Kaliningrad is a reflection of exactly that condition, a museum of dead ideology, surrounded by the ruins of an old system. Yet look closer and the city tells a different story. Both economically (it was given Special Economic Zone status in 1996) and demographically, Kaliningrad is doing significantly better than most of the rest of Russia. So which of those two images — cultural obsolescence or economic progress — is nearer to the truth?

The Russian artists in the exhibition tended to respond more closely to the stated topic. Sound artist Danil Akimov produced the most ethereal work, a small room that became the city itself: a map was projected on the floor that was sensitive to footsteps and evoked the sounds of the respective parts of Kaliningrad. Art group Tender Bints (Nezhnye Baby) showed a video, Dirt, in which two women perform a strange ritual drowned in mud, telling a sad story of the women of the Curonian Spit, the enormous sandy peninsula which sweeps out from Kaliningrad towards Lithuania and forms an isolated enclave within an enclave. Some of the Polish works meditated on neighborliness and hospitality, kindness and the lack thereof. Karolina Breguła's 'Good Neighbours', for instance, showed the artist walking around Kaliningrad knocking on people's doors and introducing herself as "your nice neighbour from Warsaw". For the most part, however, the Polish works in *Enclave* were Ostalgic - wistful portrayals of Kaliningrad that focus on the ruins of the previous system, and in particular on the most

devastated elements of post-Soviet reality. Franco-Polish photographer Nicolas Grospierre focused on picturesque Soviet relics: the Palace of Soviets (constructed on the site of a castle built by the Teutonic Knights); decaying tower blocks; government buildings and courtyards; and, as an epilogue, a library in an abandoned school, replete with endless heaps of ruined books.

Maciej Stepiński's 'Exclave' series contemplated wistful trash: one of the most typical features of Kaliningrad seems to be abandoned rusty cars. As always, the problem with aestheticizing socialism like this is that it not only annihilates any potential positive uses of this project, declaring it as dead, but also provokes a melancholy longing for it. Other works not only took a maudlin look at the city, but also criticized it. In a film by Polish group ZOR the narrator, increasingly unimpressed by the concrete architecture of the city, says, "It's a terrible city. The ugliest city in the world!" Ryszard Górecki's 'You Can Scream Here' is a sign, hung on the Timber Bridge in Kaliningrad, which reproduces Edvard Munch's famous image with the invitation, in German and in Russian, to replicate that scream. Why would anyone want to scream there? "There could be many reasons," says the artist. "Germans can scream from grief for the city they lost. Russians — while looking at the city they have built. And tourists — from the disappointment of Kaliningrad." Little wonder that the sign was removed by vandals after only a week.

*Enclave* was only one of several major shows on Russian art in Poland in the last ten years. It's as if enough time has passed now that Poles and Russians are no longer afraid of each other. But that trauma clearly remains strong. Many of these exhibitions still manifest signs of fear and distrust. The banner made for one Russian-Polish show by artist Anna Witkowska read, "BEWARE, ENEMY!" One might ask whether art is the right tool for overcoming these differences. But it is, at the very least, a good barometer of cross-border emotion. If there's a show about a mutual friendship, you can bet that there are deep-running discrepancies

and inequalities. But in *Enclave* we also see Poles looking at their neighbors with a certain fascination that might just transform into closeness. If anything, this show was a reminder of colonial inter-dependencies. Poles, at least on the political right, like to see Poland as a besieged, poor, betrayed country where things suddenly got better, at least by comparison. Now at last there's someone worse off than them.

Shows like *Enclave* say more about Poles than the place they visited. One fascinating element of the transition after 1989 was the way in which the post-colonial process of "othering" had an effect on the modernizing countries of Europe. Kaliningrad easily becomes a mystified "other" for the Poles. Many of the Polish artists who visit Kaliningrad speak of the "genius loci", the specificity of the place, but fail to see it through anything other than Soviet clichés. The default reaction of the Polish artist is a traumatic image of the Communist past — and somehow we don't want that image to be challenged. We like to think of Kaliningrad only as a prison or concentration camp, even though this is not what the citizens themselves see. In the past the norm was from someone to come from the west to Poland, see the Stalinist architecture and say, "Look at these horrible Communist ruins!" Now it's Poles themselves doing that. We have done our homework on becoming a "normal European country" and now we're telling our neighbors the news. What will come next? Will there be new quasi-colonial relations in capitalist Europe? East Prussia, which became Kaliningrad, was first an object of desire for the Teutonic Knights, and then became a staging post in the Red Army's push to the west. It is, in its way, a tragic model of permanently colonized space.

## Sexy and Unsexy Countries

There's something common between all, even the most emanci-pated/cosmopolitan/hipstery/urban Poles, or maybe especially among them: when asked where we're from we never say "Poland", just like that, as if it was normal; we also don't say it with

1.6 Community Center Lobby in Pripyat, the town built for the
Chernobyl nuclear power plant workers.

pride. Most of times, we don't want this thing to matter. And if we
say that, be sure we will immediately start to explain ourselves.
"Well, you know, Poland now is not what you think it is. There was
some dramatic changes/ we're a normal European country."
Normal. European. Those descriptions seem to matter to us a lot.
We like to see ourselves as a part of something you all recognize (or
at least something we see as such), god forbid as something that
until recently was very poor, very grey, where no one from the
West, apart from expats and stag parties would like to come for a
visit, because why? I remember how deeply ashamed of being
Polish we were in the 90s. It was a bad word. Once at the very
beginning of 2000s I was taken by a friend to a Greek migrants
party in Berlin, in a nice tenement, where all neighbors got together.
My friend then told me she was asked "who are those half-
Romanians?" I didn't know there was a huge Romanian migration
wave at this point, but remember my shock at this. I didn't know
whether it was the semi-racism or the fact I was called a Romanian
that caused me more outrage. And this from a Greek!

If we necessarily have to admit we're Polish, there has to be
something that compensates for it – a necessary sense of pride.
"You know, Poland fought heroically during the war. Unlike many

others, we never collaborated with the Nazis, 8 million of us died. We had heroic resistance and Home Army, and then the communists came and with them some traitors. Which war? What uprising? What communists? You might ask, seeing, that the person probably never lived through any of those events. It doesn't matter. The war is always still going on.

As far as sexiness goes, in Poland we definitely consider ourselves unsexy. So do must other post-communist countries. Yet upon travelling across the ex-Bloc, what strikes you is the seediness, the astonishing amounts of peep-shows, sex-shops and various strip and 'Gentlemen's Clubs', and the more one goes east, the more sleazy it gets. Polish Catholicism keeps this relatively quiet in Poland, but in Prague, Budapest, Kiev, Minsk, Riga, Tallinn, Belgrade and Moscow this is not an issue. When in a hotel, on the shelf there's already lots of flyers, totally assuming you're there to use Eastern girls' charm. The sex industry that mushroomed in the East is only one side of its capitalist transition. Yet, the more sex, the less sexy it seems, the more sleaze, the less pleasure. If we're to believe the Free Theatre of Belarus' successful travelling spectacle *Minsk 2011 (after Kathy Acker's New York 1979)*, sex in Minsk is particularly off-putting. The piece collected all sorts of humiliating acts Belarusian folk have to endure and a huge dose of bleak humor as well, establishing the murky relations between sex, money and nationality. Yet the troupe displayed little consciousness about the place where they're showing their militant piece. In London, it fuelled the liberal, narcissist positions which are simply rebuking the horrid Soviet republic, refusing to acknowledge the privileged position from which those criticisms could be made. The audience clapped furiously cherishing the 'bravery' of the dissidents, while overzealous broadsheet critics believed that in Minsk you are arrested for looking at someone for too long, while the play itself, with its depiction of the streets of Minsk full of aggro, implied you would only risk a hostile look back. Belarus, "the last dictatorship in Europe", couldn't have a

worse reputation, but Western opinion, hoping for the demise of Lukashenko would gladly see also the demise of its welfare state. Western politicians and commentators clearly see it as a part of this "totalitarianism".

The "Ukrainian bride" was and still is a social phenomenon, the most abrupt meeting between the Western financial capital and the Eastern beauties' submission. So imagine my shock, when I discovered Ukrainians are using it unironically. There's a huge demand for an Ukrainian Bride, also among Poles, fed up with the relative emancipation of Polish women, who, as one of the commenters on the "Loving the Ukrainian Woman" forum puts it, expect them to help with housework and bringing up children! The patterns of exploitation are subtle. It's enough to be a little bit better off, and it's always from the West towards the East, or, as the Polish example shows, from the EU to the rest. The leader of *Krytyka Polityczna* Sławomir Sierakowski even used the term "Russian bride" in a *Guardian* comment piece, published there during their "New Europe" month (where apart from Poland, the "New Europe" was also… Spain, France and Germany). In his view, the Russian bride, all in political metaphor, "will make a good wife to the Polish husband", who will rescue it after its abuse by tsars, Bolsheviks and oligarchs. Then it only needs the polite husbandly hands of Poland.

An open transaction. A wife from an abused, impoverished country unlike emancipated westernized women is expected to be submissive, undemanding and grateful. The consequences of that model from not only feminist, but simply societal perspectives, are grim. In the popular HBO series *The Sopranos* Eastern Europeans serve as bodies to do sex and house work. At least several young Russian women come to the US, only to work in strip clubs and to find an American husband, usually becoming instead a *goomar*. In one episode the mobster Tony Soprano, when he's not able to 'perform', quarrels with his Russian *goomar*, calling her 'a communist cunt'. Judging from the series, at the beginning of the

2000s Americans had all sorts of racist attitudes towards the ex-Bloc, using all kinds of communist insults: Russian mafia are 'commie bastards', Poles are of course 'Polacks' (just like in another HBO success, *The Wire*, in which an attacked 'Polack', Frank Sobotka is trying, oh the irony, to save the dockers' union). In *The Sopranos* the economically competing deprived are hostile between each other as well, in the classic narcissism of small differences: when the Russian mistress calls Tony's house and is answered by his Polish maid, they make sure to exchange a hateful little dialogue.

The emigrant literature that we have is often treated as an opportunity to take out the regrets towards the native country rather than portraiture of the new conditions. In AM Bakalar's novel *Madame Mephisto*, the female character relishes in doing everything possible against the social norms in her country: she's single, she's promiscuous, she doesn't want to have children, she sleeps with men of different skin color, she has an abortion and she works as a drug dealer. On top of that, so as to seal her transgression, she sleeps with the husband of her beloved sister, who unlike her, is a perfect businesswoman, now consecrated as a Mother Poland with a young child. In *Illegal Liaisons*, Grażyna Plebanek focuses on the taboo of extramarital sex and gender roles. Her male character not only is supported by his better-off wife as a Euro-bureaucrat in Brussels, has a passionate, toxic affair (with unusually graphic details for a Polish novel) with a foreign woman, but also takes the weaker, "feminine" part in both relationships. Polish women find emigration liberatory, because the feminism that they don't always admit to supporting is much more present in the social reality and the legislature of the countries they visit.

This is what in the end makes migration in the times of post-Fordism and post-communism so hopeless and such a vicious circle-like experience: the exchange is unequal and set up from the very start. We go to the country which offers us a better paid job. 'I will never come back to this country' ensues, while the operation of

outsourcing is going on. The 'Don't waste your time for Poland (or, Latvia, Lithuania, Slovakia)', that people keep repeating is nothing else than a call to 'Fuck up this country even more'. The neoliberal economy sets up the most socially and economically culturally draining situation possible, yet the response to that is – more neoliberalism. Capitalism doesn't work? That means it's not capitalist enough. This is the mantra repeated by our politicians, most infamously by Leszek Balcerowicz.

Post-communist countries are sometimes aware of this and then ashamed. In a funny social media scrap, the president of Estonia Toomas Henrik Ilves started a rant on Twitter against Keynesian economist Paul Krugman, who had used his column in the *New York Times* to criticize the use of Estonia's 'recovery' from a huge crash in 2009-10 as a model for the rest of Europe – as he pointed out, a slight upswing from a catastrophe hardly counted as spectacular success. To this the politician answered with the accusation of racism. "Yes, what do we know? We're just wogs", tweeted the Estonian president - "We're just dumb & silly East Europeans. Unenlightened. Someday we too will understand. Nostra culpa. Let's sh*t on East Europeans: their English is bad, won't respond & actually do what they've agreed to & re-elect govts that are responsible." He didn't offer statistics in his defence, but asserted that Krugman's critique bore traces of even if not directly racism, then of dismissal based on his Western privilege, moreover, about a country he apparently knew nothing about. But in fact, despite that, Estonia, just like any other Eastern European country newly in the EU, simply obeys the austerity decreed by Brussels. So in his rant the Estonian president not only played the 'underdog' card, but did it to avoid a real discussion on economics. Because perhaps we do feel that we gave away too much and are overly subdued to what the West wants, yet admitting it would be too much for us.

In *The Possibility of an Island* by Michel Houellebecq, the main character, Daniel, observes the merciless conditions in which the

post '89 world has found itself, especially for the citizens of the previous so called 'demo-peoples'. Nowhere else are people so merciless when fighting for their own interests than Eastern Europe, he claims. Even the villains of the Balzacian world were nicer than those thugs. 'Let's beware brotherhood', the French writer concludes. Together with the end of the Curtain, new attitudes started emerging in those post-Soviet countries, that were relatively better off as a result of the capitalist transition, or indeed, got slightly less fucked up despite all the attempts to the contrary. Poland, due to its accession to the EU and the accompanying subsidies is, as we've seen, definitely perceived as one of the 'leaders' in the former East.

But what kind of attitudes did Poles gain as a result of the restoration of property, together with the liquidation of communal flats and free healthcare for everyone? The best way to measure it is to examine the relations Poles have to those who are at the bottom of the social ladder. As the leader of the East, Poland started to be an obvious destination for migrants or refugees of the many post-Soviet countries that were less successful in the post-89 restoration. Here, an eternal rule of capitalism seems to be at work: exploiting anyone you can, who is more vulnerable than us at this precise moment. For now, Chechens, Ukrainians, Vietnamese, are those exploited and discriminated against in Poland. A recent rental survey has shown how Poles are hostile to rent a flat or give a job to any of the nationalities above, or to someone of color.

As every neoliberal country, where ownership is the only model of living, we now have a dramatic problem with flats. Yet what happens is the city selling the debts of tenants to businessmen who then carry out brutal evictions. In Warsaw another problem is the sudden claims from all those who had or inherited properties which were there before the war and before PRL's First Secretary Bolesław Bierut issued a decree in 1948 abolishing private ownership. It was perhaps the only way the destroyed Warsaw could've been rebuilt, but now, together with the Stalinist or simply

socialist modernist architecture, it stands for the straw-men of all kinds that stop Warsaw from becoming a tacky 'Eastern tiger', like some Eastern European Shenzen, even if hopes for that are nonsense. The inheritors are blocking construction sites or evicting people, even institutions, like schools who were in the city center for decades. And when they strike back, organized crime is ready, as with the killing of one of the leaders of the Tenants Movement, Joanna Brzeska, whose body was found burnt in the forest near Warsaw and was only two years later recognized as murdered by the court. Everyone attached to the movement runs the risk of social repressions, even for a un-PC status on Facebook about the mayor of Warsaw, when someone joked about having a dream, in which the mayor was dead.

Moreover, the aggressive racist attacks, anti-Roma and in general anti-Eastern refugees become more and more the everyday reality, especially as the far right groups spread across the former East unharassed by the police. Only in the last few months, have the repeated arsons and attacks at the communities received much publicity. It's interesting that the eastern refugees stick mostly to the eastern Poland, so called Borderlands, always historically multicultural, but not now.

The problem with racism doesn't only concern Poland among the countries of the former East. Racist attitudes, especially towards Roma, are visible in Slovakia, or Baltic States, where the Latvian and Estonian speaking majority is hostile towards a very large Russian-speaking minority. But in Poland, the ubiquitous racism is even more shocking, given that currently over 2 million Poles are on an economically induced emigration in Western Europe. There are recurring opinions that Poles are merely reproducing towards the refugees what was already happening to them in the West. This is false in several ways: Poles are not political refugees, unlike the Chechens who come from a war-torn country - and their country isn't as poverty-stricken as Ukraine, let alone Vietnam. This outright racism is often justified by the ethnic cleansing that

Poland, like many Soviet-occupied countries, endured after 1945. The Yalta conference and Stalin's idea of 'national' socialism led to the expulsion of Germans, Ukrainians and Belarussians from the territory of the new post-war Poland; and Poles were expelled en masse from Soviet Belarus and Ukraine. This, combined with

1.7 Friendship as an alternative to the state, a temporary drug Nirvana

the Nazis' extermination of Polish and Soviet Jews, left ethnic homogeneity and an ethical abyss. This way from what was historically a multi-ethnic territory, Eastern Europe has become divided into several strange, homogenized wholes. This argument often serves another opinion, that as artificial national constructions, cobbled together by Stalin, the socialist experiment in Eastern Europe couldn't succeed.

Feelings of superiority, racism and xenophobia are gradual. There's always someone less well off than us – so while a Pole can suffer hostility in the richer Western countries, for himself poorer and more geographically Eastern countries may start playing the same role – we've seen a sophisticated version of this in Kaliningrad. As Poland, since the Holocaust and Soviet homogenization, is 99% Polish, its attitudes can be extremely racist. It is often too hastily and too easily justified by the economic issues, yet it doesn't seem enough of an explanation for the enduring hostility Poles have towards Roma, Vietnamese, Belarussians, Chechens or Ukrainians. Expressing racism is nothing to be worried about, as there are no organs which would take care of hate speech. When a Warsaw policeman shot an illegal trader from Nigeria, he wasn't even charged. They cultivate feelings of hatred and irresponsibility, out of twisted revenge on 'komuna'.

But are Poles or other Eastern Europeans, who do suffer racist

attacks in the UK, actually so ready to fight back? It transpires that Eastern migrants in the UK hardly ever claim benefits and rarely organize or unionize against the exploitative conditions of their work. They seem silenced in the West, where they could have stood up against actual mistreatment. Why does it happen? Is this traumatized subjectivity, or maybe, as they usually come from countries where a welfare state is not obvious anymore, they don't even know they have a right to it? This doesn't stop articles on cunning Eastern European benefit scroungers appearing often both in the UK gutter press and in the more classy press in Poland.

A depopulated main street in the former cotton-manufacturing city of Łódź appeared recently in *The Sun*, titled as 'the Polish city that moved to Britain' as an effect of migration. Yet, the paper's photographer had to try really hard and photograph it at around 7 in the morning, because usually Piotrkowska Street is one of the liveliest streets in the country, full of original cafés, clubs, restaurants and singular shops. But if the *Sun* went to any similar mid-sized British city, there it would discover the real misery, depopulated streets, ugly retail shops and Bargain Booze. In terms of devastated cities, the UK has a visible primacy.

## Post-transitional cruelty

One of the topics that keeps coming back recently in the Polish press is the problem of the mutual cruelty between Poles. From boorishness in everyday contact on the street, pushing each other, quickness to aggressive exchanges of words, to tolerating the suffering of others; accidental police and law enforcement victims, eviction victims, women who didn't get medical help if that 'threatened the foetus' and died as a result, tolerating domestic violence and sexism, not tempering racism. All this in a country declaring itself 90% Catholic, which has apparently never heard of Christian charity.

Various explanations are given. Poles got savage because of communism, say some, it's obvious, that this state where education

was insufficient, conditions and hypocrisy brutal, must have led to the brutalization of society in the process. It's a 'peasant mentality', say others. Poland had centuries of peasant serfdom, who had to give all their work to the master. At the other end, since the era of 'noblemen's democracy' (in the Seventeenth and Eighteenth Centuries a single nobleman could stop the whole national assembly with his veto) and then the 123 years of partition and occupation that followed, we have a complex where under the clothes of many an average Pole there's a impoverished nobleman, resentful of his fate.

The third and most likely answer is different, and possibly contains the other two. It is the brutal capitalist transition, the sudden loss of jobs and security by people who were never before endangered by unemployment, the collapse of the economy, inflation and loss of security that made people unforgiving, hateful and vulnerable. Despite this, Poland is visibly a richer country than many in the former Bloc – it is the only major European country to have avoided a recession, thus far. Yet the growth figures hardly manifest themselves on the faces on the street. Life is a daily struggle: to buy for less, to get before someone in the queue, to gain something, anything, even if it'll be just brusqueness towards the neighbor or getting a better deal than him.

'No big deal' is the popular saying in Poland: no big deal someone has died in a custody; no big deal someone has died in a hospital; no big deal someone was evicted out of the flat for being late with the rent, or died before they got proper health care. What matters is that I am ok, or at least better than this unfortunate.

Life is a struggle for most Poles, who earn much below the European standards, while working longer hours. In a country, that prefers to 'liberalize' the employment laws, so that they could employ people on even worse conditions, on worse contracts, with little or no social security or stability of employment. But when Solidarity union recently put out a program of action against 'junk contracts' and poor working conditions, with a general strike of

miners, metalworkers and transport workers in the industrial belt of Silesia, employers claimed that it was they who were doing the workers a favor, not the other way round – the employers who work hard and are being exploited. It's unfair that the poor 'entrepreneur' has to pay health insurance for the worker, because clearly, it's him who studied harder and in general invested more into the greatness of the new Poland. These faithful students of Balcerowicz walk around as the Polish elite now, part of the establishment, intent on shutting down those last few remnants of the old system: schools, cheap milk bars and social clubs. They advocate demolishing Poland's post-war modern architecture, but the future in Poland clearly belongs to them. Represented by the ruling party Civic Platform, they declare and believe themselves to be 'modern', which in their language means: privatize, be entrepreneurial, work only for yourself.

So it may just be precisely otherwise: the brutishness and cruelty Poles share to each other is due their lack of security, the poor housing, the instability of employment. I feel that every time I travel on Wizzair or Ryanair back home, which each time is a painful disappointment. People push and never help each other. Mothers never comfort their crying children. The mistreatment by the airlines results in a mistreatment of each other. It's all in all a very depressive image. Cheap airlines and their opening simultaneously with the New Europe, and the extension of the EU around 2000s was decisive in making this whole human experiment possible. Before people were, of course, coming to Western Europe and trying to work illegally, spending days on buses, or even clutching the underneath of a truck, as depicted in the famous Polish film from 1988, called aptly *300 miles to Heaven*, where two boys, facing the hopelessness of the grim late 80s Poland, decide to escape their parents and hold onto the bottom of a truck, illegally getting to Sweden. Watching this film as a young girl, just like the boys, I believed this temporary suffering may be worthwhile if it serves the future.

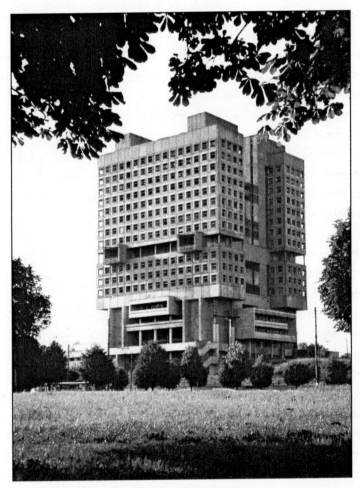

1.8 The derelict House of the Sovets in Kaliningrad

Poles hating on each other on a Ryanair flight is the Polish class system in a nutshell. Despite the everyday declarations of politicians about growth, Poles still prefer to leave than sit jobless. And 'Western' has always meant 'better', so even a job much below your qualifications, but for higher wages, is a success. This is a vivid illustration of the continuing 'Eastern syndrome'. Class differentiation is the most visible element in post-transitional societies, where the visible impoverishment of the communal spaces of

neighbors, the overexpenditure or the tacky luxurious office blocks housing the chosen, those who were better off through the transition, especially those who successfully turned into real Europeans and work as creatives, they look sceptically at the working class majority, that doesn't look good as a neighborhood and spoils the Polish success story as a positive narrative. On the other hand, the Polish press is full of two kinds of emigrant stories. One has a dark, tragic tone and worries about the effect on Poland, the other are stories of the cunning, 'smart' Poles as welfare kings and queens, normally spread by tabloids like the *Sun*. In Poland they are written by the intelligentsia daily *Wyborcza*.

## Dark art for dark times

Of course, the way people reacted to the capitalist changes differed with respect to the nature of communism in their country. In Poland people tend to react with greater sense of blessed dignity, given that one of the reasons Poland so enthusiastically reacted to the capitalist 90s was the catastrophe following the 'Martial law' of the early 80s and its aftermath, where Solidarity was banned and repressed. Poland paid for it with isolation. Martial law, with all its grimness, greyness, lack of goods, and a nightmarish national debt that resulted in dramatic shortages of food and all possible goods. The rationing of food meant that a typical phenomenon of the 80s were the 'packages' from the West, mostly America.

With my family for the first eight years of my life I lived in the gigantic Warsaw estate which is world famous for standing as the epitome of 80s depression and anomie, in Krzysztof Kieślowski's *Dekalog*. Shot in 1988, Kieślowski's vision was highly influenced by the recent Martial Law, which left a stigma on Polish society, the last humiliation, which tainted our way of leaving communism. Ten episodes take place in one and the same grim huge block estate. Its inhabitants are subjected to various moral dilemmas, all tracing around the modern meaning of the ten commandments. What shocked me watching it recently for the first time since the 90s was

the difference in my reaction. I remembered *Dekalog* as only bleak, tragic, with some cheap metaphysics and touchy-feely moralism inserted in between. What I saw now was a masterly, extremely intimate and emotionally truthful portrait of Polish society, in which communism isn't even what matters. Kieslowski seems to say that our moral integrity is often a question of coincidence, an accident. Someone officially respected can turn out unreliable; someone untrustworthy can be a saving grace. Nobody in this cycle seems to blame their misfortunes on Komuna, although it exists in the very essence of this film, its visual sensitivity and bleak style. It depicts a society on the brink of collapse, with all the social bonds seriously damaged. Yet what Kieślowski is interested in is the assessment of social bonds, social trust and inter-human relations. Interpreters usually focused on how hopeless the time of the late communism was, but what appealed to me was rather a basic belief in human decency. Politics is of course present there, but it wasn't meant to be a typical *chernukha* or 'black film' project. We had *chernukha* in Russia, the Black Wave in Yugoslavia, Black Documentary School and Cinema of Moral Concern in Poland. All were, with different moral premises, concentrated on depiction of the darkest, bleakest aspects of human existence. 'Chernukha', a strictly Soviet aesthetical complex, is about making the bleakness a style. It was partly based on the brutality of Soviet and post-Soviet life and came into use as word during *Perestroika* (though the sentiment itself can be dated back to the brutality of Tsarist times no doubt).

Kieślowski was a very prominent European filmmaker, to the extent that this cycle was shown in its entirety on UK TV. But much more present was actually his post-communist cycle, 1990s *Three Colours*, foreign co-productions partly made in France. In fact, they watched exactly the way I imagined *Dekalog*. They depicted Europe post-catastrophe in a much less realistic, less socially engaged, gritty or specific way and in a more metaphorical and in the end, sentimental manner, in the name of the three slogans of the French

Revolution. It was a clear sign that in the new postcommunist Europe we can focus on different problems. In *Blue* we even have a composer, who creates a 'Symphony for Europe', in practice the cruelly kitschy music of Kieślowski's court composer Zbigniew Preisner.

Yet the Black Cinema made its return when the post-89 economic crisis took its effect. Today, its role is taken by the Romanian New Wave and a new generation of Russian directors. *Chernukha* lives and lives well in the contemporary Russia as crime stories, TV serials and novels. It must be said that on surface they strongly confirm the status Russia has abroad: as the country of mafia, crime, cruelty, violence, the abuse of women. But on the other hand, they're often a social critique of the post-Soviet inter-regnum and dehumanisation, with in the end a strange relishing of it. From the *Bandit Petersburg* crime stories by Alexandra Marinina, to the political, postmodern SF by Vladimir Sorokin and Viktor Pelevin, and films like the two parts of *Brother*, the comedy-horror *Night Watch* (Nocnyi Dozor) and *Day Watch* (Dnevnyi Dozor), to the Sorokin-scripted *4*, by Ilya Khrzanovsky, where Russia is shown as an endlessly dark, dystopian, *Stalker*-esque post-industrial zone, a society where pigs and young women are cloned for consumption and shady political goals, evoking lost urban myths, especially Lysenkoism and the USSR's 'war on nature'. *Stalker* itself, not 'officially' set in Russia, is a kind of *chernukha* which disavows it. It managed to create a wholly original phenomenon taking only from the Russian traditions, yet remaining extremely attractive to the (also Western) viewer, partly because it indulges our stereotypical view of Russia.

In the film *Nirvana* (2008), a retro-futurist tale of two heroin-addict girls from Petersburg, the new Russia is a hallucinatory, deadly, tough country easily claiming lives. Shot in the flamboyant aesthetic of the 80s New Wave revival, it is in keeping with the ethos of the 'Piter' punk scene, recalling the times of the USSR, where the youth subcultures were a shield against the system. In

the new Russia, pervaded by crime and death, what matters is a shot of the drug, a short but certain euphoria, and friendship evolving between those abandoned by the state. *4* goes further – it's a fantasy about biological mutation, a fantasy of both Soviet closed 'science towns', where experiments are carried out, and the new anxieties of the free market, where a human becomes just a pack of meat.

*Chernukha* dominated Polish cinema throughout the 80s and 90s, but it was hard to say whether the brutalization, visible poverty, corruption and violence presented on the screen were a result of a conscious artistic concept, or simply a document of the country's cinematography falling apart. The 1980s especially were full of malfunctioning youth institutions: families, schools, borstals. We had drug films in the type of *Christiane F.*, on young people taking specially contaminated heroin, so called 'kompot'. Sinister, dejected dramas about youth drug addiction, prostitution, derailment, lack of scruples, violence and the general feeling of the world falling down, a dramatic poverty combined with the black market, gave the grim effect that "everything can be purchased for a penny". The youth fall down most dramatically, as the young generation is usually the one that is experimenting the most with their lives.

It was the time of biggest social zombiefication. In *Cargo 200*, telling a story from the 80s, a brutal political satire and horror movie at the same time, women are raped and beaten to death, while human remains coming en masse from Afghanistan in coffins, help smuggle drugs. The gathering horror in the movie was a conscious act against a growing nostalgia of the USSR, but it was hard to say, if it wasn't also the accusation against the current system. *Cargo 200* started a discussion in Russia about the interpretation of the 80s. If we recall films of this era anywhere, it was sinister also on the other side: proleification of cinema, rise to prominence of directors like Mike Leigh, and not far away the grim trip-hop and new kind of cheap drugs, especially the 'brown

sugar' kind of heroin. To this Polish hip-hop also responded, especially Kaliber 44 and Paktofonika, two short-lived acts who lived in the proletarian suburbs of the Silesian city Katowice, whose leader killed himself at 22. Today their legend has come back as a story of Polish social transformation in a grim social biopic *You Are God* (2012), also shown in the UK.

## New architecture of memory, memory as a Commodity

Who are we then, and how could the ex Bloc have taken its chances after '89? What were the alternatives? Which way could we have gone? Many of the new ways of thinking about public space after the end of the Cold War we owe, as many other things, to Germany. After the reunification, there was insistence on and political programmes stressing the building of new "spaces of memory", which were to be devoted to the 'mutual' history of West and East Germany. In this, already the 'post-ideological' trend was brought to the public. A prolific "architecture of memory" in Berlin remodelled the city purged by war, demolishing old and setting up the new buildings, in so doing created a logorrhoea of signs, a new center that had to fill the space full of voids, and the memory of Nazism still contained in the pre-war buildings. Yet, what the new authorities of Berlin did was to get rid of the memory of the DDR first.

When radically rebuilding its representational spaces, in 2002 the German Bundestag (itself, with its transparent copula designed by Norman Foster, an aesthetic just as much as political statement standing as the symbol of the New Germany) decided to demolish the 1976 DDR symbol Palast der Republik and in its place reconstruct three facades of the baroque 18<sup>th</sup> century Andreas Schluter Hohenzollern Palace. Though the demolition took place, the reconstruction still hasn't occurred due to lack of money. The Schlossplatz, still a void in the capital center, symbolizes divided German attitudes.

The last two years of protest, the Indignados/15M movement,

1.9 The wall by the Gdańsk Shipyards comemmorating the 1980 strikes. Above it, rising is the new European Solidarity Center, with auto-rusting symbolic facade

were significantly more active in the western part of Europe, despite being still more affluent. Yet it's interesting to see how Berlin, a city among the most politically active, with a long tradition of protest, behaved in this. Attending several Berlin demonstrations, including the May Day, it struck me how ritualized and predictable they were. Organized mostly by the antifascist/anarchist movements, current Berlin's culture of protest seems misguided and abortive, just as the recent 'anti-hipster' movement comprised locals (often also imported, but pre-gentrification), who blame international creatives and 'hipsters' for gentrifying their city. Their theatrically aggressive demonstrations can be compared to student demos in London, which were peaceful, but met with brutal police methods, with the famous 'kettling' for hours and truncheons.

One of the reasons for that may be mishandled mythologization of Berlin, which is currently bringing more damage than good to the conditions in which politics can be made. As its public space has been neutralized since reunification, Eastern memory has been

all-but-wiped out in what is in most respects an Eastern city. An inconvenient capital, it has become an illustration of a model post modern city, where 'past wounds' were to be evoked by architecture, not left as wounds. The two palaces–two memories competition took a different turn, when the DDR curiosity was provoked by such films as *Goodbye Lenin* though. It's partly the hedonism of Berlin, the 90s party mood, in which the hedonists would precisely side against demolishing the DDR "eyesore". Against this is the recent politics of the city, which stopped seeing the clubs as a magnet good enough for the investors and recently is known for letting the most famous clubs shut down.

It's time Eastern Man felt dignified again, for decades identified with what is the worst about civilization, without shame for what has been. Yet memory is a monster that goes its own peculiar ways. One of the reasons we didn't quite 'get over' communism yet (it keeps coming back in our debates, if only negatively) can be found in the popularity of various parks devoted to the relics of iconography of communism. On one hand, despite those relics, we get the appraisal for our good behavior – you were naughty, but look at you now, you got rid of the old symbols, now you've got membership in the EU, a capitalist economy – maybe you'll eventually even be like one of us.

Poland is one of the few countries that resisted the temptation of establishing a Park of Memory, unlike nearly every post-communist country: there's Szoborpark in Budapest; Grutas Park near Vilnius, Park of Fallen Memorials in Moscow. They enjoy ambivalent, yet stable tourist interest, yet in the latter the whole idea seems strange, as Moscow to this day has gotten rid of few of its memorials, save for Comrade Stalin. In Poland we have no major Museum of Communism. Does this mean we got over it, or rather that our recent history has been erased?

One could analyze this by comparing the political activity in the post-2008 crisis around Europe. There's no doubt that my generation, born in the early 80s, were among the most depoliticized – we

were born around the era where the biggest popular dissents were brutally crashed around the world. Solidarity in Poland, the Sandinistas in Nicaragua or the miners in the UK, they were all part of the same popular rebellion against the crashing of the post-war consensus. The recent wave of protests is very unusual, and not accidentally is done by people younger than the 80s generation. This younger protest is mostly untouched by nostalgia, although in any of the groups protesting in Moscow, Petersburg, Ljubljana or Zagreb you could probably find both people interested and disinterested in the past. The fight is the most vivid in the areas where, for historical reasons, the left and communism were less suppressed and are less an object of trauma, like in ex-Yugoslavia.

In his 1996 book *Twilight Memories, Mapping the culture of Amnesia*, the German critic Andreas Huyssen is trying to sum up what was left after the transitional time of 1989-1991. He observes an increase of the work around 'memory', which, not surprisingly revolves around maintaining amnesia. Until today, we talk endlessly of the past, but the wrong parts of the past, we could say. This growth of the post-history in the world has increased, interestingly, since the early 1980s, which you could attribute both to postmodernism and neoliberalism. Years of patrimony, devoted to specific events or artists commemorated usually in the most safe, 'heritage' way paved the way to something we know today as "Keep Calm and Carry On" austerity nostalgia, retrograde aesthetics and heritage culture. This waning of the notion of history and denial of historical consciousness, partly a result of the Fukuyama 'end of history', is standing in shocking contrast to the current reality of the crisis, with daily news about the economic collapses of countries.

Widespread debates about cultural heritage, and the compulsory plans for a museum (of modern art, of memory, of war) show we are haunted by another loss that may come. It was Adorno who wrote on the "freezing of memory in the commodity form", which provokes this weird amnesia. Huyssen is suspicious

of the German left voicing their fear about the "unreconstructed easterners". Yet it's true that the demise of the DDR was a "revolution without the revolutionaries", therefore it didn't have elites who could after the unification take up the discussion with the politicians from West Germany. How different it looked in Poland. Was Poland harder to bring down because we had so many prominent anti-communists and strong opposition?

Huyssen's book is an already prophetic insight into the future of Europe. The popularity of museums we observe today is yet another aspect of that cult of memory, but strangely enough, only the memory that is suitable for the authorities and the leading intellectual current. Huyssen focuses on Germany and observes how in East Germany, unlike in Poland or Czechoslovakia, there's a lack of discussion over the 'civil society' among the ex-East German intellectuals, who gave up their task of democracy and civil society. Also, the extensive Stasi surveillance and the short period of opposition makes the transition different than in Poland. In 1991 the mood of nostalgia kicked in - on one hand, there were those mourning social security and demise of social regulations that used to cover every aspect of life. On the other there's the nostalgia of intellectuals, who still unrepentantly believe communism was a better way to organise the state. They often were the same who were criticizing the limitations of the 'really existing socialism'. In Germany more than anywhere because of unification, there emerged the notions of underdevelopment.

From the Eastern-Western battles over memory, we see how the 'new', posttransitional version of history triumphed over the real memories of the place or even the people who used to live and work there. If there's a place in the post-communist Poland in which we can see in a nutshell the results of the capitalist transition and which is currently suffering similar 'museification' at the cost of the real people who live there, it's the Gdansk Shipyards, the legendary site where the union Solidarity was started, and then, as it is told in every history book, eventually overthrew communism.

As we speak, a great museum is being built there, in the vast, so called 'post-industrial' space. The shipyards were privatized, asset stripped and gradually sold to foreign investors, who very recently ultimately stopped the very small ship production. Now a great EU-financed building grows there, designed in corten steel, which is to create a 'living monument' – designed to look like a rusting ship, which is supposed to be surrounded by hypermarkets and entertainment edifices, now halted because of lack of money.

Just like the other crucial 'spaces of memory', the International Solidarity Center is designed to evoke the melancholy of disappearance by its very form. But isn't it too much, one may say, given that it not only symbolizes the disappearance of work and of the industry, but also of the hands that used to put them into motion? The district around the building is among the most deprived and poorest in the whole of Gdansk, the Lower City, with people living in rotting, dissolving council flats from 70s. It's a strange thing with memory these days, where the more we focus on artificial concepts, the easier it is for us to neglect the existence of real people.

# 2

# Ashes and Brocade

## Berlinism, Bowie, Postpunk, New Romantics and Pop-Culture in the Second Cold War

*Had to get the train*
*from Potsdamer Platz*
*You never knew that I could do that*
*Just walking the dead*
*a man lost in time*
*Twenty thousand people cross Bösebrücke*
*fingers are crossed just in case*
*where are we now?*
David Bowie, 'Where Are We Now?' 2013

## Drang nach Osten

Where does central/eastern Europe exactly lie? Already when trying to describe its name, we have a problem, before even starting to try to determine its geographical leanings. For central-eastern Europeans, before the World Wars there were often hardly such things as nations. When in the 1930s there was a census carried out on the Polish lands, the answer to the question of 'Nationality' was nowhere near certain: when asked to put 'Nation', the largest amount declared 'Polish', but many declared Jewish, Ukrainian, Ruthenian, Belarussian, and about 15% said simply that their nationality was 'from here' - a story often repeated by Eric Hobsbawm, the German-Jewish-English historian, a lifelong enemy of national categories. For Jews especially, the question of nationality was a question of their being or not being – particularly in Berlin, the largest city in central-eastern Europe. At least since the Weimar period, Berlin had a reputation as a capital of moral

2.1 Concrete desert. A view from the Stasi HQ in East Berlin.

dégringolade: analysing the literature, pulp fiction and iconography of that era, one comes across a place that is pestilent, ridden with poverty and crime, a swarm of lust, murder and decay. At the same time, Nazism rises, offering the so-desired simple explanations for the visible decline. It's the Jews, and the Jews come from the East.

Still, the eastern part of any city is regarded a less attractive, poorer and is usually the more squalid and neglected one. In the Weimar Republic, one of the most popular stories within the expressionist period was *Nosferatu*: a decaying living dead being, who comes from nowhere else, but – the geographical east. That was after centuries of Germanic conquest of the east, the so-called *Drang nach Osten*, in which the Teutonic Knights, under the banner of Christianization, occupied and brutally conquered the eastern tribes, and to which, to a degree, Hitler referred in the Generalplan Ost – the Nazi plan to be implemented after the war, where Poland

and Soviet Union were to be ethnically cleansed and populated by Germans. Since the Weimar period Berlin was subjected to contradicting narratives. On one side: the blatant anti-Semitism, the Nazi aesthetics of *Der Sturmer*, anti-modernism, Entartete Kunst. On the other: Neue Sachlichkeit and the vicious caricatures and photomontages of Georg Grosz and John Heartfield, at the same time trying to promote socialist culture with the help of socialist newspapers like *Arbeiter-Illustierte-Zeitung*, whose caricatures and photomontages became the symbol of that time, and an alternative to the Nazi racism and pseudo-socialism. Berlin was never to shake off this schizophrenia, which it carries until today. Levelled and destroyed, divided into four zones and finally by the wall, it was to remain a sick, shaken place. Theoretically half of it was Western, but in reality it was a small island within the East, always mentally belonging there. Even the German punk, the relentless music of Neue Deutsche Welle or the beginnings of techno, where does it come from? There's something common about the Germanic music: post-punk, techno and Cold War pop. It's its piercing restlessness and mercilessness, this didn't come from under the coat of Goethe, dining at the aristocracy of little German principalities. This came to us from the times of the grim Weimar era taking its toll, from the etchings of Neue Sachlichkeit and Expressionists. More than that: it's not even German as such, but it's Prussian and its relentless discipline comes from the East.

Berlin is an Eastern city, by geography, spirit, architecture and expression. Yet, it remains half-Western, by politics and history. But even this double status does not explain the role it used to and keeps playing in the imagination of the Western hipster youth of the last four decades. Berlin is a model city to describe what has really happened after 1989. After the unification of Germany, the capital was moved to Berlin as a symbol of the new order, re-establishing the pre-split and even pre-Nazi past. It was an element of the *Vergangenheitsbewältigung*, so called 'overcoming of the past', a term taken from the post-Nazi period and the technical solutions

the Germans applied in another stretch and twist in their gallery of history-changing concept-making: *Modell Deutschland*, something ever popular in a country with a lot to 'overcome'.

## Berlin as capital of Post-DDR melancholia

In Poland, where the ideology was most obviously forced, it never really succeeded: tensions between the authorities and the society were always enormous, and exploded in a series of general strikes and protests. In Germany the ideological apparatus and disciplining was much higher and much more self-imposed. It is shocking to compare Polish and German parades and ritualistic May Day or anniversary demos, in which participation was compulsory. Until the very last moments of the DDR, East Germany was demonstrating in the full scale paraphernalia, and with mass participation, while the critical mass within the Polish opposition by the late 80s made these rituals more empty than ever. In East Germany, ideology and the regime, precisely because of the closeness of the West, were no joke.

It's interesting to what extent the contemporary, supposedly 'edgy' youth coming to this parody-of-a capital, sticks solely to the center. Their trips don't usually extend beyond the district of Friedrichshain-Kreuzberg. There you can find the typically ahistorical, uprooted relation postmodern man has with history. The CIA spy base of Teufelsberg in West Berlin, squatted for several years, has by now become so banalized it lauded as an exciting tourist attraction even in Ryanair's in-flight magazine, confirming that any historical artefact can become banal in contemporary Berlin. Nostalgic parties with an 'a la DDR' aesthetic are popular among the youth all over Europe. Warsaw clubs took to this fashion much later, and simply borrowed it. In both cases history becomes meaningless against the 'right to party'.

I checked this by visiting the places connected with the regime in the most straightforward way: the Stasi headquarters in the Eastern district of Lichtenburg, and Checkpoint Charlie, the former

border crossing in Kreuzberg. The Mauer-Museum by Checkpoint Charlie is today a pitiful, private but very popular Axel Springer-owned font of Ostalgic souvenirs. By contrast, the Stasi HQ is located in deep eastern Berlin, which to this day is strikingly different from what is a couple of kilometres west. This eastern part of the city strangely gets hardly gentrified and remains extremely sinister: the tower blocks have not been repaired, there are no signs of nice shops or galleries. This part of East Berlin, more than anything, felt like home. Located between grey towers, the HQ immediately brought to my mind every other military museum in Eastern Europe. Time has frozen there. Sad elderly male guards give you tickets with bored expressions on their faces, and the place exudes the typical smell of an old attic, untouched for decades.

Time frozen – yet, perhaps sometimes to good effect? There was a clear decline in the quality of artistic production on both sides of the Wall after '89, which proves how the framework of Cold War preserved the modernist approach to making art. Whether teddy boys, mods, popists, new romantics, new wavers, synthpoppers, punks or freaks, young people remained modernists, in their precise and sober approach to art, which was to transform the world, if not powerful enough to change the world around them, then to change the one inside them. They became the 'explorers of inner space'. This transformation of taste started, if the we're to agree with Dick Hebdige, with the 'streamline style' of the 30s which led to pop-art, from the beginning described with distaste by the upper classes as 'art of poor taste'. We'll be understanding pop-art as a complete creation of the Cold War era, made within specific tensions around the fetishism of capital, where youth, even if it becomes an arch-commodity, finds in it nevertheless a way out for itself.

The musician Felix Kubin, involved with the German techn-odance/electronic scene, founder of a label called Gagarin Records with many established links to the previous Neue Deutsche Welle, used post-89 Germany's combination of smugness and schizo-

phrenia as an occasion for subversive performances. At the start of reunification he and his friends formed Margot Liedertaufel Honecker, which proported to be the choir of a DDR youth organization Freie Deutsche Jugend, who made surprise 'patriotic songs' performances to an unsuspecting public. They saw the hurrah-optimism of the new unified Germany as hypocritical, designed to sweep the old crimes under the carpet. In one improvised flash mob that interrupted some yodelling corporate events in a super-market, the group, dressed as poker-faced East German Komsomol, bewildered the public, claiming they were really supporting a DDR renaissance. In the early 90s seeing East Germany's characteristic yellow compass and hammer or the two shaking hands could have been equally scary as a swastika. Symbols, uniforms, performances, all aimed to disclose Germans' uneasiness in confronting anything other than the artificial 'model reality", stripped of anything historically uncomfortable.

Thus, the foundations of modern Ostalgie were established. The term was coined in the 90s after many in the East firmly voted for the PDS, the former communists, in elections - an act, at once of anti-capitalist politics and ideological emancipation. 'They want to tell us our lives were all a waste' – went the typical comments of the ex-DDR citizens – 'and that was the happiest time of our lives.' Disappointed by the character of post-unification Germany, people refused to suddenly reject all their past, as if in another, twisted-capitalist version of communist era 'self-criticism'. Despite being 'masters of the world' in memory, Germans still, until this day have problems with dealing with the post-DDR reality, and the greatest example of that is the position of Berlin itself, a failed capital.

This Berlin, that we tend to consider a vibrant Cold War city, was initially anything but. The Year Zero saw it completely destroyed, and the social fabric, not even mentioning the cultural one, had to be seriously resurrected. And as Berlin was basically an extended prison back then – divided into sectors controlled by four different national powers - it was an international playground for

the victorious forces. Post-war Berlin deserved a lot of spanking from those with which it is supposedly most associated. On the brink of famine, in ruins, it was called by Brecht, upon his arrival, a "heap of rubble near Potsdam" an "etching by Churchill based on an idea by Hitler", where he could smell "the stinking breath of provincialism…"

But the competition was launched, and Stalinallee, finished in 1957 (later renamed Karl-Marx-Allee in the early 60s by Khrushchev, who renamed the streets and took all the Stalin statues down), the gigantic Stalinist architectural complexes, and the Hansaviertel, built by all the big Western names, from Corbusier to Gropius, made this torn city's fabric an ideological battleground. Yet people didn't want to live next to a prison, where the third world war could start any moment. The city slowly became more and more fractured, with the Berlin Blockade in 1948, and fear of Soviet totalitarianism – upon workers strikes in 1953 the Russians sent in the tanks - until, finally in 1961 the wall was erected. Those easterners who had managed to relocate to the West populated a

2.2 Unsalubrious work conditions of a Stasi functionary.

city largely abandoned, a situation that led to the arrival of waves of Gastarbeiter, mainly from Turkey, since the 70s.

The East-West distinction still has an impact in spatial thinking. Berlin, always a part of eastern Germany, was always inspiring mixed feelings in the west. The first post-war German chancellor Konrad Adenauer had a lifelong repulsion towards this city, in his opinion, too 'Eastern'. It was only Willy Brandt, who started to take the bad associations away from Berlin again. Yet, with cultural workers leaving for Munich, Düsseldorf, Cologne, Frankfurt, before the slow re-emergence of the New German Cinema of engaged directors, like Kluge, Fassbinder or Schlöndorff, of Serielle/Elektronische Musik with figures like Stockhausen, writers like Heinrich Boll, Gunther Grass, playwrights Peter Handke, Peter Weiss, it really was the way Kraftwerk described it in interviews: Germany was a cultural desert, and initially the only culture there was straightforwardly American, clubs didn't have other music to play. And Berlin? In the opinion of the robots, it was 'just a museum.'

This museum started provoking culture within its rubble. Feminist filmmaker Ulrike Ottinger describes living there in the early 70s, in districts like Kreuzberg: desperately poor, full of refugees, but still with immense artistic ferment. Berliners themselves created a culture based on trash valued positively, art growing upon political tensions, with the Neue Deutsche Welle in particular, and since the late 70s a defeatist response to the country's ultimate civil death after the killing of the RAF's members. For guests from the outside, those tensions – the Wall, the wars, Nazi past, ruins - were an antidote to the blandness of living in their respective countries. And the electrifying knowledge of the Bloc round the corner was everywhere.

What I'll be calling 'Berlinism' is the twentieth-century phenomenon of the German capital as a dreamland for both easterners and westerners. Arguably, it starts after First World War, when the Weimar era turns it into a capital of all sorts of

debauchery and transgression, in culture, politics, literature, art, music and theatre. What built Berlin's reputation is a combination of German expressionism and cheap rents. Arguably the first Anglo who set foot there solely with the wish of participating in the cool was Christopher Isherwood, who came there in the 1920s in the search of forbidden homosexual carnal pleasures; for not only was Berlin permissive, it was also cheap. Years later, the writer recalled in his memoirs: I wish we went to Paris, but Berlin had the boys. So Berlinism means the conscious use of this ambiguous cultural capital, made of sweat, camp and danger. The current career of the city is a complex coincidence between its history and the decline of cities as we knew them, through the disappearance of their industry.

Thirty years after the war, the characters of Wim Wenders' early films are shipwrecks of this post-industrial world, raised on the scraps of American pop culture, giving up their life for the sake of a certain form of American dream. Hence their uprootedness, solitude, abandonment, their Quixotic relations with the world and *Weltanschauung*. Those West German easy riders long for something more than their flat life. But what the hero of *Alice in the Cities* discovers is the artificiality of his American dream. Not only that, but the little girl he meets in New York and then drives around the Ruhr, Alice, is in every respect a child of Wenders' post-hippie depressed generation, mature too early, all-too-understanding of her elders' neglect and decrepitude. Looking at her sage little face, we see Christiane F., the famous author of the teenage drug addict memoir, a few years earlier. When Wenders' characters feel let down by their American dream, they start to look inward, to Germany itself. By this time, he wasn't the only one.

## I could make a transformation

*Is there concrete all around or is it in my head?*
David Bowie, 'All the Young Dudes'

The 1970s were the era of defeat. As the 60s were extremely intense in terms of political and social change, from the early 70s the flux went steady. David Bowie, who debuted in the late 60s, marked this change when he invented Ziggy Stardust in 1972: no more real heroes, from now on the most desirable thing was to be fabricated. What is genuine, authentic, is boring. The only hero that really matters, is pure artifice, cut out from the comic books, movies and dressed in everything that's glamorous. Bowie more than anyone contributed to the cherishing of artifice in pop music, realizing the idea of a "hero for a day", only following the course mass culture had been taking for decades. Was he conscious of that? Some of his lyrics of the era mark the mourning of the depoliticization of his generation: in the lyrics to the song 'Star', he mentions "Bevan (who) tried to change the nation", and posing himself instead as someone who "could make a transformation as a rock & roll star". Facing the growing nihilism of his generation, he still believes that as a star of artifice, he can carry on their political task. 'All the Young Dudes', a song he wrote for Mott the Hoople in '72, reeks of the youth's disappointment and disillusionment, forming a kind of "solidarity of the losers" anthem. Bowie, always too erratic to make any firm political commitment, was rather in love with various dubious figures, "cracked actors", (the inspiration for Ziggy was a forgotten singer who was believed to be a combination of god and an alien), necromantics like Aleister Crowley, Kenneth Anger's satanism, Fascist dictators. He was, nevertheless, obsessed with certain elements of modernity. He was driven to German culture, especially the Weimar period, expressionism, Neue Sachlichkeit, theatre, Brecht. His first break-through hit concerned a man lost in space, after all, and the space age gets a strongly melancholic treatment from Bowie, as his character Major Tom is rather terrified by the silence of space. Another obsession, as we will see, was Orwell's *Nineteen Eighty-Four*.

Bowie's fixation with 'totalitarianism' applied to both sides. At one point he planned to stage an adaptation of the Soviet-Czech

comic book *Octobriana*, about a socialist she-devil super-heroine - a samizdat publication, that was circulated between creators only through the post. Bowie could only have learned about it from its 1971 American edition. On the other side, his dalliance with the far right was something more than just the famous Sieg Heil he made to fans in 1976 at Victoria Station. It's not an accident pop bands are very rarely left-wing, and Bowie's reaction to the economic crisis of the 70s was to imagine becoming a right wing politician who'll "sort things out". 'I believe strongly in Fascism', Bowie said; 'the only way we can speed up the sort of liberalism that's hanging foul in the air is to speed up the progress of a right wing tyranny. People have responded always more efficiently under a regimental leadership.' Bowie recognized, if only half-consciously, the appeal and meaning of the pop idol as a dictator. In Peter Watkins' film from some years earlier, 1967's *Privilege*, a young, cherubic, mega-popular singer is hired by the fascistic authorities, who use his popularity to ensure their control over the masses, in a truly Orwellesque, Big Brother-like take on the police state (which here has much more to do with Nazi Germany than communist states). Yet Watkins' scared, weakened, traumatized singer, terrified of the masses, couldn't have been further from Bowie, who relished in fame.

So Bowie's fascination with Germany and Berlin was only partly expressionism – much of it was also quite simply, fascism. He became a chief *Schwarzkarakter* for Rock against Racism, whose magazine pictured him next to Enoch Powell and Hitler. The press deemed his Thin White Duke look 'more Nazi than Futurist (sic)'. He also caught the attention and sympathy of the National Front, who in an article called "White European Dance Music", said that 'Perhaps the anticommunist backlash and the aspirations towards heroism by the futurist movement, has much to do with the imagery employed by the big daddy of futurism, David Bowie. After all, it was Bowie who horrified the establishment in mid 70s with his favorable comments on the NF, and Bowie who might have

started an "anti-communist" music tradition which we now see flourishing amidst the New Wave of futurist bands'. Who might the NF's publicist have meant as the "futurist movement"? It was the growing synthpop and New Romanticism that was emerging from the post-punk bands. Punk by itself might have evoked a resistance towards the establishment, but by then it was dissolving. Although we are used to seeing industrial/synthpop/postpunk as ruthless modernists, the bands were actually rarely openly left wing. The political message, if any, was rather vague. Bands dwelling on the space age came often from dispossessed areas, which they then made topics for their music, but the result didn't have to be politically sound. It was this later, new romantic period that brought Bowie to the left, with the stern words about 'fascists' on *Scary Monsters*.

But even if we treat those remarks as just the drugged out delirium of a coked-up degenerate, which they were, it can't be denied they had an influence on popular music. If you take the whole fascination with the Germanic in post punk bands, like Siouxsie and the Banshees or, omen omen, Joy Division, the twisted outpourings of their leaders weren't just simply teasing their parents. They were flirting with the outrageous (Siouxsie), against the war generation, or they were openly right wing, like Ian Curtis. They had little to do with the struggles of Baader-Meinhof that ended tragically few years back. Curtis was confusing his obsession with Hitlerism with another obsession with a concentration camp prisoners (Stephen Morris has said in an interview that Joy Division were supposed to look like Nazi camp *victims*) or wider, the idea of the underdog, which tapped into their Bowieesque Eastern Bloc fantasies, like that of 'Warszawa', an eternally concrete, sinister city. Yet Bowie's image of contemporary Berlin must've been seriously twisted, if he thought he could find shelter there with another drug addict, Iggy Pop, in a place that had already become one of the most narcotics-dependent places on earth. West Germany and West Berlin had for years been a territory

of political dysphoria. The New Left's legacy was melting. In a context of pseudo-denazification, militancy reached its peak around 1968 and the police shooting of Benno Ohnesorg. By 1976, when Bowie moved to Berlin, it had become the armed terrorism of RAF, the Red Army Faction.

## Oh we can beat them, forever and ever

If you look at any footage of the West Berlin in 70s, you see a murky city, gravitating around the Wall. Living next to a prison, even if theoretically you're not the prisoner, you can develop symptoms of suffocation. Knowing people can be killed over an illegal crossing of the Wall, not being able to walk all of your city, imagining what there can be on the other side. Rainer Werner Fassbinder felt shame for the post-war West Germans, for the way the West stuffed their mouths with consumerism and told them to shut up. During his 1978 film *In a Year of Thirteen Moons*, he punished the viewer with a ten minute sequence of rhythmic murder and quartering of animals in the slaughterhouse, a senseless death that is then wiped out and put into neat plastic boxes. Half of his films are acerbic commentaries on the situation of the left, until they start to look more like funeral elegies. Fassbinder was friends with Holger Meins, who was a cinematography student when he joined the RAF. He later died in prison after a hunger strike. In May 1976 Ulrike Meinhof committed suicide or was killed, followed by Ensslin and Baader. In the 1981 film *Christiane F. Wir sind Kinder vom Bahnhof Zoo*, when Christiane and her boyfriend Detlef have awkward, clumsy teenage first sex, it's on a lair of bloodied, dirty sheets cobbled together in their drug den. Poor kids, they and their teen friends have all their injections, trips, they hunger, shake, ejaculate and overdose under one and the same face of Ulrike Meinhof torn out of a newspaper.

One of the reasons the punk generation reads dystopias like *Nineteen-Eighty-Four* and *A Clockwork Orange* as if they were their lives, and looks longingly towards the communist East in their aesthetics, is their depoliticization. The generation of their grand-

2.3 Perils of European melancholy

parents was the one who survived the war, believed in socialism, was changing the world, joined political parties. Earlier, to piss off your parents, you'd join a Communist Party. By the 70s, those who wanted to change the world were discredited and all they had left was the aesthetics. A generation or two before, people believed in the modernist ideal for living: built estates for collective life, in which neighbors were to meet in the patio and socialize. The 1960s and 70s also marked the crisis and decline of the nuclear family. In the regress towards private life and individualism, with a growing number of divorces, this generation was paying for the necessary experiment of their parents by not having anything in return for what they'd given up. The counter culture as a resource/channel of political culture also began to decline. What was left were the drugs. Berlin since the 70s started having an enormous population of drug addicts.

The 70s were an era of abandoned children, with no more support in institutions. *Christiane F. Wir sind Kinder vom Bahnhof Zoo* (this sentence has the same structure as the "Wir Sind Helden", *we are the heroes*), the 1981 film, opens with a murky shot of Gropiusstadt, the most infamous block estate in Berlin, by then decaying from social and material neglect, plagued by crime and violence, which brought more and more arguments to a new class of politicians who deemed the ideas of modernism 'bankrupted'. The infamous St Louis estate Pruitt-Igoe was taken down in the mid-70s. Groupuisstadt *is* scary, but wasn't meant to be. Former Bauhaus director Walter Gropius designed it as a quite modest, low-density estate. Later, with migration from East Berlin rising, it was rebuilt several times to cram the new population in growingly lesser quality flats. Christiane hates Gropiusstadt, where she lives with her single, always-at-work mother, who is always absent, unless she is fucking her dodgy boyfriend. The only company and community she finds is in the night clubs and friends, who are all into drugs. She goes to the Sound, the famous disco club, labelled as "the most modern discotheque in Europe". She starts lightly, takes speed and coke, but the whole thing is about "H". H is her obsession, a gate to a different reality, where she can communicate with her idol, Bowie. Seeing her friends all drowning in H, she thinks this transgression is the only way to belong to their community.

Bowie, when a Thin White Duke, had cocaine as his toxin of choice, the typical drug of someone who insists they have the full "control" over their habit. The first half of the film is basically a Bowie fan story. Christiane has all his records (which she, when the first part ends, symbolically sells to get money for drugs). Bowie is the god for her post-political generation, who recreates politics as spectacle. In the film, he's present everywhere, as music or endlessly repeated image: his music oozes out in clubs, at the Zoo station, where the young addicts gather at their alternative home; they hear him, when they forget themselves in the drug haze. He

looks at Christiane and others from posters, like Big Brother from the LP covers, in their dreams; his concert, central to the film, is the EVENT she waits for. It is her most intimate company, it accompanies the kids, when they prostitute themselves, and when they inject the drug and go on a trip, he *IS* that trip and that drug and that malaise.

In "Heroes", Bowie makes a final declaration: there's no more heroes, long live the heroes! Yet, his character, the new, bodiless, endlessly androgynous, sexless figure, has still some miasmas, he's yearning: "I can remember standing by the wall/ and the guns shot above our heads/ and we kissed, as though nothing could fall/ and the shame, was on the other side." is this purely the obligatory anti-communism? There's more: *"Heroes"* and *Low* are psychogeographical albums, where he takes us on various trips to places charged with history, various stops around Berlin, Neukölln, the Wall; then Warszawa, Japan, China, yearning for the East. And it is the easterners who shoot, who perpetrate the terror, it's true: it was the choice of the DDR government to erect the Wall, as between the establishing of the republic in 1948 and 1961 their population was growingly defecting to the West. This was the ideological failure of the East, who had to lock their citizens to convince them they live in the best of the worlds. The children of Bahnhof Zoo don't understand this *Drang nach Osten*, but why else do they'd stick to the DDR-owned and operated Zoo Station, the filthiest, most brutalized part of West Berlin? And next to it: the bling of the Ku'damm, along which they walk searching for drugs and soliciting for clients. Just like characters in Fassbinder's *The Merchant of Four Seasons*, they look at the shop window displays as at the promise of a life they will never have.

Five hours away from that city was another one which was also levelled to the ground, but by Germans. 'Warszawa', Bowie's most sinister and mysterious track, appears in the film in the grimmest moments, when they first take heroin. It was also full of young, emaciated people. Perhaps the boredom the Polish youth felt at the

time was the result of that isolation. Warsaw didn't have the Wall, but the lives of its people gravitated no less around what happened with this piece of concrete. In 1981, the year *Christiane F* was screened, it was invaded by its own tanks. Bowie was a tourist, who left Warsaw a postcard, and then left. They couldn't, continuing to be trapped with their lives. For young people of the declining late 70s, Bowie - an endlessly enigmatic hero for one day, less real than celluloid, replaced their politicians, parents, institutions, their god. But how to stake your whole life on something that does not exist?

The Drinker, the heroine of Ulrike Ottinger's *Bildnis Nach Trinkerin*, shot at the same time in 1979, is played by the splendidly dressed Tabea Blumenschein, Ottinger's lover and muse, as a beautiful mysterious millionaire, landing at Tegel airport, who chooses Berlin as the scene of her destruction, with alcohol as the drug. She's always wearing splendid clothes, inspired by early Dior or Balenciaga, with the rule: dress well for your death. To make it funnier, Ottinger accompanies her with a choir of three women, dressed in identical uniforms: Social Question, Accurate Statistics and Common Sense, who comment and cheer her on. She drinks in the bars until she's unconscious, meeting various weirdos, cross-dressers, punks and transes on her way. Her only friend is a homeless woman. She goes around degenerate Berlin, full of trash, which, together with homeless Lutze, they gather in a supermarket trolley (Ottinger was friends with Wolf Vostell, artist of destruction, who appears briefly in the film). She picks a random from the bar and takes him on a Berlin night *derive* without end. She does a lot of pointless things: one sees her balancing on a tightrope in a ridiculous ballerina dress, against the towers of Gropiusstadt, after she joins a circus troupe, a regular Ottingeresque bunch of weirdos, of society's marginals, who take a dim view of her circus art. After several attempts, when she manages to degrade herself completely, she goes to the Zoo station, as if looking for a way out. Yet, she's is overrun by the careful, punctual German middle classes, hurrying to work. The film's alternative title is *Ticket With No Return*.

*Christiane F.* is a weird kind of a zombie movie, where the action takes place only at night. When we first see Christiane going to a night club, it resembles hell. Gradually, all characters, as the habit develops, start to look more and more like ghosts, or rather zombies.

2.4 Meeting with the idol

Director Uli Edel is too literal when he throws Christiane into a nightclub projection of *The Night of the Living Dead*, we can soon see that from their disintegrating faces, changing expression only upon the sight or possibility of getting the drug. Everything becomes clear during the ravishing sequence of the Bowie concert. If they're zombies, Bowie is their zombie-king. As Christiane looks her all-prepared, artificial idol in the face, then at his absolute artistic heyday, we start to believe he's not only the sun they need to exist; tragically, in a horrific vision he, or rather his persona, becomes identical with the drug, the reason for their degeneration. What follows is the naked horror of addiction: physical and mental degradation and prostitution of these 14-year old kids, while their bodies waste away. Larry Clark's 1994 *Kids* is a version of this, post-AIDS.

Berlin is there a hard-edged, harsh city with no mercy, ruthless, easily claiming lives, once ascending city of modernity, where their dreams have died. We are in the realm of "joy division": their passionless sex, their un-joy, resignation, their absolute nihilism. Punk was dead. West Berlin was full of pale, lifeless, sleepwalking young people (Hitler called Germany a "nation of sleepwalkers"). The real Christiane F (Felscherinow) was offered a career as "tell us our story". She recorded hours of material that then became the famous book, and then the film. When her story broke, it caused a wave of outrage and self-accusations over the 'health of the nation' on the part of a nation still living in the shadow of its Nazi guilt. It seemed like the post-war optimism was finally over and the children of the hippie generation had been submerged by the

nihilist punk wave. Christiane wasn't abused, didn't lack education, didn't grow up in poverty or worse yet – she wasn't an *East German* - but she was alienated and she was from a broken home. She was raised in the personal freedoms promised by liberalism, that in the process became meaningless.

I read the book at 13, a greasy copy that we were passing between us girls in the state school I attended in a working class tower block estate in Warsaw. We were so bored and craved boys and experience, that despite the grimness, the filth and horror of the addiction, for weeks me and a friend lived only on dreams of putting ourselves into the frame of the story. I was looking at the attractive, too-soon mature face of Christiane and I envied her so much that I'd gladly sleep on the floor of the Zoo station, just to be there, see the Ku'damm, see David Bowie. On my first trip there, in 2000, when I was 17, the Warsaw-Berlin Express landed me at the Zoo, but nothing of the legend was left anymore. The story leaves us with the track of corpses under the wall, with the sinister towers looming everywhere.

## Mauerszene

'A film about a woman who fucks an octopus' – that was the way Andrzej Żuławski pitched his 1980 film *Possession* to the producer, fresh after the success of his French film *L'important c'est d'aimer*, about a fallen actress, played by a sad-eyed Romy Schneider, who is made to act in pornographic movies, surrounded by other failed artists, including an unusually melancholic, tender performance from Klaus Kinski. He was also right after the fiasco of his three hour long monumental metaphysical SF *On a Silver Globe* (1978), an adaptation of a fin de siecle futurological novel by his great uncle, Jerzy Żuławski, pulled before completion by the hostile communist authorities and shelved until 1987, when Żuławski was given the chance to "finish" the film. Around that time, he was abandoned by his wife Małgorzata Braunek, actress in his *Third part of the night* and *The Devil*, due to his famously domineering and possessive

personality as a partner and a director. Left in shock and depression, he started plotting a misogynist fairy tale about a monster....

The sleep of reason produces demons, and one of them materialized, when Anna, living in West Berlin with her nice functionary husband and child in a neat, 3 storey block estate, realized she despised her husband. She confesses that to him. The rest is what happens after that confession.

*Possession* was made in the golden era of exploitation cinema, and it must be due to the communal genius that things conceived as forgettable schlock to this day shine with a magnificent mixture of the visceral and the metaphysical, with cinematography, colors, costumes and set design taken from a masterpiece. Argento and the lesser *gialli* creators, Jean Rollin with his erotic horror, the expansion of an intellectual SF, inspiring Tarkovsky, all paved the way for *Possession*, a still unrivalled study of a marital break-up, thrown in the middle of political turmoil in divided Cold War Berlin. Still, *Possession* had a special "career" in the UK, if by career we understand horrible reception, extremely negative reviews and eventually putting it on the 'video nasties' list of banned films. It was deemed 'too arty for the flea pits and too trashy for the art house'.

Today few people can imagine what it was like to live in a city surrounded by barbed wire and under the constant look of armed guards. When we first see Anna, played by a disturbingly pale, un-Holy Mary-like Isabelle Adjani and Mark (Sam Neill), we instantly see something is terribly wrong: their windows are under constant scrutiny, and surrounded by wire – the symbol of political oppression just as of the marital prison, of conventional life. Mark's job is not what it seems – he has completed a secret government mission, which he wants nothing to do with anymore. Meeting with mysterious grey-suited men, it's clear he's involved in high

rank espionage. Anna can't explain what is driving her towards the mysterious lover. She wears her deep blue, up-to-neck gown of a nineteenth century governess, which walks her through all kinds of atrocities as if untouched, as if it's a secret armor.

The Berlin U-Bahn is a character in its own right, the scene of her neurotic commutes to the fatal flat on another end of Kreuzberg, again, by the Wall, with screaming dramatic graffiti: FREIE WEST and MAUER MUST GO (despite its location in the east of the city, Kreuzberg was on the West side of the Wall), and in its underpasses is the most terrifying scene of her possession, where she issues green-yellow gunk among terminal gargles. In all this there's a place for comic relief: the whole character of lusty Margie, played by one of RW Fassbinder's iconic actresses Margrit Carstensen and her comical enormous leg in plaster, with her failed courtship of Mark; in one of Żuławski's turns of surreal genius, when a stupor-ridden Adjani is on the tube, she's robbed of a bunch of bananas by a homeless man, who takes one and gently puts the rest back to her bag. Luxury goods were an issue in the East, mind you.

The demon can be many things: her anxieties, her neuroses that take the shape of an evil monster. The monster can be also simply a misogynistic punishment for the unfaithful Żuławski's wife. A chronically decaying demon, built out of corpses, can also be the sum of the traumas his generation had to go through. It is common to say of JG Ballard that everything he ever wrote bore the shadow of the scenes he saw in a concentration camp in war-ridden Shanghai. Similarly, it is generally believed of Roman Polanski, that all his films, revolving around pain, trauma, sickly sexuality and claustrophobia, reveal the daily atrocities he saw as a child in the Krakow ghetto. There's no doubt Żuławski also went through a traumatic childhood experience, motifs which he obsessively came back to throughout all his career: war, isolation, madness relishing in taboo eroticism, violence, evisceration, Polish *romanticisme fou* and our tragic history. Born in Lviv, Ukraine (then in Poland) in 1940, he barely survived the war, once nearly hit by a bomb,

2.6 Afterlife of Christiane F as a chanteuse. The cover of her 1982 maxisingle Final Church produced by members of Einsturzende Neubauten

2.5 Children of Ulrike Meinhof on the road to perdition.

witnessing the destruction of the city and his family at a very early age. In *Possession,* as in all of Żuławski's films, we observe from a claustrophobic space the decay of the family, of the city, and of the world.

Most of Żuławski's and many of Polanski's films, like *Repulsion, Cul de Sac* or *The Tenant,* all associate eroticism with perversion, anomaly, and fetishism in a genuinely surrealist way. Sex is creepy, sex involves an exchange of ugly secretions, preceding our inevitable decay; in fact, sex is a delight in revulsion, in turning to rot, to a corpse, an acceptance not only of dying, but also of dying disgustingly. Also, due to the amusing, pretty-ugly soundtrack of Andrzej Korzynski (re-released recently, characteristically by English aficionados Finders Keepers), the tale gains the feel of deceit and malice and of a childish game all at once: here music is at the same time parodic and deadly serious. Korzynski had a longstanding relation with two Polish directors: the great Andrzej Wajda and Żuławski, which can be compared to the greatest director-composer couples in cinema: Leone-Morricone, Argento-

Goblin/Morricone, Fellini and Rota. In *Third Part of the Night* it was more art and free rock and prog - a bricoleur, it's clear he was taking from wherever he could. Some of his musique concrete experiments may owe a lot to the seminal activity of early electronic pioneers like the Polish Radio Experimental Studio and Wlodzimierz Kotoński. In *Possession*, he takes typically romantic styles like tango or waltz, and turns them upside down; similarly, he takes a children's ditty motif, played on a broken harpsichord, and twists it with sardonic, scary undertones, like a parody of a cheap Hollywood film noir. Every romantic illusion, every fantasy of a nice, unproblematic life, must in the end collapse and rear its disgusting head to us. The motifs come back on a loop, signifying the hopeless routine, in which the life of Mark and Anna has hung, and how terrible the way out of it must be.

Anna's 'nymphomania' can be also explained by her lack of orgasm. The whole film revolves around her lack of pleasure, or in general, woman's incapability to get an orgasm from the men who surround her. Her craving for the beast is a typical Freudian case of women's narcissism growing out of imprisonment and solitude (much like the aristocrat in Borowczyk's *Beast*, who also craved a monster as a source of unbelievable ecstasy). 'Almost' we hear from Anna each time she has sex with her husband, with a tragic facial expression, typically, almost feeling sorry for him, not for herself. Woman blames herself for the lack of orgasm, never her lover. Neill is in his role often disarmingly, charmingly naive: he's chasing his wife, this woman, whom he doesn't understand a bit, always several steps behind her, disoriented. I'm sure this way Żuławski wanted to suggest who is in fact the vulnerable sex, cheated by the deceitful womanhood. As a proof of that, we have also Anna's double, their son's teacher, like in many other films (*Third Part of the Night*), replacing the (dead) Anna, who's less demanding in bed.

Anna is disintegrating, gradually possessed by demons: with her body becoming like a lifeless marionette, sleepwalking through

the besieged city, with uncontrollable self-harm, shaken by one shock after another, obsessed with bodily mutilation (never before has an electric knife and kitchen automat meant so much in the marital drama). She's breeding her monster on her neurosis, guilt and repulsion (like Catherine Deneuve keeping a dead rabbit in the fridge in Polanski's *Repulsion*). I always actually thought the monster is primarily an idea, Anna's punishment, her thoughts turned into flesh. A housewife and mother who has fallen from grace, living on sex like a vampire lives on blood, driven to madness by the increasingly mad Berlin, Anna falls out of her previous gender roles, challenges all the clichés of a woman of her class or position and mocks this spectacle. The only healthy products she keeps in her fridge now are the macabre heads and body-parts of her victims. It's a story of a woman who stops controlling herself: stops controlling her libido (then of course she must fail as a mother), stops controlling her mind (madness ensues), then stops controlling her body – and then her fluids start to flow freely regardless of decorum: a dress is torn, a woman fucks an octopus, a woman expels vomit, yellow prenatal waters and finally the foetus, shaken, in a shocking scene, through all her orifices.

And then there's the characteristic claustrophobia of all the interiors, as if the closeness of the eastern border and the restriction by the wall, especially felt in Kreuzberg district, caused a specific Island Fever mentality (*Insellkoller*). Polanski's *Tenant* (together with *Last Tango in Paris* and *Possession* forming a great film trilogy about the madness induced by the claustrophobic bourgeois tenements), tells a story of a man slowly assuming the identity of the previous female tenant, who killed herself (it also casts Adjani against type as an unattractive, bespectacled woman who grows friendly with Polanski's character). Similarly, Anna's monster belongs to the insalubrious, skanky place of their love, feeding on the negative aura surrounding the place, just like on the blood and the headless bodies she brings him. Żuławski had a proper budget

behind him, so it is funny and telling that the beast was made by the special FX specialist Carlo Rambaldi, known mostly for his outstanding work on Ridley Scott's *Alien* (as well as Argento's *Profondo Rosso*; he also amazingly went on to model the little body of E.T.) and it would be tempting to compare *Alien* and *Possession*'s main females. The glass-blue eyes of Isabelle Adjani seem to tell the truth beyond recognition, beyond understanding... She knows that the only way through the Cold War of Europe and of her own marriage is to live it, become like them: crazy.

All this to the accompaniment of the melody of the sardonic music box, deriding the characters. The queasy, sickly and morbid ditty owes a lot to Polish Jazz and Komeda's deliberately frantic notes, or the soundtracks to Lenica and Borowczyk's animated films like *House* or *Labyrinth*, or Polanski's *Cul de Sac* with its fucked up organ melody in a false key, just as the cheap soundtrack to horror movies. They all belong to something that could be called a Polish surrealist tradition, similar to the experimental Czech cinema. But its driven synths are another issue entirely, taking from the italo disco frenzy of the era, Giorgio Moroder's Munich Machine.

The genius of *Possession* is that it's at least three films at once. On the surface it is a horror movie, if slightly metaphysical, a giallo with images terrifying beyond comprehension, with a monster, cannibalism, blood, forbidden sexuality, macabre murders, corpses etc. On another level it is a marital break-up drama, much in the style of many Bergmans, like *Scenes from a Marriage* or *From the Life of the Marionettes*, with spouses self-harming, humiliating, and tearing each other apart. But that still wouldn't explain why they act the way they act, at least if we won't accept the rule of exploitation: there's no rules, and a plot of no plot. Here, there definitely is a plot, and it develops with the inevitability of Greek tragedy. Because another level of this drama is a political movie, set in the key city of international secret services and a scene of ideological war. Anna and Mark may live the relatively privileged

life of expats, in their nice low rise modernist flat, but are still subject to increasing alienation and isolation, harassed by men of mystery in ridiculous pink socks.

Trouble with sexuality pervades the whole film – woman's sexuality, the murder of a homosexual couple, Anna's previous lover ridiculed as an amateur of tantric sex and martial arts, and all this finalizing in a third world war subplot. The early 80s were the era of a 'second Cold War' entering a new phase, a nuclear crisis which could lead to World War Three, which is implied by the final carnage between the secret services and the aftermath. Extremely theatrical, like a lot of the rest of the film, it's very much in the 'postmodern' style of the French Neobaroque. For me, *Possession* is one of the most prophetic movies for the 1980s, predicting the Polish Martial Law of the 1981 and the great depression that followed.

Żuławski's genius was to see the personal drama as political, and the visceral and the sexual as coming from the social and political oppression. Incredibly stylish, haunted with beauty and austerity, it's a world torn between Marx and Coca-cola (with Anna in one scene smashing the portraits of the classics of Marxism) and Żuławski is not necessarily a Marxist. The choices of many in that generation, and later - which they made as soon as capitalism entered Poland - wore serious traces of reacting over a trauma. Still, Żuławski remains a Romantic: revealing that love is the darkness, against the common, desexualized, sanitized convictions within capitalism.

Berlin serves here as a House of Fear, but at the same time, a threshold of Europe – not many dare to go further east. You're not in real danger, but close enough to feel it. If you're a foreigner, then you only feel the thrill of it. Often in Żuławski we have the situation of a house or a family unit, isolated drastically from the rest of the world, which contrasts with the upheaval and the dissolution of the world around them. there's a war going on and people slaughtered, but we rather watch the main characters' anguish

about their wife's death or infidelity, families plagued with incest and self hatred. It bears a strong resemblance to a compulsive ritual, an acting-out of a traumatized subject. "Zulawski" must've seen something there in Lvov and never forgot it. His family torn apart there, he re-enacts it in every film, seeing it behind every atrocity, and as egocentric as it may be, it's also visionary: to see the nations fall within the destruction on the basic, human level.

The 1980s was the time of a real nuclear danger with its double dip Cold War, raising to the extreme the anxieties of an already paranoid popular culture. An example of a B class even if enjoyable punk-Cold War paranoia exploitation flick is *Decoder* (1984) by the mysterious Muscha, boasting the participation of several icons of the underground: Christiane F. pairs with William Burroughs as two junkies in hallucinatory, abandoned dystopian Hamburg. Unusually not set in Berlin, this punky Gotham City is managed by criminals, putting the citizens into a trance through a poisonous muzak. This is interrupted by a rebellious DJ working for the corpo (played by FM Einheit from Einstürzende Neubauten), who works on an anti-muzak formula, which instead of pushing into submission, politically activates and radicalizes the youth. The riots emerge on the street of every German town.

Acted with lovely bored sulkiness by Felscherinow, then also a punk icon, with a brief career as an underground singer with the single *Wunderbar* produced by Alexander Hacke from Einstürzende Neubauten, it displays various radical political groups, including the Temple of Psychick Youth, staring all day at the Brion Gysin Dream Machine, over which hypnotized activists plot destruction. What's omnipresent is the destroyed space, trash and sleaziness of Hamburg – here a fallen city, dominated by prostitution and corporations, seedy bars & peepshows, where people eat horsemeat burgers. Soundtracked by arguably the sleaziest and most hedonism-devoted synth pop duo in history, Soft Cell, the only group too cool for Berlin namechecking, with 'Seedy Films' (with the phrase *Sleazy people in seedy City*) as a main theme, from *Non*

*Stop Erotic Cabaret*. Sex is here a hard currency, but sex understood as the metropolitan perverse filth rather than eroticism in a more titillating sense. You can look, but don't touch.

## Fear in the Western World

*Riding Inter-City Trains*
*Dressed in European Grey*
John Foxx for Ultravox, *Hiroshima Mon Amour* (1977)

If the invention of 'youth culture' was so dependent on capitalism, was there ever possible a youth culture that came from somewhere else? The first answer is right – this culture was an extension of Romanticism, where the cult of youth, death, free love, truth,

2.7 Sucked into the miasma of the East. Isabelle Adjani in Żuławski's Possession gravitates towards the Wall.

emotional intensity and political radicalism were turned for the first time into a position which radically opposed the accepted, general order. Therefore we have the 'New Romantics', a youth culture born during the difficult time of the second Cold War. The

Soviet Bloc was then everywhere again: it was in kitschy Hollywood films, Hunting for Red October, it was in mainstream pop, Elton John's Nikita and Sting's dreadful 'Russians Love Their Children Too' (wonder if he knew that 30 years later he'd be good friends with the daughter of the absolute ruler of Uzbekistan, turned from Soviet Republic into a personal despotism). From the New Romantics several Cold War movements exploded, like Neo-baroque film in France. Luc Besson's *Subway* or *Nikita* are perfectly transitive Cold War films, made up all from international spy plots, criminal big capital, shot in flamboyant, ultra-modern urban areas, made up only of dizzily colorful 80s fashion and crazy car chases.

The weird aesthetic space that emerged between the neoliberal space opening in the late 70s, means that commodified subcultures become an ersatz of a political emancipation from the past which is no longer available. Subculture replaces political engagement which, for different reasons, can't be expressed politically (the Bloc for the suppression of dissent and in the West for its dependency on the market). Tension arises. A closer look at the art production after the war will show how it was America, not simply everything west of the Iron Curtain, that served as 'West'. America was the 'unconscious' behind all the artistic movements or subcultures, even if by the force of negation, regardless if in Western or Eastern Europe. So feared that in post-punk and some new romanticism it found the fiercest, most refined critics. Especially intense in this matter was the early Ultravox, with John Foxx. Their second album *Ha! Ha! Ha!* is fuller of angry exclamations of fear and loathing for Western civilization than any other record of that era; with the typically Burrougsian/Ballardian visions of deadly, decaying Western cities full of savage scenes of murder, sex and violence, with evil high-rises populated by corrupt politicians, and all this to noisy, angular punk. Each song screams of this paranoia, voicing the fears of the Western world: of the Bloc and the Third World rising, the cold Bloc freezing the West, not alive, but not quite dead yet, a zombie, the character moves between atrocities, "Divine Light, chemicals,

Warhol, Scientology (*Artificial Life*)'. In *Hiroshima Mon Amour* the title is at the same time a yearning for a delightful self-annihilation (longing cheerfully for the whole thing to burn) and of course expressing the real nuclear fears people had during the Cold War. Last but not least, it's a confession of a film-buff, boasting his love for the famous Alain Resnais film with Emmanuelle Riva, controversial for levelling her trauma at losing her German lover during the occupation (paid for by shaving her head and a public disgrace) with the tragedy of Hiroshima, where she cures her trauma through passionate sex with a Japanese lover. Through this, it reveals a perfect, dandy-like combination of self-hatred and style. And of course, how better this style can be displayed than by a Weimar-suit dressed Kraftwerkian traversing the continent.

Kraftwerk made train journeys not only fashionable again – they brought train-crossing a wholly new mythology. For the UK musicians and scenesters the experience of trains had to be necessarily also an experience of Europe. This way, Europe and trains and the strange thrill of it (borders, passport controls, forbidden lands) made them again what they used to be to the revolutionary Russian artists. Just as Constructivists, by design, and filmmakers by preparing newsreels, like Dziga Vertov or Viktor Turin of the *Turksib*, (1929's pioneering documentary on the great Soviet train-systems, which made the industrialization of the gigantic country possible (Turkmenistan-Siberia)) participated in the preparation of propaganda trains. Some of that excitement of travel got into the bloodstream of the synthetic/techno/pop sound of the era.

The later Ultravox, with Midge Ure, made of the famous Conny Plank-produced 1980 album *Vienna* a real catalogue of Cold War obsessions: from the sentimental, but meaningful title song (the video purporting to be the formerly four occupations-divided European dream-city was shot in Covent Garden), the man of mystery Mr X or the Western Promise, all cut in punishing, aggressive synths. What else was this to suggest rather than 'the East is coming"?

2.8 This means nothing to me!..Oh Vienna! Midge Ure mourns the lost Europe in the golden Ultravox! album of the same title

This Soviet-mania persisted in Ure's previous band, the notorious Visage, known for the best outfits and the best hits in the industry. Steve Strange's biography is often silent on political matters, but this Tory felt moved by the Russian motifs sporting, among a thousand others, the look of a Russian Cossack or muzhik. The Cold War was in the air, but what else was the color grey was in their biggest hit Fade to Grey if not for the sake of the concrete? Strange wanted to be anything but grey, yet within the relentless, Moroderesque Germanic blasts from the synthesizer, they perfected the plastic look from the future of the endless Cold War (as in their cover of 'In the year 2525' as the biggest "machines think for you" Orwellesque nightmare). Damned robots don't cry, yet the pathos of 'Night Train', the weird affection towards the mechanized and the Russian kitsch in 'Moon Over Moscow', with male choirs and Cossacks doing Kalinka. They could pair with the Leningrad Cowboys, whose trilogy by Aki Kaurismaki was equally the most ridiculous and the greatest of Cold War epics.

They say that if you can make up a city, you can make up a world. Each city has its legends, and for the mythology of postpunk and New Romantic, three cities only really mattered. The still going railway, whose stations read like a history textbook: the Berlin-Warszawa-Moscow express, used to map the phantasmagorical geography of the Eastern Europe of the mind, which was made in equal part of ashes and of brocade, death and glamor. As if via a cybernetic radio, small islands of people were communicating with each other. We will try to visit all three of them here.

If post punk had a father and a god, it was David Bowie. Our man, partly as a result of the galloping drug addiction, depression, world-weariness ("world" here being the West, America, that

scared the shit out of him), and a taste for history, he is looking for a place of refuge to save his precarious life. He looks towards the east – he had travelled there before, to Moscow in 1973, and he took a train back from there to West Berlin. When he travelled there again in 1976 with Iggy Pop, 'they saw towns still pockmarked with bullet holes and a landscape scarred by unrepaired bomb craters; drawing alongside a goods train in Warsaw, they witnessed a worker unloading coal piece by piece in the gray, freezing sleet.'

By this time Brian Eno, his collaborator, was already working with Cluster in Dusseldorf, who had worked with Neu!, who in turn were once members of Kraftwerk. 'Autobahn' was a novelty hit in 1974, and their perfected look of Constructivist Robots lands among the stunned Europe. Neat, disciplined, glamorous Robotniks looking as if they just came from the heroic Socialist Realist canvases, they expressed a longing for the lost Europe, wanting to reclaim Germany's past from the Nazis. The red and black of their clothes were the primary colors, the colors of the spiritual Goethean palette, for de Stijl, Bauhaus, the Constructivists and the Nazi Flag. Fascinated with the idea of mechanical ballet by the painter and Bauhaus theatre designer Oskar Schlemmer, combining to the same degree the spiritual and mechanical, and by Meyerhold's theatrical ideas of biomechanics, Kraftwerk built a bridge between the early hopeful, ambitious modernity of Weimar and the dispirited, broken post-60s reality, when cars, highways, speed of life, computers and robots became a natural part of our existence. The obsession this era has with the mechanical, controlled man evoked the fears of totalitarianism and the state control just as a deeper fantasy of human efficiency. The measurement of the body, of its possibilities, was at the start of the technological revolution, and organization. It was a dark echo of the Golem, puppets, Karel Capek's robots, and Fritz Lang's *Metropolis*, the real source of post-punk imagery, although of deeply dubious politics. Punks, a lost generation betrayed by history, were obsessed with it, despite claiming a lack of any

interest in the past. Their obsession was a fantasy within the late capitalist, increasingly post-Fordist society, where efficiency was already beginning to be replaced with dubious financial capital. The mechanized organism was a Fordist obsession, and found its sickly, glam repetition in Klaus Nomi, a Bavarian former pastry maker, who discovered an operatic countertenor in himself. In the famous *Saturday Nigh Live* performance with Bowie in 1979, they channel the German avant-garde, dressed in Sonia Delaunay-inspired bombastic dada-suits, with exaggerated inflatable arms and legs, Bowie using also a puppet and a communist China blue suit with a Mao-Collar, but equipped with a skirt.

With the political crisis approaching, the post-boom generation, as if feeling that history was going to strike back again, took on the task of performing painful historical exorcisms on themselves. They lived as if it was the 20s, 30s, 50s or 60s, and yet they lived

2.9 Is it NY or is is Moscow. New Wave hipsters haunted by Soviet aliens in Liquid Sky, 1983.

inevitably in the present. They knew Constructivists from art schools, and saw Ballets Russes' designs. Hence the sad pierrots and cosmonauts, able workers and 50s Soviet beauties among the new romantic crowd. There was the end of history and there was no future. In the dying industrial town of Cleveland, Ohio, the young members of DEVO imagined they lived in "1920s Central Europe" and constructed Hugo Ball-like costumes from rubble; OMD, Spandau Ballet, Joy Division, all were dressed as if in homage to the builders of a better socialist freedom. They were all looking east, but not to the demonic Bloc, but rather its threshold. Germany, via its brilliant development in electronic music, via Stockhausen, stimulated by other centers of electronic music, including Warsaw, was a laboratory, a window, from which you could comfortably observe the history behind the

barbed wire, but safe enough not to get bruised by it. Kraftwerk provided a sound, but the Westerners were only guests on the Trans-Europe Express. It was Bowie who put the elements together. Bowie, a model postmodernist, someone who built his life and art out of the artificial, the fabricated, who went though pop art, comic books and Brecht, needed the necessary frisson of the real, which he found in Berlin, Warszawa and Moscow. There, you had no art of style to be consumed, but the burden of history, that could be tracked on the gigantic spaces of consuming emptiness and morbid austerity. Berlin was a relatively safe option, a city of vice and excitation. As we saw, he was the wall against which Christiane F. and her drugged, prostituting young friends were projecting their saccharine dreams that never came true. Berlin was, like any other big post war metropolis raised from ashes, a scene of "modernity's failure", with the decaying tower block estates, like Gropiusstadt, which for Christiane is in turn everything she fears and hates. Christiane F., who after the publication of her memoir became a figure with a cult following, although she never managed to completely drop her addiction, later debuted as a singer, with the gleefully sleepy *Wunderbar* single, co-produced with members of Einstürzende Neubauten.

As ever, Warszawa, the place, had to be satisfied by this cult, but received a niche fame from the Bowie track. Later Joy Division couldn't decide whether they should call themselves Stutthoff, Auschwitz or Warsaw, while sporting shaven looks of the camp victims. The enduring image of the East was still the one from George Orwell's *Nineteen Eighty-Four*. When the said year finally came, both Poland and the UK were in the middle of crisis.

## A Totalitarian Musical

Orwell's *Nineteen Eighty-Four* has been an enduring obsession of popculture since its publication. Bowie had been fixated on staging a opera based upon the novel, which, after being aborted by Orwell's estate, transformed into the album *Diamond Dogs*, full of

the images from Orwellian catalogue: of urban decay, prophetism, fatalism. Big Brother harassed the wrecked up and paralyzed survivors of the year of scavenger and the season of the bitch, heroes felt hysterical detachment, stark robotic images from *Metropolis*. Bowie was also, afterall, a William S. Burroughs fan, to which referred the spoken opening piece.

Bowie wanted a 'sexy', glamorized vision of *Nineteen Eighty-Four*, a totalitarian musical, a glorious authoritarianism, which

occurred to him not via reading the book, but via an actual visit to Moscow (which was to be one of several) which he undertook in 1973, on the way to Japan - by taking a train, of course. He saw it with the perhaps clichéd eyes of *Nineteen Eighty-Four*. Yet, by the 1970s a very different author's future would join Orwell's. It was the conservative Catholic modernist Anthony Burgess whose terrifying vision of modish city oiks turned Soviet was the one which kept stirring generations of youth and became a foundational text for the glam and punk generation. *A Clockwork Orange*, of which we speak, had its roots in a

2.10 Reconctruction Time. Depeche Mode gets a Soviet treatment from Melody Maker, 1983

trip Burgess took to Russia in the 50s, when he got beaten by Western-dressed smart looking young delinquents in Leningrad. It was the era of arguably the first youth subculture in the UK, Teddy boys, the first who consciously used/appropriated the dress of the upper classes, to distort it and make it theirs. After the war British upper classes revived the pre-WWI style of the Edwardian era, the last one they were comfortable in, as a look for their anti-austerity, anti-socialist values. In the hands of working class boys, taking it straight from dandies, combining it with their violence, the idea "of clothes as a threat to society" was born. Burgess, seeing the similarities between the Soviet and British fashionistas, drew the conclusion (and in the era when the Soviets could still defeat the

West) that after the inevitable Soviet invasion, the future subcultures will be speaking Russian and will be violent.

The legend wouldn't have been born without the shock of the Kubrick film from 1971. Before it was banned, a few people, including Bowie and the future movement, saw it (it was cited as influence basically by the whole synthetic generation - in Sheffield only, there were groups called Heaven 17, Clock DVA and They Must Be Russians). At the time of the Ziggy Tour, Bowie used to inaugurate his gigs with Wendy Carlos' brusque, startlingly futuristic synthetic soundtrack, which made a furore and a lasting impact. Kubrick himself used dazzling psychedelic designs but also Soviet murals in the vision of society, using the Soviet parable to take on the conformism of the British.

Michael Radford's film adaptation *1984*, was shot in the same year in the dockland area of London, before it got redeveloped, which at the time looked exactly like a place where the war was going on. In its look though, the film is anything but futuristic – it rather takes the cue from the book, making everybody look as if it was 1948, or 1940s fascism, as if *It Happened Here* really took place. The only 'futurist' element in the film is the soundtrack made by Eurythmics, amplifying the mechanized (*Sssex Crime!*), yet with its postindustrial rubble and decay in the frame, it provided a feeling not far away from Jarman's slightly later new romantic catastrophic *The Last of England* (1986).

In 2013 after a 10-year hiatus, Bowie surprised everyone with a sudden comeback, with an album *The Next Day*, very consciously referring to his "Berlin" period, with a conceptual cover, in which the iconic leather-clad Bowie from *"Heroes"* is covered by a white superimposed square. Bowie at once wants to cut off from the burden of the legendary past and escape constant comparisons to his most legendary period, yet it makes a strongly nostalgic leap, with the lyrics of 'Where Are We Now' recalling his stay in Berlin, recalling his then-hang out, Dschungel bar, the department store on Ku'damm, KaDeWe. He's "a man lost in time".

## Stilyagi of the New Era

*Dissident faction/secret stylists/youth movement/rebel gang!/ bring your foreign radio!–* shouts the vocal over the merciless synthetic rumbling in 'Stilyagi' (1979) by Vice Versa, an obscure, strictly post-punk/new wave Sheffield outfit which later became the super-successful ABC. We now may learn who beat up Anthony Burgess in Leningrad. It is interesting that by all means uncensored British youth would take the late Stalinist era youths as role models. They called themselves Stilyagi, from the dancing style, a la twist, which was called *stil*. In *Stilyagi*, a popular Russian film from 2005, Burgess' fantasy of overtaking the West assumes quite spectacular,

revanchist shapes. But with their anachronistic quiffs and neon-colorful clothes a few years before Elvis, they rather remind us of the newly emerged Russian hipsters, or worse, with their fabulous connections, being mostly well off - the ruling class. Amongst the grey 50s, grey as can be, with the streets full of identically dressed and coiffed folk, carrying their bags heavy with *briukva*, a group, fantas-tically colorfully dressed, somewhere between rockabilly and the *Wizard of Oz* - these laughing, beautiful young people, who call themselves Stilyagi. They were Soviet

2.11 The cover of the famous 'Red Wave' Russian punk compilation released in America

beatniks, who loved jazz and the early rock and roll. Their ethos comes partly from as early as the 1920s avant-garde – and the stylings from Popova and Stepanova's designs were much revived by the later Stliyagi, especially in the 80s. In reality, mostly they were trying to emulate the style of their American counterparts, listened mostly to jazz, and treated style with dead seriousness. Completely harmless westernised petit-bourgeois, or the precursors of the whole youth rebellion in Russia? Opinions are divided.

Yet Burgess' idea of fab clothed youth gangs speaking Russian

were fulfilled the most in another film. The most obvious clash between the East and the West occurred when the stream of Eastern, mostly Jewish migrants started rushing to the mythical Amerika – and this recurs in 1983, when Russian émigré directors invented their own Russkii Novy Jork. New Romantic cult classic *Liquid Sky* was the new wave/post punk fantasy of Slava Tsukerman, his own americanist interpretation of the charmed disco lives from the perspective of a Russian émigré in America. In Moscow, Tsukerman was a student of Lev Kuleshov, the tireless propagator of Americanism, Productivism and the abrupt juxtapositions-montage of the Russian film avant-garde. Tsukerman began his career with that typical genre of the 60 and 70s, the educational, scientific documentary, an element of the space age competition that provoked extraordinary decorations. This scientific sobriety didn't get in the way when he went to the New York in the 70s, by then a city drowned in total bankruptcy and shrinking, and as if in the reaction to that, it was drugged out to the extreme and dancing on its own grave – these were the last days of disco. In amongst this degradation, all the same hordes of fabulously dressed beautiful people marched, which seduced Tsukerman, who dreamt visions of Amerika just like his famous predecessors, like Mayakovsky, who he had made a film about just before leaving the USSR. In *Liquid Sky* we mostly stare at that glittering sky, while standing on the gloomy skyscrapers – a position to behold a city proper for a Muscovite. If we're to believe this vision, then Moscow becomes New York, or other way round, and the jelly sky produces monsters. Ten years earlier in *Mean Streets* by Martin Scorsese, Charlie, played by Harvey Keitel, is most unhappy when taken away from his city on a mafia-forced exile. 'I want to smell the dirty air and see the mountains! Mountains, skyscrapers, what difference!'

*Liquid Sky*'s cameraman, Yuri Neyman, had been involved in making films with Sergei Yutkievich, a collaborator of early Soviet avant-garde directorial duo Kozintsev and Trauberg, the set

designer for their American-influenced Eccentric Theatre. Together this team of Soviet émigrés, stranded in America, transposed their Eccentricism to New Wave New York, the place stigmatized by yuppie culture and its extreme consumerism, at the height of the Reagan era, but also with a flourishing emerging art scene. In this drugs-driven phantasmagoric New York, various eccentric creatures potter about like failed Warholian Superstars, currently on health leave. The sound of New York music, as if feeling the decline of the real industry, was also shiny, metallic and new – embodying the Soviet idea of melding flesh and metal, industrialization and computing, a combination which was to finally overtake and bring down the Western world and to create a world in which mechanization, work, sex, pleasure and leisure would coexist in a perfect balance.

Meanwhile, disco producer Giorgio Moroder with his uberwoman Donna Summer, had completed a perfect musical combination of electricity and a female orgasm in 'I Feel Love'. Orgasm, pleasure or un-pleasure is also important in *Liquid Sky*. The nonstructure of the film evolves around two identical-looking characters, male and especially female - a New Wave model, constantly pursued and exploited by her clients, a bitterly sulky, miserable Snow Queen literally killing, as we'll learn, with her cunt. Played by one actress, Anna Carlisle, her cynicism, nihilism and hatred of humanity could fill the whole Siberian steppe. Trapped between non-jobs and exploitation by the fashion industry, bored to death, she's persecuted by the evil aliens (Soviet, no doubt) who render her sexual powers lethal. Anyone, who comes "into" her, dies, as the aliens live on their orgonal energy. But the most mysterious part of *Liquid Sky* is its soundtrack, based again on imagining the disco music of New York rather than knowing it from experience. Working in isolation, Tsukerman and his collaborators created operatic synthpop resembling more Bach's baroque oratorios than music to dance to, indeed based on the French baroque music of Marin Marais or the Nazi-era anachronistic

neoromanticism of Carl Orff's *Carmina Burana*, and featuring the new wave gem 'Me and My Rhythm Box' by Anatole Gerasimov, sung by terrifying psychopathic dyke Adrian. And if they do dance, these drugged-out hateful New York bohemians, they turn it into an eccentric theatre, with angular body movements, that freeze like a tableau vivant of Egyptian statues.

The band possibly most obsessed by the Soviet Bloc was the enigmatic Jersey post-punk supernova Xex, a band so obscure that upon the small re-release of their one album in 2004 some people thought that they were a contemporary spoof. They sounded just too knowing, too cool and too rich in their exact references to be real. Active around the year 1980, their ecstatic, minimal, homemade, charmingly amateurish disco sings of the perils of compulsive shopping conflated with the story of Stalin's daughter, the Red Brigades and the possible attack of Soviet Nerve Gas, for them actually entirely deserved by the West. This strange sovietophilia they shared with the British or European acts, especially Sheffield synthpop; and because of this political fascination they were characteristically cut off from their American contemporaries in the CBGB scene such as Talking Heads. Formed in a Jersey art school, they must have been strongly influenced by the area's Polish community, with the band's leader called Wa(rsa)w Pierogi. With their motto "Be a good Bolshevik – don't be a nogoodnik!", they mixed hallucinatory Soviet patriotism and Cold War paranoia. On their only album *Group:Xex* one song is about Svetlana Alluliyeva, Stalin's daughter who famously defected to the West to become *'a revisionist nightmare/She's a capitalist pig/If daddy were alive now/He'd depersonalize you/send you to Siberia/Cracks in the Kremlin Wall now!'* Appearing all over their songs were random primal shouts, screams and exclamations, standing for some unspeakable, unexpressable libidinal energy, something that is too rough, to visceral to be said. Eroticism is too easy for this rough world, instead you have :XeX:, something that is too sharp for the common 'sex'. There's a surplus of terrifying

desire, desire which has no reference, no object, no language, no expression. Pioneered by the prototypical synth duo Suicide, this overtook the rest of no wave by several years. The paranoia of being attacked by the enemy block and the toxic diseases of the futuristic scientific experiments explodes in 'SNGA': *'Soviet Nerve Gas Attack/in six seconds you'll be twitching on your back/get a drop on your skin/and convulsions will set in'*; the usual punk obsessions of decay recur in a bizarre new form: *Soviet nerve gas is strange/in a missile with a thousand mile range/it spreads out a mile/to contaminate a while'*, because *'it's genocide again!'*: *'there's no color there's no smell/but it works very well'*. If the world is ending, what is left there, if not a post-apocalyptic perverse relishing in decay? Indeed: *'Soviet nerve gas is fun/if your pleasure is killing everyone'* which makes one wonder if that was the mysterious weapon the aliens had in *Liquid Sky*. No doubt, *because the third world is shrinking and the politics are stinking like a Soviet nerve gas attack'*.

## They walked in line

The West was immersed in crisis. The young people in Germany fought and lost with the 'Auschwitz generation'. Berlin was still a combination of ruins and voids. Fashion creators experimented with the soldier look. War was in the air. Electronic music evoked a reality, that was gritty, grey and concrete, scary, an uncontrollable modernity that we couldn't quite master – and geographically, that was Eastern Europe. The land of SF's dystopian visions. In 1972 Tarkovsky premiered *Solaris*, his metaphysical meditation over modernity, with weary-looking Soviet people in cars driving through menacing cities full of flyovers, freeways and austere, concrete blocks. This was the reality of the post war Europe as such. Joy Division needed an estrangement factor to clarify their vision: the Holocaust, totalitarianism - but they grew up in a very similar reality to their Eastern peers. Both of them lived in industrial areas, which developed their own proletariat, attached to their machines until Thatcherism came. Some of the Sheffield groups, like Richard

Kirk of Cabaret Voltaire had been fellow travellers of the CPGB. Membership was also a windup towards the conservatism of parents, as in the case of Green Gartside, who named his band after Gramsci's *Scritti Politici*.

British subcultures in the punk era, between mid-70s and 1989, were especially cast against the rest of the West, fascinated and stimulated by the totalitarian East. Much of that was prompted by a similar experience of the war. Born to a large degree in the 1950s, the main personnel of punk grew up in amongst ruins and rubble of the war and the post-war austerity. At this time traces of WWII were still everywhere, not only because now we had the Cold War. Ian Curtis collected books about the Third Reich and was obsessed with an idea of an underdog in the totalitarian society. They got

2.12 Wielkanoc 1988 photograped by Mirosław Stępniak

their name after the pulp Nazi camp fiction, *House of Dolls*. Joy Division's 'They Walked in Line' can evoke equally the broken citizens of any totalitarian state. Yet the fascination with the Soviet Bloc by the disillusioned 70s generation already had nostalgic undertones. Vic Godard of the Subway Sect got obsessed with the Bloc after a trip to the Soviet Union, covered his room in Soviet posters and colored everything in grey, The Human League made the punishing, machine music *The Dignity of Labour* (1979) about the Soviet space programme and put Yuri Gagarin on the sleeve – and of course Joy Division were originally called Warsaw.

The proto-Ostalgie in the untamed cultural expression of the 70s and 80s punk, post punk and new wave may be misleading, because just as much the bands were obsessed with the underdogs behind the Curtain, the East in their view was a land that

overlapped with quite a lot of the West as well. A lot of this 'Ossie' sentiment was a Westalgie, commenting on the dream of the Welfare State that they were about to lose.

"Everyone says Joy Division music is gloomy and heavy. For me it was because the whole neighbourhood I lived in was completely decimated in the mid-60s. At the end of our street there was a huge chemical factory" – says Bernie Sumner in a Jon Savage interview - "there was a huge sense of community where I lived. I remember the summer holidays when I was a kid. What happened in the 60s is that someone in council decided that it wasn't very healthy and something had to go and it was my neighbourhood that went. We were moved to the tower block. At the time I thought it was fantastic: now of course I realise it was an absolute disaster." Sumner and Co had a real experience of "collapsing new buildings" (or, as they say in German, *einstürzende neubauten*). Via the obsessions of their leader, they started putting them into this extremely sombre music, which, with double irony, affected people incredibly in Eastern Europe. The so-called cold wave started to emerge across the Bloc, with similarly sinister vocals and nihilistic lyrics. Sumner: "By the age of 22 I had quite a loss in my life. I understood that I could never go back to that happiness. It's about the death of a community and a childhood. The music was about the death of optimism, of youth." Bands from the industrial areas – soon to be deindustrialized - seeing its deprivation, were becoming 'engaged'. "We had so much aggro going on" – says Peter Hook. It wasn't the metropolitan youth, but those from deprived areas, which made music that resonated. There was a general sense of nihilism – and in this sense, it was close to certain really dark right wing ideologies. Part of punk is to examine this dark side of humanity. Savage: "Punk is primarily libertarian, anarchistic – and as oppositional to the power of its day, the late social-democratic consensus, it marked the end of an era." Curtis liked bohemian modernist writers like Ballard and shared Bowie's fascination with Burroughs. The sleeve of the first Joy Division single 'An Ideal for Living'

featured a Hitlerjugend boy drumming and a child from the Warsaw ghetto. Curtis even made his wife sing a hymn to the tune of 'Deutschland Uber Alles' on their wedding and was obsessed with the film *Cabaret*. "For me it was about World War Two, because I was brought up by my grandparents and they told me about all the sacrifices people had made (...) we had a room upstairs with gas masks, sand bags and English flags, tin helmets. The war left a big impression on me, and the sleeve was that impression. It wasn't pro Nazi, quite contrary. I though what went on in the war shouldn't be forgotten so that it didn't happen again."

Joy Division were English boys for whom the end of the world as they knew it resulted in bleak fascination with the other side: people under totalitarianism, with whom they felt a secret affinity, making music as if their world was their own. But it also worked the other way round. The morbidity of their music hit exactly the emotions disaffected young people felt behind the Curtain. The extent to which Polish fans identified with Curtis's cold-war nihilism can be seen in the reaction to his death: the leader of the punk band Bexa Lala hanged himself, also after watching Herzog's *Stroszek*! I'm not sure what is more moving about this scene: the literality with which the singer took his own life after his idol, or the fact even the final moment of somebody's life, the final truth, could've been to this extent copied from someone else, someone who was to the guy like a film star, no doubt. I wonder if they realized Curtis life wasn't that dissimilar to their own?

## Europophilia

By the late 70s and especially in the 80s, the era of the 'Second Cold War', the post-war austerity became a club décor in the New Romantics mecca, The Blitz. When in 1979 a group of future Blitz frequenters made their visit to Berlin, what they really couldn't wait for was to get smuggled to the East. As it was deadly cheap, they went to the revolving restaurant in the TV Tower and ordered the most expensive dishes in the card, champagne and caviar, later

dropping by to the Palast der Republik for a cocktail and ending up eating other people's buffets, after which, attacked, they comment, "You'd think the Germans would've learned by now!"

The idea of 'Europe' within the popular music culture was very new, and has a direct relation to the Cold War. Before, pop and rock bands straightforwardly identified themselves as American. Arguably the first band to openly identify themselves as European were Kraftwerk. But by the 80s, synthesizer bands spread across Britain because the cold sound of synthesizer was the most straightforwardly identified as the sound of the future, it was evoking the industrial or post-industrial dystopia, because the future realized itself exactly according to some of the SF dystopian visions. And where else could this idea could develop better than in the land of George Orwell?

Today many of the ambitious pop bands from the 70s and 80s are likely to be put under the label of 'post-modernism', where post- is clearly being confused with the clearly 'neo' approach of the renewal of the lost elements of modernity. It wasn't a gesture of 'ending', but the reverse, of reopening. Kraftwerk, by calling themselves simply 'power plant' risked ridicule and ostracism in a hippie-driven culture of early 70s. But their plan was to restore the belief in technology, in a growingly schizophrenic world, in which, although technology was ever expanding, the public acknowledgement had increasingly become an obscurantist fear and anti-modern neglect. It was the legacy of the ambivalent 60s, where the modernist ideas of housing and living were bravely introduced into life. 'Europe' as a fashionable object is also an effect of the mutual isolation, best expressed by the Berlin syndrome. *Trans-Europe Express* was a hope that once Europe was this much more organic structure, but now, if we'll have the technology, finally, the *Europe Endless*, or rather a certain dream of it, can become a united organism beyond divisions.

The *FACE* magazine was the bible of the new pomo aestheticism of the 80s, with the ever-whimsical, period defining graphic design

by Neville Brody, borrowing from all avant-gardes, yet capturing something true about it, even if it is an authentic of inauthenticity. In 1983 they ran a special 'European' issue, with an article on Vienna describing it as tired, decadent and bourgeois, but noted its avant-garde, Actionists and kitsch postmodern architect Hans Hollein (but no mention of Ultravox!, who made Vienna fashionable), pictures from Milanese and Roman jet-setting, and erratic design works run alongside reportage about *Ulrike Meinhof's Children*, her two daughters as well as a metaphorical one, Christiane Felscherinow, in a typical shallow-deep combination. Yet, there's very little on any of any Soviet Bloc countries. The Wall was where this interest stopped. We shouldn't underestimate the real political borders. Yet, the *FACE* remained a product much mythologized and desired, of high demand on the Moscow black market, where old copies could go for as much as 80 smuggled dollars. This paradox of desire and not being able to have it, is most painfully addressed in a UK Levi's commercial from 1986, in which in a scary sotsrealist hall the 50s rocker-looking delinquent is being searched on the occasion of smuggling Western goods, by the scary looking Soviet customs inspectors in fur hats. They discover an issue of the *FACE*, but not the trousers, which he enjoys in his socialist tenement. Even the lettering of the commercial is in Cyrillic, yet it's all a fake: the tenement is Robin Hood Gardens in east London, the sotsrealist hall the Royal Horticultural Hall in Westminster - and of course such a "subversive" commercial would never run in Russia, where it would actually have been subversive.

The East must've been perceived as universally grey, unattractive and scary, yet, when Thatcherism was taking its toll in the mid-80s, The Style Council, Paul Weller's next outfit after mod-revivalists The Jam, came to Warsaw to shoot their clip to 'Walls Come Tumbling Down', as an act of solidarity with the persecuted Eastern folk, and the class war in the UK, in the midst of the miners strike. The effect is interesting – we see the musicians, stylishly

dressed (or so Weller boasted) in the grey streets of Warsaw, with footage emphasizing the somberness of the Stalinist Palace of Culture, the monument to the Soviet Soldiers and the sheer roughness of the everyday life: shabby trams, poor people, greyness. But the whole clip is interspersed with the band playing for a small enthusiastic crowd in Jazz Club Akwarium, with radiant faces, modernist design and actually everything against the stereotype.

## Depeche-Mania

*We are Depechists the same way others are communists, or fascists* – says one of the Russian fans in the DM-mania devoted documentary by artist Jeremy Deller, incidentally blocked by the band itself. In Russia and Germany, the band had a fanatical following, which was a separate subculture. Depeche, vaguely dwelling on various elements that could've been identified with the Soviet regime (underdogs, master & servant, heavy industry), especially in *Construction Time Again*, toyed with workerist visual imagery, along with a critique of capitalist production and perils of selfish, ruthless competitiveness in songs like 'Everything Counts'. Recorded in the Hansa Studios, mythologized by Bowie's Berlin Trilogy, with recording sounds resembling the everyday toil of the factory in a *musique concrete* fashion, the songs were centered around endless, hollowing labors which, as in 'Pipeline', not only sound like workers poetry: 'Taking from the greedy/giving to the needy/working in the pipeline', but also touch on socialist realism: 'From the heart of our land/to the mouth of the man'. In the last song of the album they even suggest to the world's revolutionaries, to tear up the map and start all over again, yet, in the end, it's again just to serve individuality. If there's a revolution, then it's pathetically self-centered, Thatcherist self-reliance, not more than an ad slogan: 'All that we need at the start's universal revolution (that's all!)/and if we trust our hearts, we'll find the solutions'. Yet, Depeche brought solace to millions of fans especially in the Bloc,

who, as we can see in Deller's film, found alternative communities, where they dreamt of a better future.

Still, the fashion for the DDR never dies, recently confirmed by the *Electronic Beats* magazine, which compiled a multi-part DMGDR series, centered around Depeche Mode fandom in East Germany. In another regular series, *EB* does a "24h in (insert a city from the former East here)", in which a correspondent goes to another burgeoning "creative hub", asking its creative class (DJs, promoters, copywriters, bar/club PR/owners) to boast about two things: how much it has changed (read: since the end of communism) and how much resemblance their city bears to the obvious ideal, the only one worth comparing to: Berlin. Any political event is assessed according to how much it is going to affect the 'creative sector', it behaves as if possessing such sector was the only thing that mattered, also as something that somehow helps to fight contemporary fascism. If they complain about the recent neoliberal or fascist politics, creatives from Budapest, Prague or Moscow do so only in as much as it blocks the 'hubs'. Basically, you know how close you are to becoming a modern, creative city if you're able to approximate it towards Berlin. 'Nearly like Berlin' or 'As good as Berlin' were the words I heard only too often when still living in Poland (I was later assured by UK friends they heard exactly the same in various artsy colleges around the country). And given the trouble Berlin is now in, and the unique, not really repeatable status it has due to its history, I don't think this dream is ever going to come true. This is yet what our creatives, if not always our authorities would like to see us as.

Recently it was young Berliners, that is people who cannot remember it personally, who defended the East Side Gallery, the remnants of the Wall that were preserved around the district of Friedrichshain, preserving the artworks endured as fragments. What keeps attracting the youth to that myth is the sense of community, political radicalism and history attached to the Wall and Cold War, that they feel profoundly lacking in their own lives,

in a depoliticized time where there is no alternative.

## System to fight the SYSTEM

Warsaw during communism was a city that had to change dramatically into a completely different place than it was before the war. It is a miracle, and proof of an extremely strong identity and the love of its inhabitants, that despite this drastic change Warsaw still lives all of its previous lives, and one can easily trace every era of its life. There's a legend that during his two hours train-break in 1976 Bowie stepped out at Dworzec Gdański, and walked towards the modernist area of Paris Commune Square (now named after Woodrow Wilson), where he allegedly stopped at the record shop and purchased some folk music LPs. It remains unconfirmed by Bowie himself, but very likely one was by Silesian folk dance ensemble "Śląsk", who were then directed by Stanislaw Hedyna and his original interpretations of native music. Śląsk's 'Helokanie' is shockingly similar to Bowie's 'Warszawa', and the brief visit is to this day mythologized by Polish fans. 'Warszawa' was a later, much more mature version of Bowie's earlier vision of *1984*, minus the glamor and camp, but with a dramatic, heavy beauty. For 'Warszawa' Bowie reserved a sombreness and seriousness typical rather for modern composition. It remains his most mysterious track.

And how was it heard in Warsaw itself? The Polish punk rock groups of the late 70s and early 80s tended to draw on other influences than Bowie. Yet it was a touchstone for the later, 1990s poet Andrzej Sosnowski, now our foremost neo-avantgardist, who would use "Warszawa" as a hidden reference in his work. Sosnowski's Warszawa is always filtered through Bowie's Warszawa, meaning there's a mythical, concrete, bleak Warszawa that Bowie had in mind, that only partially is the real Warsaw. In Sosnowski's vision Warsaw is a late-postmodern, bleak Baudelairean vision (immortalized also in 'The Waste Land', quoting his *Fourmillante cite...* from *Fleurs du Mal*). In this Warsaw

we encounter a similar mixture of flattened eroticism and feelings from different orders, metaphysical, sexual and bluntly mundane, all mixed up. A shop mannequin gives him an erection, and the crotch and the wallet seem to be erect in the same place.

PRL's dull fashion somehow went together with punk. In a way the ugly clothes made of poor quality fabrics, badly made angular shoes, suits and shirts were already very punk. The tasteless, shoddy and shabby, cheaply produced Eastern fashion, making things look not obviously pretty, against conventional beauty, turned them into an anti-fashion. To look deprived, to look as if a bomb exploded next to you, was to contest capitalism – but what about countries without capitalism? If in the West the ostentatious fashion a la dispossessed was a political statement against the society of the spectacle (and at the same time, a signal of its material decay), what did it mean in the East? Perhaps both should be put as expression of late capitalism, in their rejection of order and beauty as equally banal and uninteresting, and often hypocritical. Lacking the funds for consumerist transgressions, Polish punks made up their own, often sexual. One of the open secrets of the scene was its sexual excess. Festivals were also not free of such debauchery. During one Jarocin festival gig of the punk band Zbombardowana Laleczka (Bombarded Doll), the vocalist started to perform fellatio on one of the musicians, and photo reporters jumped over themselves to immortalize this scene of ultimate Polish transgression. Yet, despite the band winning the audience prize because everybody hoped for a repetition, sadly this never occurred.

In Russia the reaction to the system could be in itself reactionary. Yet the strange continuation the subculture world has in Russia until today, means the parallel world called at the time SISTIEMA, the counter, alternative system to fight the other system, is still at play. Yet subcultural life in the Bloc wasn't always just simply against the system. 50s Stilyagi definitely were contesting it, but the later emerging thaw generation, who often

became dissidents, like Yevtushenko, were those who wanted to reform the system, not simply to abolish it. Anyway, the Stilyaga weren't militant either.

It is understood differently now in Poland and Russia. Several books, which came out recently capitalizing on the punk legend, usually universally dismiss a system which didn't allow young people to be the way they were. Censored and often arrested, they still seem not to notice that at the very same time in the dark, industrial Poland of the early 80s another dream was burgeoning: a dream of quasi-efficiency, as if aimed against the authorities. People's Poland, as is not mentioned enough today, provided a stable cultural system within its planned economy, of Domy Kultury (local culture institutions, helping to find talent), phonography, festivals, creating a circuit in which musical culture could flourish. Everyone in Polish punk who mattered made their début this way. In communist reality, especially the late one, music existed in state controlled festivals. In the punk era, each band had to get an official approval from the censoring organs to get to play at one of the main events of the time, Jarocin punk festival. It was allowed by communist powers in the 70s, including the then-sport minister, Aleksander Kwaśniewski, the future president of democratic Poland, some say, as a safety valve, so that after the protests on '68 and in the 70s the youth got their music and calmed down. Yet it was still often raided by the police with truncheons.

Simultaneously to this, as a result of the post-Martial Law years of depression, other, independent channels of counterculture emerged. The counterculture was determined by the conflict between the communist authorities and the Solidarity alliance with the Catholic church – punk's sympathies may have been with neither, and they shared this with several punk-influenced artists who favored a dirty, black realism. Out of that period emerged Łódź Kaliska – a radical movement combining pornography, anti-bourgeois, anti-moralism and political sloganeering for the sake of a loosely understood "freedom". Then there was the so-called

Culture of Gathering. The members of this 'tribe' were creating something – lacking means, often endangered by prison, they created out of anything that could've simply been'gathered' by the other group members. To this group belonged artists later renowned for Critical art, like Zbigniew Libera. There was also the continuation of the experimental film movement, growing from Polish conceptualism in the 70s, with Jozef Robakowski. In Poznan, Kolo Klipsa applied the dark, punk imagery to late conceptualism, and the blasphemous Group Luxus, experimented with a trashed, impoverished version of pop art, and with striking intelligence and vulgarity analyzed the primary elements of the rough 80s Polish reality.

In Russia the movement developed differently. Under much more pressure, they only could have the expression of punk late, during the *perestroika* and *glasnost* period in the mid 80s. The stylings of the Sov-punks are often astonishingly sartorial and various, as if against the stagnant politics. Described as an "aesthetic war between Soviet couture and black market fashion", it brought back lots of the early Soviet fashion, which was forgotten in the era of late Soviet blandness, which was to be followed by dull import in the 90s. One of the most intriguing and puzzling elements of the 80s underground look and subculture is a weird revival of the 50s – elegant dresses, clips, neat hair and film-noir trench coats (yearning after the New Wave 50s/60s cinema that missed them). In terms of image, punkers were skilled postmodernists, applying various looks with a chameleonic easiness. The reference to the glamorous female workers with headscarves, earclips, and nice knee-length skirts and for boys, the look perfected by Kraftwerk. For the punk generation it meant the rejection of everything hippie – the hippie generation was the one to have it all and exchange it for depoliticized drug-haze. The 1980s version of post-punk was someone who had his mind drugged enough by media and politics, with a much more rigorous attitude towards reality. For the Sov-punks, it means they could catch up with all the

decades where they weren't allowed to flourish: hippies, rocka-
billies, metalheads, punks, breakdancers, rockers and New Wavers.
A popular trend was wearing "smoky makeup", dressing as robots.
For everything there was a metaphorical name. A 'nightingale'
meant a heavy drinker, who could stay up all night. A decade later
and most of these movements were eclipsed by the commercialism
of mainstream fashion. It is characteristic for contemporary times
how many glossy, coffee-table punk albums were published,
speaking nostalgically about fighting communism with clothes, at
the time when all the possibly positive elements of this reality were
dismantled. In Poland it was *Generacja* and in Russia *Hooligans80*.

Misha Buster, who authored the latter, says "In the *perestroika*
period many adolescents took up brutal non-Soviet concepts
characterised by anti-heroism, bravado and the originality of the
hooligan. All this happened as part of the clash between the
'normal' and the 'abnormal' and these style images, in turn,
protected our own adolescent idealism and became key criteria in
the search for others like ourselves on the streets of many Soviet
cities." With that there were bands: Grazhdanska Oborona, Kino,
Bravo, and characters: Zhanna Aguzarova, Garik Assa, Alexander
Petlyura, Andrey Bartenev, Viktor Tsoi… The variety of photos
show the fascinating Soviet city spaces: metro, escalators, railway,
bus stops, stadiums… But as the clothes were to shock, or challenge
the social conventions, they weren't creating a real menace
anymore. The never-ending, even until this day, rhetoric of 'fighting
the system' hides another apology, this one of contemporary appro-
priation, of Russian 'creative hubs' that are supposed to change the
subject from its grim current politics. As we know, the colorfully
dressed punks didn't actually create an alternative, nor construct
any political force in the new Russia. But perhaps that was the short
moment, when young people experienced new freedoms, not yet
filtered by the capitalist market, possibilities of life-experimen-
tation. Of course, it wasn't their fault, as the fast-changing post-
Soviet reality of the country didn't leave them much choice. Yet I

see the current nostalgic trend of remembering punks as largely reactionary. In the *Generacja* book, characters are largely disappointed with their lives.

One exhibition press release on late Soviet underground lists combinations of "hoop petticoats made of climbers' blankets and French lace, uniform tunics boasting open backs, and skirts with folds suspiciously reminding of draperies." And as we can see later, this initial fresh amateurism was changed into professional, capitalist fashion, as if it was from the beginning only there to attract the West. Vivienne Westwood, who allegedly said "there could be no fashion in the country of sickles and hammers", together with other Western designers, was coming to the specially organized shows. Slavonic women were becoming Miss World in a timely moment: Aneta Kreglicka in 1990 and Bronya Dubner becoming Alternative Miss World 1998.

2.13 Made in Poland frontman Rozzy at Jarocin 1985 photographed by Tomek Barasiński

It's obvious by that by the late 80s everybody was sick to death of the system, especially if they were a young intellectual dreaming of having a band. But the brutality of the year 1990, when so many promising bands vanished overnight, because the contracts and previous system turned out to be not valid anymore, shows the darker side to it. Though several groups had records released, one group, Made In Poland, had their 1985 début pulled, and now we can only speculate whether it was for the nihilistic, anti-state lyrics. One of the most interesting groups never even had their records released, caught inbetween the two regimes.

*Virgin Mary does the splits – the world falls in!/The communion of holy white wafers of snow covers her eyes and face/ The world of white*

*altars – cemeteries of paradise.* This is not, surprisingly, from any Norwegian death metal band, but a song called *Snow Queen* by the Polish new wave group Wielkanoc (Easter, or Great Night, to render its double meaning) from the small Polish industrial town of Lubin, in Lower Silesia, who lasted less than 3 years and were killed, alongside with so much of what was interesting in the Polish alternative scene, just after the collapse of communism around 1990. *Dziewczyny Karabiny* (Girls carbines) was never actually released before 2010, and compiles live recordings from the festivals where the group wowed the public and critics, such as Jarocin in 1988, or from the Rozgłośnia Harcerska radio show (known for its support of progressive groups in People's Poland) the same year. No wonder they did – live Wielkanoc was a knockdown combination of the moody and the unpolished. Even today it is amazing, how such sophisticated groups were possible in the suicidally grey Poland of the 1980s. As young people from a small industrial town, they knew they had to invent a world around them to have anything on their own. Pretty much, you could say, as did the post punk bands of British industrial areas, but they certainly didn't have the Citizen Militia running at them with truncheons after the gigs.

What is greatest in Wielkanoc is probably the unmatchable energy of the playing and real provocation in the lyrics. Kasia Jarosz was a truly charismatic vocalist and lyricist, introducing to the nearly all-male Polish scene a rare, assured yet raw female presence, and giving the censors lots of work. *Regular meals/Warm checked blankets/Speedy sidewalks/Slit-eyed spiders/Rainy alleys/Train station open/public toilets/female male copulate/The promised protein/no-man's protein.* Nobody at that point dared to sing about grim sexuality in communist Poland like this, and there's definitely no sadder elegy for a spared sperm on the toilet door in any music.

The album's publication after so many years comes as a part of a wider retrieving of the lost legacy of the Polish punk scene by the same people who were engaged in the volume *Generacja.*

*Dziewczyny Karabiny* tells a fascinating story of the functioning of the new music under the decaying socialist regime. Mainstream and alternative meant something completely different in this economy, where every small *dom kultury* had a certain budget they had to spend, and frequently supported young rock bands, running alongside the first attempts to capitalize on the music by the more commercial bands of the era. And the fact 1990 destroyed such a rich musical culture only adds another fascinatingly ambivalent layer.

1990 killed many interesting bands who identified with the previous era of resistance. Now Poland was drowned with the hideous poor quality clones of the Western bands and our music industry in a way still hasn't got out of that crisis, in which it resembles the rest of the world. The Curtain was the dam which was protecting culture from money being the only reason it was made. With the obliteration of political tensions, and especially in the newly democratized countries, nihilism, punk, angularity, difficult obscure lyrics, weren't welcome, opening an era of the new Paneuropean post-socialist realism, in which everything was beautiful.

## Goodbye, Berlin

A similar recuperation has happened to many ex-revolutionaries, especially Slovenians Laibach, initially a protest-conceptual band, which invisibly changed its strategy from political and conceptual to purely conceptual, becoming ritual Slavonic clowns for the more edgy and demanding crowd. But how can any of the surviving post-punkers still maintain any menace to the public sphere?

*Every movement that tries to perpetuate itself, becomes reactionary* – so said no one other than Marshal Tito, repeating Marx. Ask Laibach fans what they think about it, I wondered one windy night in March 2012 at the sinister edifice of Tate Modern, where the band were to perform a show of 'Monumental Retro Avant-Garde', watching them monochromely clad in black leather ankle-length coats, white shirts with omnipresent medical looking Malevich

crosses, thigh-high platforms and officer boots. The discipline of a Laibach fan is military, not only to get the quickly disappearing tickets. Like mercenaries for hire, wristbanded, we queued, surrounded by men in black. As long as it is for fun and we don't really have to worry about the rise of the far right sure, why not!

In the Turbine Hall, Albert Speer-like as ever, they showed typical communist agit-prop for an hour, after a conference that was taking place all day in the Tate itself, where Laibach themselves were discussing their status as the walking work of art. But as became clear during this show of Monumental Retro Avant-garde, it was exactly this strong insistence on their origins in art and their relation with the art world, that in the end, instead of adding another layer of meaning, turned back on them. The problem with many groups of 'conceptual' provenance is that they overtrusted in irony, overidentification, 'intellectualization' as if it was in any case a road to artistic success. The knowing kitsch, vanity and irony, implied by the NSK (Neue Slowenische Kunst) movement is precisely what is pre-empting the possible ideological menace both politically and as objects of art. The questioning of ideology and post-modern mindset of NSK (which included artistic groups such as IRWIN, Novi Kolektivizem) begs the question as to whether by questioning the political order of the 1980s the group was yearning for the early communist collectivism or merely was embracing the Western version of capitalism.

When the Fab Four, or rather the inter-generational combo, retrospective also in terms of line-up, entered the stage and began their freak show, the latter seemed more possible. The monumental *Intro* was stupendous, and then they go nostalgic – fittingly with the Retro-Avant-garde in the title, they played a bunch of songs from the early postpunk period as a reconstruction of historical performances at Music Biennial Zagreb '83 and Occupied Europe Tour from the same year. Milan Fras has the lowest, darkest and most piercing of basses – not surprisingly, Laibach did an opera once – and the first five or ten songs sung in

Slovenian possess a dark, menacing, almost chthonic power, culminating in *Mi Kujemo Bodosnost* (We're Forging the Future), which, accompanied by the images of gigantic factory hammer and machinery, provokes instantly the opposite thought: *No, you actually aren't anymore!* Because if this is just a joke, irony, they don't really mean it, what is actually the point? The constant references to industry, which shaped their youth and pervades especially their early work, can be now rendered only in an aestheticized form in a former power station turned gallery.

More Slovenian songs, like *Smrt za Smrt*, cues applause and sing-alongs from the Slovenian community in London by my side. Like on every cult band gig, there was a strong sense of a ritual going on between the band and the crowd. Everything seems synchronized. A spectacle is a spectacle and Laibach are better at it than anyone else. We watch Yugoslavian newsreels, party meetings, fragments of Leni Riefenstahl and Yukio Mishima's *Patriotism*, Stalin and Tito speaking over the scene, which is decorated with a deer's head. When Laibach were asked about their political views at a press conference when touring Poland during the late Martial Law in 1983, they replied "we are communists", much to the organizers and crowd's dismay. The band's excavations when they started in the late 1970s/early 1980s, were not intended to call the late Tito's (the marshal died in 1980) socialist Yugoslavia 'Nazi', 'fascist' or 'Stalinist' – rather, as eternal pranksters and born postmodernists, they wanted to wind up 1980s Slovenian society by quoting its 1940s and 1950s past. The aim always was to shock and repulse.

Whatever works: in 1983 it was communism, in 1987 it was "songs for Europe": a Nazified Queen's *One Vision*, *Geburt Einen Nation* and Opus' *Life is Life*. That was probably their peak and the songs of course appear in the gig, as carefully planned encore. Not only did it work at the time as a wind-up, it was really touching upon unhealed traumas and real shame in the country: the Nazi era or collapsing communism. Laibach were the anti-

Kraftwerk, a projection of Ian Curtis's turned real. In the Turbine Hall in 2012 they were stripped to what they have always been, fancy dressed pranksters, a pantomime without much reference to what is now happening in their country: a sharp recession after joining the Eurozone and mass protests. In them, we seemingly cherish everything that is disturbing in art, from Wagner to Leni R. to Syberberg. But here, we can start asking questions, whether they really could be put in the same line? There's nothing they can do to still shock, cause resonance, even if they did a Socialist Realist album on how their native Slovenia is now in crisis after it joined the Eurozone. Instead, they did a soundtrack to a film about Nazis in space.

Equally telling is the example of Einstürzende Neubauten. Their music embodied a vision of post-war West Germany: their name was a blow to the post-war policies. Their aesthetics evoked Entartete Kunst, Cold War, DDR, Berlin Wall, *overcoming of the past*, decomposing cityscapes, fall of industry, Cage, Stockhausen, trash, punk, destruction, morbidity, dada, and in general the bleakest unfulfilled promises of modernity. You can't think of them without seeing the cityscape of Berlin, which was their site of creativity/destruction, and indeed they contributed to its lasting image as infinitely edgy place of experimentation, even if it bears little resemblance to the current reality. They also pressed heavily on the "Ostalgic" buttons, having had played in Berlin's Palast der Republik in 2004 shortly before the venue was demolished for purely ideological reasons, again, as a part of "overcoming the past".

They were the part of the *Nachgeboren* ('born later', after Brecht's famous poem), stylistically put between the Darmstadt school of Serielle/Elektronische Musik and the Kosmische-Krautrock eruption. Yet today, I'd put my money rather on dance-rhythm oriented bands, like D.A.F., Grauzone or Palais Schaumburg. DAF, the leather clad techno nemesis were consciously referring to the Soviet Bloc in their aesthetic (as in the socialist realist cover of their

album *Die Kleinen und die Bosen*), while their fascist-homosexual entourage was a million times more disturbing and politically dangerous. Neubauten never were a band of tunes, they were a band of style, more like a conceptual theatre of method actors or performance artists, a cabaret in a post-Baader Meinhof house of fear, where Berlin was re-enacting the German trauma through their driven shows. With their name calling for 'new buildings' to collapse, they were the model for a post-68 disillusioned generation lost in the ashes of history, unsettled by the uneasy peace West Germany had made with its past.

But it is this cultural meaning that today serves the art world so well. They keep being referenced by the new generations of visual artists: in 2007, Jo Mitchell performed 'Concerto For Voice & Machinery II' at London's ICA, a reconstruction of an infamous Neubauten-related performance at the same venue in 1984, which caused some riots and destruction. Namechecking Heiner Müller, Diamanda Galas, Dadaist performances, cabaret and non-Western practices, it is clear that what Blixa Bargeld was absorbing was not identical with his creation. Maybe this is what has become of many of those bands, now titillating exactly for what used to be subversive and revolutionary. Today it seems the most 'subversive' thing is not to quote theory, but to risk one's own back at a demonstrations. As the music industry is now anything but what it was 20, 30 years ago, finding itself in the greatest financial crisis, now the art world is its only chance, subsuming the radical chic of punk. The new Bowie album can be hardly purchased in a record shop (as they keep shutting down for good), but he could be seen on dozens of silver screens at a bigger-than-life V&A *David Bowie Is* exhibition, which sold 50,000 tickets before it was even opened. The man, aptly, didn't come – but who would like to attend his own funeral?

# 3

# O Mystical East

## East European Orientalism

*Oh mystical East,*
*You've lost your way*
*Your rising sun shall rise again*
*My Western world gives out her hand*
*A victor's help to your fallen land*

*This is my Western promise!*
Ultravox, *Western Promise*

### To despair is to be Romanian

"It's awful to be Romanian; serious people smile at you dismissively. When they see you're smart, they think you're a cheat." – so wrote the philosopher and essayist Emile Cioran in his diary in 1933. While Cioran may not be the best name to be associated with, because of his various involvements with Romanian fascism, his position faithfully and possibly most fully shows the place of an intellectual or an artist from the periphery, when he comes to the West. As a result of his feeling of insignificance, he decides to shake off all the signifiers of his previous existence: his language (he writes entirely in French, an act, some say, of "unwriting" his previous Romanian books) and dreams "to become a stranger", resisting the "temptation to exist". "All my life I wanted to be something else, anything but that I already were". Being and exile is now a vocation, and he starts specializing in theorizing this position. Was part of that a shame because of the specifically brutal forms that anti-Semitism and the Holocaust took in Romania, or really, something so petty as a self indulgent, self-regarding,

3.1 FEMEN, on their annual protest against the regular summer hot water switch off in Kiev.

solitary cry of "me me me" sounding there, in the dark? Definitely a sense of shame at one's crimes can be transformed into less officially disturbing senses of shame. One may think there's something wrong with their looks, with some small elements of their appearance. With their brains, talent, skills. Provinciality is part of them.

"To despair is to be Romanian", "I'm ashamed to be a Romanian." "Romania will never become a culture (nation)." "They can't blame anyone but themselves for being a total historic failure." It recalls the complaints of many bourgeois intellectuals, incapable of contributing to their own culture. But also it's said with the exasperation of someone whose ego doesn't allow him to withdraw for a bit and think that he and his experience may not be representative.

At the same time, this man, whose aphoristic writing never achieved nor strove to find a traditional coherence of prose, is perfectly attuned to the smallest shivers of his soul that provoke his weird logorrhoea. But it was precisely Cioran's capability to endlessly dwell on the catastrophe that made him, despite or maybe because of his uprootedness, good material for a post-war thinker "of ruins", of a fallen civilization, and of the margins – his

own marginality helped his writing talent to flourish. If you construct your whole life as an exile in the world, then you model it as sick, and then you parasitically live off the sickness. A weird hubris is feeding this as well: everything, starvation, blasphemy, only not to become a "poor, unknown stranger". This was a fear of another exile, a poet, who we couldn't polarize enough against Cioran, the Shoah survivor and a fellow Romanian (although not of choice) and Jew, Paul Celan. Living at the very same time in Paris, Celan had similar thoughts and anxieties, feeling trapped within a world that was meaningless to him, with his language for his only homeland – and that was German, which precisely was the most sublime tool of his torture. He never could write in any other language, but thanks to this he is now a poet of the canon – would that be the case, if he had chosen to write in Romanian or in Yiddish?

Cioran enjoys today an ambivalent fame, to a degree like Louis Ferdinand Celine, as a thinker with whom the difficulty is that his brilliance cannot be distinguished from his despicable racist views. He died in 1995, never wanted to go back to Romania, for a few years before his death already "freed" from the Ceauşescu regime. What would he see, a character in every possible way from a different era, looking at the country he abandoned in shame, after years of its destruction and marginalization? Cioran, no doubt the least likely hero for any positive political post-socialist movement, someone who was banned under Ceauşescu, is interesting, as looking through him we discover suppressed truths.

Ilinca Zarifopol-Johnston, the author of his only English biography, herself a political, though self-imposed exile, left Romania in the 70s with an attempt to break completely with the past. In the 1990s, wanting to write on her hero, she had to come back and she's obsessed with finding the downfall in anything: the plane is full of smelly, Securitate-like unpleasant men, making rude jokes. Everything is dilapidated, as if two, not one natural disasters came upon the country. Cities are dirty, she chokes with fumes,

drivers are irresponsible. Streets are Dickensian. "I live in a slum. The whole country looks like an extended slum." She can only compare herself to a Proust, when stumbling upon a pothole. The country "looks like a vast apartment that has just been ransacked by the Securitate and left in shambles. Heaps of junk, piles of garbage, stones, earth broken pipes, and other machinery. Broken down cars everywhere." Everything is "chaos", wheeling and dealing. The mafia do their trafficking, "gypsies" beg and peasant babushkas do their business in the market. She goes to see their old flat, but can't photograph it, as it would break her mother's heart. The mafia is mushrooming, red Ferraris stand next to beggars and thieves. Bucharest, with its concrete towers, clearly disappoints her, she feels shame for being there, because she IS from there. Their shame is her shame. Sometimes she can see a glimpse of the old, less grim Bucharest, but then returns to her alienation.

It is an image of a country in ruins, no doubt, but ruined not only by its mad ex-dictator but also by the later neglect. As we've seen, post-communist economies almost entirely experienced a massive collapse in the early nineties, as they were seen only as a land ready for exploitation by foreign investors that didn't always come. Truly no-man's lands, looking towards the West, they gained only in as much that they were now exploited in the Western way.

Zarifopol sees everywhere sad, disillusioned, dejected, aggressive and despairing people – they were supposed to be like that before, not after the magical '89. In the face of all this she can only repeat her master's voice: how can one be Romanian? But is really an uprooted ex-fascist émigré the best guide to what Romania should be? The typical reaction of migrants who came back overlapped with the countries' own view of themselves: dismissal. We suck. We are poor. We failed. It is the West that is beautiful. Where the invisible hand cleans everything, without the help of human sweat. Zarifopol managed to interiorize the Western attitude and perceptions, but not completely, as the part of that is ashamed reveals a post-colonial subject. Also, the recent interest in

Eastern European art could be easily qualified as orientalism, in the way the recent Western publications on Eastern European art define us and 'discover', as if we weren't just a few hundred kilometres from them. Interestingly enough, out of this feeling of dissolution, it was Romanians who created the most acute, accurate films about the transition, especially after the EU accession, presenting a country in flux, full of social tensions, new problems, for which there are not names yet.

Cioran creates a tension between the center, that is the West, Western thought, the Enlightenment, the dictatorship of the one and only Reason and the periphery. Modernism challenged that, but still, until quite recently, scholars had problems with placing "The East", which becomes a mythical and phantasmal, rather than geographically accurate place. This aura of the mystical, irrational east is still going on, despite the communist years, which from the perspective of the West were years of "disobedience". The province versus the center is also something that was and still is persecuting me. One of the most prevailing elements of that inferiority thinking would be: "there wouldn't be a center without the province" or "the province had to have it shitty, with all the perils of totalitarianism, communism, lack of democracy, so that the rich west could boast with their social democracy and regard for human life". This would be attractive, if it wasn't challenged by the existence of countries like Spain, Sweden or Norway, who despite being geographically and historically peripheral, managed to become affluent like the West and to remain culturally in the mainstream circuit.

Popular culture in the Western sense didn't make its way to us until the late 80s. If you ask me what was the major cultural feature of the socialist Poland, I'll tell you: high-mindedness. We also had our mass culture, but we didn't have permissiveness for schlock. Lacking that, we also, until the 1990s at least, didn't develop any postmodern easiness or ironic distance towards this schlock. The first thing that I observed, when I started being a regular user of the internet, was its capability to write on everything as if ideas were

3.2 Malczewski's Polish Hamlet torn between two Polonias. the
youthful and the old one, in chains.

lying in a supermarket. When I go to the former republics, I take
the dilapidation for what it is: a sign of impoverishment, and that's
it. There's too many people to blame. It wasn't always like that,
though. Contact with 'the West' may still cause a shock by the level
of consumption. My first trips abroad on my own, since I was 15,
that is in 1998, were all to the West. London shocked me, then Italy
– grand tour, France, mostly Paris. Blind towards my privilege, I
saw myself there rather than in the streets of Moscow, which I
must've imagined exactly as Zarifopol describes Bucharest. Then
when I moved to England in the middle of the post-2008 crisis,
nothing was more sobering. It was living in the overpriced, shabby
and ratty flats of London, which more than anything resembled the
inflation-mad, drowning, death-driven Weimar Berlin, dancing
over a volcano which killed the idea of "the West" for me, as
preserved by the Eastern European intelligentsia. And as if from
the disgust of that image, I started travelling East. The East, that
besides short school trips, I deliberately stayed away from. Yet the
perhaps most important experience I took from these trips is that,
of course, the Eastern and Western Europe still constitute an entity
of the West in any comparison with the real east, like China. In

every respect, Europe, this pitiful, self important tiny strip of land, culturally is connected in ways more intricate than we can imagine, and this we owe perhaps also to the Cold War. In this sense, even if throughout this book I use the expression 'former East', I can use it only parodically, ironically. I can use it to indicate financial and emigrational differences between them, yet still bearing in mind how restricted this view is. This book perhaps should be even ashamed of how little of our problems it manages to cover.

Can we turn the communist experience into an advantage? The popular response from historians and theorists is usually: no. For instance, Marci Shore's recent book *The Taste of Ashes* on the aftermath of communism in Europe, hesitates between the appreciation of basic facts (communism meant a lot of evil to a lot of people. Many suffered censorship and torture in it), and coming to terms with the stereotypes that are produced about it, finding herself unable to reject all of them. Current migration doesn't have the luxury of self-recognition, not being based on the previous class and cultural signifiers. Unlike the Polish or Russian emigration to the US or UK before, this emigration is equipped with less cultural capital, yet that doesn't limit its capacity of creating a meaningful relationship and domesticating their new home – perhaps to the contrary even. It is the end of migration as a privilege of the rich, intelligentsia or middle class.

## Not Really White

It is commonly believed among Westernized liberals, that "Russia is not Europe". Especially today, even speaking from diametrically different political stands, it's impossible not to criticize Russia, which embraced a criminal economy and heads towards nationalist theocracy. Yet this polarization of the East and West seems growingly a fantasy of the two sides previously involved in the Cold War conflict. On one hand, liberal pundits like Anne Applebaum still embrace an idea of the "West" which is strictly Cold War-like. Upon Margaret Thatcher's death, the late British PM

got praise from Applebaum as someone who "understood the power of the West"; on the other hand, we have recurring projects of building the alternative, an Eastern European Union, a project vivid especially in right-wing circles. This inscribes into the thousands of years long rivalry between the East and the West, when any balanced values of one and another were crushed with the brutal Christianization, even upon peaceful Eastern civilizations. Since then, an image of the East persists, as in love with feudalism and despotism, subjugational, undemocratic "by nature". Why not rather: permanently colonized by the West in a persisting Drang nach Osten?

Yet, despite both the influence of the west over the impoverished Bloc, and the subsequent westernization after 1989, for obvious economic and cultural reasons we often seem worlds apart. Recently the feminist Ukrainian collective Femen came to prominence, famously demonstrating half-naked in cases of women's rights abuse, coming from a country with an extreme and enormous sex industry, abuse of women and patriarchy, and also third world levels of poverty. They're known for their performances, often in Eastern European countries known for their lack of respect for human rights, like Belarus, where they were beaten and abducted, but also increasingly in the West, stopping various international summits and ceremonials. But then they started to 'recruit' young Muslim women in France, criticizing them for wearing headscarves as limiting their freedom as women, conflating, stereotypically, Islam and patriarchy/misogyny. But in doing so, they were not only racist, they neglected the meaning of years of struggle that are behind defending the rights of women from different than European/white background.

Expectedly, they were dismissed by Western feminists for crypto or even open racism and nudity-obsession, regardless of the context. In this case, both sides misunderstood the delicate circumstances. Intersectional, progressive Western feminists, concerned with the risks of racism and (post) colonialism, speak of Femen's

unhealthy obsession with nudity with suspicious disdain, not seeing that behind the admittedly "primitive" methods and controversial approach there's a very specific reality that Femen are fighting.

Femen's message and actions are not universal, and it would be good if the activists were aware of that. In a Guardian piece responding to critics, Inna Shevchenko gives a clear message of her obsession with Putin, his regime and Ukrainian situation. This is Femen's context: the post-communist desert of sex industry, sex clubs, girls at your wish every minute of the night and day. When you check in a hotel, you're totally expected to be interested in the wide offer of sex infrastructure, with "Gentlemen's Clubs" at every step of the city centers. Their protests before and during the Euro 2012 football tournament alerted many to the degree that the event would increase the exploitation of Ukrainian women, whose bodies would be in high demand. It is common to present Eastern European women as a commodity: in the popular series *The Wire* we encounter a container stuffed full of Ukrainian women, who were sold and smuggled in those inhuman conditions for prostitution.

To this there's the post-communist neglect or permissiveness to the worst kinds of women abuse. There were recently several cases that left the Ukrainian-only context, which shocked the public opinion. In one, Roman Landik, son of a renowned politician Volidimir Landik, was observed publicly beating a young woman for half an hour in a restaurant, to which nobody reacted. Later the comments in the media were basically suggesting the girl was "asking for it". The other, much more serious case concerned Oksana Makar, young girl who was gang raped repeatedly and then burned alive. This terminally barbaric case ended in Oksana's death and without any attempts at pursuing and catching the perpetrators, as, again, they were too prominent.

Easterners may be white Europeans but the Western feminists refuse to see varieties within that. For the first time in the UK

actually, I heard that Eastern Europeans are not really considered white! Few Westerners see the abuses of post-communism. Femen are an example of an interesting strategy, powerful in its own right, which may outside of its context, go wrong. Their stripping not only makes them resemble the women who are exploited and who they're defending, they symbolize women's position in the society, whose presence and often meaning is reduced to their bodies. The terror on the politicians faces proves they manage to touch something visceral, something that they can't even openly address. Their fearlessness, or flippancy, disrupted and disclosed the hidden meaning of situations that otherwise would have gone undisturbed. Yet the latest clashes with the Muslim community in France reveal the limitations of a victim's position, who becomes selfish and wary only of its own suffering. Now it seems a typical case of mutual misunderstanding, with each side blind to each other's concerns: Femen doesn't see racism behind their calling patriarchy "Arab", and the Western pro-underprivileged women of color feminists see in Femen only the distasteful theatre of naked boobs, which overlooks their needs, not seeing how they remain blind to the post-communist reality Femen represent. How "intersectional" is that?

White doesn't always mean 'privileged' - especially for women in the UK, seeing how many Eastern European women are working in the sex industry in here, not having much other choice, or clean or serve in restaurants and do other unqualified jobs, despite often holding degrees in their native countries, And funnily enough, because of a similar experience of 'colonialism', though in a much wider sense than the obvious, those two groups should recognize the mutual underprivilege and abuse. Still, it's painful to see the notions of 'postcolonialism' only in the most obvious places. The post-communist "east" had and still has its own share of colonization and suffering, which should be recognized. The accusation that Femen are "fast-food feminism" suggests that those women come from some areas full of bling and money, when in

fact this should stand only for how precarious they really are.

There's many reasons why the ex-Bloc may feel resentful towards the West, but does it mean we shall embrace any idea of nationalist East supremacism, building a mirror-empire? Not only does this idea appeal to many, but, already, Vladimir Putin, who once openly told Russians that "you and I live in the East, not the West", would much rather ally economically with China. The new Cold War, indeed, in the way we deserved it.

But is the answer building the counter-empire? The answer to that is no, of course, not only because the Western empire is visibly crumbling, as the desperate PR efforts from the Keep Calm Britain or American liberal pundits like Applebaum prove. We are witnessing what may be the final decline of the West, which, it can be said, has been in decay for the last several hundreds of years. A State of Permanent Crisis is something the West knows and indulges in for a very long time, needless to say, with splendid influence on culture. There are waves to this state: periods of aridness interweave with those of fruitfulness and richness. Yet the feeling of depression is now too overwhelming. As the economy shifts to the East, this process is too scary to even think of. The ways this shift may fertilize our dried out, dying culture remain yet in the dark. Yet, the intelligentsia, regardless of their economic class, shouldn't reject those "Western" values, that brought ideas of socialism, equality, tolerance, respect and protecting the weak. We're irreversibly children of this twentieth-century formation, and its gains should be kept.

## Misbaptized

We Poles have an overdeveloped psychotic factor. History is to us traumatology – we were beaten, enslaved, tortured, killed, humiliated. This traumatology becomes then a traumatophilia – if you tell us that someone has suffered more, like the Jews, we go into a competition of trauma. Is there a life beyond this 'Christ of nations'?

3.3 National history as a delirium. Jacek Malczewski's Melancholia.

"History is a nightmare from which I am trying to awake." This sentence uttered by Stephen Dedalus from Joyce's *Ulysses* fits Poles like no one else. Czesław Miłosz wrote that Polish literature, and generally Polish culture, is like a "jacket with one sleeve for a dwarf, and the other one for a giant". The larger sleeve symbolises our ambitions of being a part of Europe, the smaller one is the expression of "the oppressed nation", fighting for Polishness. On the one hand, there is the idolization of the West, and on the other – contempt and a sense of superiority towards the East. Poles – for many decades bereft of their own statehood – are not happy to revise the elements that comprise their national identity. The writer who has devoted most energy to analysing Polish culture and its tensions, displacements and limitations kept hidden under its unrevealing cloak is the academic Maria Janion.

Janion deals with representations, apparitions, delusions, hoaxes, hallucinations, dreams, and illusions, and the impossibility of expressing them. She subjects history to revaluations, seeing the history of Poland as an amalgamation of disorderly narrations; full of cracks, tensions and displaced traumas. Thus frequent in her works are questions about the experience of transgression, about

the bones of content in Polish identity, about the revival of meanings that have seemingly been classified. Hence the portrayal of the unnoticeable marginalizations and the focus on themes that have been glossed over in history.

In the latest link in her odyssey to the hidden history of Polish phantasms, *Niesamowita Słowiańszczyzna* (roughly translatable as 'Uncanny Slavism') Janion finds the source of Poland's complexes in the rejection of its specific heritage, meaning our Slavic identity, together with its mythology and beliefs, displaced due to the exceptionally brutal Christianization of the Polish lands that began in the tenth century and continued until the thirteenth. (There are still some sources that claim traces of pagan religions could be found in Poland as late as the seventeenth century). For Janion, the amputation of Slavic spirituality, and together with it, of a complex identity, founded on a dual Slavic–Christian pedigree, as well as the introduction of monotheist Christianity left Poles bereft of a founding myth, and at the same time forced us to seek a new one. Following the logic of a "libidinal economy", the wild nature displaced from the Slavic spirit and represented by the world of "primitive" beliefs was replaced with a nationalism that finds its fulfilment in the form of Polish Messianism. In this way, our suffering, inabilities, and lack of independence immediately gained a new meaning: Poland, in national poet Adam Mickiewicz's phrase, is 'the Christ of nations', suffering for millions. The identification of Christianity and the West with "civilisation" and the disdain for the "primitive" Slavic beliefs resulted in a rift in Polish spirituality, a wound that could not be healed or covered by scar tissue – a place "misbaptised." Devoid of their mythical origin, Poles became the orphans of Europe, marginalized in the West and unable to find themselves among the Slavic culture they lost. Naturally, they were helped in this by history: the tense relations with Russia and the Partitions of the eighteenth and nineteenth centuries, and the lasting reluctance towards an East identified as Russia. The surrogate phantasm of Messianism that our national

myths have fed on for centuries became necessary for the theodicy of Polish martyrdom. Janion sees in this a strategy of displacement, of being orphaned.

## Poland as a post-colonial country

The most inspiring claim in Janion's disquisition is the portrayal of Poland as a country that is, in a sense, postcolonial. Inspired by Said's *Orientalism*, Janion presents Poland as a country of dual entanglement: colonized but at the same time colonizing (in Kresy, i.e. Borderlands, its 'eastern marches', an empire that once stretched across what is now Lithuania, Ukraine, Belarus and western Russia). This duality and lack of statehood brought about the lack of a coherent identity. The subject is present in Witold Gombrowicz's prose, where the eternal Polish complexes go hand in hand with a lordly contempt for the otherness of the East. In Janion, colonialism intertwines with gender questions: Poland's masculine arrogance, brimming with a sense of superiority, juxtaposed against the image of it as a degraded female. It would be hard not to notice this gender moment; as in its iconography, Poland the Brave is always a woman. This "Logo Polonia" in manacles is heroic or melancholic as the Black Madonna, suffering and unhappy in 'Melancholia', the famous painting by Jacek Malczewski, in other iconic paintings chained to a rock, bound with a chain or put into stocks. A woman passes the test as a symbol due to her indefiniteness and lack of a permanent place in culture. In a natural way, the womanhood of Polonia also symbolizes her frailty.

What identity, after all, can we talk about here if the tradition of this state, besides Poles, is claimed also by Ukrainians, Belarussians, Lithuanians, Germans, Jews, Armenians, Karaims, and Tatars? The most tragic dimension of this lack of communication between the nations is naturally present in the Jewish community. Even such national heroes as the revolutionary nationalist Tadeusz Kościuszko hailed from Orthodox Ruthenian gentry.

Mickiewicz's family had similar roots. It is interesting that in diagnosing our tendency to mythologize defeat, and falling into melancholia, we hardly ever notice how the Polish experience as mediator between the East and the West has been accompanied by a mysterious self-destructiveness. Our identity took shape in the no man's lands between a suppressed Slavic spirit and an assimilated Westernness, between rationality and "barbarianism", betraying later all the symptoms of the experienced trauma. Poland's ostentatious turning towards the past and the inability to live "in the present", which is always in this or that way unsatisfactory, has also made it impossible to get even with what has been suppressed. To hide away, to ham it up – this is "our" way of coping with trauma that every now and then come to the surface. It seems that the Polish tendency to fantasize themselves as 'Sarmatians' the ancient Iranian tribe that allegedly came to Poland and whose myth endures in the Polish aristocracy, the fantastic projects that sprang up from the minds of Polish writers and artists, took their source from a certain cultural deficiency We endlessly play up our funerary ceremonies, traumatically repeating our defeats.

(A tragic-absurd epilogue to this was written on the April 10th, 2010, when 93 Polish politicians, writers, heroes and dignitaries died in a plane crash over Smolensk, en route to the site of Polish martyrology, the Katyń forest, where thousands of Polish officers were killed by the Red Army in 1940. Accordingly, Smolensk has become a founding myth of the new far right in Poland. I say new, but it is actually very old. Mentally, this formation is precisely the un-dead of a Polish right-wing Catholic/Russophobe/anti-Semitic/homophobe formation, that haunted Poland since the regaining of independence in 1918. therefore the huge wave of reaction which is de facto a restoration of the interwar, chauvinistic Poland.).

No deeper analysis is needed here for the superficial symptoms of 'returning to the roots', as in for example the "peasant mania" of Young Poland (the Polish Art Nouveau movement) at the turn of

the century, or the Zakopane Highland aesthetics in decorative arts. The true romantic mysticism, as in *Król-Duch* (King–Spirit) by the Romantic poet Juliusz Słowacki, or Konrad's nihilism in the third part of Mickiewicz's play *Dziady* (The Forefathers' Eve) - a character, who in order to fight for Poland, has to change his identity into an evil one - finds a culmination in the decadent polymathic painter/poet/playwright Stanisław Wyspiański's *Wesele* (The Wedding), where it becomes stripped of any illusions. The mad Straw Man's dance, for a century a symbol of political and mental Polish futility, there is laid bare as a 'Sarmatian' melancholia, feigning the consciousness of defeat lodged somewhere deep in us. This image of melancholy, known from the iconic painted representations by Malczewski and Wyspiański, makes use of the uncanny and imagination for the a deliberate hiding of the rift between intention and action, typical for the melancholic Polish nature that is always – following the oft-repeated saying by Witold Gombrowicz – half-baked.

## The Polish Uncanny

Yet not all is lost. The suppressed demanded disclosure, and it was the (post)-Romantic literature and art that were most often haunted by the suppressed Slavic identity. It is not a coincidence that the blossoming of phantasms combining Polish identity with the Messianic mission took place in Romanticism, much like the interest in the Slavic. The theory of culture that emerges from the Polish Romantics' arguments from before 1830, a period when the Polish state was ruthlessly dismembered and oppressed by its neighbors, vests the perfection of the spiritual state only in the past. The past "was as if a natural state of poetry, clairvoyance, and unity with nature." (Janion) The romantic severance from the rule of Logos, the ideological dispute between the Romantics and the Classicists, was in Poland an additional battle for the definition of Polishness. The Polish Romantics were aware of the Slavs' past but, as Janion notices, romantic art continues to portray "this state of

dolorous oblivion or non-recognition." The Slavic character returned in literature as a suppressed non-Latin inheritance. It would crop up in the forms of the secret rite (Mickiewicz's *Forefathers' Eve*), a drama about the chthonic powers of nature, interfering with the human world (Słowacki's *Balladyna*), a 'philosophy of genesis' and the fascination with the cruelty of the mythical rulers (by Słowacki, in *Król-Duch* (The Spirit King) and *Genesis z Ducha* (Genesis from the Spirit)). The uncanniness and horror inscribed into that heritage find their culmination in modernist authors: Wyspiański and Witkacy. Even the research into the "savage" conducted by Bronisław Malinowski can be a derivative of this.

Mickiewicz's *Forefathers' Eve* is the work of key importance for Polish culture, presenting its continuity as a "misconducted" Zaduszki (a Polish All Soul's Day ritual), which one cannot become liberated from. The connection between the living and the dead was severed, as a variety of skeletons are stuck in the closet, and the mourning work has either not been performed or held back. The fear of enlivening something considered dead is one of the most primary features of the uncanny in Freud's notion of the *Unheimlich*. Freud's aesthetics, e.g. his considerations on jokes, prove that his notion of the unconsciousness, the phantasmic, and the uncanny have their roots in romantic irrationality. Especially "the phantasm" - fantasy as defined by Freud-signifies the very core of "psychological reality", which is not the transparent self-knowledge of the subject but rather alienation from reality. The uncanny is manifested when what comes to light are the contents that, though hidden away from us, are not entirely alien to us. The condition for uncanniness is its previous "canniness" – what is familiar but pushed away into the realm of the unconscious. "The prefix un is a symptom of suppression."

The uncanny, for Freud, boils down to brushing with various forms of death. And the greatest anxiety of the living is that death does not occur fully. The Polish Romantics' predilection for the

occult and the return to Slavic beliefs were like discovering a fissure: a crack in the image of the world that cannot be filled. The misburied dead drive the Polish Romantics to madness.

## The chimeras of Sarmatian melancholia

In her earlier book *Wampir: Biografia Symboliczna* (Vampire – A Symbolic Biography), Maria Janion followed the figure of the vampire, which may embody the displaced Slavic character and be the alternative self, a lost component of humanity. The popularity of the vampire as a protagonist of the literary canon is intriguing. It is enough to quote, besides *Forefathers' Eve*, Wladislaw Reymont's *Wampir* (Vampire), and Witkacy's *Matka* (Mother) making an allusion to sentencing the contemporary to vampirism and the loss of the prophetic gift. Janion mentions also the theme of vampirism in the field of art, sucking the life forces from the artist. This was a well-known subject for the decadents of Young Poland, connecting in a peculiar manner with the Polish sense of impotence. In Malczewski's painting 'Zatrute studnie' (Poisoned Wells), the numerous Chimeras and other creatures haunting the artist's

3.4 Me, or not me. Spectral Witkacy, 1915.

imagination and rendering creation impossible are a personification of Polish ills. The figures in his famous 'Melancholia' appear as if they were lastingly detached from all reality, suspended in their passive comings and goings. Here, the space of the painting holds any potential movement at bay. This predominant passivity limits man even in open space: the limitless space of mountains brings no consolation to Kazimierz Przerwa-Tetmajer, the author of *The Tales of the Tatras*, who rather writes about pensiveness and melancholic '*osmętnice*' – a neologism for the mythical 'sprites of sadness' of Polish mythology, who lingered in cemeteries, and killed men and women by kissing them.

The iconography of melancholics usually presents male figures, while Malczewski portrays a woman's form, dark and veiled. Nothing would portray the withdrawal, so characteristic for the melancholic state, better than this veil of black. "The nothing that hurts", as literary critic and novelist Marek Bieńczyk put it in his book *Melancholia. On Those Who'll Never Regain the Loss*. What is unknowable, this deficiency, disrupts the cognitive process. A parallel, invisible, and hidden world is growing, defined in one of Malczewski's paintings as the 'Polski Hamlet'. Melancholia is born from the deficiency that, from its very essence, may not be satisfied. It is not a momentary disposition: one simply is a melancholic. Freud in *Mourning and Melancholia* describes it as the result of a turning away from reality, leading to the appearance of an attitude based on holding doggedly to the object. Melancholia is a pathological mourning: "in the case of mourning, it is the world that is desolate; in the case of melancholia – it was the very 'self' that became pauperised and desolate." Moreover, the state of melancholia is defined as a "withdrawal" into the depths of the self and the contemplation of the "self". Of key importance for the melancholic is the moment when the liberated libido (here perhaps the love of the fatherland) loses the object of anchoring and becomes withdrawn back to the "self" - a classic "Hamletism" of attitudes of Polish heroes. Possibly the most famous presentation of Polonia is contained in Malczewski, a portrait which provides a clearer allegory of Polish Hamletism, torn between the young and a revolution in manacles, symbolizing military defeats, returning to the subject of Polonia's eternal womanhood with persistence verging on obsession. There is in Malczewski's oeuvre an image of Polonia as a totally naked winged woman who shows the future with an energetic gesture of her hand - a unique, triumphant Polonia. Yet the Polish Hamlet in his own manner seems uninterested in any of these versions of history, and his eyes are melancholically turned to the contemplation of its own interior.

Where does this conviction about our weakness come from? We

return to the cracked identity, limiting the Slavic character to the dimension of tedious sentimentalism, which easily turns into a certain 'Sarmatian' melancholia. 'Sarmatism' is our awkward imitation of power, shame displaced into the subconscious. One of the results of the mythicization of our defeats may be atmospheric art, immersed in symbolism. A similar threat was noticed by Wyspiański and it was also well seen by the early twentieth-century novelist and unorthodox Marxist philosopher Stanisław Brzozowski. We are aware that we neglected something, that we lost something never to regain it again. The internalized melancholia merges into a unity with the vaguely perceived "Slavic soul". Thus the Polish artist claims to communicate directly with the demons of the past. The grotesque ruled the imagination of Polish painters like Malczewski and Witkacy, as the symptom of a world that was falling apart before their very eyes.

The development of Polish art progressed nearly parallel to the acquisition of nationalism; hence it is inseparable from discussions on the shape of the national style, continuing especially during the two decades between the World Wars. The regaining of Polish independence in 1918 was followed by numerous initiatives to form social and artistic life anew. Literary life was flourishing, and a peculiar euphoria ruled. On the other hand, the programmes of "returning to nature" increasingly often became a part of state ideology.

It is worth remembering here one of the most bewildering Polish artists as a symptom of the unconscious background to those events. Stach z Warty Szukalski (1893–1987) has to this day remained an inconvenient person, hard to be dismissed with regular ideological criticism. Szukalski ostentatiously contested the ideals of the newly enlightened and modern Poland, and all the milieux contemporary to him. This son of a Polish blacksmith who spent his youth in the US, was a self-made ideologist playing a Renaissance artist, putting forth his vision of Sarmatism, allegedly undistorted by outside influences. According to his so-called

Zermatism, predecessors of Poles hailed from Easter Island, via the isles of Lachia and Sarmatia, they travelled via the summit of Matterhorn and moved to Poland from the town of Zermatt. Analysing rock art (possibly the most ancient representation of man's artistic activity), he arrived at the conclusion that Poland was the first land to emerge from the Flood, and all the languages of the world took their origin from the primordial Polish vernacular. Much like Nietzsche, he delved into pre-Socratic Hellenism, believing that it is only by re-approaching the Greeks' tragic period that we shall discover something "of our own truth". Szukalski believed that Polish culture found itself in a state of collapse, with an alien element not only having taken away our statehood but also dictating cultural standards. He perceived traces of cultural purity in the pre-Slavic. Worried about the fate of all of Europe, he perceived an opportunity for its salvation in the establishment of an alternative, totalitarian vision of the continent, "Neurope", with the participation of all the states – apart from those spreading the worst corruption or immorality, namely, France, Germany, and England – under the aegis of a new reborn Poland. This Poland would profess its ancient and freshly invented mythologies and heroes. The Wawel castle in Krakow and Duchtynia (neologism for Temple of the Spirit), designed by Szukalski, would be its spiritual center, something akin to the Germanic Valhalla, with Marshal Jozef Piłsudski, the de facto dictator of Poland from 1925 to 1935, being the incarnation of the King–Spirit, his mythical creation 'Politwarus'. It was to be a monument to the 'Miracle on the Vistula', when Polish forces defeated the Red Army just outside Warsaw in the Polish-Soviet War of 1920, described by the author thus: "the linkage of three national emblems of Poland, Lithuania and Ruthenia, as the Nation and its Youth fought and died for our common geographic-historic Freedom".

Interestingly, despite being obsessed with the Slavic, Szukalski's iconography draws strongly from pan-German aesthetics - possibly the place where he unconsciously located the source of power. But

3.5 Portrait Company of Stanislaw Ignacy Witkiewicz at your service. A Mr and Ms Nawroccy in the full paraphernalia.

by combining this with elements from Native American folklore, his work is strikingly harmonious with the notion of Polish post-colonialism. Szukalski's chauvinistic ideology is too ambiguous to be entirely dismissed. He dared to reach deeper than the woolly mountain mythologies that dominated interwar Poland. What he arrived at, however, was not a gentle vision of the Slavic but blood-spattered clashes of power and a struggle for domination, anarchy, and anti-Christianity. This sounds familiar when juxtaposed against Poland's history of 'noble anarchy', and the self-destruction of its nobility.

Since the authorities, not even necessarily totalitarian, discovered the political usefulness of references to nationalist ideologies of "blood and soil", the uncanny was capable of becoming a functional part of ideology. We could turn our attention to the Polish phenomenon of building mounds – by "the hand of the nation" – to great national heroes (like Kościuszko or Piłsudski). A certain culmination of the discussion of the national style between the two World Wars was the competition for the monument to Józef Piłsudski in Warsaw, announced just after the

Marshal's death in 1935 (Szukalski sent in his design of Duchtynia from America). This death and the competition, whose winner faced an opportunity to be recorded for posterity, resulted in an extraordinary activation of national solemnity, Slavic myth, and symbolic and phantasmic representations of Polishness among the designers. Examined today, the designs dazzle with their bombastic nature, and as designs, they simply seem bizarre. The sublime was imagined in the typically Germanic, classicist style: "All of Poland is a pyramid rising from his (i.e. Piłsudski's) life," said General Wieniawa-Długoszowski on the occasion of the competition

## Catastrophism

Polish Romanticism would also inevitably run into its antithesis, namely positivism and the Galician myth, being the reverse of the mystic Zakopane style. Among the advocates of this other side of the coin was certainly Stanisław Brzozowski, although his attitude is among the more complex. One of Poland's few European-class intellectuals, in his *Legenda Młodej Polski* (Legend of Young Poland (1910)) he attacked Polish writers for yielding to pseudo-mysticisms. Young Poland was a movement where fin de siecle decadence mixed with mystical nationalism. As Brzozowski says, Poles want "to keep for ourselves the possibility of internal life outside the law, to outlaw the entire world. The logic of life and the logic of thought become outlawed and make every poorly fledged Polish 'self' gain over them Caesarial power in their own eyes. The cognitive infertility, inactivity in life and economy are always false even though they were to be found 'at the source of the Polish soul." Following a deeply traumatic experience in his youth (blackmailed by Tsarist police, he was forced to testify and incriminate his colleagues, and throughout the rest of his brief life was haunted by a sense of guilt), Brzozowski had an obsession with guilt and with struggling out from the gutter. In his philosophy, he would equally obsessively seek power in the place of the traditional Polish genealogy of defeat and weakness. As Cezary Michalski aptly

noticed in his foreword to his *Głosy wśród nocy* (Voices in the Night) reissued after a nearly hundred years: "A reflection on individual subjectivity has always been weaker in Poland, when compared to the reflection over the collective subjectivity: as shallow as ritualised, as omnipresent and cornering." With all his work, Brzozowski aspired to restore a proper economy of Polish subjectivity, and fought for liberation from immaturity and impotence - for their "reworking". Initially, he saw the reasons for such a state of affairs in the cheap decadence of Polish aesthetics.

In his *Legend of Young Poland*, he charges this milieu with weakness and lassitude of will. But even Brzozowski's naturalism, positivism, his 'philosophy of work', and the called for intellectual fortitude were not free from a specifically Polish mysticism bearing fruition in the extraordinary mix of Bergson's vitalism, Sorel's philosophy of power, and the symbolism of the soil and the nation. Brzozowski was inspired at the same time by Nietzsche, Darwin, and Marx, and wanted to reconcile his fascination between Catholicism and Marxism, and cultural nationalism with literary modernism. The fact that, after his untimely death, he was read both by communists and nationalists with fascist inklings is a testimony to the ambiguity of his project. Michalski, for example, points at the person of Andrzej Trzebiński, the leader of Sztuka i Naród (Art and Nation) who would become engrossed in reading Brzozowski in occupied Warsaw, building at the same time grotesque dystopias in the style of Witkacy and Gombrowicz. As we shall see, Witkacy (Stanislaw Ignacy Witkiewicz, 1885-1939) and Witold Gombrowicz (1904-1969) actually undertook the same subjects of spectral and pompous Polishness, yet in an entirely new, grotesque manner.

With his vitalism and solemnity, Szukalski seemingly stands on the antipodes, and yet he becomes a part of the same decadence. Everything became mixed. His concepts were blatant contaminations without chronology or logic. His attacks on the academic system demanded a return to the spirit of the medieval guilds, and

only the art of the medieval Piast era or with a folk pedigree deserved the notion of "pure". One cannot discuss Szukalski's entanglements at the level of sign or form. They are perfectly legible, much like his ideological grounds. What distorts an unambiguous assessment of the artist is rather his instability between the professed love of things Slavic and European orderliness. Our Slavic character is situated on the emotional plane, which partially explains the incoherence of positions, both of the Young Poland and the more Europe-oriented avant-gardists of the period between the two World Wars. The notion of the 'Slavic soul' disturbs the pure "aesthetic course" of inspiration and its conceptualization, and remains a burden on the advocates of Europeanness. Yet there is no art that would bring back the contact with the past. The attempts to return to our very deep roots, undertaken by Szukalski, discloses a deeply buried complex.

Between the wars, Piłsudski's superoptimistic and nationalist vision of Poland "from sea to sea" went alongside a catastrophism, whose most distinct preacher was definitely the polymath Stanislaw Ignacy Witkiewicz, known by the pen-name Witkacy. Known for his dislike of Russia after he had seen the aftermath of the October Revolution, he distanced himself from the Slavic, as he believed it annihilated individualism – the only reason behind the existence of the Individual Being. He believed that there is something in 'eastern mentality' that predestines it to totalitarianism. The plot of his *Nienasycenie* (Insatiability, 1932) takes us to a not-so-distant future. The protagonists are a gang of decadents and derelicts, representatives of the artistic Boheme, drowned in lethargy, drugs and mental illnesses. At the same time, there appears on the black market a pill created by the Mongolian philosopher, Murti Bing, which liberates the individual from any tormenting doubts of a metaphysical nature and turns him or her into a polite citizen devoid of any views. This takes place at the moment when the Chinese–Mongolian army that has already conquered the whole of Eastern Europe is just about to attack

Poland and complete its Orientalization, which is tantamount to the annihilation of all and any individualism. Torn between politeness and anarchism, Witkacy's Poles confirm their schizophrenic condition.

The moral chaos that interwar society was plunging into was presented probably most insightfully by Bronisław Wojciech Linke, one of the most astonishing and original Polish artists of the first half of the twentieth century. An amalgam of the leftist politics and surreal imagination brought about a vision that was far closer to the delusions of symbolists, expressionism, Neue Sachlichkeit (New Realism), and Goya's wartime cycles than to communist propaganda. The nervous line is what connects Linke to Witkacy. Linke's world of small towns becomes inundated in an increasing chaos, yielding to the domination of capitalism, and its degenerations. It was not a coincidence that Linke's favorite reading was symbolist Alfred Kubin's *Po Tamtej Stronie* (On the other Side), in which the German Expressionist described the blueprint for the Land of Dream, perceived as an ideological escape from Europe, engulfed at the time in class struggle, capitalism, poverty, and the growing power of totalitarianism. This new version of Europe does not provide, however, any relief even in art. Following Kubin, Linke is a pessimist and catastrophist, which does not diminish in any way the horrors of his cycles on Silesia and the Jewish Holocaust during the Second World War.

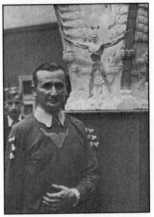

3.6 Stach z Warty Szukalski is forging the new national art. Here posing at an exhibition in Cracow, 1936

The romantic transgression portrayed "pathological" sexuality, clairvoyance, psychological illnesses, lunatic states, magnetism,

doppelgangers, and vampires. This "dark side" has its geography: Count Dracula comes naturally from the East, which is the house of all evil, chaos, and unbridled lust. Gothicism was never present in Poland on a popular scale. A castle was the hero of many Gothic Romantic texts, enough to mention Poe's *The Fall of the House of Usher*. The Gothic personified the horrors of Romanticism, and negative aesthetic experience or the sublime were impossible without the addition of atrocities.

A significant example here is Mściwy Karzeł i Masław, Książę mazowiecki (*The Vindictive Dwarf and Masław the Mazovian Prince*), a Gothic novel by Zygmunt Krasiński, whose plot transports us to the vicinity of the family estate of Opinogóra. The book presents in a grotesque manner a downright cruel figure of a sadistic local chieftain, and weaves elements of exotic Transylvanian vampire legends into the Polish landscape. The Slavic lands are portrayed here as cruel, where the uncanny is discovered in a very homely countryside. Interventions of the grotesque and Gothic into the rational world are not innocent: they are rather a testimony to fundamental doubt. The world is managed by an impersonal, ruthless force, which simply does not need to be the "chaos" destroying order, but rather a force that reveals the permanent chaos onto which an illusory order was imposed. One does not need to go far to seek this, as chaos is already triumphant in Mickiewicz's *Forefathers' Eve*, best described by literary scholar Ryszard Przybylski: "everything is unbelievable, mad, maddening. The living talk to the dead. In a cemetery chapel, the people together with the departed souls perform an opera for intellectuals. The frustrated specter falls into logomania and begins to talk as if he were paid for it. Clocks strike. Candles are extinguished. Existence caves in into the darkness. In prisons, between interrogations, the best of our youth exchange jokes and sing songs. An epileptic soars towards the stars. History shakes a fist at Transcendence. Waving his tail, the Devil takes pity over criminals. Forgetting about the crowd of victims, angels make fuss over a poet

filled with vainglory. A visionary babbles something about numbers. A filthy villain sneers at the mother of a son tortured-to-death. Blasphemies, prayers, and helplessness. Conspirators, traitors, and martyrs. Half-rotten informers choke on the smouldering soil of the graves. A glimpse of a cavalcade of kibitkas (carrying away prisoners) between cemetery trees at dawn. Philosophic perambulations of the streets of Kyrgyz–Kazakh Babylon. Looks as cold as dagger blades, and silences are pregnant with events. All this is Polish, arch-Polish - to tears. As becomes the national specter, the work has a shape as misshapen as mysterious."

Poland can be neither parted nor unified. Our melancholic complex behaves as an open wound, drawing life energy from everywhere. The joy in self-flagellation means the satisfaction of sadistic and hateful tendencies, which have no-one to transfer themselves to. Poland is the ever-renewing wound, clotted into the state of melancholia and disallowing contact with the Real.

## Living with phantoms

This is where we could place the activity of Tomasz Kozak, the contemporary artist who may be the most intensive in trying to come to terms with romanticism and its exorcisms. His diabolic–grotesque rephrasing of Artur Grottger's prints is even too obvious a commentary on the Polish–Russian, or Polish–Eastern, relations. The January Rising of 1863 against Russia has been coded in the minds of successive generations of Poles in the form given to it by Grottger, becoming another link in the history of martyrdom. Kozak's murals approach our Messianism as a murderous grotesque. The enemies that our demonic fellow nationals stand to fight are the eternal Jew and the Bolshevik. In turn, in his Yoga Lesson/Luciferian Lesson diptych, Kozak wanted to touch upon the most demonic and ambiguous elements of the Polish psyche. The artist comes straightforwardly to contemporary art engrossed in shamming a variety of activities

and art's dumbness resulting from anti-intellectual positions. The relief comes unexpectedly from the past from the emanations of anachronism, which derailed from the grooves of history, reveals its subversive face. Kozak is interested in compromised ideologies, which cause only embarrassment in the days of political correctness. Yet this moment of shame is most precious for us: it is a legible trace left after the displaced dream of power. The task behind the prophet's aureole and mysticism, as Kozak believed, was to transplant the Arian myth into Polish soil, combining it with the mysticism of the Tatras and with spiritual purism.

The 'Young Poland' writer Tadeusz Miciński's mythology is, besides Szukalski and numerous others, another version of identity compensation disclosing a terse commentary upon the chaos of identity in the contemporary Pole, lost in stereotypes. In Kozak's narration it becomes the elaborately edited shreds of a vision from which he still cannot awake. The avant-garde, and especially that of communist and revolutionary provenance tried to distance itself as much as possible from this infested discourse, as Kozak rightly noted. Our eternally unfulfilled longing finds expression in the elections won by the right wing. Again, we deal with a Nietzschean movement: Miciński fought against the dwarfing of culture, which disposes of its horror and tragic spirit appropriate for a bygone time. Kozak even uses Janion's phrase: "phantasmic criticism" against the simple call for involvement of art in social life and "political criticism" (as heralded by Artur Żmijewski, more on which in Chapter 4). Inspired partly by Benjamin he used film as the final personification of phantasms, making use of the "modern" methods of manipulating images, as for example editing.

Szukalski and Miciński both represent the many undiscovered paths of the canon that were marginalised, mostly for ideological reasons. Their political incorrectness is punished with a lack of presence (absence from textbooks and any other circulation), and given a hallucinatory existence. From here it is only a step to ghast-liness and fantasticality, continuing as a sequence:

invisibility–unburial–obliteration. This is a reverse strategy. Instead of entering the mainstream of official culture, and also – to quote Szukalski – the correct "sexless humanism" – it holes up even deeper under the hood of melancholia.

The subject of hiding away and shame was quite recently undertaken in an interesting manner by the project–book *Inhibition*. As its author, Roman Dziadkiewicz says, the inspiration for it was the discovery of non-canonical works in the archives of the National Museum in Krakow, and in those works, the displaced narratives of Polish art. "The project digs out the shameless emotions, at times charming, aristocratic, futuristic, and all of the sudden verging on fascism. Today they're easily ridiculed by saying that they have survived in the caricatural form of the argot of right-wing politicians. Yet I am interested in what has become of them. Maybe the post-war, democratic, flattened culture failed to rework them and had them quickly displaced? And they were an important part of culture between the two world wars." It is also a penetration of a toxic, contagious Kraków spirit in its numerous manifestations, as the symbol of Polish "culture" and "avant-garde". Dziadkiewicz chose the person of Emil Zegadłowicz, an ambiguous writer of Young Poland, who knocks down our conventional thoughts on the era between the two World Wars. The Author of *Zmory (Nightmares)*, Zegadłowicz was perceived in his time as a leftist, but could also be associated with 'National Democracy', conservatism, praising the charms of the landowning lifestyle, rural character, and the specters of early Christianity. Dziadkiewicz "repeats" Zegadłowicz's gesture through a book–reenactment, issuing a reprint of the "secret" erotic poem Wrzosy (Heathers) in five copies, repeating at the same time the artist's gesture in making illegible his own strategy, so that the "modernist exaltations become a carrier of contemporary content, providing historical and psychological backgrounds." Similarly, the anachronism of Kozak's actions deciphers the works of Miciński and reverses the process of rendering his art illegible

through a range of falsified readings of previous interpreters. It is only in this manner that the deep traditions – and these are the traditions in the plural form – can be "delved into". There are many more sources of contemporary emotions than are presented in official culture. Some needs were simply displaced from official circulation, yet they remained in hiding and this is why they may come to life at all. As Dziadkiewicz says, "in the unmanaged strands, demons or hallucinations start to be born."

In searching for the "other Traditions", as American poet John Ashbery put it in the title of his book, the marginalized narrations that break up the canon, the reclaiming of the "untimely" artists, discovery is coupled not only with the unearthing of shameful content but also with the overcoming of shame, dressing the melancholic wound, and breaking away from the vicious circle of phantasms.

So it seems the miasma is our pathological, guilty pleasure, we continue to live like zombies, cultivating our martyrology, relishing in death. I seldom see my country as ravingly happy as when somebody dies, as if we were secretly waiting for it. Even when Margaret Thatcher died, there was something to the coverage and the politicians' behaviour, as if they got a new spur in life, now planning to call squares after her and erect memorials. But in a greater sense this means a traumatophilia which doesn't let us get over the past. The Other in Polish history and of the whole East are of course, its Jews.

But how can you psychoanalyze the whole nation? With history "visited by the smoke", to use the expression of Polish feminist writer Agata Araszkiewicz, over and over, way too many times? In a city with a history of uprisings, and all of them lost? The painful method is to recall the tragically erased Jewish presence and its forms of life on the eastern European lands. There appear new attempts on behalf of the remaining Jewish community, shrunk now to 20,000 people, strategies to fight the noxious feeling induced by yet another Catholic feast of vainglory and vampirism in our

states. Foreign minister and Bullingdon club member Radek Sikorski and his like go on non stop in the EU parliament about how Europe can only unify when Western Europeans will "feel our pain" from the twentieth century. We're always willing to play the suffering card. And yes, to an extent it's justified. Poles feel their history hasn't been recognized enough in the world. Yet what we need is not another attempt to induce more Polish martyrology, we need more counter-attempts to ground it in the counter-history, to recall the forgotten Jewish past, then we'll try to reconciliate with it. To commemorate the Ghetto Uprising against an increasingly sickening stuffing of the Warsaw Uprising gives us more alternative heroes, more reassessment of the "red", unwanted history of Poland, before the war and during People's Republic, instead of relishing in the most reactionary elements of interwar period, with all its xenophobia, anti-Semitism and nationalism. Let's, even if that seems crazy enough to a Pole, make it more rational, humane, reconnect with the unrealized socialist past, which was suppressed, and for which, our unsung heroes, like those in the Warsaw Ghetto fought, to the silence on the other side of the Wall.

Even before the dissolution of the Cold War order, post-communist studies within post-colonial discourse were mapping the problem of the way our dependency influences our psyche. This is even often called post-dependency studies. Yet another dependency was less direct, yet as influential - that is, upon Western, capitalist imperialism. Such groundbreaking books as Maria Todorova's *Imagining the Balkans* or Ivan Colovic's *Balkans – terror of culture* analyse the idea of balkanization and the influence of self-colonization as one of the responses to westernization since the ninteenth century. At a recent series of events in Warsaw, *Panslavisms*, scholars and artists from the former republics debated over how they might save the idea of the East without it becoming chauvinistic. They proposed among other things the rethinking of Polish ninteenth-century nationalism, with its slogan *For Our Freedom and Yours*, which meant that one nation's liberatory fight

would liberate the others, in this case other eastern countries from the Tsarist, Hapsburg and Ottoman Empires; the group Slavs and Tatars contributed a poster translating the slogan into Russian and Farsi. Today, that may mean liberation from a westernizing neoliberalism, which is experienced acutely in Eastern Europe. They also seem inspired by the idea of the Polish-Lithuanian Commonwealth as a multi-racial, 'Sarmatian' eastern empire of Poles, Lithuanians, Jews, Ukrainians, Armenians and Tatars, while criticizing the actual reality of it, in the colonial relations Poles had towards the *Kresy*. I was surprised though, that throughout the many discussions over how this new eastern international association could look like nobody even mentioned the most obvious one, that actually existed for decades: the Soviet Union. The answer to that is obvious – it's too discredited in the intellectuals eyes to seriously consider it. But the USSR at first wanted to be the most accomplished realization of eastern internationalism. Even in its name, it refused to use any national territory, proposing instead a perfectly abstract association of territories run by workers councils. In reality, it eventually became just another realization of Russian Empire. The next chapters will discuss more at length the communist culture of this Empire, and the reality of communist ideals.

# 4

# Socialist Realism On Trial

## Post-post-modernism, avant-garde, realism and socialist realism in our time

*It is not a way back. It is not linked to the good old days but to the bad new ones. It does not involve undoing techniques but developing them. Man does not become man by stepping out of the masses but by stepping back to them. The masses shed their dehumanisation and thereby men become men again – but not the same men as before.*
Bertolt Brecht, *Against Georg Lukács*

*A considerable part of the leading German intelligentsia, including Adorno, have taken up residence in the 'Grand Hotel Abyss' which I described in connection with my critique of Schopenhauer as 'a beautiful hotel, equipped with every comfort, on the edge of an abyss, of nothingness, of absurdity. And the daily contemplation of the abyss between excellent meals or artistic entertainments, can only heighten the enjoyment of the subtle comforts offered.'*
György Lukács, Introduction to *Theory of the Novel*

*Culture is continuation of politics by other means.*
Socialist slogan

*Here we are now, entertain us!*
Nirvana, *Smells Like Teen Spirit*

## The real in the new reality
If by chance you'd had gone back in time to 1990s Poland, you'd have been struck how 'reality' had been suddenly changed into an augmented cardboard maquette made up of commercial products.

Buildings become mere canvases for gigantic bottles of Coca-Cola, Snickers or West cigarettes, old neon signs were taken down for the sake of big logos of McDonalds and Burger King, the familiar grey newspapers started to have tons of very bright colors applied to them, and the marble of Stalinist buildings was covered by big stickers, where somebody's teeth were bigger than people's heads. It was like that in the whole Bloc. "Advertisements have conquered civilisation," Russian writer Arina Kholina said in 2011 in a Russian literary journal, where she compared bannered promotions to "knickers drying on a balcony". Public space was swamped: *Turn left after Toyota, there you will see L'Oreal, and after Pepsi turn right – for the house where Sony is,* sounded the typical directions. Many of the new ads were illegal, contributing to the general image of the former East as an easily conquerable no-man's land. To this day not much has changed. Yet, today not only the East, but the whole neoliberal capitalist part of the world finds itself in a great crisis of representation, sitting somewhere between the big Virgin Media signposts and the "tasteful" retro of Keep Calm and Carry On. Despite it touching both political sides, the aesthetic crisis doesn't bother the ruling class nearly enough. More worryingly, this also concerns the progressive side, whose political paralysis paralyzed its aesthetics too. Between gifs, the hideous layout of social networks and tumblr, rots the corpse of reality. As this book is interested in looking back at the reality of socialism, this chapter wants to go back – as you do these days - against what Brecht and others wished for, and ask archaeological questions about Realism as the lost model for involvement in reality. What was the realistic solution in the state controlled art and later, in democracy?

'Socialist realism' was a style that transcended both Russia and the 1930s. The first Western reactions to sotsrealism were hostile. America before the Cold War was a country in transit where socialism was popular, and the two empires were watching each other closely. As English art historian Herbert Read justly pointed out in the 1950s, sotsrealism was not simply kitsch, but derived

4.1 Human species, man and woman - crude Sotsrealist gendering.
Peasant Man and Woman on the Green Bridge, Vilnius

from the general nature of the popular arts in various epochs - art which "had never been of any great cultural or aesthetic significance, and the reason for this we ascribed to its realistic nature – the very quality which is in Russia extolled as the supreme aim in arts". An example of this is Mexican muralism and its great influence on American art of the New Deal era, which was a contemporary to Soviet sotsrealism and was made overwhelmingly by Mexican communist artists. It's a rare example of art's influence going from a poorer country to the more powerful one, bottom-up, and not top-down. There was also an uncanny similarity between the mass culture in the States and Soviet Russia, where in both cases, grand scale realism was a low, popular art. Simultaneously with the invention of the New Person in USSR – a sporty, cultivated, harmoniously built man - you had the

emergence of comic Superheroes, equally unreal in their fitness. Both were 'men of steel'.

Yet avant-garde and realism were constantly opposed to each other. It mostly derives from the reading of post-war (sometimes even pre-war, like Clement Greenberg) critics, who were to quick in interpreting the new realism of the 1930s as necessarily complicit in totalitarianism, ignoring the political nuances of certain forms of realism. In this chapter I'll seek a theoretical redemption of realism, that at the same time could serve for a better interpretation and historicization of 'real socialism' and the current difficulty in which militant art has found itself. It will be necessarily a tough task, but realism needs no redemption – it still happens in arts, only popular arts, like TV shows and still sometimes happens in its critical, Brechtian, form. It goes largely unnoticed by the critics, with the prominent exception of Fredric Jameson, who has promised to devote a still unpublished book to the question of realism, and wrote extensively on the contemporary historical novel and 'realist' TV serials like *The Wire*. Realism seems an unfashionable position to take, which necessarily re-emerges within the post 9/11 world, and especially, in the post-2008 financial crisis world. If 2011 started what can be interpreted as the gradual rejection of the 1980s order, both factors – financial and political - seek their expression via the most available channels – internet, youtube, social networks. Cell-phone films pose the question of reality vs. simulacrum, in which we have to believe in reality again, a reality for so long smashed to pieces by the mediation of TV news and computer simulation. The greatest success of postmodernism is that we still behave as if we don't believe what was going on. The mass of depictions of current wars, revolutions, riots, protests, show trials doesn't seem to make them *real* enough.

The years 2012 and 2013 will write themselves in the memory of posterity not only as an explosive year of double dip recession, but also as a year of necessary disappointment in the outcome of the revolutions of 2011, that spread across the so far silent or silenced

areas of post-communist Eastern Europe, with the anti-Putin protests and jailing of anarcho-punks Pussy Riot (alongside with dozens of unsung others), and similar anti-austerity protests in Bulgaria, Romania and Slovenia. But is there anyone who still remembers the fact that leftist art was given the biggest official power and exposure in 2012, at the Berlin Bienniale, turned by Polish artist and curator Artur Żmijewski into a showcase for radical art collectives and Occupy protesters. The Berlin Biennale was as intensely commented on in the months succeeding it as quickly it was later forgotten. It was the year of massive exposure for so-called engaged art: with the big exposition by Jeremy Deller in Hayward Gallery, *Joy in People*, coinciding with the publication of Claire Bishop's *Artificial Hells*, a summa on socially engaged arts and relational aesthetics, working with and through communities/groups and the delegation of others. Yet, there are very specific reasons why 'socially engaged' arts started getting prominence and an increasing interest in the artworld, perhaps the most important being that after 1989 a lot was done so that the notions of history and politicization were dismissed and put in the museum. Everything solid should melt to air now: old battles should be forgotten and we cheerfully gave ourselves to the post-communist transition-induced consumption. Everywhere, not only in the Eastern Europe, this transition was felt, as the 1980s especially were a process which touched us all.

But from then on, as the world of politics was undergoing the increased post-modernization and spectacularization, culture was similarly focused on not even celebrating the surface as depth, as in the 80s, but celebrating the surface as surface. "Here we are now, entertain us" – this lyric by Nirvana best sums up the time, when the prolific production of the most insipid entertainment and pleasure-making went together with the biggest possible deflation of pleasure, experienced now as passive-aggressive, endless reproduction of nothingness. The "disappearance" of history from the everyday made its arrival into the most unexpected place, visual

arts. The influx of money, made on financial speculation, made it necessary to invest especially in the areas of the immediate social prestige, yet strangely enough, despite its particularly spectacular monetization, art still remained a critical space.

With this success story came the remorses of conscience, not so much on the part of the galleries, but of the artists, still holding to the traditional romantic notion of an artist. There appeared new forms of specifically "user-friendly" art, which were now denying that "it's not about the object, but more about the relation between the artist and the public" (or artists and other artists, more like). That was 'relational art' – a rather unhappy pop-theory term coined by Nicolas Bourriaud, which helped to cover a lot of crap touchy-feely, meaningless, ingratiating middle class art and smuggling it into the museums as avant-garde for the large part of late 90s/2000s. But while it claimed its "openness" and welcomeness, it was rather set up to obscure the really existing divisions and inequalities. It was a perfect post-post-modern theory, where the differences first obfuscated in the transition from modernism to postmodernism were now further obliterated, for the sake of the ideas of fun, false togetherness and a fetishized 'relation' which at best lasted five minutes in the gallery.

Relational aesthetics aside, in recent years something emerged that we can call the 'third avant-garde'. These are artists or groups which subscribe to the ethos of the avant-garde, referring to their aesthetics (including open citation of their work), while not shying away from the contemporary political issues and Marxist theory, and often through their work discussing some of the problems of the contemporary, which by necessity also touch artistic production: from the financial crisis and precarity to the difficult, ambivalent relations art itself has in this equation. This went together with the risk of 'recuperation', haunting the arts since the end of the conceptual era. The endlessly rehearsed "aesthetics of" punk, Situationism, or old avant-gardes such as Soviet Constructivism, the well known phenomenon of radical chic, was

4.2 A middle finger to the state. Voina paints a penis in front of Petersburg's FSB offices.

always supposed to suggest or evoke rather what has been, hardly communicating with contemporary issues.

There's suddenly a 'demand' for politicized aesthetics, which is hanging often in a political void, since political aesthetics is by necessity something which doesn't just appear somewhere all of a sudden, but is and always was emerging and developing together with the social movements and events which were provoking it. Today we have a glimpse of a social movement, yet without the aesthetics, and massive amounts of art production, yet without any real movement or thought that it would result from. How to create art in the post-socialist world, in moment of social dejection and depression?

Community art was inadvertently embracing both aspects of its own impossibility: the one of short temporality of its effects and their actions, and the fact it was still selling pretty well. The works are often about working with a given community, and doing a collective project with them, usually as a kind of palliative therapy against the effects of a dysfunctional society. This "art through delegation" – as Claire Bishop described it in her essay "The Social Turn: Collaboration And Its Discontents" – is most notably made by artists like Jeremy Deller, Christoph Schlingensief and Artur Żmijewski. Here artists invite so-called ordinary people to take part in their work, seemingly to include them in the process of social sculpture, but with greatly varying ethical and aesthetic

results. The danger is artists fetishizing certain old, well known aesthetics of protest (like May '68) which when put into a gallery space become objectified and clichéd.

How to put history back into the frame, without necessarily falling into the traps of naivety, without repeating the same mistakes, without fetishizing politics and instead, practising it? One solution (as far as art works are concerned) to this problem may come from study and knowledge: as such, projects can become deep researches into long forgotten histories of dissent that can teach us something about the present, rather than just being objectified. Opportunities we missed, perhaps, that become valuable again, as after decades of silence, the old struggles reemerge.

## Critical Art, Engaged Art

Meanwhile, in Eastern Europe, what the accession to the capitalist West did for Poland and many others was accession to the much desired art market. In the 2000s there was something of a boom in Polish art, with even attempts to label it Young Polish Art, after the British equivalent. This trend has now begun to fade, especially since numerous events during the long Polska! Year promoting Polish culture in the UK failed to attract as much publicity as might have been hoped. Mirosław Bałka got a prestigious Turbine Hall commission in 2009/10, which is as close as you can get to canonization in the modern art world, but it worked more as promotion for Bałka rather than for Poland.

What has shifted is the political impact of Polish critical art at home. Polish art, rather than being simply an entertainment for the rich, started to engage with politics on the levels many of the Western artists gave up a long time ago. In the Polish 90s it was much more unleashed – suddenly there was a freedom to speak, but there was no infrastructure. Soon enough it turned out that what could be said was very limited anyway. There emerged the "critical artists", who were questioning Polish moralistic hypocrisy, and especially

the treatment that "minorities" were getting: women, LGBT or handicapped people. In this, the visual arts challenged a society in a harsher and deeper way than film or literature. Practically immediately after '89 artists rushed to get at those elements of reality which went repressed or unrepresented under the old regime. Even before that date, after the Martial Law in the 80s, there emerged artistic groups, like Gruppa, whose especially obsessive painters were painting and reproducing the symbols of communist reality, as if they wanted to reappropriate it, or via this pop art gesture, put them to the same level as Warhol put Mao and Marilyn all together.

The critical artists were reacting to the years of censorship and to the superficiality of democracy, revealing limits of the new democratic reality. It was our Viennese Actionism, but in place of the old fascists they fought pathologies of Catholic fanaticism and the far right. Artists such as Katarzyna Kozyra, Artur Żmijewski, Zbigniew Libera, Robert Rumas and Grzegorz Klaman were excavating Polish traumas, touching upon themes such as Polish religiosity, the too-soon forgotten memories of the Holocaust, intolerance and exclusions, various taboos, like non-normative sexuality, the body and its visceral aspects or ageing, and the way individuals are controlled in a purportedly free, but actually extremely oppressive, society. Unfortunately, the inequalities wrought by the transformation from communism to capitalism were present in the artworks much more rarely.

They took up the task of testing democracy: it was the system on trial, exposing the fact that the choice between one oppressive system and another is not really a choice, at a moment when the majority of society regarded liberalism as the only option. By self-exposure (such as Kozyra, who posed as Manet's Olympia while suffering from cancer) or assuming the role of a perpetrator (Żmijewski asking a former concentration camp prisoner to "renew" the number tattooed on his arm), critical artists were frequently becoming the object of harsh, politically motivated

censorship and hostile social ostracism by the right-wing press. Gallery closures were common, as was the removal or even destruction of work. The most famous case of censorship was the 8 year long trial of Dorota Nieznalska, concerning her 2001 work Passion, where she put a photograph of male genitals onto a cross. She was finally cleared of the charges, but this trial remains a reminder of the abuse of free speech in Poland.

Yet history didn't stand still, and when a new leftist circle, Krytyka Polityczna, was founded, Żmijewski started to criticize this kind of art for being self-indulgent and for its lack of visible political success. Critical art had not disrupted the system, it was claimed. Worse, it had become a playful, attractive gallery object, all the more pathetic given its initial ambitions. In 2005, Żmijewski became an art editor at Krytyka Polityczna's journal, where he published his manifesto, 'Applied Social Arts', which prompted fervent debate about the political impact of Polish critical art. Interestingly enough, at the same time Żmijewski was accusing his peers of political indifference and lack of taking serious risks, he, Kozyra and Pawel Althamer were becoming renowned names, appearing frequently in international art magazines. And exactly when a new generation of artists born in the 70s and 80s entered the scene and were cutting off from the "critical" generation, they, to whom Bałka also belongs by age, had started to get the official nod: there were huge retrospectives for Libera and Kozyra as well as big group shows in the key Polish art institutions. Apparently, they no longer threatened the establishment, they wouldn't shake Poland. But was this really the case? In this one sense Żmijewski was wrong: critical art was capable of political agency, because it provoked national debates that redefined the status quo.

Yet the appearance of Krytyka Polityczna and Żmijewski's manifesto instigated polemics within the scene itself. Artists who obviously had strong political agendas weren't used to inscribing themselves strongly on the "left" or any other political side, as that language was a taboo in post-communist Poland. Not all of them

were happy with Żmijewski's manifesto, as other, less obvious elements played a role: Krytyka and Żmijewski were in Warsaw, the capital, where all the cultural capital went, unlike some other critical artists, and in the new Poland the rest of the country was becoming increasingly marginalized and, in effect, was turning to reactionary politics.

Żmijewski, as if in an act of expiation for his previous, not engaged enough art, responded with a number of socially engaged works: he filmed dozens of demonstrations, rallies and protests for his ongoing series *Democracies*; in his *Work* series he filmed people doing particularly unattractive, numbing jobs: a cashier in a hypermarket or a street cleaner. Then the Smolensk catastrophe happened. Żmijewski then responded with a film about the mourning on the streets of Warsaw, *Catastrophe*, which studied the behavior of the crowd that stood in front of the Presidential Palace brandishing a giant cross, raising all kinds of social tensions. Żmijewski himself chose provocatively to side with the religious crowd, presenting them in a positive light, rather than the counter-demonstration there, whose marchers, yearning for a secular country, called for the release of city space from the church's domination.

Żmijewski's aim is always to provoke the viewer into recognizing his own political choices, yet someone less sympathetic could also see in this a search for 'sensation', simply some good and provocative material. I sympathize more with the actions in public space of the "post-critical" artist Joanna Rajkowska, who often comes into spaces between conflicted groups, and tries to mediate between them. Some of places she chooses formerly belonged to one ideology, and later were obliterated. One such space is the square in the former Warsaw ghetto where the contemporary Israeli trips come to the Synagogue, and a nearby church was selling anti-Semitic brochures. In this toxic area Rajkowska built an artificial pond, a so called 'Oxygenator', that was mainly used by the formerly neglected pensioners living nearby, who were

4.3 Pussy Riot perform in front of a Moscow cathedral.

suddenly enjoying public space, and created a different view for the Israeli teenagers on their compulsory Holocaust trips to the "land of death". Despite the pond's popularity, city authorities objected to prolonging its few months existence. Later they built a typical, much less inviting or original pond there, which is hardly used as much as its predecessor.

The art historian Piotr Piotrowski calls this gesture "agoraphilia", an obsession with the public space and the community(ies) it's evoking, and which for long had no right to exist. Yet, in so doing, Polish critical artists neglected many other groups, like the new underclasses, which also emerged after '89 and went unnoticed or kept going, yet were crushed in the new economical reality.

## An "Impact on Reality"

Joining the international circuit contextualized Polish art. Globalization runs deeply into our part of the world as far as economic aspects are concerned: we inherit post-Fordism and crises, but in even more blatant forms. Becoming part of the same processes, the art of the former East went through a hastened course of all the currents that omitted it in the past 50 years, gaining some of the new ambivalent consciousness or making critical art

which then becomes part of the market. Yet there must persist still something of a myth of the East, since many of the interesting artists emerged from its politically unquiet clichés, and what's more, make art which exactly fits into those expectations.

By now the critique of instrumentalizing political issues, and of relational aesthetics especially, has become nearly banal. It is made from different perspectives though. The Berlin Biennale got criticisms for its complete ignoring of the "real art" (that is, paintings, installations, objects). The more progressive circles critiqued the way that Żmijewski simply assumed that socially engaged actions wouldn't become merely objectified themselves. In this it's certainly no better than just another exhibition with canvases on the wall. By the sheer inviting of leftist artists or the Occupy activists and closing them in a gallery, it's rather just objectification, making ideas harmless.

Yet this could lead us to rethinking some old and mis-used notions of art, like "reality", realness and, in the end, realism. Żmijewski is a perfect example of an artist who felt a 'social' calling and is consciously now using his high position in the art world, to, at least according to him, make it more politically expedient. Yet, expectedly, it didn't have any other effects than a smug shaming and alienating of anyone with a different approach. Yet, there's not enough examination of the sheer notions that this kind of community art operates under: care, interest, politics. In Żmijewski's works, we usually end our knowledge/relation with its subjects exactly where the film finishes. The artists bear no interest in the further lives of people they engage, despite them providing the material for an attractive, "subversive" work of art. Many characters of his films, like the Holocaust survivor who tattooed his concentration camp number again on his forearm, or the people who took part in his 'repetition' of Professor Zimbardo's Stanford Experiment, or deaf children singing Bach cantatas, disappear with their problems so that we can move on. The 'realism' of their lives and suffering is a fictional realism, since it fails to create a

continuous reality between what is in the gallery and their lives.

It is clear Żmijewski and his like suffocate in the present climate, yet the bona fide solutions they find to it are bound to fail, for obvious dialectical reasons. The situation of an artist who hates 'art' as a bourgeois concept or simply an ideological veil for capitalism is obviously not new and dates from the early twentieth-century avant-garde. When the consumer society started to emerge, artists, especially in Weimar Germany, felt that they had to react against the increasing appropriation of art by the market, but not by necessarily rejecting it completely, even if that was possible. Art could still be a practice, which would come from some everyday job, which could still feed their art. Left-leaning avant-garde artists like Dadaists Georg Grosz, John Heartfield or theatre reformer Erwin Piscator were rallying to the progressive cause. For modern artists there were specific progressive approaches, Grosz and Wieland Herzfelde claimed: "if he doesn't want to be an idler, an antiquated dud, the contemporary artist can only choose between ideology and propaganda in the class struggle. In either case, he must relinquish 'pure art'. Either by enrolling as an architect, an engineer, or an advertising artist in the - unfortunately still highly feudalistically organized – army which develops the industrial forces and exploits the world, or by joining the ranks of the oppressed who are struggling for their share in the world's value, for a meaningful social organization of life, as a recorder and critic reflecting the face of our time, as a propagandist and defender of the revolutionary idea and its supporters.'

Propaganda, instruction, fact, zero psychologism and illusionism – these were the principles of the new art, that was from now on to mingle with the most everyday, most common and banal: newspapers, advertising, radio, cinema, also theatre. Those were there for the artist to use to spread the word. This referred also to the Soviet factography, yet, as the historian specializing in the magazine LEF ("Left Front for the Arts") and productivism Ben Brewster writes, it "must be seen in a triangular debate with

psychological realism and revolutionary romanticism", which were the necessary backdrop. Living in the era of screaming fascism, artists saw the mass media as the field in which they had to fight the Nazi propaganda. At least in the case of advertising this prospect ended in a tragic misunderstanding, in which it was capitalism that devoured agit prop, not vice versa. Yet the message is clear. The artist should do the possibly least artistic thing in his other life if he's to remain an artist – a classic TS Eliot formula (see his *Tradition and Individual Talent*), where the artist was supposed to transfer his talent into business, like advertising, banking or the press. Even if in capitalism advertising wasn't transformed by the propagandist experience into revolutionary art, it showed the ways a radical socialist art could be practised. The artist was at best a virus on capitalist society's unhealthy body, infecting it with ideas.

A group from the "oppressed East" today worth mentioning in this context is Voina – a collective from St Petersburg who in the last few years have provoked the Putinian regime by many flippant actions, the most famous being drawing a gigantic phallus on a drawbridge next to the KGB headquarters, just before it was raised. They are also definitely regarded as part of the 'third avant-garde'. In their case it's less about the sophisticated artistic means, but the *real* risk the members are putting into their work. Żmijewski made them the co-curators of his Berlin Biennale as an attempt to save them from arrest. Many of the artists engaged in the Biennale came from places where it can't entirely be said there's no movement or no serious political cause. If we say that everything that gets caught up in the rigmarole of late capitalism is necessarily formatted by it, does that mean the mystical Russian east manages to exist somehow outside of it?

Yet, for that reason precisely Voina have become the best-loved darlings of the Western artworld, which craves nothing more than their authenticity, which, in effect, despite the real life risks the artists are taking, does not essentially change the meaning of their gestures, which now visible in billions at computer screens or news

portals, become just another sexy news story, and this time with poor oppressed artists as a background. This reality principle is manifested in the jailing of Pussy Riot (several members of whom were also members of Voina), despite, or maybe with the help of the wide support they received around the world, leading to curious events such as the "staging" of their trial in the London Royal Court and Pussy Riot-themed symposia where pseudo-folk artists like Emmy the Great are asked to "discuss whether feminism in art is dead" or something similarly ludicrous.

Voina as an organization compare interestingly with Femen. But whereas the latter base themselves on their victimization – the protests can only succeed if they fail, if they will be caught by the police or are abused/arrested - Voina operate exactly to the contrary. Voina may then be an antidote, together with other groups which emerged on post-Soviet ground in the shadow of the brutality of authorities, like Chto Delat or Zagreb's Badco. Voina's members are an embodiment of Fransiscan non-violent resistance: they treat art as it was their everyday life (or vice versa), they embody what they do, they don't use money, they reject property. Their main feature is their invisibility, so that they can't be punished for what they do. They never celebrate going to prison, and if they do, they get out of it soon afterwards and easily.

The importance of artistic groups in Russia and Ukraine doesn't diminish because of their lack of real political power or claims to it. In the current protests Voina probably played a crucial role, after the giant dick waved at the KGB HQ had done the rounds on TV and internet and shown people that everything is possible, even this kind of massive disobedience to the state. Within the absence of democracy those movements play a double role, activizing society. Voina and Pussy Riot successfully instigated an important debate on the connections between artistic action, politics and the state. At the same time, much art that is supposed to stand for "avant-garde" today seems to be in an irreconcilable crisis. It would like to dwell on the experiences (and propagandistic successes) of the previous

movements, and yet today it is marginalized and insignificant as never before. The problem with Żmijewski and others in the contemporary avant-garde, like the Otolith Group, is that they often use the methods and forms similar to the leftist and conceptual avant-garde existing around the year 1968 but taking them out of their original context and the initial ideas that fed them. Żmijewski was a student of Grzegorz Kowalski, member of the Polish conceptual scene whose original methods of work applied the Polish post-war architect Oskar Hansen's theory of 'Open Form'. Kowalski pursued transcending the notion of a simple artwork and directed artists to create situations, always open-ended, which he popularized in the free, open space of his studio at the Fine Art Academy in Warsaw. Yet the methods of Kowalski were deeply rooted in his own practice and experiments, grounded in the reality of 60s, 70s and 80s People's Poland, while Żmijewski simply takes them and reuses in completely different contexts, as if he was thinking simply that the interest in 'leftist' ideas makes a 'leftist' artist. Decontextualization is often the case with recuperation. Żmijewski often wants to see a 'result', an effect, no matter if this effect is in the end positive or negative. The maximal amount of 'leftism', or 'engagement' is supposed here to give the critical mass of leftism that will finally explode into some leftist paradise. But putting the Occupy movement within the gallery walls will remain as an objectifcation of the movement. With the recent discussions on the immaterial work and unpaid work of artists, it becomes simply a way the art world cleans its bad conscience at having a more pleasurable, concern-free life than most of the people who have to work for a living.

## The New National Art, or the New Socialist Realism

Contemporary art, even of this kind, that genuinely is sensitive to the political state of affairs and sees its role as similar to the previous engaged avant-gardes, finds itself alienated from the popular sphere. When researching this book in summer 2012, I

encountered two symptomatic exhibitions. The first was conceived as a "parallel action", to borrow an expression from Robert Musil, to the Berlin Bienniale: *The New National Art*, in Warsaw's Museum of Modern Art. The second was *Interrupted Song*, a huge exhibition of socialist realism in the Slovakian National Gallery in Bratislava. One was a retrospective of the 50-year old examples of this style of fine and applied arts in communist Czechoslovakia, the other was

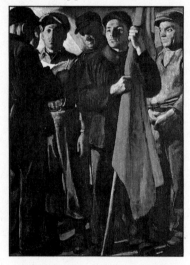

4.4 False or true empowerment. Wojciech Weiss, 'Manifesto', 1950. In Socialist Realist painting people were bigger than life.

collecting and positioning the new, inconvenient flourishing of amateur national/patriotic art in Poland, which, with a bit of a stretch, its curators said could be called 'the new socialist realism'.

Both couldn't have made a different impression, which rather undermined the intentions of the Warsaw MoMA's curators. The Bratislava National Gallery – in itself a stupendous example of socialist modernism, with its cubist, experimental form, - presented 'sotsrealism' in its all visual forms, from paintings to street decorations and banners, to the design of a flat and souvenirs.

If anything, this *Interrupted Song* showed sotsrealism as a prisoner of its conventions and political conditions. Uncountable amounts of canvases, over and over, of heads of state, boring, repetitive identical depictions of street demonstrations, colossal, monumental figures of workers like gods. And, at the same time, a feeling of inappropriateness: should we really *look* at them? Sotsrealist paintings now made an impression similar to pornography: we feel we shouldn't be looking and yet there's something in it, the feeling of the *Verboten*, that makes it

exciting. This is also the way Boris Groys writes about socialist realism: today, hidden in the museum magazines, it is not the avant-garde that seems to retain a subversive power. But can we honestly say that it can be found in paintings which were often endorsing dictators, turning famines and bloody events into kitschy neo-tsarist poetry? What impressed in the Bratislava show, apart from the sheer quantity, was the seeming 'amateurism' of Sotsrealist art, seeing how many of the previous styles and poetics persisted within the new, obligatory style, unnoticed or rather transferred too amateurishly so be taken seriously.

*Interrupted Song* showed how within sotsrealism we can seldom find the things we usually associate with artistic excellence: the notions of originality, individuality or technical accomplishment, cease to exist. Instead, we encounter rooms full of almost identical paintings, in which we wouldn't be able to distinguish the artists if not for the labels next to them. Sotsrealism encouraged nationalism, but was selective about which elements of a particular country's patriotic traditions could be used – after all, they could start giving people ideas. In this way the impeccably folksy, reactionary nationalist Slovak painter Martin Benka was banned as a "formalist". Czechoslovakia had strong pre-war avant-garde traditions, especially surrealism. So we still find some quite stupefying examples of Sotsrealism informed by pre-war ideas, like Ladislav Guderna's constructivist, aggressively colored *New Machine Station*, or Edita Spannerova's *In the Kindergarden*, where an uncanny, brightly lit group of little children and their maids sits closer to Balthus' underage Lolitas than to the distinguished men of Stalin's portraitist Gerasimov. We can also spot hints of Gustave Dore, Gustave Courbet or Expressionism. But mostly, the rooms of the gallery were filled by insipid large-format portraits, pathetic, metaphorical visions of worker's labor and the forthcoming Golden Age. Individual talent ceased to have any importance. What was important, at least in intention, was how art will *transform* their lives, how it'll play a role within their most

everyday life: lets remember sotsrealism wasn't only, although it was in huge part, monumental paintings cherishing agriculture and heroic labor. Sotsrealism was supposed to encompass the *totality* of human life – which today, with the complete dismissal of any project of totality as totalitarian, is completely rejected, supposedly for the sake of 'pluralism'. It'll be better to understand the specificity of sotsrealism by remembering what came directly afterwards: Poland and other more liberal satellites adapted a more modern style in art and design, a Brussels Expo '58 colorful optimism, while Russia remained skeptical towards abstraction until the end.

Another level of sotsrealism is architecture, which was, as some say today, pioneering of postmodernism, in its neoclassical or eclectic revival. Maybe that's why there wasn't a great deal of controversy when the infamous publishing empire of Dr Andreas Papadakis, with its flagship magazine *Architectural Design*, was in the 1980s regularly publishing outpourings of Charles Jencks in praise of the tastes of HRH Prince Charles, Leon Krier's praise of Albert Speer and Anthony Gormley's monumental, figurative sculptures next to Russian correspondence on the Sotsrealist mosaics of the Moscow Metro and the fair at VDNKh (the All-Russian Exhibition site in Moscow, representing an especially flamboyant type of Sotsrealist architecture), often by the great specialist in Russian avant-garde, Catherine Cooke - because in the end they all expressed the same aesthetic sensitivity. "Pluralism", as understood since the 90s, meant usually the horrific monumental neoclassicism of sculptors like Igor Mitoraj or Zurab Tsereteli, not dissimilar to the 'Gormleyism' spreading across the British Isles.

By contrast Warsaw MoMA, normally devoted to sophisticated conceptual art or rediscovering socialist modernism (like the pioneer feminist sculptor Alina Szapocznikow), for the whole summer of 2012 was a strange house for the creativity of the political "other side", showcasing the aesthetic expressions of the recent right wing movements and its sympathizers in Poland.

Among them were "flower carpets" made by women from the church circles during the processions of the Corpus Christi holiday, fragments of the gigantic figure of Jesus (bigger than in Rio de Janeiro) from the small town of Swiebodzin, visual frames from football matches (e.g. mass ornaments on the terraces, with a gigantic face of Jesus inscribed into the team logo), covers of the "intellectual" journals of the Polish right like *Fronda*, clips/visuals from Polish nationalistic hip hop, and most preeminently, artworks and projects associated with the infamous Smolensk plane catastrophe.

The Smolensk catastrophe spawned political divisions and many right wing conspiracy theories, but hasn't, surprisingly, affected the polls – more people are still voting for the neoliberals of Civic Platform, leaving the right wing, Catholic and nationalist Law & Justice behind. Yet, ideologically, society is divided. Smolensk augmented the break within society that existed already. The works collected at the exhibition largely dwelt on emotions "repressed" from the modern progressive discourse, like patriotism, nationalism and piousness in the Catholic religion. Granting them a place in a prestigious gallery, seemingly brings these repressed discourses into art, which polarized Polish society after Smolensk. This is neither 'relational' nor it is simply 'authentic' art. It was rather folk art – fulfilling all the premises of this kind of expression. As Alex Niven in his *Folk Opposition* points out on the British context any spontaneous, anti-bourgeois, working/peasant class expression has been today either neutralized and taken over by the middle classes, or given a political label of far right. For the progressive, liberal art circles if means (mostly) "don't touch". Yet it could be felt that the show electrified the debate, as it gathered what perfectly fitted the fetishized category of 'authenticity', realness and all sorts of street-cred. The presented artefacts are similar to the art most willingly promoted by the progressive institutions: they are second or third circuit, and were done according to the DIY ethos. They are the 'unofficial narrations', those "other

traditions" we mentioned in the third chapter. Yet the same spirit is expressed by the popular and often reactionary historical superproductions at the cinema, ubiquitous in the former Soviet Bloc, with films like *Battle of Warsaw 1920* taking revenge on communist times. Made for millions of taxpayers money and promoting nationalistic behavior, they couldn't be further from folk art.

The artefacts presented often came to existence in the process of collaboration, group activity and within the direct engagement in reality, and within unofficial, spontaneous channels, which sounds exactly like the community art ideal. Yet what "effect" these works may have – and do – on the reality, is strengthening the feeling of national identity, of feelings that are often xenophobic and lead to an exclusion of others, which of course couldn't be further from the ideas of the leftist avant-garde. Coming back to TS Eliot's essay title, where is the relation between the tradition (which the avant-garde rejected in strongest terms) and the individual artist? As for the aesthetics of the presented works, they were mostly complete amateurism combined with a reactionary mindset that sometimes produced accidental aesthetics, as if from a fanatic Sunday artists club: they dwell on the passeist aesthetics, freely mixing the imagery from different levels, pop with world art movements and sacred art. There are exclusions: *Fronda*'s covers from the beginning presented a very high level of graphic design. What of it though, if they're serving a despicable cause?

If anything from the past, this art reminded me of the spontaneous artefacts created by the members of the Solidarity movement – by workers interned, under arrest or during the difficult period of strikes in 1980-81. Political, agit-prop leaflets, posters, banners, picket placards, stamps, postcards, badges, prints on fabric, magazines, even jewellery made of barbed wire - all DIY, all printed, Xeroxed and distributed with often the most primitive methods. Overnight workers had to become propagandists, paint their own posters, which often presented an extremely high and interesting level of graphic design. They combined collage, comic

4.5 Flower arranging at the New National Art exhibition at the Warsaw
MoMA.

strips, quotations from older art, prison associations, elements of
mass imagination, verbal jokes. They also use the visual symbols of
the forbidden historical events – the Warsaw Uprising from 1944 or
previous, bloody strikes. The symbol of the union itself, the famous
red lettered SOLIDARITY in itself is a magnificently done logo.
Although often expressing the anticommunism and devotion to
Pope John Paul the Second, there was something carnivalesque to
the way workers – artists, amateurs - treated any available element.
The carnival of Solidarity, as those two years were called, brought

a short lived unity which, subsequently, was lost. The pre-existing divisions within the movement won out after the unjust division of power after '89. The right wing within the movement formed a stubborn, closed front, where it was becoming increasingly reactionary.

In PRL, in order to be considered an artist, one had to have permission from the state, with proper studies finished, and to be registered. Yet the contemporary sophisticated leftist movement don't seem interested in working out a strong, appealing, powerful aesthetics, and reject it as kitsch or superficial. We used to have a powerful aesthetic of protest in the form of a strong grassroots movement, which today remains in the hands on the other side of the barricade, as the other side has a 'cause' it strongly believes in. Aesthetics develop alongside movements, and the greatest failure of the post-communist countries is the inability to create a strong labor movement. If the aesthetic of the right seems strong now, even if amateurish and not according with our sophisticated expectations, it's a manifestation of a movement we ourselves don't have.

The show revealed two Polands: one, which spoke though absence and which its liberal elites aspire to, and another one, abandoned by the state, used by the populists, but also poorer and less well educated people. Yet it retains a powerful position as "this is what the majority wants in Poland", serving as an excuse for the politicians to continuously refuse rights for the minorities. We live in a reality in which those two groups are constantly and rightly, antagonized. The novelty is that the former are no longer happy with the status of the uneducated masses. There's the new intellectual right, which takes the lesson from the sophisticated left by founding magazines and discussion clubs not dissimilar to the left. This is not a Polish specificity, as the most prominent example is perhaps the Italian Casa Pound. The anachronistic, national or even folk/legendary aesthetic is what the abandoned parts of Polish society hide behind, scared of modernity. Yet, unlike the Romantics, who wanted to re-examine and exorcise Polish traumas, they are

interested only in preserving the life-giving power of trauma, of mythological wars, without which they'd lose their raison d'etre. Yet it also discloses the great failure of the intelligentsia, who lost the battle for the forms of modernity. Instead of the modernity of socialism, we got a modernity entirely stolen by the neoliberal version of capitalism.

Hardly "the new socialist realism", this, as sotsrealism was a state art, if equally an expression of nationalist kitsch - and, of course, there couldn't be a term that would cause greater offence to the communism-loathing far right. Yet, if sotsrealism was apart from nationalism, an expression of several other ideas, what do the artefacts grouped in Warsaw MoMA represent by comparison? Of course, this isn't sotsrealism in any practical sense, only metaphorical. The people who make this art do not possess actual political power. But they do epitomize a political force that can't be ignored, like the Catholic Church. The question about New National Art remains: is the notion of "art" in here actually neutralizing something that is possibly much more dangerous? It wouldn't be the first time in history that the right wing and avant-garde would meet. Art historians still have problems how to categorize the views of the Futurists, or Vorticists like Wyndham Lewis, and how to appreciate art which was inseparable from their often despicable, fascist political views. So is it merely just "the other side", we should think, or a reverse of what was happening at Żmijewski's Biennale? This new 'folk art' should be cherished by the artists connected to the relational/participatory/engaged aesthetic: it is popular, it is made by 'ordinary people', it is 'spontaneous'. Yet, how to deal with its ideological content? Doesn't it rather reflect the social construction of the masses created by the sophisticated, educated, liberal elite?

An equally curious example of reinterpreting Socialist Realist aesthetics is a work by Israeli artist Yael Bartana, shown recently in the UK, *And Europe Will Be Stunned*, a staged video trilogy about a fictitious "comeback" of Jews, killed in the Holocaust, to Poland.

4.6 Polish intelligentsia in the lost cause. Bartana's fantasy of the Jewish return back to Poland.

The first part of the video is called "Phantoms-Nightmares", which could be a semi-conscious reference to the uncanny tradition of Polish Romanticism in the writings of Maria Janion, to whom we referred to in Chapter Three of this book – something which Bartana could have learned via her collaborators from Krytyka Polityczna. It's also a reference to the evil which was done to the Jews in the Holocaust, who are now called to come back – yet in what form? Does she mean the descendants of those Jews who were killed? Or does she demand a return of the dead Jews? And on which premises, who gives her the right, one might ask? And if they're dead, are they to make a rebirth, and in what form? As the phantoms in the Forefathers Eve? Or maybe as zombies from a nightmare? Despite being Israeli, Bartana became the artist of the Polish Pavilion in the Venice Biennale 2011. The first part shows the informal 'leader' of Krytyka Polityczna, Sławek Sierakowski, stylized as a 1950s Polish 'intelligent' – dressed in thick glasses, jumper and in grey colors, as he delivers a passionate speech in the empty – significantly – 10th Anniversary Stadium in Warsaw. This Stadium had a rich history – built in a socialist modernist style, it was one of the first buildings in 50s Poland where architects successfully negotiated the rules of socialist realism, and was recently demolished for the sake of the new, bombastic Polish-flag-wrapped kitsch of the National Stadium, ready for the Poland/Ukraine Euro 2012. The speech, co-written by Sierakowski, is a pathetic address to the – dead? alive? – three million Polish Jews to come back to the land, which previously brought a Holocaust upon them or forced them into emigration in 1968. It's an apology for their suffering and promise of a new alliance, in which Poles and Jews will no longer be hostile

to each other. The second part of the triptych shows the Jews that responded to the appeal, coming back and building a kibbutz in the place of the former Warsaw Ghetto. In the third part, the Leader, Sierakowski, is assassinated during another speech and buried.

Art was in this case to have real life continuation – there was, during the aforementioned Berlin Biennale, a Symposium of the Jewish Renaissance Movement. In Poland, among the Jewish community itself, it caused mixed feelings. We know that the idea of a "comeback" of Jews couldn't be farther from reality, not only because of the mutual attitudes of Israelis and the continent. The Polish-Jewish historian Jan Tomasz Gross, author of breakthrough books on Polish anti-Semitism during and after WWII like *Neighbours*, on a pogrom in Jedwabne and *Golden Harvest*, on Poles betraying Jews for money, said about this project that only treated symbolically does it make any sense. In the history of Poland we heard various directives telling Jews where they should go, from Madagascar to Palestine, during the anti-Semitic 1930s, so telling them to come back to Poland is not innocuous. Poles need to realize the hole, the void that was left after the Jewish population's extermination. Bartana's cycle, even if objectionable, historically simplifying and too easily sidestepping the profound problems it raises, was interesting because of its form: its Sotsrealist aesthetics was partly intended to evoke the lost early socialist past (and political aesthetics) of Israel, land of kibbutzes, where the pioneers were to found a new world. The films, especially the middle part of the trilogy, evoke the socialist propagandist newsreels, full of healthy bodies affirming their physical fitness and beauty so conspicuous in early socialist heroic art. The question whether the film's message is 'for real' or a political spoof and political scandal is hanging there, to the delight of the artist, no doubt. Yet, Bartana seems to take this at face value, unable to give a counter, critical look. The text of the speech is ludicrous, and neglects the contemporary position of Israel as oppressor of Palestinians. It is a mock

politics, conveyed in a knowingly cheesy form.

## From avant-garde to realism (and back again)

Artists today can once again take Marxism seriously, yet its effect is necessarily weakened by the lack of a strong movement such an art could represent. But is another weakness leftist art's devotion to old notions of the avant-garde? Andre Bazin in his essay on realism pointed out its hunger to "bring back to life", a hunger (not accidentally having here sexual connotations), that can be compared to Badiou's passion of the Real. What lies behind the fear of realism? It's an aesthetic that has been ridiculed and become politically bankrupt, as in the cases of sotsrealism in the Soviet Union or China. Socialist Realism was a question of life and death to many under socialism, and hence is part of post-Soviet trauma. We often see it and think about it with shame. Not only in art, but also in literature and architecture, sotsrealism is an easy straw man, as it's easy to see an oppressor and oppressee in there, and we're never the oppressor. Surveying Sotsrealism requires from us a complete redefinition and rethinking over what was the function of the artwork, what was the idea of an artist, what was his role.

It was in the 80s that artists and critics began to confront Sotsrealism again, after Martial Law in Poland, when the disgust at the system reached its limits and the system itself began to decay. There were new possibilities for boycotting the system, there appeared new options for democratic opposition, and critics wanted to somehow regain sotsrealism, as the style-purveyor of realism, figuration and painting. At this time people were disillusioned with the avant-garde. And exactly then the slim but controversial book by Boris Groys was published, in 1987: *The Total Art of Stalinism* (*Gesamtkunstwerk Stalins* in the German original).

Historically the first avant-garde was trying to bring art back to the everyday, and its practices were eventually to transform political and social reality. In every respect, 'avant-garde' is a retrospective, synoptic term, used by critics such as Clement Greenberg

(late 1930s), Harold Rosenberg, Peter Burger (since the 1950s), to describe more than just art itself, often conflated with modernism, but also its political context. 'Avant-garde' artists were in fact calling themselves the Neues Bauen, Neue Sachlichkeit, Futurists, Constructivists, Expressionists or Dadaists. Later, with the consolidation of Stalinism in the late 1920s USSR, a new style, 'socialist realism', was the expression of the spirit of 'socialism in one country'. Art was supposed to be 'national in form, socialist in content'.

In recent years, some historians and critics have started to re-examine Sotsrealist artists like Alexander Deineka or Yuri Pimenov, both of whom had participated in the experimental period of Soviet art during the NEP era, before turning back to the style of the nineteenth-century Society of Easel Painters. In their work it was possible both to fulfil the rules of sotsrealism and still retain an ambivalent, uncanny avant-gardism. In Pimenov's painting *New Moscow* we see for instance a New York-like landscape of skyscrapers, and a girl in the car riding through this uncanny atmosphere, with the allure of emancipation from the usual feminine fate of kitchen and family. In the example of Sotsrealist artists who managed to retain and entangle the new demands with their previous personality, like Deineka, we can see a continuation of avant-garde stylistics taken into new territory. In many 1930s paintings we can still see the remnants of other, pre Sotsrealist styles, before they were banned, especially Expressionism and Neue Sachlichkeit, with their montage-like, overtly industrial, half abstract compositions experimenting with perspective. But while their earlier works genuinely tried to work out the contradictions within the socialist reality of the 1920s, after that they presented too easy a pictoriality, and a problem-free vision of collective life.

Presently the viewpoint that the Sotsrealist doctrine was simply "imposed" on artists is being actively challenged by art historians. As Christina Kiaer writes in her essay *Was Socialist Realism Forced Labour? The case of Aleksandr Deineka*, artists were not only victims

but also necessarily helped in constituting the predominant ideology. The opening of their art to the widest possible public by the state might have just as well freed the artists from the market necessities. Yet their pictures of the "collective laboring body" create all sorts of negative as much as positive images of the meaning of communism in Russia. As Sotsrealist paintings are both realistic and heavy on metaphor, they are in their idea not dissimilar to the avant-garde, Constructivist idea of a work of art which would use both modernity (photomontage, abstraction) and a literal socialist message (slogans, lettering). Technology meets abstraction, and a photorealism of depiction meets a crass yet optimistic message.

The replacement of the precious collective genius by the sole leader must've meant a readjustment - hence the endless production of 'heroes'. All Soviet art, regardless, was characterized by a positive take on materiality, and extreme juxtapositions. At the same time, Deineka produces the complete vision of the New Person, accentuating physical strength as beauty, which was at the same time, a realisation of Meyerhold's avant-garde ambitions: 'the biomechanical actor partook of the discipline of the dance', through linking the dancer to a good laborer. A distrust in Freudianism was shared both by the avant-garde and sotsrealism, with their bio-mechanics and focus on materiality. As art historian Hannah Proctor writes, "the oft-repeated Soviet injunction to make sacri-fices in the present in order to reap the eventual benefits of the bright Communist future corresponds to Freud's reality principle, which he defines as the 'temporary toleration of unpleasure as a step on the long indirect road to pleasure'." If we take up this distinction between the critical and automated consciousness, we'll have the avant-garde and Sotsrealism described quite adequately.

The Russian formalists and constructivists saw the new art movement in terms of how it displayed its modes and devices of operation, art being its own undoing, a defamiliarizing, critical negativity. In sotsrealism the consciousness of an audience was

4.7 The New Man. A mosaic in the Moscow Metro by Aleksandr
Deineka - the unobviousness of Socialist Realism.

automated, in the Pavlovian sense. Yet sotsrealism was far from
simple. It wasn't only a state, total art, creating a whole with the
state apparatus, it was also intended to act dialectically. The dialec-
tical act was constituted when a person was seeing not what *is* but
what *should be*. Sotsrealism, though claiming realism, was never
realistic in the veristic sense. It was projecting the reality that didn't
exist, but was to be created as the final goal of Soviet history. We
were anticipating the future of socialism that never came. Also,
Sotsrealism is devoted to depicting a time and space richly filled –
quite contrary to the stagnant, eventless, empty and wasted time of
the reality of socialism. Sotsrealism represses eventlessness, in

theory precisely to liquidate the gap between life and art apparently created by formalism. The relation Sotsrealism had with reality was schizophrenic, with its tension between what 'should be' and what really is.

Sotsrealism's main theoretician Maxim Gorky criticized constructivism for being distant from the workers movement, for fetishizing technology, for being too Western and 'decadent'. This work was now dubbed 'formalism', in Germany it was called Degenerate art, and in Anglo-Saxon world, USA and the UK – modernism. In the recent discussions of the legacy of the counter-cultural movement and conceptualism, especially in the post-communist countries, like Poland, it's is largely referred to as the "avant-garde" and continued to be after the war, as documented in Piotr Piotrowski's useful compendium on Polish conceptualism of the 1970s, *The Avant-Garde in the Shadow of Yalta*. The so-called second avant-garde after the war was an aesthetic effect of the development of capitalism: on one hand, in America, pop art was a partly critical/fascinated result of the progression of the capitalist market. On the other, it was a result of the invention of the youth in the 50s, the growing independence of the younger generation, developing a critique of society, aesthetic emancipation, anti-market alienation and creating a counterculture against the "establishment".

The role of art changed: before the war it was mostly a 'national' question and, in the case of Poland and many other underdeveloped countries from outside Western Europe, also a ticket to (understood more or less in a Western way) modernity. After the war, art radically changed its meaning, being still nationalistic in form, but in a unified, Soviet way and presiding over its own Soviet version of modernity – at least officially.

The fundamental difference was that whereas the avant-garde found the only confirmation of its existence in a constant, methodical erasure of its own methods, a constant self-erasure, Socialist Realism was searching for what is eternal. Boris Groys'

book was written exactly when the communist construction was falling into ruins. The avant-garde was supposed to create a New Man, to create not only the visual environment, but to change the world itself, and this, as Groys suggests, "destroyed them". After 1917, with liberalism discredited after wars and pogroms, progressive workers and intelligentsia took the side of socialism and communism as internationalist, emancipatory movements, which made them the front guard of humanity, heirs to the progressive leftists from Chernyshevsky's novel *What is to be Done?* American historian Marci Shore calls their engagement in the communist regime a 'loss of innocence'. Yet what was the alternative, and what innocence can we speak of in the case of those who had just gone through the experience of war, mass killing, revolution and great crisis? Isaiah Berlin writes in *Russian Thinkers* on their 'fanatical devotion to ideas'. Perhaps this was the case with Herzen, Chernyshevsky or Trotsky, but not of the white intelligentsia, who didn't risk nearly enough. Groys' thesis is that we cannot make the distinction between the early avant-garde and the later sotsrealism, as the generation engaged in Bolshevism was the same who later helped create the total state apparatus and so had a distant role in the crimes of Stalinism.

Let's remember about the breaks within the avant-garde itself – dada detested utopianism, yet it supported the communist movement in Berlin, and the constructivists in Russia were looked at skeptically by the revolutionary establishment in the 1920s. They were naïve, says Groys, as it is obviously the Party who were really controlling the changes that were taking place, not artists. Groys argues that the same generation of educated elites conceived sotsrealism, and that this realism was brought about by the same kind of future-oriented thinking. Yet, as the ruling class of Stalinism recruited mostly from the generation born in the nineteenth century, they endorsed art with which they were familiar, i.e. the grand scale naturalism and realism of the Tsarist nineteenth and early twentieth century. The problem was that

realism became the official, state art not only in Russia, but also in Nazi Germany; that it helped not only to cover a reality of political barbarity, mass murders and famines, but it helped to stabilize and consolidate this power.

Socialist realism was very much connected with the personality of Stalin – and it quickly disintegrated after his demise. After that Russian art (and art within the Bloc in general) went two ways: it copies Western, partly abstract, modern art, which is with time incorporated within the state; or by pursuing conceptual ways, it continues with a realist mode, which in Russia created 'Sots Art', a sarcastic version of Western Pop Art, which instead of symbols of consumerism, inverts it and takes up the symbols of real socialism: images of the first secretaries, Soviet rituals and state control expressed at every step of life.

Sots Art mocked the facadism of an unbearable, ritualised Soviet life. On some of the most recognized Sots Art works Western symbols appear, like Coca-cola, next to the rough symbols of Soviet

life, predicting already at this point, not only how easy it will be for Western capital to infiltrate and take over the weakened, demoralized structure of late Soviet reality; it also puts them where they belong. All, Lenin, Mao and Coke, belong to the same order of images, the same degraded realm. Nowadays, this naïve juxtaposition of ideologies doesn't flatter these works, when we're far more aware of the political value of the real complexities between the capitalist transition and

4.8 Attempting normal life among the ruins of the old world. Wolfgang Staudte, The Murderers are Among Us.

the role that the East played within the post-communist reality in the West.

The reason Sots Art was among the most instantly popular exports from the East to the West was the easiness and instant

understandability of their communiqués. Similarly, the work of many of the Moscow conceptualists, including the sophisticated installations of Ilya and Emilia Kabakov or the scornful duo Komar & Melamid, were initially read simplistically, as gestures of resistance to the oppressive Russian reality. We see now that they didn't simply refer critically to the Soviet reality, but saw already the traps of what is beyond it, of all the capitalist world, and that there's nothing really oppositional between the myths of Uncle Joe and Uncle Sam.

## Inside the Socialist Reality

*I should be compelled to abolish reality!*
Ulrich in Robert Musil's *The Man Without Qualities*

Yet the critique of avant-garde methods wasn't always drably primitive obscurantism. The reason we can still consider it today is largely due to György Lukács' insightful criticisms of so-called bourgeois modernism, in works like *The Meaning of Contemporary Realism* (1957). Lukács deeply admired much early modernism, especially Thomas Mann's bourgeois grand novels. Early on Lukács saw the predicament of modernism as precisely its malaise: it wanted to present the disintegration of a certain world, but at the same time, it indulges itself with the same decadence it's trying to describe.

What he called the "modernist ideology" underlying modern literature was the contradictory attempt at a rejection of narrative objectivity and the surrender to subjectivity, whose results may vary from Joyce's stream of consciousness to the studied objective passivity of Musil, or Gide's 'action gratuite'. The problem is Lukács doesn't accept the positive sense of the 'dissociation of sensibility' found in its negativity. For him, realism 'aiming at truthful reflection of reality must demonstrate both the concrete and abstract potential of human beings in extreme situations'.

Actions then must reveal themselves dialectically, in their becoming. The 'critical realism' he proposes was not far off Brecht or the Frankfurt school's idea of the partial, potential unveiling of an artwork's reality, by which they expected to inspire and activate the reader to become the part of the story.

For Lukács, modernism didn't have enough of an educational, parable-like quality. He didn't reject experimentalism per se, as we can see in his lucid words on Musil. The latter is quoted saying that although one could tell without doubt that his *Man Without Qualities* takes place between 1912-1914, he 'has not, [he] insists, written a historical novel. I am not concerned with actual events. Events, anyhow, are interchangeable. I am interested in what is typical, in what one might call the ghostly aspect of reality." The problems with Lukács' doctrine start with his criticism of Western 'degenerate' modernist art. In his critique 'Franz Kafka or Thomas Mann', pointing out the former's decadence, isn't he merely repeating the arguments of the brown-uniformed gentlemen from two decades earlier? Lukács is of course too sophisticated for that. Yet his idea of the 'inside' and 'outside', where a socialist realist work is the one speaking of socialism from the inside, is deeply dubious.

Lukács was no Zhdanov and saw the great tragedy of the modern artist as someone who lost the ground under their feet, but, as with Musil, treated this as an advance rather than a difficulty. What Lukács was rejecting in modernism was dictated by his sensing how easily modernist devices can be transformed basically into an aestheticization of politics. This must be in the end a failure, because the recognition of art's value must lose set against the necessity of art and literature to have a proper effect on reality - and such effects cannot be planned. In theory, these works would be playful, when in practice, Sotsrealist literature was anything but: rigid 'production' novels replaced any expression of art which didn't have the desired direct meaning. Yet Lukács did understand the doubly contradictory nature of the avant-garde (self creation

and self-destruction), and wanted the new socialist art to avoid its negative effects. According to Lukács, the work of art must represent totality as well as legibility. He objected to the avant-garde idea of the aesthetic of fragments (practiced by the Russian avant-garde of Constructivist provenance and Objectivist circles in Germany), which will be only made legible within the dialectical process of understanding by the audience, actively participating in the constitution of meaning, a so-called "critical realism".

His theories were recognized in the DDR especially, where they became a part of official national aesthetics. The "anti-modernist" programme of Lukács was taken up and discussed by the academics and literary critics, since this 'pre-modernism as realism' became an obligatory art in socialist republics until the mid-1950s at least. In cinema, this expressed itself in thousands of films, whose sole purpose was to be screened for the workers in the factory cinemas. In socialist realist films, like novels, you had the epics about Production and Construction (*Aufbauroman*) and depicting the development/arrival into socialism on a mass scale. Yet these were the *Nachgeboren*, to quote the famous poem by Brecht, 'To Those Born Later'. Was it really too late?

With cinematic sotsrealism, the problem is that the actual examples of this cinema are often unwatchable today apart from as curiosities of the era. Let's take as an example 1940's *First Horse - Breakthrough on the Polish Front 1920*, which was recently shown as part of the Panslavisms festival in Warsaw, where it was to be an antidote to the anti-Bolshevik contemporary superproductions. Its astounding schematism, boredom and systematic lying about history (with the sudden insertion of Tovarisch Stalin into events in which he didn't participate) made it very difficult to watch. On the other hand, it could produce films that are quite fascinating. Take for instance several works by the Polish-Jewish director Aleksander Ford, who in the 50s became the omnipowerful boss of Polish cinematography, like *Border Street*, about Jews in wartime Warsaw, saving *themselves* throughout the war, or *Five from Barska*

*Street*, about a gang of petty criminals that turn into Stakhanovites. The first of these especially presents an interesting counter-narrative to the typical Holocaust film, where Jews are always powerless victims. Socialist realist film didn't always mean the same thing, and largely depended on the talents of its creators. You had also many liminal cases: such is *Generation*, the first full length Andrzej Wajda film (1954), which opens in many ways The Polish Film School, in which the young director is trying to "cheat" his bosses (with Ford as the leader) that he's making a sotsrealist film, while smuggling a new, more neorealistic, psychological style and also a less propagandized version of history. The film tells the story of the last few years of the war in Warsaw, with the group of young friends, who fight and try to survive. While characters still have "proper" proletarian backgrounds and there's no mention of the Home Army, the sheer style, authenticity and lack of pomposity of the film made it a breakthrough of Polish cinema.

What is most interesting is when the directors, especially towards the Thaw, were trying to "cheat" the strict rules by nuancing the compulsory black and white characters, and not necessarily serving as unilateral praise of the Party. Cinema in the Eastern Bloc didn't fall under the necessity of sotsrealism immediately. The first few years still left this door open. In East Germany you had films like *The Murderers Are Among Us* by Wolfgang Staudte (1947) on the difficulties of denazification in the still Nazi-ridden DDR society or, a year later, *Rotation*, about a socialist father forgiving his son, who had become a Nazi during the war and denounced his parents. In these, the first post-war German films, Staudte retained the ideas of the Brechtian epic theatre (even quoting his songs), experimental editing, and in general, the style of the pre-Hitler avant-garde. The Weimar provenance of those years was strong, and *The Murderers Are Among Us* gained considerable success in the USA, where its female star Hildegard Kneff briefly became a household name. Those who came back after the war, amongst other places from Moscow, wanted to organize a new film

industry and thus DEFA (*Deutsche Film-Aktiengesellschaft*) was founded as a German joint-stock company, with blessing from more liberal Soviet representatives.

Only later the ruling SED (*Sozialistische Einheitspartei*) seized a controlling influence on DEFA, when it was put under the Propaganda Division of the Central Committee of the Party. At this point the Wall still hadn't gone up, and for several years they produced anti-fascist films, which tried to balance a socialist message with artistic accomplishment, tried to address the idea of how to live in Germany after all that had happened.

Socialist film and literature is today often described as "kitsch", this eternal, it seems, problem of dissident intellectuals. This is how Milan Kundera defines it in his *Unbearable Lightness of Being*, where Sabina, a free artist, leaves Czechoslovakia because she can't take the kitsch of living under Soviet rule anymore. Films of the actual sotsrealist era both in Poland and in Germany are difficult to watch without a certain ambivalence. Artistically they're often awful, and we watch them only as documents of an era. One of the essentials was to "reject the Western way of life", "To learn from the Soviet Union means to learn how to win" was the leading slogan. There was a great need after the war for a new, necessarily positive Kulturwelt, especially in the East, whose future suddenly drastically narrowed. Iconic East German writer Christa Wolf describes this in her memoirs, how building the new, idealized future/reality of socialism was an urgent alternative to the catastrophic past.

The production of agit-prop films started running from the late 1940s on, and the aesthetic that was prescribed was a seemingly naïve realism. Films describe the construction sites all over the Wild east in a heroic tone not different from the 30s in the USSR. The films that endured until today and have been released on DVDs are usually the artistic crème de la crème of those productions: Staudte, Konrad Wolf, Kurt Maetzig or Frank Beyer. The best and most renowned films of East Germany were made during the Khrushchev Thaw, though they still retain some Stalinist rigidness.

Often brave ideologically, the best of them were subsequently banned, when artistic freedoms were curbed again in the mid-1960s. Yet they provide an interesting counterpoint to the ritual accusation that these were ideologized and thus poor artworks.

The first wave were antifascist films, that had to react towards the reality of a post-war sense of shame. With what the West was making looking colorful and sexy, the East was making up by ideologization. The characterization of personages, the situations in which they were involved, always seemed a tad artificially constructed, focusing on the social problems, including the shortages in industry. Yet, in this way they deconstructed other, traditional clichés of cinema. What in capitalist conditions would've become a couple-only focused melodrama, with all the kitsch that entailed, in DEFA couldn't be just that. Characters couldn't just be slackers devoted to sweet love, as any kind of defeatism and slackness was severely punished. In Thaw films like *Born in '45* or *Divided Heaven*, or the later *Solo Sunny*, we see the dissolution of the couple, where it's usually the woman who retains 'dignity' and searches deeper into things.

Directors like Konrad Wolf wanted to come to terms with the hardest period of Stalinism. Hence films like *Sunseekers*, an astonishing mixture of Soviet avant-garde and harsh, workerist content, with such a realistic presentation of the post-war conditions in East Germany (it takes place in a uranium-mining town) it had to be banned. Filmmakers tried to negotiate the conditions of the DDR, but because of the closeness of the West, the censorship was some of the hardest in the Bloc. Even a small critique of the shortcomings of industry, like in the film *Trace of Stones*, which would have passed uncommented in Poland, could be banned. The building of the Wall in 1961 was the final blow. The abrupt turnaround of the DDR economy in the mid-60s led Erich Honecker, then number two in the Party, to blame the artists for the economic disaster of the new economic policy. After the infamous 11th Plenum several films/cause célèbres were banned until 1990, including such

outstanding examples of DEFA cinema as *Trace of Stones*, *The Rabbit Is Me* or *Divided Heaven*.

From today's perspective these films often seem slightly naïve, very righteous and with laughably idealized characters, with pure hearts devoted to the party, even in the artistically most accomplished of them. What is left for the contemporary viewer is the way the films looked. They were Marxist in every sense, yet trying to combine artistry with the depictions of workers struggles. Konrad Wolf's films (*Sunseekers*, *Divided Heaven*, *I was Nineteen*) didn't pretend there were no problems affecting the socialist life in the DDR, and his films escape idealization. In *Sunseekers* everybody is dirty, hungry and frustrated by living in this middle of nowhere mining town, sick of their jobs -

4.9 The New Woman vs Men of Marble. The fearless feminist director Agnieszka in quest for truth about the communist past, also prophetic of the later obliteration of women's role in Solidarity.

but with the implication this is the best they can have for a while. Especially in comparison to the official TV, these DEFA films were very brave indeed.

The main difference between the Eastern and Western film culture may actually be their approaches to sex. Just assuming that the Eastern Bloc cinema was more prudish would be a simplification. In the sotsrealist years, of course there couldn't be any mention or show of a single body part or action related to the sexual act. Work and healthy life meant at the same time a complete desexualization of its objects, decent socialist citizens, concerned with work and the serenity of socialist life rather than dark desires. The sanitized iconosphere/iconography, especially up to the mid-50s is full of awkward moments. In the words of many

Polish authors, even those who remained subjugated to the rules of the new style, workers, especially women, assume strange desexualized forms, for which they're later mocked or patronized. The physicality of those who worked was often described as asexual, disgusting and dehumanized – suggesting that it's only a bourgeois woman who can be truly feminine. Yet sex comes back through the back door in DEFA's Thaw films, to suggest either the general repression and despondency of the young (*Born in '45*) or of the repression of women in particular, as in *The Rabbit Is Me*, where the openness and honesty of a story about a young woman having an affair with a married man well connected in the Party was considered a threat to socialism and banned. Critical films were getting made, yet then deemed not socialist enough. Censorship was much more liberal in Poland in this respect, where from the late 50s, in our version of New Wave and in our comedies sex scenes, though still tastefully arranged, often didn't leave things only to the imagination and didn't get banned. They were no more or less sexually explicit than what you could see in your average Antonioni or Angry Young Men film.

The socialist body within the Bloc was purified and asexual. Also, it is the women who were supposed to carry the burden of chastity. In most DEFA films it is the women who are trying to be good socialists, and the men who are weaker, and who drop out or defect to the West. Socialism is identified with woman's personal strength and virtues. Christa Wolf presented this in *Moskauer Novelle*, where a member of a delegation to the Soviet Union has to deal with a Nazi trauma which is identified with eroticism. She was in love with a Nazi, and only via a repression of sexuality she can become a viable, real socialist. Only after dealing with it, is she now carrying something Slavoj Žižek describes as a "sublime communist body", where the body of communism is marked by redoubling.

Any idea of the original, sexually open communism is suspicious: in the banned films, heroines have a mostly uninhibited,

healthy relation to their bodies. Stalinism was repressive, moralistic and authoritarian towards sexuality, especially female. How different the relation to the body and the past is in Marguerite Duras and Alain Resnais's *Hiroshima Mon Amour* (1961). There, you also had a woman who was punished for her past passion for a Nazi, but it is only via uninhibited eroticism that she can overcome the trauma and stand on the side of the living. Yet a sexual revolution happened on both sides of the Curtain. In fact, initially we had similar levels of sexual freedom, but we parted our ways only later: over the years a pornographic film industry developed in the capitalist West, which for obvious reasons didn't happen in the East. Young people from my mother's generation stormed cinemas when they were screening Milos Forman's *Loves Of a Blonde* in 1965: for those two minutes of male ass and female half-breast, just as they no doubt did in the West about the scarce nudity in *Blow-up* in 1966.

It is similar in *Divided Heaven*, another of Christa Wolf's novels, adapted for the screen by Konrad Wolf, where similarly the female character's sexuality (in this case an infatuation with a man who turns out to be a weak defector to the West) must be given up in the name of remaining 'faithful to the socialist motherland'. When we meet her, she's just trying to be a good communist: she's a member of the youth branch of the party at school and remains in the DDR even after the wall starts to be erected and there's still time to escape. Perhaps this fatalism was what contributed to banning of the film. Many of Wolf's films shared a similar mood and destiny. The most artistically accomplished DDR director, he is remarkable for showing all the contradictions of socialist commitment, with, yet, the commitment winning out over other, less patriotic feelings, which retain a bitter taste.

Perhaps the most shocking film of all the East German productions I saw was *Hot Summer*, a terrifying, relentlessly silly, pushy and propagandistic "youth film" set against Cliff Richard's *Summer Holiday* in the cultural war with the West, with sing-alongs and a

plotless structure with unfunny gags – and all this in 1968! What a move backwards in comparison to the post-Thaw cinema. Yet, the Eastern Bloc didn't simply return to pre-modern forms of art. And if the workers were screwed over by the authorities, there were artists aware of it and capable of honestly depicting it on the screen.

## We were men of marble

The conception of women as the carrier-filter of past socialist ideas continually returns, as if it was the notion of female purity and a lack of fixed identity that allowed them to be a good medium for directors to talk about history. This is what happens in Andrzej Wajda's film diptych *Man of Marble* and *Man of Iron*, astonishing films made in the rare but brief little thaw in the 1970s, which share a main female heroine, despite talking about the man-made history. *Man of Marble* was made in 1976, its counterpart, *Man of Iron*, in 1980. The first was affected by the Polish 70s, an era of relative relaxation, after Edward Gierek became the First Party Secretary. The 1970s were a time of seeming 'prosperity' in Poland, when the government wanted to stifle dissent (after the student protests of March '68 and the brutally repressed workers strikes of 1970), via massive international loans that later pushed Poland into great public debt and financial and political crisis. This was the time Wajda, an internationally successful director, could come back to certain traumatic themes from the Polish past, now available again. This sudden relaxation lasted very briefly though, and ended in political crisis which then led to the rise of Solidarity and the crisis which ended in Martial Law in 1981.

Wajda's films frame that period. A young, go-ahead, charmingly self-assured film student, Agnieszka (known only by her first name) is determined to make her graduate film on a forgotten Stakhanovite from the 1950s, Mateusz Birkut, whose rise was as quick as his demise. She's subsequently discouraged by practically everyone she talks to: state television producers, collaborators, people from Birkut's life who she's trying to make speak about him.

For everybody it seems an unwanted topic – a trauma, which is not only identical with the trauma of Stalinism, but also with the failure of the "dictatorship of the proletariat" which, though promised by the authorities, never really occurred. The films Agnieszka watches in secrecy from her superiors are the verboten images of socialism: the first, made during the early post-war years of acute poverty and devastation, shows state violence against workers, among them Birkut, who is beaten by a functionary while queuing for a plate of soup. Those forbidden fragments are mixed with the "official" ones, where Birkut is recognised in his role as a socialist hero and worshipped by the party officials and the masses. Two images, which couldn't be more different, now equally stranded in forgetfulness.

Agnieszka goes through the museum magazines full of the now-hidden, scorned and despised monumental art. Gigantic heads, torsos and flags, with bombastic declarations, now empty and meaningless. Yet, it also means the workers principles become meaningless too: Birkut, a complete ingénue, a Polish Yuri Gagarin with an innocent, charming smile, a true believer in socialism, which gave him literacy and transferred him to the city – is first given the highest applause by the authorities. Delighted that he can now do something for his country apart from bricklaying, he starts heralding demands for the better existence of workers, which would be nothing but the logical consequence of a true proletarian dictatorship, if such existed. He doesn't realize the facadism of the system, he becomes a liability to it, which, in the person of the terrified party officials, then does everything it can to silence him. Finally, an accident at the construction site is arranged, leaving Birkut handicapped and unable to continue physical work – and quickly his monumental portraits are taken down from the 1st May march decorations and other propagandistic spaces as he slips into oblivion.

Yet the way the film posits questions about the aesthetic and political quality of the forbidden Sotsrealist materials is surprising

in its subtlety and intelligence. Wajda didn't use a single second of 'real' archive materials, and every black-and-white newsreel or old propagandistic fragment we watch is utterly fabricated by the director. Through the eyes of Agnieszka, as she slowly discovers the mystery of Birkut, embodying the time of the title's Great Heroes made by the state, we are also ravished and gradually seduced by the aesthetics that accompanied them. Wajda, obviously on Birkut's side, finds himself unable to simply mock sotsrealism. And in the end, he unconsciously adopts some of its principles - heroism, monumentalism, pathos, characters so positive that they're rendered incredible - to make the second part of his film, *Man of Iron*, situated in the Solidarity strikes in the Gdansk shipyards in summer 1980.

Agnieszka doubly represents her generation here – the same who abroad sang 'we could be heroes" or "no more heroes", where heroes disappeared, because either their time has passed or they got discredited. Way ahead of the later Hollywood use of fabricated old newsreels (as in the dreadful *Forrest Gump* and Woody Allen's superior *Zelig*), Wajda posits the question of the authenticity of history as historical material and also as a style, which, now forgotten and denounced, is at every step being recontextualized in his film by the sheer stylization of what "has been". The episodes from Birkut's life are constantly flirting with socialist realism, the then-compulsory style, using its strictly monumental features to the utmost filmic effect. Is Wajda endorsing sotsrealism or ridiculing it? Is he in favor, fascinated or just coldly looking at it? Is he just quoting Eisenstein, or playing with old cinema, a style that in the West, was already then known as "postmodernism"? He's doing all of those things at once. Through the use of the wonderful, mimetic/illusionist powers of the cinema, we at the same time watch the illusion AND the forbidden archive material which was supposed to rot away from the public eye in the cellars forever.

The film is the first proper reassessment of socialist realism not only in Polish cinema, but also in visual arts. Agnieszka, this new,

dynamic woman symbolizing her own time in the best sense, is suddenly confronted with a past she has no grasp of. Her film on Birkut is pulled, she's hopeless, she blames herself for opening too many wounds from Birkut's life – but that brings her to his estranged son, a former student, who, in a typical idealistic romantic gesture drops education and starts working in

4.10 Men as Giants. Wajda repeats the Sotsrealist Gesture in Man of Marble

a factory, as a belated homage to the killed father, to his memory and to affirm his working-class background.

Krystyna Janda, playing Agnieszka, embodied a new woman – a bit imaginary, with a bit of wishful thinking, being bold, forthright and jeans-clad, fearless and self-assured. She was a feminist without even realizing it. She looks exactly as if she came from a Second Wave demo or a women's lib Agnes Varda feminist film. She was a feminist, in a patriarchal socialist Poland full of open sexism, and what's more, men recognized her as their equal and respected her. To this day I think Agnieszka was a phantom. She never really existed, she was the projection of a director who wanted a real opposite gender partner whom he respected, although she may be partly based on Agnieszka Holland, prominent director of the Cinema of Moral Concern, who also later became famous in Hollywood. In this sense Agnieszka's fate was prophetic of many Polish women involved in conspiratory politics, the Solidarity movement – and there was no shortage of women in the democratic opposition – who never really reached any significant positions first within the union, and then within the party system or government in "free" Poland. Their often-crucial role was never properly acknowledged. This is predicted in the film, by the sudden change Agnieszka undergoes, when she becomes the companion and wife of Birkut Jr, and later a mother of his child in *Man of Iron*. Her decisiveness disappears, she is interned in prison,

from which she's beatified in her role as a suffering mother, subjugated both to 'the cause' and her husband, a Gdansk shipyard worker.

Even the characteristic transubstantiation of matter from one film to another – from Marble, symbolizing the Stalinist past, to Iron, symbolizing the iron will and boldness of the Gdańsk shipyard resistance, no doubt - rings ironic, given who used "Man of Steel" as his pseudonym. *Man of Iron* represented the optimism of Solidarity's first years, completed during the euphoria of Gdansk in summer 1980, only partly predicting that what will happen will be another facadism of behind-closed-doors decisions, and yet another betrayal of the workers. It also glossed over the ideological discrepancies and disagreements within Solidarity itself. It's an incredibly idealistic image of the time, the way Wajda would have liked things to happen: people getting together, a peaceful revolution and a more just world for all. Today we know, too bitterly, how wrong he was, yet it's intriguing that when given an opportunity to finally show Polish society in its most ideal form, he chose an idealized realism – the very style he was supposed to reject.

And what about Agnieszka, our absent Woman of Marble? There's another aspect to the film, which became clear with the next leading role of Krystyna Janda, only year later in 1981, in Ryszard Bugajski's *Interrogation*, where Stalinist repressions were shown from another angle, in the most shocking depiction of that period ever committed to the screen. After playing her contemporary, obsessed with the Stalinist past and doing their victims justice, Janda took the part of one of *them*. In *Interrogation* (finished just a few days before Martial Law was declared that December) she's playing Tonia, a revue-cabaret singer and dancer, touring with a troupe and performing for soldiers and peasants across the miserable landscape of the ruined post-war country. Living the life of a gypsy, careless, constantly under the influence of alcohol, she doesn't even notice when one day she's captured by two hangers-

on and taken to the secret police commissariat. There she is brutally groped as part of a "forensic examination" while she's still unconscious from alcohol.

This symbolic "rape" of her body is done repeatedly by other means, when she's thrown like a sack of potatoes to the overcrowded cell and then wakes up to gradually realise what has happened to her. She's accused of collaboration with "the enemies of the people", and her reaction suggests she didn't even realise these Stalinist processes and purges were going on behind the closed doors. Despite her initial fragility and erratic, unreliable character, the more atrocities, humiliation, violence, terror and abuse she experiences from her secret police perpetrators (the terrifying Urząd Bezpieczeństwa, Security Police), mostly psychotic sadists, to "break" her, the more defiant and stronger she grows. Fascinatingly, Bugajski shows Stalinism as indeed the nightmare of patriarchy as such: from the female victim's perspective and with men as their ruthless abusers, predominantly as a specific abuse done to women's bodies. Feminine Tonia is, in the course of the tortures (she's near-drowned, beaten, isolated, refused food, kept awake, used sexually, denied contacts with her family and finally betrayed by her husband) turned into a pale ghost of herself, with her charms erased, as a special kind of humiliation – to leave a permanent sign. But she grows something else instead: courage, strong will and fearlessness in the face of the state repression apparatus. She's repressed as a woman: her interrogations are to prove her fault on the basis of her promiscuity and humiliate her chiefly as a "whore" without dignity who sleeps around, so that she's in a way punished for her sluttiness, not for real treason against the state.

The "treason" is typically Kafkaesque, and the punishment is for something she hasn't done but she's supposed to realise as her guilt. In the course of the film also her "fault" becomes meaningless: her oppressors don't really care what she's done, the only thing that matters is her *self-criticism*, admitting the crimes she

hasn't committed (because the socialist state "never makes mistakes"), written and signed, and this is exactly the thing Tonia repeatedly denies them. It's also a story of solidarity growing in most uninviting conditions: the brutalized women in the cells, apart from the expected brutality to one another, express also solidarity and mutual support. Janda opposed the initial script with her character as a victim and rebelled against her role as somebody broken, creating a rare if not unique feminine perspective on the atrocities of the worst period of Stalinism with a woman as an individual, free subject. In this way she widened the historical construction to incorporate also the woman - the *other* of history, absent from the pages of books and largely absent from cinematography, where only the heroic male perspective was favored. She was reclaiming the Women of Marble, the Unknown Heroines, how different and yet similar in their naïve heroism to Mateusz Birkut, both even after the damage is done still believing that justice will prevail. Yet *Interrogation* is the underbelly of *Man of Marble*, where all the sotsrealist decorum is stripped away for the sake of the naked horror of torture away from the officiality and the public, where it's the women, who pay the political price. Also, in *Interrogation*, the divides in social class and background between the women inmates were becoming invisible, they became equals – and in this way Tonia, as a female heroine, stands for all the forgotten women of socialism, of all social classes whose work and contribution has been neglected.

## Soap operas about late capitalism

What is the contemporary socialist realism? One could definitely think here of today's Russia, with all its comeback of the bombastic Tsarist aesthetic and the great-master tastes of its business aristocracy – oligarchy as a sad façade of its undemocratic political processes. Recently Vladimir Putin brought back the Stalinist award 'Hero of Labor', among whose previous recipients are Stalin, Khrushchev and Sakharov. Some people could instantly think of

this as an act of completion of the restalinization of Russia. But let this not mislead us. If anything, the massive Soviet nostalgia of contemporary Russia is another façade: a façade designed to hide the degree of neoliberalism in the Putin era. As many Russians, whose lives got worse after 1991, yearn for the 'comeback' of the old times, Putin cynically tunes in to those moods by creating a façade of a strong, resilient country, with election candies such as the reinstatement of the Prize. Yet this action should pass as nothing more than cynical play at the masses, aimed also at winding up all the liberal intellectuals, who much in the style of the nineteenth-century "pro-Westerners" sigh at it with disgust. Their main medium is a magazine called *Snob*, after all. One facadism is replaced with another. It inscribes itself within the whole presidency of Putin, whose main feature seems to be in combining the lure of the old times with a ruthless, galloping oligarchical theocracy.

What then, in a time of self-marginalization of arts as a "mirror to reality", still plays the role attributed to socialist realism, depicting totality while retaining a mass appeal and on a mass scale? What are most discussed as a new form of depicting the current late capitalist reality are TV serials. *The Wire*, but also *The Sopranos* (the earliest, which started the whole trend) and recently, the Danish *The Killing* are all multifaceted, mosaic, complicated portrayals of the world-system; and its history is depicted in *Mad Men*, whose creator, Matthew Weiner says he'd ideally lead his characters until the present. What *Mad Men* does with the 60s, *The Wire* does with the contemporary neoliberal world. It is, by far, the most complete, dense and complex rendition of how the contemporary world, or the contemporary neoliberal city, in this case, is functioning. It also has a very nineteenth-century development, unfolding characters and plots like in a classic novel. Many interpreters of *The Wire* have recalled Fredric Jameson's concept of "cognitive mapping", dating from his *Postmodernism, or the cultural logic of late capitalism*. Initially, Jameson's concept was purely

metaphorical, taken from spatial methods of analyzing culture. What Jameson meant was art that cognitively "maps" the reality that has seemingly become unrepresentable. What he writes about is an art that instils class-consciousness towards capitalist reality, which, as an American academic, he couldn't just explicitly use as a concept.

Jameson, influenced by the Lacanian distinction between reality/realism and the "real", takes up once again the problem of representation, in which he observes among other things, in a search for some kind of new totality, how "a certain unifying and totalizing force is presupposed here, although it is not the Hegelian Absolute Spirit, nor the party, nor Stalin, but simply capital itself". He took up the concept of totality again, after Lukács, posing a question of totality vs. partiality against the growing unpopularity of 'totality' as a concept, which came largely after the 1968 generation "discovered" Stalinist crimes and started identifying every attempt at totality as a straight path to the gulag. Totality as a concept was passé. Another question is that of representation. Postmodernist art's role was, via means like dispersion of form, to make the world unintelligible, convincing the viewer/reader that he cannot grasp the total view of reality. It is not enough just to "come back" to the old ideas of the avant-garde, even if such an operation was possible. Jameson brings back instead the idea of critical realism. The more 'realistic' ideas of the iconoclastic, critical avant-garde could also be part of this, to mention only the *sachlichkeit* of Brecht or John Heartfield, which came up with an augmented, sharpened realism, creating the *Verfremdungseffekt*, alienation effect, while still using a 'realistic' method of representation.

Lukács wrote that 'socialist realism is in a position both to portray the totality of a society in its immediacy and reveal its pattern of development', a form of art that had 'the ambition to portray a social whole'. Is it then that the success of *The Wire* or *Mad Men* lies in precisely their focus on the totality, that links every form of our being, every possibility – capital? One of the main features of

*The Wire* is it's classical narrative – the show operates within the present, develops linearly in time, and also quite slowly, never really using any devices like flashbacks - it stubbornly stays in a dead end, just like the lives of its characters. The serial takes its form from a novel, furthermore, a novel, as it was in its golden era, the nineteenth century: a "low" form, printed in a newspaper, in episodes. Many of the greatest novels of all time were published in episodes: Balzac, Dostoyevsky, Dickens. The novel was "low" in comparison to the metaphorical language of the heroic epic literature, instead talking about everyday life. One of the milestones in the modern novel was *Don Quixote*, a satire on heroic romances detached from the world. The novel was always a tool for social critique and satire, it was fictionalized but realistic. Even extreme examples, like Laurence Sterne's *Tristram Shandy*, have an experimental form, which use the idea of the world that is impossible to tell to a positive, constructive effect, enabling one to see the production of clichés and stupidities within the process of storytelling. We can argue that representation of reality is always different from fiction, a failure of someone who tries to tell their life story as fiction. That's why *Tristram Shandy* was loved by Russian formalists, as a work that is about constructing, about technique, about devices.

Modern works of art always strive to cognitively map the world, says Jameson, to explain it. *The Wire*'s apparent ability to depict totality more successfully than experimental cinema or engaged art can help us in explaining the relation of socialist realism to the avant-garde, and effectively explain the current weakness of art as a tool in cognitive mapping. The televisual form (all-available, democratic) makes it popular. Each of the serials I mentioned is produced in specific conditions: by a private channel, with a big budget. Can you really compare it to art that is made in different conditions? But you can compare it to the work of Rainer Werner Fassbinder, a former underground director who produced several works for television in 1970s West Germany. Most of his

films concern the left movement, Germany's Nazi past and its repercussions on the present. Fassbinder never questioned 'representation' as such, as did the more radical part of the New German Cinema, and never produced a 'film-essay', but instead always created realistic narratives.

Situations and performances from Fassbinder's movies often seem nearly comically overwrought, over the top, where the grotesquely exaggerated dialogue and acting serves as a running locomotive of stereotypes, even if the behaviors of his characters are often non-conformist and non-normative. Fassbinder often took his situations from pornographic movies: but here sexuality is rather a way of driving certain attitudes present in the society to their radical end. In his films relationships between men and women, but also between men (not always, but mostly, homosexual) and men, full of sadism, masochism and hatred, are depictions of the real power relations within society. Despite actors who are often compelled to act out in the most hysterical way the schizophrenic relation within society, Fassbinder remains genuinely sympathetic to his characters. This director emerges today as one of the most acute critics of the post war capitalist Germany, as a residuum of un-dead fascism, racism, greediness, which expresses itself in radical violence and cruelty.

In the novel, Peter Weiss attempted a similar radicalized realism. Weiss was one of the most sensitive and complex artists to comment on the Cold War reality of a split Germany. His monumental 1980s trilogy *The Aesthetics of Resistance* is a retrospective look at the German past, to create possible scenarios for the German future. In the novel he follows a fictitious anti-Nazi resistance group, who spend their time in intellectual disputes, and meet up in galleries and museums, to link their ideas of radicalism with the past ideas of art and ethics. The author does resist the bourgeois individualism often evoked by such discussions (as we know from the modernist novel, from Mann to Proust) by replacing a singular individual character with a collective political mind of the resis-

tance group. In doing so, Weiss was looking at the aesthetic premises of sotsrealism: heroism, grand scale, nineteenth-century realism. Yet his novel is not simply a repetition of the previous realism, with its academism and conservatism, but instead manipulated consciousness by using devices and provoking specific emotions. It is a rare example of a historical novel, which for Lukacs was the pinnacle of realism.

So, at least in my language, the call for new kinds of representation is not meant to imply merely a return to Balzac or Brecht. Realism and the avant-garde are historical concepts, rooted in their time and place, and it'd be impossible to bring them back as they were without falling into quite obvious forms of kitsch, as it is clear from so many post-Soviet artists, who were, especially in the 90s, making "liberation art", endlessly recalling the years of the regime. A new realism will include the new ways we live our lives today, unknown to the previous generations; the ways neoliberalism is perverting the spaces of our work and privacy; a new precarious aesthetic. The reason we exclaim often while watching *The Wire* or *The Sopranos* at the aptness and intelligence is that in fact they are syncretic. *The Wire* shows the full spectrum of the changing social classes, the personal is always attached to some wider impersonal structures: politics, union, police, financial. The world of *Sopranos* often uses oneiric, retrospective elements and unrealistic devices, but always in the end to enrich and nuances of the portrayal of the reality of its inhabitants. But what politics is produced by these serials? Might it only produce the protests like those against ACTA, when the thing that finally spurred young people was the ban on endless free downloads of their favorite serial? The availability of TV online, especially in this really refined latest form, only deepened the already existing retreat into the private zone. In the end, in the current climate, even the most intelligent television may transform your politics, but it won't make you act.

German artist Hito Steyerl, in her essay *Is the Museum a Factory?* asks a question about the growing harmlessness of political art

today, which is closed in the safe space of the museum. She even quotes Godard himself, who said recently that "video artists shouldn't be afraid of reality" which suggests that they obviously are. This made me think about Wajda again, as *Man of Marble* and *Man of Iron* interestingly compare to Harun Farocki's *Workers Leaving the Factory* as oppositional "archaeologies of (non) representation of labour", as Steyerl describes Farocki's film. Wajda wilfully fabricates the images of workers at work: in the factory, laying bricks or even starving and being beaten - and confronts that with the facadism of work shot "as newsreels". Farocki doesn't strictly shoot anything, putting together footage from eleven different decades depicting workers all over the world after they finish their day. Yet nobody in their right mind would call Farocki's film 'realistic', just as Wajda's film is realistic in an obvious way, shot in a "traditional", historical movie manner.

Both depict the life of a worker living in the time of a manipulated world-image. Farocki's work uses documentary and absolutely realistic parts, it uses unrealistic devices, and it's neither a documentary nor a fiction film, but an installation, created in a way similar to the avant-garde – via editing, defamiliarization, the old avant-garde techniques. Maybe there are two kinds of realisms at play: while the traditional realism of Wajda or *The Wire* continues the old Story, the Great Narrative, the artist, whoever it is, will try to engage the viewer on a more intimate way. "Every spectator is either a coward or a traitor", Steyerl quotes Frantz Fanon, postulating greater political closeness instead of spectatorship. The cinema which will embrace such intimacy, must be secondary, not primary, to the political space that emerges.

# 5

## Applied Fantastics

### On the "catching-up" revolution in the Soviet Bloc

*Not only the New World street is new*
*For us every Day is New!*
*Everybody is looking as if*
*They saw their city for the first time*
*('The Red Bus')*

*We'll build the new Poland,*
*We'll build a new world.*
*Where everything will be better*
*Where there'll be new order!*
*The most beautiful cities, the most beautiful villages,*
*We'll build Poland beautiful like in a dream!*
*('We'll build a New Poland')*

*In the morning your hands were mixing cement*
*But now you shine like a star!*
*('The Girls from Fab-loc')*

*Because MDM, MDM grows upright night and day*
*Below: sand and rubble,*
*In the evening I look:*
*It lightens up like in the theatre!*
*It's the workers day and night*
*Warsaw houses.*
*And like a beautiful dream*
*Work will burn in our hands*
*Like in our million hearts*

(*'MDM'*) (A song on the flagship Socialist Realist estate in Warsaw)

Fragments of various popular songs from early 1950s

*Suddenly we were surrounded only with photographs of food and shoes. Maybe food and shoes are the new sex?*
Arina Kholina, *Snob* magazine

*'Could I have a coffee without cream?*
*Sorry sir, there's no cream, there's only milk.*
*Ok, so could I have a coffee without milk?'*
Joke from the Polish People's Republic

## Learning modernity from the east

In recent decades, notions of center and periphery have become completely central to so-called 'subaltern studies', and are seen as the most revealing way to analyze our seemingly naturalized ways of seeing the world. And despite the tremendous effort of thinkers and philosophers to make the periphery more interesting than the center, as a citizen of a post-communist country I experienced how these categories can have a direct influence on your life. It goes without saying that Western Europe is Center, and Russia, for example, which probably produced the greatest amount of outstanding artists in the twentieth century in the world, is not even considered 'Europe' by many.

*Europe...is not Russia!* exclaims Croatian journalist Slavenka Drakulic in her dramatic essay from *Café Europa*, one of many post-Soviet memoirs, written soon after 1991, when "explaining" the former East to the West - in a double sense of guilt and revelation - was suddenly considered necessary. As an "expiation" for the pitiful life we lead during *komuna*, we now greedily appropriated everything that was Western. That it was better than anything we could possibly produce went without saying. The transition to

capitalism happened in Eastern Europe at the worst possible moment – the system imploded after years of financial crisis, misinvestments and as a result of a massive debts taken decades earlier. The patient was nearly dead, so it's no wonder that in this state, after everything was pumped out of him, he died immediately.

Europe's Cold War borders were decided through the cruel geopolitics of the Yalta treaty. Some countries were thus attached to the Eastern Bloc against their will, like Poland; others were included against the popular will into the capitalist camp, like Greece. The West supported fascists in Greece against the communist partisans, to eliminate the possibility of communist governments arising outside the agreed-upon Soviet Bloc. This divide was reinforced by the Marshall Plan, where American money was lavished on a ruined Europe. Communist countries were also offered Marshall Aid, yet they were forced by the USSR to reject it, mainly because it meant opening up the books of the economy to American examination. It's not like this aid to Communist states was proposed realistically - it was proposed in such a way that the East had to reject it.

Western Europe had massive investments from America, creating a huge boom.

Although the communist economies grew throughout that period, especially Yugoslavia and USSR, they were basically still command economies, with all the inefficiency that entailed. The post-war order was established so rigidly and with such a great support from the USA that it ensured communism would be once and for all confined to the East. It is common to believe within the ex-Bloc, that it was the lack of Marshall Plan financial help that decided our belatedness. A popular conviction today is that because of this it was actually the Western countries who could really afford to put into life elements of the socialist programme, realized as the welfare state.

It is not the ambition of this chapter to decide whether the

compromised version of monopoly capitalism that occurred in Western Europe was a real solution, but to look at what the alternative to it was, or could have been. We're so used to thinking of the economy in the whole Eastern Bloc as obviously inefficient, that we're now shocked when names of Polish and Soviet economists, like Nikolai Kondratiev or Michał Kalecki, are called upon as to explain the capitalist crisis. Yet in the post-war years, the Soviet Bloc not only produced an outstanding economic theory, it had its own ideas for socialist-led economy. Most famously, market socialism in Tito's Yugoslavia and the whole Non-Aligned Movement fought for an economy of the 'third way'. But also during the post-Stalinist years of the Thaw, scientists had Nikita Khrushchev's permission and enormous amounts of money to work on new, alternative methods of directing the economy without resorting to capitalist methods, in the specially designed Academic Towns, like Akademgorodok, just outside Novosibirsk, the subject of Francis Spufford's scientific-historical novel *Red Plenty*; "closed cities" you needed permission to visit, devoted to the development of science.

## We will bury you!

According to Spufford, during his visit to America Khrushchev was first of all astonished by their level of life and dreamt about a similar standard for his people. The famous temperament of the charismatic leader is of course best remembered from his speeches in the UN. "We have to try to be friends, a peaceful coexistence" – he says, despite waving sputniks and rockets behind him or the famous declaration "We'll bury you!" or banging his shoe on the conference table to get some attention. In Spufford's account Khrushchev loved hamburgers and the idea of a cheap, rich meal that was available to everybody.

There used to be a different model of modernity than that we know now – things were tried and then discarded. In this chapter I want to take the reader to this very specific moment of history, in

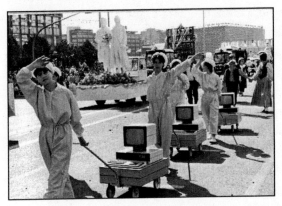

5 A late communist parade in East Berlin 1987. Computers taken
for a walk.

which an alternative modernity to that of the West was not only
possible, but started to be introduced in life. There existed a world
of parallel, socialist-only economic systems, where technique and
utopianism went together. The Soviet reality until the mid-50s
experienced a tragic waste of life, mass murder rivalled only by
Hitler, famines, horrific politically motivated purges and the
spreading of the disease that was the Gulag Archipelago. With
such amounts of blood on their hands, Soviet authorities were
especially interested in redeeming the Soviet project. After decades
of undernourishment, and terrible problems with supply of food
and other products necessary just to live, Khrushchev's idea was to
finally bring to the Russian people the plenty they had sacrificed so
much for.

This was to be achieved through a revolution within the Soviet
economy, which was until then centrally planned. Central planning
was a command, 'shouting' economy: the orders were given from
the top and had to be fulfilled no matter what. What mattered was
the quantity, not quality. More of everything, regardless of
demand, was the best, albeit primitive, form of accumulation. In
this way you would have vast levels of production of steel, while
there were not enough shoes. Without central planning it would

have been impossible to build a gigantic industrial base in the underdeveloped, post-Tsarist country, yet over the years, it started to be a burden to the communist economy and a chief problem in the 'catching up' or even 'overtaking of the West', which was the slogan of the post-Thaw era.

According to central planning, USSR could outproduce the US in raw industrial tonnage, yet often at the cost of poor quality. This is why it was the most basic goods and infrastructure that were always important for communist planning: railways, metro systems and other public transport, mass housing, these were all often of very good quality and sometimes better than in the West. It was the consumer goods that were the Achilles heel. That was the reality of constant shortages, queues and low quality goods. The new economy, which was to be introduced in the 1950s, bore resemblance to both the socialist and capitalist system. Instead of the centralization that resulted all-too-often in barter, bribery or inefficiency, it was supposed to be more like a network. It was striving for more quality stuff, more high technology and more available consumer goods, of ever-better quality. In order to do this, Soviet economists had to introduce some market mechanisms. In central planning, if the center committed mistakes, they were reproduced by the rest. Without the permission of the Party, you couldn't rebuild or adapt any project, including the heavy pre-fab, system built mass housing, which was everywhere the same, from Vilnius to Vladivostok. The successes of the Soviet economy had been based on military discipline - under Stalin you had to meet those targets or you were shot – and this too was to be abandoned. The Soviet economy had accumulated; now it was time to redistribute.

The ideas of the Soviet economy had to be reformulated: instead of simplistic measurements of the rise in production, demand was to dictate prices, which should, as the most radical economists of the time insisted, be set by computer networks. Cybernetics, a very important branch of science in the Soviet Union, was developing, trying to marry economics and computerization. In this Soviet

science was potentially really overtaking the West by producing original computer systems, just like they were at this point well ahead in the space race.

And for a bit, in the 1950s and early 60s, the economy didn't differ so much, or at all, from what the propaganda was saying. Not overtaking the West, it was nonetheless an advancing economy, the sweetest moment of socialism, closest to the idea of 'red plenty'. Yet quickly the limitations of the Soviet state appeared. Expectedly, the price rises on sundries insisted on by the economists started to cause social dissent: riots and demonstrations, which ended tragically with the shooting of demonstrators in Novocherkassk. These limits revealed how the Soviet state couldn't go on without the total support of its citizens and a total acknowledgment of its ideology. Any dissent would be a threat to the state integrity. Or so they thought: ideological purity turned out to be more important than the lives of the citizens. After that, Khrushchev was removed from power, and replaced with the much more conservative Brezhnev, who brought back the previous rules. From then on there was a policy of "no more revolutions". No more experiments, no more attempts at democracy, no lifting of censorship. Some of the promised consumerism was realized during the Brezhnev 1970s, but on false premises. This was already the era of stagnation, the lack of any innovation, in the name of not taking risks, slowly descending into the eventual massive crisis in the 80s, which, accelerated by the turbo-capitalist transition, led the country to complete economic disaster in the 90s.

What was the American reaction to the competition? It was often outspoken ridicule. In one of the funniest, if incredibly heavy-handed Western comedies of that era, by a Polish Jew and resident of Vienna and Berlin in the 1930s, Billy Wilder's *One Two Three*, we have the symbolic war between the two camps banalized as a romance. The misalliance of a rich, American girl – the daughter of the factory boss who James Cagney's manager is working for, stationed in West Berlin – and an East German boy, a

completely ideological, anti-capitalist worker, who'd rather die than betray the ideals of the DDR's Communist Party. The whole film is full of gags and jokes recalling the famous appearances and speeches of Khrushchev, from the "bury" speech to the 'overtaking'. The crudeness and lack of lustre of Eastern life, its glamourless roughness, is key to the way the Cold War is presented here, and what we're led to believe it *really* is: Easterners are of course a bunch of crassly dressed, dirty, styleless drunks, and the DDR police is of course the cruellest. So it's a mere difference of style!

The American sector, where the company and the factory of our

5.1 One Two Three - the German Democratic Republic as American grotesque.

friend are, is of course warm-hearted, even if not always that efficient. The joke is not completely lost on Cagney, as, awaiting the visit of his American missus and a little son, he's eagerly ogling, or maybe more, the charms of an attractive blond German secretary. The scandal of his powerful boss' daughter's alliance unfolds exactly as he and his wife are to pay a visit to Berlin, where Cagney was supposed to "take care" of this crazy, irresponsible child. Yet, the up-to-now posh and vacuous girl all of a sudden, under the influence of her new love, decides to reject the earthly pleasures of capitalism and the American oil fortune, to defect to the East and join

the CP with her fiancée, looking exactly as if he just left the Berliner Ensemble playing a courageous worker in one of Brecht's plays. In order to save face and job, Cagney must now, within less than 24 hours, convince the now pregnant & married daughter to dismiss her husband or... do everything she can to get the boy to defect to

the West! The results of his mission are uncertain, and involve a lot of jokes played on the Eastern proletariat. Yet in the end, not only does the daughter realize just how stupid her idea of living in the rough East was, but also, by way of blackmail and a crude arrest by the DDR police, the boy himself is not so Marxist anymore, and successfully pretends to be a rich aristocrat in the eyes of the potential parents-in-law. Though the transformation happens due to an army of stylists and good-manners teachers, which uproot all the communist roughness out of our sweet boy, it's all only a pretext to yet more gags at the communist regime's expense.

This dream, that we can 'overtake the West', existed for less than two decades, somewhere between late Stalinism and Brezhnev, somewhere between the secret speech of Khrushchev and the rise of Władysław Gomułka to power in Poland in 1956 and the anti-Semitic purge of March 1968; somewhere between the walk Jeanne Moreau took into the Parisian night in search of her lover in *Ascenseur Pour Echaffaud* and the sleepless night in Prague that a married couple of system beneficiaries endures in Karel Kachyna's 1969 *The Ear*, wiretapped and scared of a visit from the men in black suits. It starts somewhere during the Space Age era of Bikini costumes, Googie-style diners and Atomic TV sets. It shares the enthusiasm of the colorful designs presented at Brussels Expo '58 and follows the splendid monument to Le Corbusier's brutalism in Marseilles. It shyly explores new, previously nonexistent worlds in laboratories and sound studios across Europe: Pierre Schaeffer's first experiments with musique concrete since 1948, and the Polish contemporary music festival Warsaw Autumn beginning in 1957. Karlheinz Stockhausen executes the first electroacoustic music experiments in Cologne, inspiring students Holger Czukay, Ralf Hütter and Florian Schneider, later of Can and Kraftwerk fame. Modern Polish designs cause a furore at international festivals: they win the first Textile Biennale in Lausanne in 1962 for an innovatory, unconventional approach to textiles as a new kind of work of art. New Wave cinema flourishes everywhere,

Polish and Czech dramas films win prizes on international festivals, and so does the music, at Cannes, Donaueschingen, Darmstadt. It is this territory that this chapter will explore.

## The Meaning of the Thaw

Khrushchev's Thaw in '56 marked a significant liberalization of this same high-up bureaucratic class, as he fought the new hierarchies within the party structures. He significantly cut the payments of the upper echelon (for which reason he became unpopular among them), as well as liberalizing the harsh Stalinist laws on divorce, abortion and women's rights (but he kept the criminalization of homosexuality). Yet although he was a believer in equality, Khrushchev, the former butcher of Ukraine during the great famine and the great purge in the 1930s, still remained a conservative.

On a certain scale, the Polish Thaw looked similar, but Poland went further to become the most liberal country in the Bloc. It also had immense influence on its culture for over two decades. In Czechoslovakia, though it was brewing for several years, the Prague Spring lasted only about six months in 1968, and was crushed by Warsaw Pact invasion, and in films, the New Wave lasted at most about 4-5 years. Hungary after the crushing of the '56 revolution had milder censorship and a much more advanced 'market socialism', but it drew very different conclusions from the triumph of the Polish October '56. While Polish workers strikes in Poznań in '56 led to the seizure of power by the more liberal part of the communist party, led by Gomułka, who successfully reassured Moscow that he could maintain socialist order; in Hungary, student-inspired protests were took place in the capital, with secret policemen strung up on lampposts, and with Imre Nagy's cabinet containing non-communists and promising withdrawal from the Warsaw Pact. This ended in the bloody Moscow intervention in Budapest. The unsung revolution of '56 in Poland is unpopular precisely because it was in a way successful – you cant romanticize it in the same way as the Budapest revolutionaries, who keep being

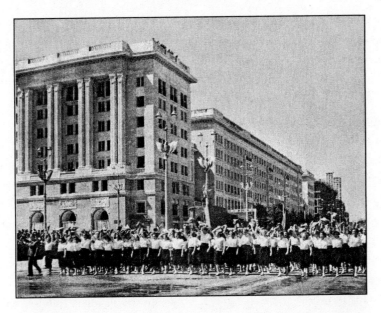

5.2 Youth marching amongst the new Palaces for the People, MDM, Warsaw 1952.

immortalized in films and popular anti-communist sentiment in contemporary Hungary. Back then, in a sense, we both ended up with less harsh communist regimes, but in the Hungarian case, after a bloodily stifled revolution.

This began a decade and a half of liberalization. East Germany, though relatively affluent, as the most western of the Eastern Bloc countries it had some of the harshest censorship and secret police in the whole Bloc. Especially against this background, Poland's liberalized culture had splendid artistic results: its famed cinematography, which excelled from as early as 1955 (with the first Andrzej Wajda films, starting the phenomenon of the Polish Film School), and it continued to produce great films and directors well into the 1980s. This extended to literature, music and the press, which in particular will be the subject of my inquiry later on. Often, this movement criticized the system in the most open and direct way. Poland seemed to have won its revolt in 1956, which

made many sympathize with it - but instead of revolution it gave people the so-called "little stabilization": more flats, more cars, but still of poor quality, and without the promised withdrawal of censorship. The growingly disappointed followers of the system started criticizing it, which led to March 1968 and the infamous purges of the Jewish citizens and "revisionists", which once again, tragically sealed Polish destiny. But first, we'll look at the two fighting ideals of culture, proletarian and bourgeois, which opposed and competed with each other in socialist Poland.

## Was there a proletarian culture?

While we condemn the socialist period for the belatedness of our economy and being the "lesser Europe", the future of our modern history was already decided in the small industrial enterprises and factories in the imperial United Kingdom. I will focus here on the un/development of the working class culture in Poland, to demonstrate some of the many reasons why the anti-capitalist revolution didn't succeed in Eastern Europe.

Poland, though a major European power in the early modern era, experienced much slowing of its development, as its elites of the seventeenth and eighteenth centuries weren't interested in the accumulation of capital via cities and coasts, both decisive for the progress of capitalism, but mainly in the lands worked by serfs that they owned in the East. Subsequent wars and annexations weakened Poland to the degree it was partitioned in late eighteenth century and was swallowed by Prussia, the Russian Empire and Austria for over 120 years. Poland entered the twentieth century underindustralized, still with the terrible effects of peasant serfdom and the cult of the aristocracy-landowners and the Catholic Church as the carriers of Polish patriotism. This wasn't a great soil for a strong labor movement. Despite this, a certain proletarian culture started to develop in big cities, especially in the Prussian partition in Poznań and Silesia as a result of industralization begun in the last decades of the nineteenth century; and in the Russian partition,

there were strong socialist currents in Warsaw and especially Łódz, where a movement against both Tsarist and industrial exploitation, concentrated in textile factories, had a major role in the 1905 Revolution. But in general, the labor movement and labor culture were not strong in Poland.

After independence in 1918, the newly formed Communist Party was banned. The moderate socialist party, the PPS, was influential in the factories and in the parliament, but its power was circumscribed after the May 1926 coup by its former leader, Marshal Josef Piłsudski. So despite the efforts and the memory of 1905, Polish proletarian culture was weak. In the 1930s, the whole of Europe was characterized by growing nationalisms and dictatorships, and it was no different in Poland under the dictatorship first of Marshal Piłsudski and then his associates. Our traditions were weaker than in the Soviet Union, where the massive revolution of 1917 pervaded the whole nation. We also had a weaker trade union movement than Germany and France. All this made the development of 'proletarian culture' unlikely. But it wasn't even bourgeois culture that was considered the national culture. It was the deeply rural peasant culture and the aristocratic culture of their landlords. This caste was also identical with the bearers of Polish patriotism and, though it's never named this way, our "imperial" aspirations and ambitions - sympathies which were kept alive throughout the whole existence of the PRL by the intelligentsia. In this way the liberatory forces in the Polish tradition were at the same time often deeply reactionary, and the only vision of Poland that was truly Polish had to be necessarily a vision that was nationalistic, Catholic, and what's more, a vision of the grandiose Poland, claiming the ownership of the *Kresy*. As it's beyond doubt that Poland has borne a huge burden of suffering – the Holocaust, severe repression and destruction by the Nazi occupiers, and then Stalinism - it proposes a history in which only revenge over the enemy is at play, refusing to see or recognize its own colonial claims and nationalism.

Although these were among the reasons why the Polish social experiment that started after 1945 and lasted for 44 years wasn't that successful, much else was the fault of the communist regime itself. It was imposed from the outside, set up initially as a Soviet colony, and it committed many crimes, which didn't exactly help to legitimize it. It systematically lied about its recent history – about everything from the dissolution and mass murder of the first Polish Communist Party by the Soviets in the late 1930s, to the denial of Soviet responsibility for the massacre of thousands of Polish officers at Katyn.

But many of today's class relations and people's relationship to the recent history, as well as the refusal to criticize the capitalist transition, still comes from this pre-Soviet history. As it should be clear now, even if the war didn't happen, Poland would still hardly have been on the economic level of the Western countries, even if we are to devote our time to such speculation. Yet we base our pretensions and dreams of being a 'regular European country' precisely on those claims. But the new regime, even if it raised Polish cities from the rubble, didn't make it easier to identify or accept its rules. Even if it was introducing egalitarian rules, it was doing so via coercion. As it was rebuilding the country and elevating the peasantry or proletariat to previously unknown levels of literacy (books went from having a circulation of 1000 before the war to have 50,000 or 100,000 – the number often proudly displayed on the title page), building schools, libraries and propagating culture, at the same time it fought the intelligentsia, who were plagued with repressions. Under Stalinism, if the Party wanted to promote the proletariat, it did so by keeping children of the intelligentsia out of university, or sending them to the country for 'reeducation'.

At the same time, they necessarily created their own ruling class and their own intelligentsia. This meant the upper echelon of the bureaucracy, but also a wholly new class of specialists, engineers, scientists and teachers, newly educated in the new circumstances.

5.3 Monumentalisation of labour. Stalin removed from compulsory worker's reading after 1956.

In some way, there was a continuity with the past, as a part of the previous intelligentsia survived the war. Yet, despite building this new ruling class, they couldn't openly admit that they, the Communists, had become it, as to do so would be to abandon any claims to socialism.

The lyrics listed at the beginning of the chapter come from songs, which, mostly in the Stalinist period (1949-54) and around the Thaw (1956), were intended to encourage, empower and ennoble the working class and the task of labor. They were mostly written in the poetics of socialist realism - incredibly simplistic, grandiose, spectacular and heavy. The style spread from the architecture of Stalinist skyscrapers to the choral songs, played on the radio, exalting the labor and glory of the working classes, resur-

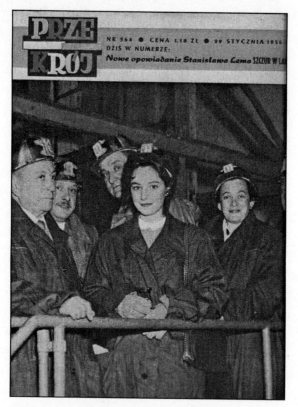

NR 564 ● CENA 1.10 ZŁ ● 29 STYCZNIA 1956
DZIS W NUMERZE:
Nowe opowiadanie Stanisława Lema SZCZUR W LA

5.4 Przekroj. The beauty of labour.

recting the dead, destroyed Polish cities from the rubble. The moment to build a new culture after the war couldn't have been more perfect: there was literally nothing left, as the Nazis left Poland in pieces. With its bourgeois and nationalist traditions, Polish society, only after enduring the loss respectively of its Jewish proletarian-petit-bourgeois base and a great deal of its intelligentsia and elites, had the ground "ready" to completely reformulate its structures.

In principle and on the surface, within socialism it was finally the proletarian culture which was to become the dominant culture. Also, for the first time it was given a splendour, scale and magnificence it never had before. Never before were such palaces of marble

and gold, devoted to culture and development of the laboring class ever built. Proletarian culture became the official culture: culture designed for the working classes, in theory at least. Because it must be asked if people really did enjoy it or feel that it was theirs? The solemnity, heaviness, seriousness and scariness of the new sotsrealist art must've been also a deterrent. Especially in its Stalinist period, it was designed by the same token, to discipline and intimidate people: the grandiose socialist realist design had the effect of domination and stifling as much as 'encouragement'. In reality, both reactions to the new culture were conceived to discipline people: as we know, communism was by no means accepted by the whole Polish society. So the initial efforts of the new authorities were designed to both please and rule an unruly society.

Post-Thaw, when there briefly was relative freedom and a lowering of censorship, culture, while becoming less heavy and rough (as must've been the stereotype of the proletariat), became lighter, more elegant... could we say more bourgeois? Today the locally patriotic songs sound nearly charming, especially about the biggest success of the post-war reconstruction, that is the capital, Warsaw. There are hundreds of propagandistic pro-Warsawian songs, often dressed as popular radio songs. From lighter tunes, cherishing the beauty of the Polish cities' streets, with "I could be a Parisian boulevard flaneur, but would it be as good as promenading in Warsaw?" (of course, the question is rhetorical), to the much scarier and heavier, choral songs such as "We're building the new Poland", giving the quasi-religious or even operatic properties to these – what are they? – folk songs? Agitation songs? Of course, the political song has a long tradition. But it was only by "stealing" from the already existing and established high cultural forms that the pathos and splendor could be given to this equivalent of proletcult.

But was this culture really empowering by the sheer value of singing of the working class? First of all, the new culture, even though it was glorifying "labor" and workers, claimed that labor

was in fact a pleasure and an honor, because it served the building of the beloved socialist country, never mentioning the unpleasant, wearying, life-shortening aspects of hard work. Work becomes the "most beautiful dream", membership in the party or organizations becomes "a new life", and the factory becomes "our beloved port". Crude and unimaginative as they are, they projected a reality on which work had incredible dignity, importance and its role was finally valued properly according to the value it had in the society. Yes, the working class is a necessary muscle of every society, without which any other activity wouldn't be possible, yet it's ritually dismissed and never written about in bourgeois art or literature. That was now to change. But was that just a revenge? And was PRL just a revenge on the previous exploiting class?

Cinemas were now full of films where heroic, beautiful proletarians (though with a rather characteristic muscular beauty) were reclaiming not only the themes and medium up to then reserved for the upper classes, but were also introducing a completely new aesthetics to that medium. But could we, at any step, call it a proletarian culture? Or was it rather another propagandistic way to keep the people out of the streets, to prevent any social dissent? From the beginning it was artificial: never being the real, spontaneous culture of workers, socialist realism was imposed on them from the start. But then we'd have to answer the question, what is the 'real' proletarian culture? A similar example is the way the 'folk culture' existed in PRL – in the form of orientalized, exoticized mass produced 'folk art', like that stocked in the national chain *Cepelia*, who sold examples of Polish folk art, relying on a patronizing, compromized vision of the Polish countryside.

Last but not least, proletarian culture couldn't really be dominant, but constituted a certain façade: PRL wasn't exactly a dictatorship of the proletariat, but a clandestine rule of the bureaucracy, which only gave the surface impression of letting the working class govern: the workers were a rising class within PRL, yet with no actual power, except perhaps briefly for the workers

councils of 1956. The only real revolution that happened in Poland was the one forced without the participation of Poles at all, at least according to the 'lost revolution' thesis of the Freudian thinker Andrzej Leder, expounded recently in *Krytyka Polityczna*. The social revolution was the erasure of two social classes: Jewish labor and Jewish entrepreneurs destroyed by the Nazis, and the Polish landlord class destroyed by the Soviets. That's why it could never be acknowledged. As they themselves had not carried out this revolution, the mentality of most post-war citizens was determined by the countryside, and they took that consciousness to the city with them when Poland urbanized and industrialized. Yet, for political reasons, this goes completely unacknowledged by Polish society, making it impossible to gain any sort of social class-consciousness. That's why we prefer to choose myths about ourselves: noblemen, landowners, the myth of the intelligentsia of interwar Poland.

This analysis would be attractive, if it was at least trying to present the point of view of all classes: yet eventually it's just another analysis from the point of view of the bourgeoisie. There are many erased histories within the post-war period, and the Holocaust was not discussed enough in PRL, and nor were the pogroms started by Poles themselves. Yet this analysis doesn't want to be compassionate with another 'other' in Polish consciousness - the proletarian. It chooses instead to present the masses as inherently primitive, peasant-like, backwards, conservative and reactionary, never public spirited enough to be really 'collective'. A huge counter-argument against this theory is the existence of Solidarity, the union and the movement, which counted 10 million people at its peak in 1980-81. On one level, Solidarity may have been traditionalist, wedded to patriotism and Catholicism; but it was also based on the premises of equality and self-organization, and really proletarian in its political outlook, at least at first. Solidarity, rather than being the expression of some primitive peasant consciousness, was a collective, civic-minded

and disciplined movement. But before Solidarity, there were many attempts to take culture to Poland's new working class.

## Aspirational magazines of Socialism

'I read Polish magazines', says a character in Edward Limonov's *Memoirs of a Russian Punk*, set in Thaw-era Soviet Ukraine. 'And why? Because I am interested in life and in culture'. During the Thaw, Poland had the most open press in the Bloc, in its publication of literature and also in the way its press were unashamedly presenting consumer goods, youth culture and popular culture. People all over the Bloc, like the poet Josif Brodsky, learned Polish just to be able to read uncensored stuff and world literature. The first post-war illustrated magazine designed for the new society in the wholly new circumstances was *Przekroj* (Slant) - the very same which tried briefly in 2012 to transform itself again into a leftist periodical - one of many adventures of the most important popular magazine in Polish history. 1945 was the Year Zero and as the reader should realize, the first few years after the war were a relative relaxation in comparison to what was to come. As early as May '45 *Przekroj* was founded - the first illustrated magazine of People's Poland, and which consciously embodied the revolution happening in Polish society. If I could describe it in one sentence, *Przekroj* was striving to make a magazine which could be read by all the new social classes of the New Poland, from the new elites to engineers to the kitchen lady, while at the same time smuggling in some of the pre-war charm and aspirations of the intelligentsia and bourgeoisie. It comprised of world news, columns, varying from cuisine to fashion and *savoir vivre* lessons to those serving the preservation of a material culture destroyed by the war. It had a mission, as one critic sarcastically put it, to "civilize" the nation, with the whole formation of its readers (circulation 500,000, and each copy was read by several people) considered "the civilization of Przekroj".

Visually, *Przekroj* embodied the social formation it tried to

5.5 Barbara Hoff's Przekroj fashion column

represent. And together with it went a style connected to the cultural ideal and ambitions they promoted - a combination of the pre-war intelligentsia's artistic aspirations and the new post-war democratization and homogenization of avant-garde and high art. *Przekroj* employed several graphic designers whose roots were in the pre-war avant-gardism, of course condemned as "formalism" in the Stalinist period. *Przekroj* took up what we could consider 'liberal' positions, yet the meaning of liberalism highly depends on the political context, and meant something else to what it did after 1989. *Przekroj* editors tried to discreetly 'educate' and raise the

nation, publishing suggestions and various kinds of advice, which was mostly incredibly mundane and, read after the years, reflects the dramatic shortages and grinding poverty in the early PRL. The first two decades after '45 were an era of special austerity: there was not enough good quality food, or food as such, housing was in a dramatic state, including people living in the "caves" left after bombings, crumbling infrastructure, no clothes or of very poor quality, not even mentioning care for their aesthetics or fashion-ability, and, of course, the already mentioned "social revolution", which meant that the traditional codes of behavior, of *savoir-vivre*, traced from the bourgeois society, were not only suspended, they were the part of the bourgeois past. *Przekroj* took the task of "re-civilizing" the nation in the reality of the implosion of everything that was before, discreetly reinstalling the bourgeois culture.

Advice on cuisine, where various cheap vegetables were "pretend" meat, or how to dress/make up, having neither clothes nor cosmetics, was combined with witty stories, usually written under pseudonyms by the editor Marian Eile and his deputy Janina Ipohorska, both editors and artists established before the war. Wit, charm and delicate persuasion were the weapons of *Przekrój* in their mission. This was conveyed not didactically, which was the norm in the humourless and heavily stylized socialist press, but via tasteful jokes assisted by the original graphic design and lay-out. *Przekroj* dealt with the growing alcoholism, encouraging sobriety and good manners in public places; promoted good health, advocating sport (that inherent element of every socialist politics and ideology, as a "typical entertainment of the proletariat"); and it promoted healthy eating and a less formal, democratic elegance.

The fashion column was one of the most important in *Przekrój*, and was basically a guide to how to do something and create a "look" out of basically nothing. It was initiated by Janina Ipohorska, but a few years later taken over by the young art historian Barbara Hoff, who ended up holding it for the next 50 years and becoming the first "fashion dictator" of Poland. The

nation had to be taught once again how to dress well, and the national clothing and fabric production was so poor that in order to survive in style, one had to live by one's wits more than ever. At the beginning, as Hoff has described in numerous interviews, this was an impossible task: when she realized there was nothing to write about, she asked the ministry for permission to produce a clothing line of her own. She travelled across Poland to factories, bought fabrics and ordered them to produce her fashionable, modern designs. They were still hardly available, yet Hoffland, as it was called, was, next to Moda Polska (simply "Polish Fashion") one of the rare

5.6 The unexpected return of the Thin White Duke in a book cover by socialist fashion dictator Barbara Hoff.

examples of the quasi-private, though officially nationalized fashion companies in Poland. Both have survived communism, and Hoff kept designing well into the 90s. You could be sure, that if Hoff wrote about a new style for wearing a shawl in her column, the same afternoon there would already be dozens of girls on the streets trying to copy this style. Her flagship idea was blackening the "coffin shoes" (i.e. light, paper shoes, used as footwear for the deceased) which when colored black could pass as elegant "ballerinas". As Czech journalist Milena Jesenská wrote in 1929, from a perspective of a fashion columnist,

*The fashion column is really for people for whom there is no fashion... The average person with an average job and an average salary cannot dress fashionably. She can, however, have superb clothes... It is up to her to*

*make clothes for herself according to fashion, adapting to it without aping
it. In short, the less money she has, the more art it takes to look good...
While many people think for a rich person, she must think for herself. The
fashion column in the newspaper is for people who love beautiful things
and cannot afford them. Only these kinds of people make culture. Only
these kinds of people have style: they are innovative, daring and modestly
restrained. The desire for things cultivates taste... It is a rare art to look
like a good human specimen, without much money or expenditure,
through one's own efforts and the proper organisation of one's life.*

The fashion column in *Przekrój* was doing exactly this: teaching
people how to be artists, often how to make clothes on one's own;
how to create elegance out of nothing by paying attentions to
details and creating visual sensitivity towards one's everyday life.
The images were accompanied by witty remarks and comments,
and in this, those delicate drawings by Hoff still emanate an
elegant, dandy austerity which we could look for in vain in today's
chain store driven fashion.

Only after making the everyday palatable, could the higher
needs be fulfilled, like the need for beauty, aesthetics and art. In
here is some of the greatest merit of *Przekroj*, which relentlessly
propagated modern art (in visual arts and music) and abstraction,
which extended to publishing "posters" with Picasso or Leger to
pull out and hang on the wall in the modest socialist salons, giving
away postcards of Polish abstract paintings to its readers or even
selling abstract paintings painted by the artists-editors. It also was
a vehicle to the post-Thaw eruption of the new, colorful design,
associated today with the Festival of Youth in 1955 in Warsaw and
Expo '58 in Brussels.

Yet, if this was a 'civilization', then it had to be according to
Norbert Elias's definition, i.e., civilization as something created in
the West. *Przekroj* supported the silent, careful rebirth of the 'cool'
in Poland too. It was creating 'positive snobbery' for the abroad, but
its sights were ceaselessly always turned to the Seine, not the
Moskva. It discreetly cheer-led the birth of the new, casual Western

5.7 Socialist folk queueing for better clothing. But why in French?
Cover of Przekroj authors fashion bible from 1958.

elegance, e.g. in the person of Brigitte Bardot and the new kind of free, careless, self-conscious girl. From the 60s films of the Polish school, like Janusz Morgenstern's *Goodbye, See You Tomorrow*, or *Innocent Sorcerers* by Andrzej Wajda, there emerges a certain kind of noblesse, even if produced with little money. This is the era when the youth prefer, rather than the rough sleazy American

culture they pretended to have in the '50s, a noble and stylish European version: they wear black and dark sunglasses, listen to jazz, are sexually liberated, looking like their counterparts in the later *Nouvelle Vague*. Or at least that was the image promoted in the suddenly liberated and West-friendly atmosphere of the 60s. This is the reason for the golden era in culture, art, film and design that ensues. Whereas elsewhere the 60s meant the most hectic time of social revolutions and upheavals, for the Bloc it meant that for the first time, consumerism was noble, as noble as art.

*Przekroj* was never a simple proletarian agit-prop of the authorities. It was neither bourgeois enough nor proletarian enough, said to be too westernized for the communist *poputchiks*, and too ideologized for the pro-Western intellectuals. It continued to be inconvenient even after 1989, when it wasn't socialist in content at all. So why did the civilizational mission of 'culturation' in the new society have to be always understood as 'liberal' or 'bourgeois'? To answer this question we have to come back to the previous divagations on the force of proletarian culture in Poland. And this wasn't strong enough – aside from the beleagured efforts of the PPS or the Bund, liquidated by the war, or the efforts of Polish futurists and constructivists, there wasn't much of a legacy to build upon. Or, one could say, the proletarian culture, of big cities and their industrial bases, was often Jewish, and disappeared together with their extermination. So anything culturally sophisticated was automatically suspicious (or celebrated) as being 'bourgeois'. Yet it's hard not to sympathize with the style of *Przekroj*, today inspiring only nostalgia for the sophistication of its language and good taste, which despite being egalitarian in its message, also tried to decompress the crude ideological information it had to provide.

Another level of the strange discrepancy between the official state policy in "bringing up the nation" and the practice was the strange existence of 'luxury' goods. While *Przekroj*'s strategy was to seduce, become the part of a life and then 'raise' its readers, *Ty I Ja* monthly was pretty elitist: a strange combination of an artist and

luxury magazine, with an avant-garde lay-out designed by Roman Cieślewicz. Cieślewicz was a pioneer of animated film, pop-art and Neouveau Realisme in Poland, who later migrated to France to design for *ELLE* and became one of the most prominent Polish artists living in the West. Driving from surrealism and his own version of Pop, Cieślewicz's covers invited the reader to dream, they were a window to the secret life of unexisting bourgeoisie, in the atmosphere of Bunuel's *Belle du Jour* or the erotic tales of Walerian Borowczyk, another Parisian exile. It was expensive and presented haute-couture creations from Parisian fashion houses arranged in an artistic way, houses of artists and famous writers, in a way which didn't at all correspond with anyone's lives but those of the high officials.

## A Festival of Youth

For the communist authorities one of the most important aspects of the everyday ideology was to keep home production on the level which, at least officially and in the local media and broadcasters was presented as being "as good as" the Western one. Maybe at the beginning, in the post-war years, when the countries were still in reconstruction, this aspect didn't matter, as the whole world, including the West, was dealing with shortages and austerity for several years after the war, with rationing lasting even in the UK until the mid-1950s. It was difficult in the freshly socialist, war-destroyed Poland to explain to people the shortages in production and the low tempo of the growth of the infrastructure. Yet, from today's point of view, the growth and reconstruction of Polish cities, given that it happened from scratch, was immense and on an unheard of scale. This progress occurred at the same time as the harsh introduction of the communist order, in which any remnants of the pre-war structures were leveled. One may say they were leveled by the Nazis first, but it still meant the new system had a once in a lifetime chance to change the social stratification of Poland.

Alboż wiadomo skąd się bierze kochanie? *(Sienkiewicz)*

Roztropny nie nosi drutu
kolczastego w kieszeni.
*(Bracia Rojek)*

Dobra babka nie jest zła.
*(Monatowa)*

5.8 Popularising abstract art. 'Przekroj''s postcards adorned with funny
quasi-proverbs.

To young people after the war, it didn't necessarily matter what
the big conflicts and the big history were about. For them, the
matter of life, here and now, was what counted. This is shown well
in several novels from the era, such as Skvorecky's *The Cowards* or
Leopold Tyrmand's *Zły* ('Badass'), which describe the lives of
young people right after or a few years after the war. The material
side of life, the body, sexuality, enjoyment appear here as the filter
through which young people perceive and receive the world. For
Skvorecky's young Czechs, it didn't matter if the girls they encoun-
tered were the 'enemy'. In this way we can also understand the
creeping youth revolt that was taking place, though it never really
triumphed in the Soviet Bloc, but had its phases and levels. The
youth revolt in the Soviet Bloc was weird, because it at the same
time rebelled against and embraced, or at least tried to, the very
Western "consumerism" and "conformism" the Western youth
were contesting. But who was the real rebel here and who was the
conformist? One of the most interesting views was offered by the
writer, anti-communist and admirer of all things Western Leopold

Tyrmand, in his banned *1954 Diary*, long a cult book in Poland but never translated into English:

*A great deal of anxiety about "clobber". The last Monitor announces a great failure, i.e. a new law about duty put on packages sent to Poland from abroad. This is the end, really. How to even start to show the scale of the unhappiness? Not many realize that since the end of the war three quarters of the clothing consumption of the society is being satisfied by abroad. Actually, America, a dozen charity organizations. That was the militant period of Polish fashion: the elegance was battle dress…*

*"Clobber" and color were in a great way dangerous for the system, because they were direct, everyday. Against what they say that they want to give joy, gaiety, colorfulness and carelessness, communists want only greyness, not-being, a colorlessness which wouldn't take the population away from their sacred ideals. Some kind of uniform ugliness leveled to the rank of moral norm – this is a new ideal of the common usage. They want to see us all in Stalinist jackets and overalls. Lack of charm is a virtue, the appeal of the looks is subversion. Hatred of originality, joy, brightness, individuality, eccentricity, is within communism organic, because every egalitarian ethics is about seeing good in the average and plainness. You can't show a pretty girly face on a magazine cover. But Poles, even the most stupid ones, understood, that the style one dresses is in every era a function of beaux arts, and this way of dressing is in a way an act of resistance. No iron curtains consist a barrier to it.*

Tyrmand identified the Soviet ideology with the lacklustre nature of its clothes and design. Yet today we all know how "emancipation via consumption" ends – somewhere in *Sex and the City*'s Carrie Bradshaw's epiphanies over Manolo Blahnik shoes. Fashion shows how the circumstances change the semantics of any object. In reality, the greyness of communism was another myth. But as the beauty of the system was meant to be one of the most visible and consistent elements of life under Eastern European socialism, surrounded from every side by images of idealized, fit but hunky workers, robotniks and robotnitze, looking at you from

5.9 Leopold Tyrmand's novel 'Badass' (1955) was his protest against the new reality, by celebrating Warsaw demi-monde and reviving the pre-war city mythology (cover by Jań Mlodozeniec)

the monumental art, murals, buildings decoration, banners and streets, the viewer was not always gaining in the famous Stalinist "gaiety".

This chapter takes its title from one of Tyrmand's phrases. The *1954 Diary* is a unique document of late Stalinism in Poland. Tyrmand was shaped by a different system – from a Jewish intelligentsia family, he was sent to Paris for architectural studies and survived the war in a Nazi camp in Norway. In post-war Poland he tried to pursue a literary career, publishing in *Tygodnik Powszechny* (*General Weekly*), a Roman Catholic yet progressive magazine, still for a time allowed to publish with a light censorship. After *Tygodnik's* liberal editors were fired all Tyrmand's novels were pulled by the censors. Tyrmand was an example of a liberal, pro-Western intellectual, turned conservative in the clash with People's Poland. His anti-communist crusades are today a record of what a non-communist intellectual, with the previous era in his memory, thought about the new reality. They have their limitations - Tyrmand was still very much indebted to the pre-war view of life and politics, and Western democracy remains an ideal for him, regardless of the political impossibility of its realization in Poland. A militant liberal, neither the anti-Semitic, nor nationalistic views prevalent in pre-war Poland made him embrace the new system. He became its most fervent critic, from a cultural and political point of view remaining a devotee of the West, deploring the new system's shabbiness. While a petit-bourgeois in many of his cultural tastes, valuing the easy listening of Glen Miller as the highest form of civilization, this promoter of jazz and everything Western was one of the most colorful intellectuals of the Soviet period in Poland.

As I've stressed here, Poland in 1939 was an underdeveloped

country, pervaded with all the problems of the time: financial crisis, nationalism, right wing dictatorship, anti-Semitism, xenophobia. Tyrmand chose to ignore the fact that even if the Second World War didn't happen, in those conditions Poland would at best become a minor country massively dependent on the West. Yet for him, the fact as a part of the Warsaw Pact Poland didn't have to rely on the West was insignificant. He believed that the biggest tragedy of living under the burden of real socialism was the drastic lowering of any aesthetic, spiritual and intellectual aspirations and expectations of men and women: a reality where the silent subjection of the individuals to the authorities was not enough – it also had to have power over their minds. Tyrmand's critique referred especially to the earliest, harshest Stalinist phase of PRL. As a member of the intelligentsia, Tyrmand had little understanding and belief in the efficiency of the programme of equality. The so-called social advance of the people from countryside to the cities he regarded as disastrous. The omnipresent socialist rhetoric and the newspeak of Stalinism was to him the death of reason.

Many of Tyrmand's fears cannot be completely dismissed as the typical classist fears of the intelligentsia, a la Ortega Y Gasset, hateful of the masses. Tyrmand saw correctly the abyss between the existing shortages and the promises of the authorities. His "Primer on Communist Civilization", translated and published in 1972 in the USA as *The Rosa Luxembourg Contraceptives Cooperative*, is an alphabetically juxtaposed 'komuna vocabulary', with short chapters like 'How to be/do x' or 'What is X', within communism. Topics include 'How to survive education', 'How to use a telephone', 'How to oppose', 'How to be a playboy' or 'How to be Jewish'. There's also one on 'How to be a woman', where Tyrmand seemingly demolishes the new liberties and equal rights women gained in socialism. First of all, the ideas of equality in communism were always rotten, and the in the process of joining the physical hardship of workforce, women gave up their womanhood and turned into masculinized unhumans. All this rather banal

misogyny wouldn't interest us, were it not for the fact of how little has changed. In the new capitalism Polish women have in fact less freedom and are subjected to greater misogyny than under socialism, where at least basic freedoms, like abortion, contraceptives, and equality within the workplace were officially guaranteed.

But for all his reactionary devotion to the West and his final

5.10 To consume or not to consume. The new PRL generation (Innocent Sorcerers) by Wojciech Fangor, 1960.

defection (where he pursued a career as a conservative/republican publicist and, interestingly, never wrote anything remotely as important as while living under communism), Tyrmand both observed and embodied something that was specific to Eastern European communism. In his writing he remains completely dependent, even mad about it. He constantly uses phrases and metaphors showing his lack of objectivism. He constantly uses the phrase 'they'; 'My attitude towards communism is my outcome of my life under communism', he writes. Tyrmand often behaves as if he owned communism, completely unaware

and uninterested what it might have meant for people outside of his milieu. Tyrmand, who was privileged under the socialist system, which gave free flats to the members of the writers union and supported them financially, couldn't see the connection between the censorship and the privilege he was getting. The latter was transparent to him, and often he even speaks of it as just another form of repression.

Tyrmand was not the only intellectual in the communist state, who, while using all the privileges and being implicated in it, got a sudden myopia when criticizing its shortcomings. He took his derision of working women for a serious act of system critique, rather than simple misogyny. He often seems as if he'd like no

women to work, or only middle class fashionably dressed women to do so. While seeing the poverty of the working class in post war Warsaw, he was blind to their newfound literacy; nor does he consider that giving jobs to these 'masculinized' women working in the city was a rather positive alternative to being imprisoned at home. Intellectual critics of the system couldn't take the lower classes into account, because that would ruin their line of reasoning, in which the system is portrayed only as the evil slaughterhouse of aspirations.

Yet Tyrmand remains interesting because he embodied certain aspirations just as naïve as those of his opponents. Dressed famously in colorful socks, listening to jazz, reading and writing Western-style literature, he became an idol of the nascent class of youth, born before the war, who only knew socialism, and who came of age around the Thaw. These people were the closest we had to the Americanized Western youth culture. There was the emergence of the student theatres like STS and Bim Bom, linking the traditions of surrealist avant-garde and poetry, a repressed memory of the war time illegal art and literature with the new spirit of jazz and new wave film - the spleen and the glamor of the beautiful actors in Wajda's *Innocent Sorcerers* (1961). Their literature was Marek Hlasko and Tyrmand himself, their cinema was Wajda, Skolimowski and Polanski, their music was the highly original, Polonized jazz of Krzysztof Komeda, Tomasz Stanko and Zbigniew Namysłowski, published in the famous vinyl series *Polish Jazz*.

However, like many other pro-Western bourgeois intellectuals before and after him, Tyrmand's love of the West came from the fact that the West he knew was the cultivated and sophisticated world of Parisian museums. An author on the other side of political spectrum to Tyrmand, was the reporter Ryszard Kapuściński, who, elevated and educated by the communist system, becoming its flagship journalist, actually travelled to those less known territories subject to Western influence or domination. In his recent biography of Kapuściński, Artur Domosławski notes the incomprehension of

the journalist's contemporaries, who can't really believe in these stories about ruthless French or American murderers.

*For the twenty-somethings at journalism school and Kultura, socialism is rather absurd, nothing but empty rituals and boredom. They dream of a comfortable life and the outside world: the West is where it's at! Someone is going on a scholarship to the States, someone else is off on holiday to Western Europe. In the West these young people get a large dose of new impressions, experiences and ideas. Yet Kapuściński comes back from that outside world and speaks of the West as having enslaved the poor countries of the Third World, and of the curse of 'American Imperialism'. For the young people, the stories of their colleague and master sound like sheer cant, while for Kapuściński 'American imperialism' is not a platitude but an accurate description, something he has touched, sniffed and seen.*

Domoslawski quotes one asking him 'You don't like America, but why do you carp at the French, too?' 'You know the French from Paris – cultured, educated people', responds Kapuściński, 'but I know the ones from the colonies. They are barbarians! If you get in their way or frustrate their business interests, they'll kill you'. As in the frequently quoted saying from the transition – 'they were lying to us when they told us about communism, but they were telling the truth about capitalism'.

Were all the youth of Eastern Europe all eager westernizers? Polish-Jewish Marxist historian Isaac Deutscher saw the Russian youth movement otherwise, writing in the 1963 essay 'The Soviet Union enters the second decade after Stalin':

*Western observers of the Soviet scene are often struck by what they describe as the gradual Americanization of the Soviet way of life. They notice a general preoccupation with material comfort, a weariness with ideology and a craving for entertainment, widespread profiteering and blackmarketing, cynicism and pessimism among the young, especially among the Soviet beatniks, who look sometimes like real cousins of their*

*Western counterparts. These observers conclude that Soviet society, or at least its upper strata, are undergoing a process of embourgeoisment... This view seems to me erroneous. The general preoccupation with material comfort is real enough; and so (after half a century of wars, revolutions, and Stalinist terror) is the longing for a relaxed, easy-going life. Yet, the so-called Americanization is rather superficial and transient (although it is connected to some extent with the Soviet ambition to catch up with the USA industrially).*

'The little profiteer' – continues Deutscher – 'the beatnik, the

5.11 War fashion. A photoshoot in the ruins of Warsaw in Ty i Ja, 1960s.

*stilyaga*, and the enthusiastic admirer of the latest Western pop song and dance, who so quickly catch the eye of the Western visitor – all of these are marginal characters.' To Deutscher, the appearance of the westernized youth, *stilyagi* or *bikiniarze*, didn't change the natural course of the society's structure. The 1950s were the era when the workers could re-embrace the equality from the times preceding Stalinism, regardless of the other social classes inertia. Thaw generation poets like Yevtushenko, reaching for the 'values of the 20s', were hugely popular and it was them, for Deutscher, who were really the avant-garde and the rebels of that era, not the *stilyagi*. The 'resurgent egalitarianism' was the word of the day. It was very different to Tyrmand's simple equivalence between consumerism and subversion. Both Polish Jews, divided by a generation, Tyrmand and Deutscher could not have had more different ideas about young people under socialism and their desires.

## You and Me and Things: Socialist Objects of Desire

As capitalism grew and reached its heights via textile production in nineteenth-century England, textiles and capitalism, textiles and production seem to be a perfect way of discussing the meanders of both production and social reality under communism. Its most obvious consequence, fashion, is erratic, passing, unstable and speculative – precisely what socialist production didn't want to be. In this way fashion behaves like a modernist, avant-garde movement, which has to erase everything solid, in a permanent revolution of dress. Yet Soviet man was supposed to be focused on something not only stable, but something eternal, something monumental.

As Dick Hebdige puts it his *Cartography of Taste*, in the UK 'although during the Cold War the prospect of Soviet territorial ambitions could provoke similar indignation and dread, American cultural imperialism demanded a more immediate interpretative response... America was seen by many as an immediate embod-

iment of the future taken from Huxley's *Brave New World*, Fyvel's Subtopia, Spengler's megalopolis, or Hoggart's Kosy Holiday Kamp. Since 1930 the US served as an image of industrial barbarism...A country without a past and therefore no real culture, ruled by competition'. Yet it had its extremely appealing popular culture and fashion. Fashion was an obsession and real factor during the Cold War, enforcing the easy qualifications that everything exciting comes from the West. So if fashion, as a thing that relies on a changeability that is erratic, uncontrollable, unstable, is like a metaphor for capitalism itself, what then of fashion under a planned economy, that couldn't and wouldn't be subjugated to the terror of supply and demand?

Fashion was in the post-45 Poland a matter of negotiating between what was available, what was smuggled and what could be self-produced. Women had to become at once fashion designers, illegal fair-hunters and queuing masters, trying to guide themselves to what was fashionable. Creativity, DIY and also a desire for Western goods was mediated by *Przekroj* and *Ty i Ja*, with their "moral mission" of showing post-war society a way through the perils of censorship. Fashion definitely existed in real socialism, but it wasn't really 'fashion' in the capitalist sense, fast-moving and fast changing. DIY, practiced by everybody in Soviet Bloc, was closer to anti-fashion, made against the industrial dialectics of supply and demand. Because of the unavailability of goods or the poor quality of the local production, DIY magazines and TV programmes flourished across the Bloc, counselling its citizens in areas as different as fashion and science, furniture and electric inventions, at the same time trying to trivialize the shortages and cover for the poor quality of goods by promoting the popular wisdom and the terrific skills lying dormant in every Mr and Mrs Smith.

According to Marshal Tito, socialism was an 'essentially consumerist society', and Yugoslavia, as a part of the non-aligned movement, definitely belonged to the most liberalized in this

matter in the whole of Eastern Europe. Yet it differed in this to the official version in the Bloc, where magazines promoted goods that were completely unachievable for any settled citizen, and unless smuggled, could only exist as the dark objects of consumerist desires.

Yet there were counter-strategies against the grayness, which from today's perspective can be seen as an attempt at extending the high-minded pre-war status of upper classes rather than the mere imitation of America. But the goods craved by the youth were not only cultural, they wanted good alcohol, cigarettes, pants and silk stockings (the crucial commodity through which Maria Braun makes her spectacular post-war career, in Fassbinder's *The Marriage of Maria Braun*). In socialism, one is not supposed to desire something as low as mere things and in any film from the early 50s material goods barely existed. One was supposed to withdraw the craving of things and work hard for the sake of the future and an always-postponed prosperity. This strangely enough corresponded with the pre-war ideology of the nobleman cultural intelligentsia of Poland. There, you were not supposed to be materialistic or admit you want things, which you were giving up in the name of higher, immaterial ideals. Ironically enough then, in this sense the new, post-war socialist ideal was adopted from the former upper classes.

How else could it have ended up apart from an even greater craving for the goods one was deprived of? In the Bloc, the mystery surrounding Western goods added to their metaphysical mystique, much in the Benjaminian sense of the "aura", yet augmented by the fact that even with money you still wouldn't be able to have them! Unless you had some amazing contacts within the Politburo, knew someone or were yourself involved with the smuggling of foreign goods to the black market (the essence of Warsaw described by Tyrmand), all you had was the fantasy. In later years, our freedom to buy was extended via the special foreign currency chain Pewex, where many sighed-about Western goods were available, including blue American jeans, but only with Western hard currency. It seems

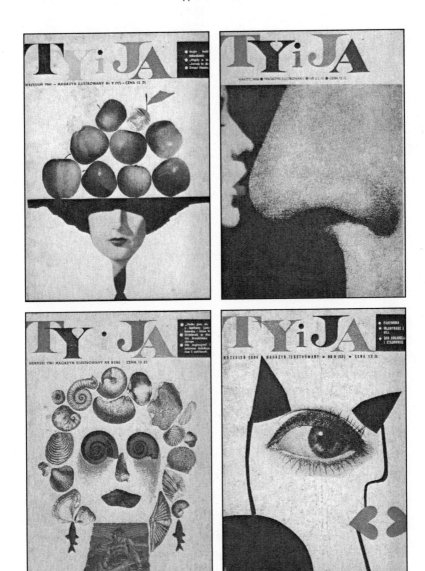

5.12a Everyday surrealism. Ty i Ja (You and I) luxury magazine,
designed by Roman Cieslewicz.

that we're still seen via this prism of fantasy-power by our Western
counterparts. Some films from the time took this easy dichotomy
and pushed it to the point of absurdity and destruction.

## Does it matter? It doesn't matter! An invitation to destruction

In Věra Chytilová's *Daisies* (1966) two young women do *nothing* for the entire film, apart from: eating; lying on their bed in flamboyant costumes; rolling in a meadow; chatting up men and making them pay for them in exclusive restaurants; catching flies; sitting/lying down, *neglige*, in stupefaction, like mechanical dolls; awkwardly trying to attract men to then run away from; and throwing and wasting enormous amounts of hard won and fought for socialist food, in an obvious act of disdain for Czechoslovakian men and women workers' toil and socialist values. If anything, *Daisies* is driven by a sense of play, so rare in cinema, with an open-ended structure, which at best works as a series of episodes. If the stabilized socialist society (as we can call the 1960s) could be characterized by the rigidity of norms, conformity, lack of spontaneity, oppression, stiff rules directing every moment of life, then everything the two Marias do is aimed exactly as disclosing the organism's diseased bones, as if even the slightest blow of unruliness could easily overthrow this carefully constructed mediocrity. In fact, the state's power wasn't exactly that frail at all, as the 1968 Warsaw Pact invasion and the end of the Prague Spring made most clear. But to maintain the ideology – similarly in Poland or USSR – the conformity of others was essential.

Made two years before the Prague Spring, *Daisies* was the product of a deep socialism, with all its sleepiness, sheepishness, closure of perspectives and with a return to private, family life. *Daisies* goes precisely against all this. Shot in radical, strong, 'hippie' tie-dyed colors, it also went against the greyness of socialism, creating an anarchic alternative. *Daisies* remains one of the rarest and strongest satires and subversive fantasies of a life under socialism, which never really took place. Maria and Maria from Chytilová's film remind me of the 'theory of form' developed by the Polish modernist writer Witold Gombrowicz. In his view, form is something negative: a pervading power of conformity,

turning us into pitiful members of mass society, an opposition to which would be a romantic aristocrat of the old type. Yet Gombrowicz was rather up for the un-made man, a man without qualities, without feelings, without dependencies. No wonder he never came back to communist Poland, but before he became canonized as a writer in France, he preferred the life of an sexual outcast in Buenos Aires, much in the Jean Genet lowlife/whore-affirmative way.

The two Maries are on a mission to unmake the socialist stereo-types of womanhood: mother, wife, worker, nice girl from youth organisation, homemaker. They want to live on the margins of this society, still manipulatively using their girlishness to obtain their goals: a free dinner, adoration and lots of fun at men's expense. At the same time Maria and Maria's excesses visibly bring them little jouissance. Whenever they're up to something fiendish, they have their little dialogue: *Does it matter? It doesn't matter!* Precisely: whatever they do, it doesn't matter. The fun derived from breaking the rules, from constant line-crossing lasts perhaps two minutes, only to make room for the usual dullness and boredom (even hopelessness) once again. The more they try, the more they go to an excess, the more pointless it is. They're on a quest for form. They are women – which means within the society they don't have an inherent form just by themselves. What for Gombrowicz was a blessing and a liberation – escaping the overpowering form, becoming a dandy of the spirit, a ready product to be admired - for them becomes the reason they fall. "We will be hard working and everything will be clean" they promise. "And then we'll be happy".

People who have fallen out of form is a frequent topic in socialist era Czech film, because not working was the highest form of subversion in countries where it would straight away qualify you as a 'loafer'. In *Of the Party and the Guests*, Jan Němec's 1967 film, a group of upper echelon system beneficiaries lose their form. In turn, they are left adrift – without the system that made them feel important, they're nothing. Planning a nice picnic with their

wives, they suddenly are taken over by a mysterious group of people – apparatchiks? Government officials? Best not to ask too many questions. Again, there's an obsession with food which can never be consumed, just like in Buñuel's *The Discreet Charm of the Bourgeoisie.*

Are the *Daisies'* Marias bored, or empty or simply stupid? Their waste of time, labor, food, and the pointlessness of their own ways suggest they are outcasts of society – and they suffer because of that. Is this film really a praise of anarchy? The girls are rather dejected and depressed by all of the increasingly scandalous pranks they perform, so joyless. They exist between automated dolls from horror movies and eccentrics from a Beckett play. Self-reflection makes them unhappy. The two Marias are also women reclaiming their time, which normally is supposed to be spent on work, nursing men and children. They try (and fail) to realize their dreams: of a pure virgin, parading on a meadow with a wreath on her head. They plant flowers and vegetables on their bed, their room is a laboratory of fantasy. They seem constantly hungry. The motif of food and femininity in *Daisies* is strictly surrealist and had great traditions in Czech art, which produced some of the most interesting art in that spirit. Food as fetish, as sexual object was often a factor in Czech surrealist art and film, from the 1930s paintings of Toyen to the animations of Jan Švankmajer.

In Švankmajer's work food becomes basically "existential" and stands for the general hopelessness of human existence; the hopeless mundanity, the routine and repeatability of everyday activities, such as eating three meals a day. This is also deeply felt in the short film 'Meat Love', and is a motif that he repeats in his late film *Lunacy,* which was partly inspired by Marquis de Sade, a huge influence present also, in a sardonic way, in his *Conspirators of Pleasure.* The world of Švankmajer is always impossibly twisted and distorted to the degree that we barely recognize the familiar elements, stripped down to the libidinal rudiments of id, all-consuming, violent and unpredictable.

5.13 Not for human consumption. Food anarchy in Daisies.

The screenplay for *Daisies* was developed together with Pavel Juráček and Ester Krumbachová, two artists in their own right - especially Krumbachová, a strikingly original costume designer, writer and director, and a somehow tragic, unfulfilled figure, who collaborated with Chytilová also on the oneiric *Fruits of Paradise*, and co-wrote several exuberant surrealist Czech classics, like *On the Party And The Guests* by Jan Němec, Karel Kachyňa's *The Ear*, and *Valerie and Her Week of Wonders* by Jaromir Jires, but then, as a self-reliant director she didn't have similar success. Watching her only film, *The Murder of Mister Devil* (1970) we see that despite being possessed by an extraordinary visual imagination, on her own Krumbachová couldn't go beyond a combination of visual gags, without a principle organizing it. In *Mister Devil*, the visual means overshadow the actual content. We see a perfect bourgeois woman in a perfect flat preparing a real feast for her rather unimpressive functionary partner/husband. The feast is completely disproportionate to the small scale of the evening, yet the dishes just keep coming and coming, more and more breath-taking, and the whole film reminds me rather of Marco Ferreri's *La*

*Grande Bouffe* or a similar transgressive anti-capitalist 70s fantasy. Yet given the title, and the superb poster, in which the screaming man is drowned and eaten in a ice-cream sundae by a smiling Medusa-woman - designed by Eva Galová-Vodrázková, in the best traditions of the Czech and Polish school of poster, with excessive

irony and surreal/dada spirit, from where Linder Sterling must've learned some of her technique too - it was a strongly feminist statement playing with anti-feminist sentiments, about a woman who's using one of her only 'weapons' - food, as a way to make everything in the world implode.

Food and wasting food is a great taboo, not only in socialism but also in capitalism. The two Marias walk on food, crush it with their high heels - an analogue scene is repeated by Ulrike Ottinger in her *Trinkerin*, with the character walking on broken glass. Yet their consumption seems faraway from a joyful carnivorous feast. Was

5.14 SCUM manifesto in Czechoslovakia. The poster for Krumbachova's Murder of Mister Devil.

excessive eating truly subversive within the socialist state? It definitely was, especially in the light of woman's role within society, of her body being ogled and consumed, combined with her role of a family food provider. This is related to the sexualization of women eating, which today instantly brings to mind images from the hardcore pornography, with the scene of a zoom on woman's face, as she licks sperm from her face, the so-called money-shot. The sexual attraction of a 'money shot' is a pure male fantasy – but the thing is, as Mark Fisher points out, that the pleasure lies not in the fact the girl really 'enjoys it', but precisely that she willingly pretends to do so. As a good worker, it's not enough she just sucks somebody's dick, she must do it with a smile. In The *FACE*

magazine in 1988 there was a photo session called 'ALEX EATS', with the relatively unknown skinny model, shot repeatedly as she eats in various settings, with the stress on the food that's being wasted rather than consumed. Overeating excessively, yet retaining her skinny flesh, Alex was openly mocking really existing eating disorders. It was the beginning of the 90s waif-like model, when magazines openly promoted an anorexic and unhealthy look. In the cardinal scene of *Daisies* involving food, the two come upon an abandoned banquet, with a table groaning under the weight of most gluttonously arranged piles of food, a real Balthazzar's feast, completely uncannily displayed in the midst of socialist scarcity. What ensues is the girls breaking into a final, elemental jouissance, where the food is consumed and destroyed, transforming into an ultimate orgy. Like children left home alone, they destroy as much as they can. They seem still addicted to the classic denominators of beauty – they must parody the fashion catwalk, dressed in mayonnaise, salad and curtains, to finally get rid of the nagging beauty ideal. They try to be flirtatious, yet they are ultimately afraid of sex: rather shy, they much prefer their own company to the boring/stupid/intimidating men.

It seems that the woman's body just never can be right, no relationship she has with food can be liberatory. Too fat/thin, or not thrifty enough. In *Daisies* the meaning of food is contradictory: the two Marias neither really chew and swallow their food nor take pleasure from their anarchic waste of it. But this association of women and food runs incredibly deep. Women are supposed to take pleasure from eating and preparing food, which makes their bodies equally prone to consumption. Natalia LL, the pioneering Polish feminist conceptual artist, made a still shocking series of so called *Consumption Art* in 1970s. The films and film stills show LL, then an attractive bimbo-blonde, 'consuming' various phallic foods: she's licking and slowly unfolding a banana (then also a symbol of luxury) and then sucking it intensely, she drinks cream and lets it dribble all over her mouth and face. She smiles seduc-

tively as she does it, licking her lips with visible lust and voraciousness. She nailed perfectly (and prophetically) the conflation of capitalism and pornography and the role the exploited woman's flesh plays in it. Not only was consumption as such a highly ironic notion in PRL – LL, like many women artists from the socialist republics, felt the burden of being thrown into a role of a

5.15 Sucking it up. Natalia LL in her dairy delirium.

'harmless chick', whose only role is to look good and conform well within the image of healthy socialism.

The Croatian artist Sanja Iveković, coming from the much more liberal Yugoslavia, similarly thematized woman's role as a 'sex kitten', in the women's magazines promoting consumerism and 'self-care', of endless making up, beautifying, sexing-up through buying clothes and cosmetic products. She exploited this in the hilarious series *Double Life* (1975), where she put together magazine advertisements with photos of sexy half-naked models in erotic poses, with her own self-portraits miming their seductive gestures. Unlike Cindy Sherman, 'deconstructing' the rules of the capitalist spectacle by pretending to be various people, Iveković stresses the sheer idiocy of porn or consumption in a country that remains much poorer than the West, with its ridiculous pretensions to Western 'glamour'. But there are much darker undertones to it yet. In the compulsory consumption of the Yugoslavian state she saw the obliteration of women's reality: in *Black File* (1976) she juxta-posed the photos of sexy pin-ups from men's magazines with paper cut-outs about missing women arranged like a police file, "Where is Liljina?" or "Brankica gone missing". Women under pressure come back in *Structure*, where Ivekovic again plays with the ironic caption-image pairing, putting old photographs of women, some looking like from they were taken from nineteenth-century

physiognomy books or catalogues of mental diseases, and pairing them with ironic commentaries, like "Expecting her master's return", "Sought consolation in horse racing and nightlife", "Had enough of being a good girl" or was "Executed in Bubanj in 1944". As if death was the only apt punishment for the nice girls gone bad.

## Give me all that I want!

The late 1970s, the end of the Edward Gierek era, when the bill for Poland's attempt to borrow its way into consumerist abundance was called in, was a moment when all the dreams of efficiency must have had reached their end. There was no possibility of pretending anymore, the decade's prosperity was a sham. The affluent 70s started to reveal itself as a delusion of wealth: achieved due to massive loans which threw Poland into a dangerous debt. A decade which started with the tragic repression of strikers on the Baltic coast, ended in the massive economic crisis that started to reach every level of society. Aptly, the Gdansk shipyard strikes were prompted by the fact that meat prices were too high. Then Martial Law came in December '81, the coup led by General Jaruzelski and his army junta against its citizens. Curfews meant people often had to stay together at each other's houses.

One of the best Polish post-punk bands of this era, Kontrola W were originally named "Kontrola Władzy" (Control of Power), but probably because the group didn't want to get in trouble, they decided to shorten it – at some gigs when they were announced, someone from the crowd said: *but you can't control power! But it's about us being controlled* by *power* – the band allegedly replied (later they claimed that the W stood for *Wrażenia* (Impressions)). Still, the lyrics remained militant and pugnacious, with the music merging retro rockabilly elegance and postpunk erudition, bringing to mind Burroughsesque topics of control from the state, communist newspeak, atomic war, nuclear crisis, hiding in bunkers, imagining the end of the world, fear of pollution and radioactivity, state-controlled media brainwashing society, erasure of the self by the

mass culture, personality crisis. Sound familiar? These were typical disillusioned subjects for punk and post punk, but they had an extra resonance here. For instance, they ridiculed and questioned the efficiency of Poland's collapsing post-81 economy. Like Xex or Devo earlier, they reacted with its absurdization: *Your factory leads in the world/they make everything the best in the world/ radioactive!/Radioactive little balloons/Radioactive ties/Radioactive lipsticks/Radioactive dummies!* Then the song comes back to the bleak reality of work: *Your leading factory/you work there four shifts a day/ and have no time/for romances/no time/to be intellectual!* The factory existence influences the whole worker's body and physiology: *Radioactive are your eyes/your hands/your heart/your brain!*

On the top of that Kontrola dressed like something between Russian futurists and post-war Polish pioneers. But we must remember what was actually happening in Poland around the time the band came to existence. Shortly after they got together, Martial Law was proclaimed, which in its first phase was like a real war for many people: tanks, food crises and rationing, curfews, people arrested, 'accidental' deaths on the streets, terror. In this atmosphere Kontrola W took part in youth festivals from 1982, and in 1983, only when the repression began to be relaxed.

Leader Darek Kulda says in an interview from 1984: *I wanted to make an ugly music. It was a period when on Polish radio there was nothing apart from hard rock, which I was sick of. I decided to create a band whose music would be unclassifiable, neither rock, nor jazz, nor nothing. We failed, cos they put us under a label: new wave.* Listening to the 6 salvaged Kontrola W tracks that have survived, despite their poor recording quality, they possess an instantly recognizable originality: a precise and smooth as hell rhythm section (drummer Wojtek Jagielski, who in 'free' Poland became a talk-show celebrity) drives the motorik of *Bossa Nova*, which starts with a few seconds of scratching, compulsive guitar strings. An out-of-tune, sick, broken rockandroll, the song progresses in angular groans and whines of guitar, accompanied with the self-possessed, very capricious

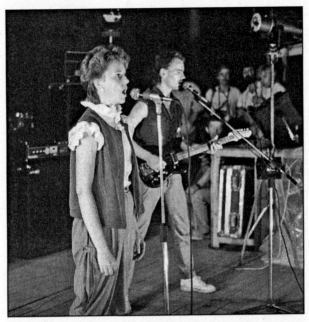

5.16 Kontrola W. Jarocin 1983, photographed by Ryszard Gajewski

screech of Kasia Kulda, in which she's trying to get rid of an importunate lover: *When there's nothing to talk about/ you persecute me at every step/ Crawling upon my feet (…)/ and if this doesn't bring effect/ you can only sing this old tune: Bossa Nova!* Kulda sings with a sharpness and panache that Siouxie Sioux would be jealous of, if she had only known about it.

In the complicated ways of the development of popular music in the Soviet Bloc it's easy to classify bands immediately as some sorts of poor, oppressed oppositionists. On both sides of the Curtain the youth felt that the current political order was wrong, that there were no opportunities for people like them. The music arising everywhere in the punk era, regardless of whether it was Eastern or Western, was directed by a similar impulse of disillusionment, of taking things in one's hands, an ability to express anger and dissatisfaction. On both sides it was a manifestation of the dispossessed: the fact that the Western youth were rejecting the

comfortable lifestyle of baby boomers, and the fact Poles had nothing to lose doesn't change this. This strange time between the fake promise of bling and the grey, concrete reality resulted in a sudden change in more mainstream Polish pop, which embraced and flirted with the fallen dreams of beautiful commodities that hadn't exactly turned into reality. The historical, economic and cultural moment was perfect for this: the old cynicism of the Party was replaced by the enthusiasm of Solidarity, and the old truths didn't matter anymore. Be it the scarcity of the official culture or the hunger for emancipation, Polish popular music in the break between the 1970s and 1980s spawned more interesting female vocalists and music personalities than ever before or after.

Izabela Trojanowska was a one-woman Polish New Wave movement, whose populist songs picked up where punk left off. Drawing on the empowered feminine-but-tough girls of post punk and pop-punk - rapaciousness of Siouxie Sioux, the girlie charm of Debbie Harry or the boyishness of Chrissie Hynde - she added a completely new air of a mature sexy femininity. In Poland, she represented a completely new kind of a pop female performer with a quite shocking demeanor of self-confidence, sex and modernity. She wore short, predatory hair, strong make up with compulsory blood-red lipstick, and an aptly *garconne* wardrobe. Androgynous suits with a feminine, perverse twist, sequin blouses in dazzling whites and zero degree of sentimentality. Walking on her red stilettos with exaggerated puff shoulders, Trojanowska was rather a communist David Bowie/Klaus Nomi, a Thin White Duke and a Bauhausian doll, and harsher than any male performer ever in the Soviet Bloc - maybe, because she understood and played well with androgyny. In several photos she assumes a pose similar to Bowie, and in one TV programme even performed dressed as a Bowieesque New Romantic Pierrot, with glitter-brocade make up on her face. Iza wore both male and female clothes, always with a dominating air: jackets with spiky, "neo-gothic" collars and shoulders in striking, saturated colors, red and amaranth leather

5.17 In Poland, David Bowie was a woman. Izabela Trojanowska.

dresses and jackets; metallic, futuristic coats, like an elegant cyborg, akin to Sean Young in *Blade Runner*, and huge, futurist sunglasses. The whole of her person seemed to exude the metallic sheen of a sexy robot.

In this she was also predestined by the self-irony with which she smilingly rejected any possible feminine clichés of life in the Bloc. She was a Helmut Newtonesque scary businesswoman, who didn't have anywhere to go to work, so in her videos she posed by the only 'modern' looking shiny skyscrapers she could find in Warsaw. She used men like toys whenever she fancied, but mostly she was self sufficient, with strong *lesbienne* undertones a la Dietrich, or flirting with a glam vampirella look. A sharp gal who couldn't stand the failure of a boyfriend to give her *all she wanted, now*. No wonder one of the first drag queen shows in early 90s Poland was an Iza T. impersonation. Imagine the shock which this caused any typical Polish man, used to a housewife who'd hand

him a hot meal and slippers in their much–awaited two-bedroom flat. In her lyrics, she was shockingly sarcastic towards socialist efficiency, mocking both Socialist Realist Stakhanovites, and the prosaic reality of endless material lacks which was everything but glamorous. The heroic times of socialism were clearly gone, as Iza T. commented with a bored, sarcastic voice:

*No more Heroes… and even if, where to take them from?:*
*So much wealth has gone to waste*
*Laurel wreaths and golden ribbons*
*Nearly ready plinths*
 *On which already someone climbed before.*
*One misty morning the Endless Olympics flown away*
*There's no more demand for heroes*
*And even if, where to take them from?*
*The jolly dancing speaker's voice*
 *Doesn't solve problems anymore*
*Paper in hand, bored, they queue*
 *With Bolek & Lolek – what a waste*
*And it is harder every day*
*For girls to fall in love in vain.*
*No more heroes anymore…*

By then nobody believed in the system anymore, but here punk nihilism was taken up by commercial pop. As Iza rejected the idea of shacking up with a boy and waiting 10 years for a council flat, she mocked the scarcity of means, most famously in 'The Song of the Brick' – in which the chorus line "pass me a brick" is a reference to a 1950s Stalinist slogan of building communist Poland. There she was in 1980, recalling the times everybody wanted to forget: just like Wajda, bringing back the trauma of sotsrealism. During a memorable televised performance at the Opole festival in 1980, dressed in the exaggerated red cravat of a communist youth organisation member, surrounded by naked

musclemen painted gold (!) she parodied the positivist, brightly colored sotsrealist boom of growth and prosperity:

> Pass the brick, pass the brick
> Let's build a new house!
> Up to our aspirations – a house!
> Rain will stop, sun will rise
> A new harvest will grow
> Through our hearts and our hands!
> Our cause is simple, our goal is clear!
> You can hear our jolly song everywhere
> In a short moment we'll even touch the stars!
> Don't stay behind, if you don't want to be left alone!
> Spring will come, and immediately
> Hundreds of Steelworks will grow
> There will be plenty of everything!
> There's no paths or ways we couldn't reach!
> We know who's our friend or foe!
> Soon we'll embrace the whole world in our arms
> And who's not with us, is against us!

All this she sung with a flirty flippancy. Her character was too disillusioned, too cynical to believe either the authorities or the men's promises. She looks with pity at the boy, who talks about the bright future,

> You tell me 'just a bit effort and the world belongs to us'.
> Well, lets say – in eight years?
> A tower block flat and a small Fiat
> Don't even think you're gonna afford it
> Cos you can give me all I need now anyway!

Iza paved the way for several sharp female performers who appeared soon after. A French migrant, Richard Boulez, known for

wearing colorful clothes in Poland, became the chief stylist of Kora, the charismatic singer of Maanam. Boulez and Kora were like the Halston and Jerry Hall or Grace Jones and Jean Paul Goude of Polish new wave: the stylist-artiste and the it-girl who has it all. Kora wore Bowieesque kimonos and excessive heavy jewellery, on synthetic bright-colored vampish sets specially designed by Boulez. Shocking the public at the Opole '80 festival in dayglo-colored clothes singing *Divine Buenos Aires*, Kora was all desire: to travel, to meet people, to shag men, to explore, to have everything she wanted.

Another 'hot chick' was Urszula, a big glossy synth-pop diva, whose productions were close to Trevor Horn's ZTT or Art of Noise. Her composers dwelled on the earlier synthesized disco of Giorgio Moroder, but gave it the sassiness of Blondie and the sublimity of 'Blue Monday'. In Urszula's songs the most mundane neighbored the most fanciful. She also fantasized about luxurious commodities, as in the ultra-synthy *The Seasonal Fashion Frenzy*, where her character can't stop thinking about buying new glittery clothes. One could ask, where in the grey 80s could she find any? In her songs there appeared surrealist flights of fancy or tales of journeys to outer space, which also appeared in Polish post-punk and new wave music, as in Kapitan Nemo's heavily synthed 'Electronic Civilisation'. Kapitan Nemo aka Bogdan Gajkowski, self-styled minimal-wave futurist in a quirky bohemian black beret, was the great uncle of all today's 80s revivalists. In his *Wideonarkomania* he pioneered a still-fresh in PRL topic of addiction to television and the suddenly available world of VHS, with a pulsatingly colorful video, where sexual lust gets confused with Cronenbergian *Videodrome* fantasies. He sounds as if he already knew that 30 years later the generation of lo-fi "hypnanogics" and Hauntologists will put the washed out distorted VHS image retro aesthetic onto the pedestal of a hipster absolute. '*This is a new hash for the masses/White screen is shaking/One move and you already live in it! And after Bruce Lee/ a bit of sex before you fall asleep.*' Delicate female backing vocals,

heavy synths and an interest in the harshest modernity put him close to a Polish Phil Oakey with touches of Gary Numan. There are also common references to sotsrealism: in *Factory Love*, love is of course "tough as steel" and "according to the safety rules".

Unfortunately, in reality, we couldn't be driving further away from space and the computer world, as Soviet technology had its most modern, forward-thinking years already behind it. Paradoxically, when we caught up with the dominating futurist fashion within pop-culture, time-traveling and computer technology, as in the children's trilogy of *Pan Kleks*, we had lost any potential to even overtake the West with our ideas. Post-81 the socialist utopia started to growingly morph into dystopia.

The catastrophic SF of Piotr Szulkin, one of the most distinctive 80s Polish visionaries, disclosed a quite different realization of the futuristic dreams, filled with fear first at the communist, and then capitalist versions of totalitarianism. It's an Orwellian vision immersed in philosophical existential deliberations over the media, cynicism and the mental destruction of the individual. According to Szulkin's films, the Soviet Bloc will be destroyed by communism, after which capitalism will take over, and turn out to be equally destructive. In a very loose adaptation of Wells's *War of the Worlds* (1981), one country, which due to English names could seem Western, is invaded by Martians, who are a 'higher' civilisation - one which ruthlessly oppresses the lower one on earth, as the Martians are bloodthirsty, horrific creatures, who vampirically live off humans. The world becomes overpowered by cynical media exploitation, and a brutal state apparatus assumes absolute control.

Even if the intention was for Martians to stand in for the Soviet Union (who were supposedly on the verge of invading Poland in 1981, which was then "prevented" by the introduction of Martial Law by General Jaruzelski's junta), in fact they rather resemble the other Cold War Empire – The United States of America. Their omnivorous media, popular culture and capitalist greed seem to be something that bothers Szulkin even more than the Soviet reality,

as in *Ga Ga – Glory to the Heroes* (1985), where in post-communist, twenty-first century Americanized reality, humanity has conquered other planets. But on the colonized new worlds, mankind installs prostitution, vice and omnipresent media rule. In the finale, the hero is to be executed at a gigantic stadium media event broadcast across the entire solar system. We live in the world after the apocalypse, that's obvious: in 1984's *O-Bi, O-Ba, End of Civilisation*, after the nuclear war the whole humanity is reduced to living underground, like worms (several years before, and in a much more convincing way, than it was done by Emir Kusturica in *Underground*) and in these humiliating conditions they wait for the mythical Ark to take them away, the Second Coming, not knowing it's only the criminal state apparatus's propaganda. Instead of the Ark coming, the copula over the pitiful hole humankind lives in is collapsing. Still, the light revealed by the cracks is taken by the humans as the arrival of the Ark. Space in Szulkin's films is nearly always one or another form of prison: people vegetate in claustrophobic, dirty hovels, waiting for miracles that never come.

At the time Szulkin was developing his visions, People's Poland was in some of its darkest periods. We had rather more mundane problems, with austerity after the Martial Law and a collapsing economy. The topic of scarcity strangely enough must have become domesticated in the pop landscape of late *komuna*, because it kept coming back obsessively in pop music. Too down to earth to seriously debate about flying to space, Izabela stuck to disillusionment.

## Lost in Contradictory Images

One of the things that has been growing obvious in the most interesting contemporary art in Poland is an interest in the visual culture imagery of the communist past. With delight artists take up and paint or re-enact aesthetic elements of the everyday life of PRL. This trend remains charmingly and quite openly close to the more general, hipster gesture of cherishing retro for its own sake. Slawek

5.18 Richard Boulez and Kora, 1983, photo by Tadeusz Rolke

Elsner repainted dozens of images from the popular weekly *Panorama*, in which he also mimed the poor print quality of 70s Poland. Paulina Ołowska, meanwhile, does not stop at re-enacting only the aesthetics, she re-enacts whole situations and elements of everyday life. She repaints the popular visual elements of socialist life: postcards with DIY fashion, often bizarre and on the verge of kitsch yet too strange to become it, or magazine covers and punk leaflets. She makes collages, merges the original print and her

creation, which become indistinguishable. Part of the appeal of Ołowska's adaptations is the sheer love of clothes. In this way she builds a significant relationship with the period, and can't be reduced just to empty retro posing of a fashionista. Maybe it's the love of material culture that puts a bridge between an empty retro-mania and the ideology these aesthetics represent. But does Ołowska identify with the women who had to sew their own clothes, as there was nothing in the shops, or is she just amused with their earnestness? Using that expression from Tyrmand, *Applied Fantastics*, she stresses rather the ironic aspect of how living in PRL meant constant improvisation and miracle-making on an everyday basis. And somehow, she's then seduced by this miracle.

It's obvious that in the work of Elsner or Ołowska, where the communist past undergoes a painterly conceptual resurrection, there's a strong hint of nostalgia - a nostalgia often inspired by the disappointment the post-89 culture brought, also visually. But this seeming longing for PRL has to be constantly disavowed. 'Polish magazines stayed on a very poor editorial level, especially litho-graphic and print techniques' says curator/gallerist Łukasz Gorczyca in his text for a catalogue of Slawek Elsner's works. Yet, as we've seen, Polish magazines like *Przekroj* and *Ty I Ja* showed a rather high and even innovatory level of originality. Polish magazines weren't just simply the poor imitation of the Western model of consumption, as Gorczyca suggests, they were often trying to build their own version of lifestyle. Yes, they were restricted by the shabbiness and limitations of real socialism, but the lacks they had made them aspire to create something on their own. Interestingly, whenever the topic of nostalgia after the aesthetics of Soviet times comes up, commentators and theorists rush immediately to assure us it has nothing to do with the politics. The recent interest of young Russians in Soviet cinema or old games, or anything connected with the system is, apparently, apolitical. Maybe this is typical of the weakness of so much of current political aesthetics, which is not politicized enough,

uprooted from its original meaning and in the end, pretty but meaningless. Photographs of people enjoying themselves in the DDR or USSR can be found all over the internet. But then people enjoyed their life and holidays also under fascism. An image proving that people enjoyed themselves playing ping pong under communism doesn't actually prove anything in particular.

„Polowanie"

5.19a DIY as a way of survival. A popular series of ideas for knitwear which will inspire artist Paulina Olowska decades later. Here 'Hunting'.

We'll never get an honest reassessment of the past if we keep denying that this nostalgia at play is also political. Or rather – that it suggests the death or lack of the politics which made certain positive elements of this reality possible. Yet the nostalgia or even sheer curiosity after this period is enormous. Any books, gadgets, memoirs, films issued from the post-war era, regardless of their value, are meeting with popularity, not only in Poland, but in all ex-Bloc countries. Socialist modernist architecture is being constantly revived. The most popular current books are invariably either memoirs from PRL (Lech Wałęsa's wife Danuta, the daughter of General Jaruzelski, or Jerzy Urban, the notorious government PR in PRL and in free Poland the king of the gutter press - to name just the biggest) or historical books, alternately endorsing and condemning PRL as a criminal regime or an "occupation". Blogs of the gadget and

5.19b Spoof or original. Paulina Olowska playing with the aesthetics of PRL within post-modern painting. Cake, courtesy of Metro Pictures.

„Torcik"

lifestyle aficionados mushroom everywhere. There're even attempts to "live in PRL" – people who have decided to live as if 1989 never happened: for a year one couple wore, ate, read and consumed only goods produced in PRL, after which they published a book about the experience.

In this way the creation of the phantasm called 'PRL' becomes just the superficial question of wearing a specific kind of clothes, living in cheesy design or eating retro bad-quality food, without any attempt to dig into the meaning of this time. There's just a façade, with nothing in terms of actual rethinking of the ideology, apart, of course, from total condemnation. But the dominating nostalgia does say more about us than we want to admit. We do feel traumatized by the transition, we do feel something is missing, but we don't openly address it. We don't want the simplistic narrative where Vaclav Havel and Adam Michnik save the world, because we feel that this isn't true. There are many academic dissertations on that period published, but nobody is trying to look at the current financial crisis and the emerging protests and the current fascination with the past as part of the same phenomenon. We may live still among the – now shrinking – architectural decorations of communism, but communism itself still stands somewhere undiscovered in its practical essence.

# Afterword

This book has probably ended up having much more of a 'local' perspective than was originally intended. I wanted to render several obsessions of this greatly obscured era, and to rectify the omissions I saw in the literature. Since I began writing this book in 2012, the political and social situation of the countries discussed were (and are) changing every day. I also focused more on Poland and the closer 'East' and less on Russia, which right now seems to be facing the greater upheaval. I tried to capture the main currents and motivations of these countries and the perceptions the West (understood mostly as Western Europe and the US), has about it, or perhaps, doesn't have at all. Living between the constant wish of being 'more appreciated by the West' and a curious wounded pride is the current reality, but must it be necessarily the destiny of the East? There are many possible answers to that. There are attempts in today's scholarship at retrieving the positive out of the position of a 'Slav' which so often in history rhymed and combined with that of a 'slave'. We were the Slaves of Europe and the first real periphery of the capitalist West, and the center cannot live without the periphery.

It is hard to talk about any "specter haunting Europe" yet, but something has happened recently. As austerity measures are taking their toll, we are surrounded by the rhetoric of scarcity. There's no more money, politicians convince us – the resources have run out. But to demand more, to demand the return of the welfare state, would be more than just childishness on the part of the impoverished – it'd be calling for… communism! Even though according to the world news, we've just had two years of constant protests, dissent and revolution, Eastern Springs, riots, Greek and Spanish hot summers, it seems that the only thing we don't have is a consolidated left. Apart from SYRIZA in Greece, who were the only far-left party in recent decades to come close to forming a government,

leftist parties are in defeat, never recovered since the 1970s. We are on the brink of the biggest crisis of capitalism in history, yet even at the slightest sound of reforms a Democrat like Barack Obama, much more economically conservative than the Republicans of the Roosevelt or even Nixon era, is called a "socialist". In *The Communist Horizon*, Jodi Dean, a professor in New York from a new generation of American Marxists, gave a full list of the new Red Scare rhetoric in America and elsewhere. The welfare state, free healthcare, free education, equality, feminism, taxation – all this belongs to the great Communist Menace, socialists lingering just round the corner. 'Communists' protested against the Iraq war, didn't vote for Bush Jr., want to tax the rich and regulate the market, support insurance and food stamps. Among the bank bailouts and cuts an unbelievable thing has happened: as we can see in Poland, it's the capitalists who speak to us in the tone of victims.

How, in the face of the current upheaval, can we regain the positive meaning of communism and use it to the left's empowerment? There's an internet meme called "Full Communism", a half-prank, half-serious critique, mostly from anarchist circles, of the left's reformism. Dean is significantly more serious than that, but she insists on divorcing the meaning of the word from its previous historical applications. Her major aim is to release the left from the deep sense of shame into which the liberal critique of communism has put it. "The mistake leftists make when we turn into liberals and democrats", she says, "is thinking that we're beyond the communist horizon, that democracy replaced communism, when it serves as the contemporary form of communist displacement", whereas "capitalism always interlinks with conflict, resistance, accommodation and demands. Refusal to engage in these struggles affects the form capitalism takes". It's a bit like Bertolt Brecht's claim in conversations with Walter Benjamin: "It's not communism but capitalism that's radical." Because it's capitalism that destroys and creates, and goes forward no matter what, and communism that wants to put the brakes onto it, to stop

it and make it think. Conservatives somehow succeeded in presenting themselves as those who come to help, despite destroying the bonds of solidarity and hence not being 'conservative' at all, pushing the destructive agenda of shock therapy. The left should stop being afraid of winning and being in the spotlight, says Dean, who wonders ironically why re-using the words "proletariat" or "bourgeoisie" seem ludicrous, while competition, efficiency, stock markets, bonuses and financial success, or the re-branding of feminism don't. All that serves to prevent us from recognizing and obliterating notions of class, work, division, inequality or privilege.

What, however, about those who remember a quite different 'communism'? It remains a dirty, bad word for those, including large parts of the left, who invariably associate it with the East, whether the USSR and its satellites, or China, to prove that it's invariably a failed project - moreover, a murderous one. In Poland, for instance, hatred of 'communism' is the only thing that unites our conflicting camps. In many ex-communist countries, especially those which joined the EU, this is a verboten word, that sends us straight back to the Gulag: when *Krytyka Polityczna* put out a selection of Lenin's works edited by and with a preface by Slavoj Žižek, it faced ostracism, and the right-wing government managed to put a ban on communist ideology equally with Nazism. You can't publish *The Communist Manifesto* in parts of the ex-Bloc without risking a fine or a ban. Meanwhile, East European representatives in the European Parliament recently tabled an official declaration that communism and fascism were equivalent. Žižek, as a former communist dissident himself, has had a huge role in rehabilitating and restoring the idea of communism as a possibility, beyond its failed realizations from the past. Dean, who does not have a background in Soviet studies, came to the idea via Western Marxism, and prefers to cite Latin American rather than East European Communists, which is admirably internationalist – but it would have been helpful if she had something to say to those for

whom the word is anathema for more reasons than red-baiting.

'The big transformative questions have generally been forgotten", said the late Eric Hobsbawm, displaced by "fanzine history, which groups write in order to feel better about themselves". Despite for the last three decades critiquing the Soviet Union, until the end Hobsbawm's 'unrepentant communism' was still hugely controversial. There's a good reason why the word instills fear during a capitalist meltdown. One of the toughest questions for any leftist is the political legacy of the Soviet Bloc. While many of us, their former residents, constantly refer to the socialist past as deeply flawed, we seem strangely possessive of the term, one that today, perhaps, has a completely different meaning and regains it in the time of crisis. Liberals in Poland routinely equate Vladimir Putin and Hugo Chavez, but their example couldn't be more different. Socialist ideas of some sort are still vital in the parts of the world that are unified by the fact they're not and never will be the 'center' – Venezuela, Bolivia, Ecuador and others are now struggling to came up with new economic policies that claim to be socialist, while the former East of Europe only ever considered a singular, and Western, option. East-West binarisms haunt us still, though, because for five decades the Cold War provided the framework and a mutual narrative, which shaped people's lives. Being from the East, and its consequences, was and is real.

I intended this book to be a counter also against another current way of treating the recent past, especially post-1945. On the liberal left we have currently a renaissance of the 'spirit of '45', to name it after the recent film by Ken Loach. From the last writings of the late Tony Judt, to the engaged intelligentsia, we experience a renewal of popularity of the post-war consensus as a reaction to the current rampant neoliberalism. This call for the social democratic spirit has its good sides, e.g. its defence of the welfare state, but it ignores completely the fact that the spirit of '45 also included Cold War imperialism, often involving the repression of (often communist)

liberation movements through colonial wars in Indochina, Malaysia and elsewhere. With the exception of neutral Sweden and Finland, Western European countries were colonial empires and were all very pro-American, which all involved the isolation of Eastern Europe. At the core of this thinking there's a rejection and condemnation of what was happening on the other side of the Curtain and their post-war modernity. Modernity is good, but only that represented by the 'enlightened' part of Europe. Needless to say it's a narrative in which people from Eastern Europe cannot find themselves, nor find a positive proposition for the future.

The other approach is that of the hard left under the slogan of 'full communism'. In the works of Dean, Badiou, Negri and to an extent Slavoj Žižek, there is a radical vision of a new communism - yet, similar to their soft-left counterparts, they also don't see the communist East as a source of inspiration. They can only embrace the Cold War past of 'real socialism' through a disavowal. Removing Eastern Europe from the 'communist horizon' can result only in its marginalization. Somehow, we ourselves already did this work for the West. We so strongly believe we don't deserve the normal conditions of a social democracy that we hardly fight for it. Eastern Europe may continue to be the 'wild man of Europe', but it could use this position to remind the West of its errors and duties. Writing this book I realized how privileged we were as a part of the world which despite its tininess, could dictate and impose its ideals on the vast rest. Closeness to the Western world, especially the European Union, still is a massive advantage - it's sufficient to look at Poland and compare it to Belarus or Russia.

Because of that, what remains of the years '45-'90 east of the Elbe is mostly melancholia or nostalgia. The melancholic approach is visible everywhere: I described it in the chapter on Berlin, where there's either a restitution of the pre-war past at all cost, or the obsessive study over trauma. The 'traumatic studies' of communism occupy several books, where the work of 'mourning' replaces action in the present, from Charity Scribner's *Requiem for*

*Communism,* to Susan Buck-Morss's *Dreamworld and Catastrophe,* or the architectural activity of Daniel Libeskind, whose most prominent projects, like the Jewish Museum in Berlin, or the Military Museum in Dresden, are done in the high-class kitsch poetics of buildings incarnating 'the wounds of old Europe'.

In contrast to that, we could be addressing the contemporary history of the former East countries, and speaking about its notorious past, but in a dialectical way, where the reshaping of the past by the present and the present by the past can become visible. The world of thought, the political world, all are in great need of ideas. From time to time there's an excitation, as if there was a great new idea on the horizon, yet most often it turns out to be just another demand for an idea. One of the ideas in this book is: "why the periphery must stay the periphery", but maybe it should be: "how can the center learn from the periphery?" In a recent interview, Russian Marxist dissident Boris Kagarlitsky recounts an anecdote about a meeting with some young Swedish revolution-aries. During the intellectual dispute it was pretty boring, but after the lecture the youth wanted to drink bottled beer in the park. Yet there was no bottle opener. Suddenly there was a fright in the eyes of the students: how are we going to open the bottles? Kagarlitsky then opened the bottles using the table and then explained there's at least half dozen of other ways. "This is the difference between the Russian intellectual and Swedish revolutionary. They know that a bottle is opened with a special tool, a bottle opener." The East of Europe, culturally a part of the West, was pushed into a parallel reality for 45 years and some of its countries are still paying the price for it today, especially compared to the affluent West. But maybe we still can come up with ways to open things that you don't and didn't have to know about.

Warsaw 4/07/13

# Acknowledgements

Writing this book was an incredible challenge. A double challenge because of the language, which is not my own, and because I dare to propose this book to the Western reader, on things which are often quite alien to him. It was initially thought as a polemical, shortish book on Ostalgia – nostalgia after communism, or rather the critique of this concept as it was becoming popular in the West. Soon enough, as my own migrant existence was becoming more intense, this occurred to me as rather too shallow for a whole book. If I wanted to achieve anything by writing it though, then it's a calling for compassion and consideration to this vast cultural and societal complex called "Eastern Europe", as it is now and as it used to be. Also, in the process of researching and writing it, from the initially hostile position towards this concept, I was growing warmer and more compassionate about it. I feel that to admit that one's an Easterner can sound ridiculous today, but I also feel this distinction can act to our own benefit. What kind of world do we want? What position should Eastern Europe assume today towards its more powerful Western counterparts? I still of course haven't found an answer for it, but this book is a start.

Several articles published before in *The Guardian*, *The New Statesman*, *Architectural Review Asia Pacific*, *Calvert Journal* and *The Wire* made their way, in a changed form, to the book. Thank you Natalie Hanman, Philip Oltermann, Helen Lewis, Daniel Trilling, Simon Sellars, Frances Morgan and Jamie Rann for commissioning them. Chapter 3 is partly based on an essay called *Forefather's Eve. On the Embodiments of the Uncanny in Polish Culture* I published in 2008 in the Polish arts journal "Obieg". Here I used a greatly modified version of the original translation of that essay into English by K. Majus. With the exception of that, all translations used here are mine.

I want to thank first and foremost my partner Owen Hatherley,

without whom nothing: my stay in the UK, my immersion in the language, my decision to write the book and accomplishing it wouldn't be possible. He was cheering me on, always supportive and ready to help. I'm indebted to him in ways which I will probably never be able to reciprocate. I also thank to Tariq Goddard from Zero Books, who got interested and decided to publish a book by a Polish journalist. I thank Anna Aslanyan, Bobby Barry, Alex Niven and Daniel Trilling for reading my manuscript and for their instructive remarks. Special thanks go to Robert Jarosz, researcher, archivist and expert on Polish punk – his own research, his expanding archive "Trasa W-Z" as well as his assistance significantly widened my knowledge on this fascinating period of Polish underground culture in the last decade of communism. To his kind help I also owe several magnificent photographs in this book – here I thank the outstanding artists-photographers: Tadeusz Rolke – the legend of Polish photography, Mirosław Stępniak, Tomek Barasiński and Ryszard Gajewski, whose great works I have the honour to host in my book and who documented the last socialist avant-garde which happened in Poland. In the same way I thank Paulina Ołowska, charismatic contemporary artist of growing cult following, who kindly allowed her punk painting of band Kontrola W to be reproduced on this book's cover and whose captivating archival work of "repainting" the past, where the unobvious socialist glamour and grind go together hand by hand, embodies the "poor but sexy" spirit to me – the ways in which the past and present of the Eastern avant-garde cross their ways.

In this book I'm indebted to scholars David Crowley, Boris Groys and Justyna Jaworska, whose refreshing approach to the Eastern European studies and ways of seeing the communist past I find very inspiring and which encouraged me to make my own move and attempt my own contribution. Equally inspirational was the style of music journalism of Chris Bohn aka Biba Kopf, who put a bridge between the East and Western music already in the 80s and

is the only music writer I can think of who understood both. I also thank my parents, Iwona and Tomasz Pyzik, for sending me to English lessons since the age of 8 and taking great care about my education, so that I could come to another country without fear and become a writer in another language.

Warszawa, 21/08/2013

# Further Reading

## Introduction

Svetlana Boym, *The Future of Nostalgia* (Basic Books 2002)

Gareth Dale (editor), *First The Transition, then the Crash. Eastern Europe in the 2000s* (Pluto Press, 2011)

Boris Groys, *The Communist Postscript* (Verso 2010)

Agata Pyzik, 'Poles are here to stay, but it will take time to make a cultural splash', *The Guardian*, http://www.theguardian.com/commentisfree/2012/dec/12/poles-britain-cultural-splash

Lukasz Ronduda, Alex Farquarson, Barbara Piwowarska (eds), *Star City – The Future Under Communism* (Nottingham Contemporary, 2011)

Dubravka Ugresić, 'To be Yugoslav now requires a footnote', (interview), at *Balkan Insight* http://www.balkaninsight.com/en/article/to-be-yugoslav-now-requires-a-footnote

## Chapter 1

A.M Bakalar, *Madame Mephisto* (Stork Press, 2012)

Ekaterina Degot and Ilya Budraiskis (eds), *Post-Post-Soviet – Art, Politics and Society in Russia at the Turn of the Decade* (Museum of Modern Art Warsaw, 2013)

Elizabeth Dunn, *Privatising Poland. Baby Food, Big Business and the Remaking of Labor* (Cornell University Press, 2004)

Andreas Huyssen, *Twilight Memories. Marking Time in the Culture of Amnesia* (Routledge, 1995)

Christina Kiaer, *Imagine No Posessions. The Socialist Objects of Russian Consctructivism*, (MIT Press, 2008)

Susanne Ledanff, 'The Palace of the Republic versus the Stadtschloss', *German Politics & Society*, Volume 21, Number 4, Winter 2003

David Ost, *The Defeat of Solidarity. Anger and Politics in Post-communist Europe*, (Cornell University Press, 2006)

Grazyna Plebanek, *Illegal Liasons* (Stork Press, 2012)

Agata Pyzik, 'Poland's Left-wing voices are being silenced', *Comment is Free*, 24 October 2012, http://www.theguardian.com /commentisfree/2012/oct/24/poland-leftwing-voices-silenced

'How people in Poland are kept from the streets', *New Statesman*, 11 July 2013

'Ostalgia Trips', *Frieze*, 11 October 2011 http://blog.frieze .com/ostalgia/

Marci Shore, *The Taste of Ashes*, (William Heinemann 2013)

Marzena Sowa and Sylvain Savoia, *Marzi – A Memoir* (Vertigo, 2011)

Blog consulted: Beyond the Transition, by Gavin Rae, at http://beyondthetransition.blogspot.co.uk/

## Chapter 2

Misha Baster, *Hooligans-80* (Anok TCI, 2009)

Deborah Curtis, *Touching from a Distance* (Faber, 1995)

Rolf Helleburst, *Flesh to Metal: Soviet Literature and the Alchemy of Revolution*, 2003

Robert Jarosz, Michał Wasążnik, *Generacja*, (Ha!art, 2011)

Theo Lessour, *Berlin Sampler*, (Ollendorf Verlag Berlin, 2012)

Mirosław Makowski, *Obok albo ile procent Babilonu?*, (Manufaktura Legenda, 2012)

Agata Pyzik, 'Laibach: Monumental Avant-Garde, Tate Modern', in *The Wire*, #340

Christopher Sandford, *Bowie: Loving the Alien*, (da Capo Press, 2005)

Jon Savage, *Time Travel* (Vintage, 1997)

Jennifer Shryane, *Blixa Bargeld and Einsturzende Neubauten – German Experimental Music* (Ashgate, 2012)

Andrzej Sosnowski, *Lodgings – Selected Poems* (Open Letter, 2011)

Kostek Usenko, *Oczami radzieckiej zabawki*, (Czarne 2012)

Blog consulted: Pushing Ahead of the Dame, by Chris O'Leary, at www.bowiesongs.wordpress.com

## Chapter 3

John Ashbery, *Other Traditions*, (Harvard University Press 2001)

Marek Bieńczyk, *Melancholia, O tych, co nigdy nie odnajdą straty*, (Sic! 2000)

Sigmund Freud, *The Uncanny*, (Penguin, 2003)

Witold Gombrowicz, *Trans-Atlantyk* (Yale University Press, 1995)

*Inhibition*, exhibition catalogue (Ha!Art 2007)

Maria Janion, *Niesamowita Słowiańczczyzna*, (Wydanictwo Literackie, 2006)

Maria Janion, *Do Europy, Tak, ale z naszymi umarłymi* (Wydanictwo Sic!, 2000)

Maria Janion, *Gorączka Romantyczna*, (Slowo/obraz terytoria, 2008)

Lechosław Lameński, *Stach z Warty Szukalski* (Wydanictwo KUL, 2007)

Adam Mickiewicz, *Forefather's Eve* (School of Slavonic Studies, 1925)

Ryszard Przybylski, *Słowo i milczenie bohatera Polaków* (Instytut Badań Literackich, 1993)

Agata Pyzik, 'White doesn't always mean privileged: Why Femen's post-Soviet context matters', *New Statesman*, 18 April 2013, at http://www.newstatesman.com/voices/2013/04/white-doesnt-always-mean-privilege-femens-ukrainian-context

Andrzej Walicki, *Stanislaw Brzozowski and the Polish Beginnings of ' Western Marxism'*, (Clarendon Press, 1989)

Stanislaw Ignacy Witkiewicz, *Insatiability* (Northwestern University Press, 2001)

Ilinca Zarifopol-Johnston, *Searching for Cioran* (Indiana University Press, 2009)

## Chapter 4

Adorno, Benjamin, Bloch, Jameson, Lukacs, *Aesthetics and Politics* (Verso, 2007)

Daniela Berghahn, *Hollywood Behind the Wall – the Cinema of East Germany* (Manchester University Press, 2005)

Clare Bishop, 'The Social Turn - Collaboration and its Discontents', *Artforum* 2006

Ben Brewster, 'Nowy LEF Documents' in *Screen* (1971) 12(4)

Matthew Cullerne Bown, *Socialist Realist Painting* (Yale University Press, 1998)

Evgeny Dobrenko (editor), *Socialist Realism Without Shores* (Duke Universoty Press, 1997)

Boris Groys, *The Total Art of Stalinism* (Verso, 2012)

Fredric Jameson, *Postmodernism, or the cultural logic of late capitalism* (Verso, 1992)

Christina Kiaer, Was Socialist Realism Forced Labour? The Case of Aleksandr Deineka, Oxford Art Journal, vol. 28, number 3, 2005

György Lukács, *The Meaning of Contemporary Realism* (Merlin Press, 1979)

Alex Niven, *Folk Opposition* (Zero Books, 2012)

Piotr Piotrowski, *In the Shadow of Yalta* (Reaktion, 2011)
— *Art and Democracy in Post-Communist Europe* (Reaktion, 2012)

Agata Pyzik, 'A sense of community in Polish Art', *The Guardian*, 17 April, 2011 http://www.theguardian.com/commentisfree/2011/apr/17/poland-art-critical-communism-polska

Derek Spring and Richard Taylor (eds), *Stalinism and Soviet Cinema* (Routledge, 2011)

Hito Steyerl, 'Is The Museum a Factory?', in *e-flux journal*, at http://www.e-flux.com/journal/is-a-museum-a-factory/

Peter Weiss, *The Aesthetics Of Resistance* (Duke University Press, 2005)

Slavoj Žižek, *For they Know Not What They Do* (Verso, 2008)

Artur Zmijewski, 'Applied Social Arts', in *Krytyka Polityczna*, at http://www.krytykapolityczna.pl/English/Zmijewski-Applied-Social-Arts/menu-id-240.html

*Ot avangarda do postmodernizma. Mastiera Isskustva XX Veka* (Tretyakov Gallery Catalogue, Moscow 2006)

Blog consulted, Hannah Proctor, at http://hhnnccnnll.tumblr.com/

## Chapter 5

David Crowley, Jane Pavitt (eds), *Cold-War Modern*, (Victoria & Albert Museum, 2008)

Artur Domosławski, *Kapuściński – A Life* (Verso, 2012)

Slavenka Drakulić, *Café Europa* (Penguin, 1999)

Isaac Deutscher, *Russia, China and the West, 1953-66* (Penguin, 1970)

Sławek Elsner, *Panorama* (Dumont, 2008)

Dick Hebdige, *Hiding in the Light: On Images and Things* (Taylor and Francis, 1988)

Sanja Ivekovic, *Unknown Heroine*, exhibition catalogue, (Calvert 22, 2013)

Justyna Jaworska, *Cywilizacja Przekroju*, (WUW, 2008)

Milena Jesenska, *The Journalism of Milena Jesenska, A critical Voice in the Interwar Eastern Europe*, edited by Kathleen Hayes, (Berghahn Books, 2003)

Jan Kamyczek, Barbara Hoff, *Jak oni mają się ubierać?*, (Iskry, 1958)

Andrzej Leder, 'Kto Nam Zabrał Tę Rewolucję?' in *Krytyka Polityczna*, at http://www.krytykapolityczna.pl/artykuly/opinie/20130419/leder-kto-nam-zabral-te-rewolucje

Eduard Limonov, *Memoirs of a Russian Punk* (Grove Press, 1990)

Paulina Ołowska, *Book*, (jrp ringier, 2013)

"Piktogram", magazine, no.16 2011/2012.

Agata Pyzik, 'Review: Artur Domoslawski, *Kapuściński – A Life*', *The Guardian*, 2 August 2012

— 'The Many Returns of Socialist Realism', *Afterall*, 2 May 2012 http://www.afterall.org/online/the-many-returns-of-socialist-realism/1

Francis Spufford, *Red Plenty* (Faber, 2012)

Leopold Tyrmand, *Dziennik 1954* (Wydanictwo MG, 2011)

— *Zły* (Wydanictwo MG, 2011) (English translation as Man With White Eyes, Knopf 1959)

— *The Rosa Luxemburg Contraceptives Co-Operative* (Macmillan, 1971)

*We Want To Be Modern. Polish design 1955-1968 from the collection of National Museum in Warsaw*, exhibition catalogue (National Museum in Warsaw, 2011)

## Afterword

Susan Buck-Morss, *Dreamworld and Catastrophe* (MIT Press, 2002)
Jodi Dean, *The Communist Horizon* (Verso, 2012)
Tony Judt, *Ill Fares The Land* (Penguin, 2011)
Charity Scribner, *Requiem for Communism* (MIT Press, 2005)

## Further Listening

David Bowie, *Diamond Dogs* (RCA, 1974),
— *"Heroes"* (RCA, 1977)
— *Low* (RCA, 1977)
— *Station to Station* (RCA, 1976)
— *The Next Day* (ISO, 2013)
Depeche Mode, *Construction Time Again* (Mute, 1983)
— *The Singles 1981-85* (Mute, 1985)
— *Some Great Reward* (Mute, 1984)
Deutsche Amerikanische Freundschaft, *Alles ist Gut* (Mute, 1981)
— *Die Kleinen Und Die Bosen* (Mute, 1980)
Joy Division, *Unknown Pleasures* (Factory, 1979)
Einsturzende Nuebauten, whole discography, especially *Kollaps* (ZickZack, 1981), *Silence is Sexy* (Mute, 2000)
Kapitan Nemo, *Kapitan Nemo* (Tonpress, 1986)
— *The Best of Kapitan Nemo* (Sonic, 1996)
Krzysztof Komeda, *The Complete Recordings* (Polonia, 1996)
Andrzej Korzyński, *Possession* (Finders Keepers 2011)
— *Third Part of The Night* (Finders Keepers 2012)
— *Secret Enigma* (Finders Keepers (2012)
Laibach, *Opus Dei* (Mute, 1987)
Maanam, *The Singles Collection* (InterSonus, 1991)
The Sex Pistols, 'Holidays in the Sun' (Virgin, 1977)
Izabela Trojanowska, *Iza* (Tonpress, 1981)

— *Układy* (Tonpress, 1982)

Ultravox! *Ha! Ha! Ha!* (Island, 1977)

— *Systems of Romance* (Island, 1978)

— *Vienna* (Chrysalis, 1981)

Urszula, *Malinowy Król*, (Polton, 1985)

Vice Versa, 'Stilyagi' (Backstreet Backlash, 1980)

Visage, *Visage* (Polydor, 1980)

Wielkanoc, *Dziewczyny Karabiny*, (W Moich Ovzach Trasa W-Z, 2011)

Xex, *Group: Xex* (What's that Music, 1980)

*Zagubiona generacja* (Noise Pop, 1998)

*Złote Przeboje Socjalizmu Cz. 1* (*Golden Hits of Socialism*) (Polskie Nagrania, 2005)

## Further Viewing

*4* (Ilya Krzhanovsky, 2006)

*4 Months, 3 Weeks, 2 Days* (Christian Mungiu, 2007)

*Academy of Mr. Kleks* (Krzysztof Gradowski, 1983)

*Bildnis einer Trinkerin* (Ulrike Ottinger, 1979)

*Born in 45* (Jürgen Böttcher, 1965)

*Border Street* (Aleksander Ford, 1948)

*Boys From Barska Street* (Aleksander Ford, 1953)

*Christiane F – Wir Sind Kinder von Bahnhof Zoo* (Uli Edel, 1981)

*Czarna seria* (Black series of Polish documentary) (J. Hoffmann, E. Skórzewski and others, 1954-59)

*Daisies* (Vera Chytilova, 1966)

*Decoder* (Mucha, 1984)

*Dekalog* (Krzysztof Kieslowski, 1988)

*Democracies* (Artur Żmijewski, 2008-ongoing)

*Divided Heaven* (Konrad Wolf, 1964)

*The Ear* (Karel Kachyna, 1969)

*Eskimo Woman Is Cold* (Janos Xantus, 1983)

*Ga Ga Glory to the Heroes* (Piotr Szulkin, 1985)

*Goodbye, See You Tomorrow* (Janusz Morgenstern, 1961)

*Generation* (Andrzej Wajda, 1954)

*Hiroshima Mon Amour* (Alain Resnais, 1961)

*Hot Summer* (Joachim Hassler, 1968)

*In A Year of Thirteen Moons* (RW Fassbinder, 1978)

*Innocent Sorcerers* (Andrzej Wajda, 1960)

*It's a Free World* (Ken Loach, 2006)

*I was Nineteen* (Konrad Wolf, 1968)

*Jowita* (Janusz Morgenstern, 1967)

*Liquid Sky* (Slava Tsukerman, 1983)

*Lift to the Scaffold* (Louis Malle, 1958)

*Mad Men* (Matthew Weiner and others, 2007-present)

*Man of Iron* (Andrzej Wajda, 1981)

*Man of Marble* (Andrzej Wajda, 1976)

*Mr Kleks in Space* (Krzysztoif Gradowski, 1988)

*The Murderers are Among Us* (Wolfgang Staudte, 1945)

*The Murder of Mister Devil* (Ester Krumbachova, 1970)

*Nirvana* (Igor Voloshin, 2006)

*O-Bi, O-Ba, end of Civilisation* (Piotr Szulkin, 1984)

*One, Two, Three* (Billy Wilder, 1961)

*The Party and the Guests* (Jan Nemec, 1966)

*This Love Has To Be Killed* (Janusz Morgenstern, 1972)

*Possession* (Andrzej Żuławski, 1980)

*Privilege* (Peter Watkins, 1967)

*The Rabbit Is Me* (Kurt Maetzig, 1965)

*Rotation* (Wolfgang Staudte, 1948/49)

*Solaris* (Andrey Tarkovsky, 1972)

*Solo Sunny* (Konrad Wolf, 1979)

*Single Woman* (Agnieszka Holland, 1981)

*The Sopranos* (David Chase and others, 1999-2007)

*Sunseekers* (Konrad Wolf, 1958/72)

*Stalker* (Andrey Tarkovsky, 1979)

*The Pictures Came From The Walls* (Jeremy Deller, 2009)

*Third Part of the Night* (Andrzej Żuławski, 197)

*Trace of Stones* (Frank Beyer, 1966)

*Travels of Mr Kleks* (Krzysztof Gradowski, 1985)
*War of the Worlds* (Piotr Szulkin, 1981)
*The Wire* (David Simon and others, 2001-2005)
*When I'm Dead and Pale* (Zivojin Pavlović, 1967)
*Workers Leaving the Factory* (Harun Farocki, 1995)
*You Are God* (Leszek Dawid, Poland, 2012)

Contemporary culture has eliminated both the concept of the public and the figure of the intellectual. Former public spaces – both physical and cultural – are now either derelict or colonized by advertising. A cretinous anti-intellectualism presides, cheerled by expensively educated hacks in the pay of multinational corporations who reassure their bored readers that there is no need to rouse themselves from their interpassive stupor. The informal censorship internalized and propagated by the cultural workers of late capitalism generates a banal conformity that the propaganda chiefs of Stalinism could only ever have dreamt of imposing. Zer0 Books knows that another kind of discourse – intellectual without being academic, popular without being populist – is not only possible: it is already flourishing, in the regions beyond the striplit malls of so-called mass media and the neurotically bureaucratic halls of the academy. Zer0 is committed to the idea of publishing as a making public of the intellectual. It is convinced that in the unthinking, blandly consensual culture in which we live, critical and engaged theoretical reflection is more important than ever before.